A Year in Art
A Masterpiece a Day

ART FROM THE STAATLICHE MUSEEN ZU BERLIN

In cooperation with bpk Bildagentur für Kunst, Kultur und Geschichte

SM
B Staatliche Museen
zu Berlin

PRESTEL

Munich · Berlin · London · New York

© Prestel Verlag, Munich · Berlin · London · New York, 2008

© of works illustrated by the artists, their heirs or assigns with the exception of: Max Beckmann, Marc Chagall, Giorgio de Chirico, Max Ernst, Lyonel Feininger, Hannah Höch, Wassily Kandinsky, Alex Katz, Paul Klee, Fernand Léger, and Sol LeWitt by VG Bild-Kunst, Bonn 2008; Salvador Dalí by Salvador Dalí, Fundació Gala-Salvador Dalí/VG Bild-Kunst, Bonn 2008; Alberto Giacometti by ADAGP/FAAG, Paris/VG Bild-Kunst, Bonn 2008; Henri Matisse by Succession H. Matisse/VG Bild-Kunst, Bonn 2008; Joan Miró by Successió Miró/VG Bild-Kunst, Bonn 2008; Edvard Munch by The Munch Museum/The Munch Ellingsen Group/VG Bild-Kunst, Bonn 2008; Pablo Picasso by Succession Picasso/ VG Bild-Kunst, Bonn 2008
Erich Heckel by Nachlass Erich Heckel, Hemmenhofen
Georg Baselitz © by Georg Baselitz
Ernst Wilhelm Nay © by Ernst Wilhelm Nay
Gerhard Richter © by Gerhard Richter
Ed Ruscha © Ed Ruscha. Courtesy Gagosian Gallery

Prestel Verlag
Königinstraße 9, 80539 Munich
Tel. +49 (0)89 242 908-300
Fax +49 (0)89 242 908-335

Prestel Publishing Ltd.
4 Bloomsbury Place, London WC1A 2QA
Tel. +44 (0) 20 7323-5004
Fax +44 (0) 20 7636-8004

Prestel Publishing
900 Broadway. Suite 603
New York, N.Y. 10003
Tel. +1 (212) 995-2720
Fax +1 (212) 995-2733
www.prestel.com

The Library of Congress Control Number: 2008933300

British Library Cataloguing-in-Publication Data: a catalogue record for this book is available from the British Library.

The Deutsche Bibliothek holds a record of this publication in the Deutsche Nationalbibliografie; detailed bibliographical data can be found under: http://dnb.ddb.de

Prestel books are available worldwide. Please contact your nearest bookseller or one of the above addresses for information concerning your local distributor.

Editorial direction by Katharina Haderer and Claudia Stäuble
Copyedited by Chris Murray, Crewe
Quotes: Claudia Hellmann, Edgar Kroll, Katie Singles
Picture research for the Staatliche Museen zu Berlin: Lynn Rother
Cover and layout concept by LIQUID, Augsburg
Production by Astrid Wedemeyer
Origination by ReproLine Mediateam
Printing and binding by C&C Printing

Printed on acid-free paper

ISBN 978-3-7913-4074-6

The aim of art is to represent not the outward appearance of things, but their inward significance.

ARISTOTLE

Beauty, sweet Love, is like the morning dew,
Whose short refresh upon the tender green
Cheers for a time, but till the sun doth shew,
And straight 'tis gone as it had never been.

SAMUEL DANIEL

Young Lady with Pearl Necklace, *c.* 1662–1665
Jan Vermeer van Delft
Gemäldegalerie, Staatliche Museen zu Berlin

1 2 3 4 5 6 7 8 9 10 11 12 13 14 15 16 17 18 19 20 21 22 23 24 25 26 27 28 29 30 31

JANUARY

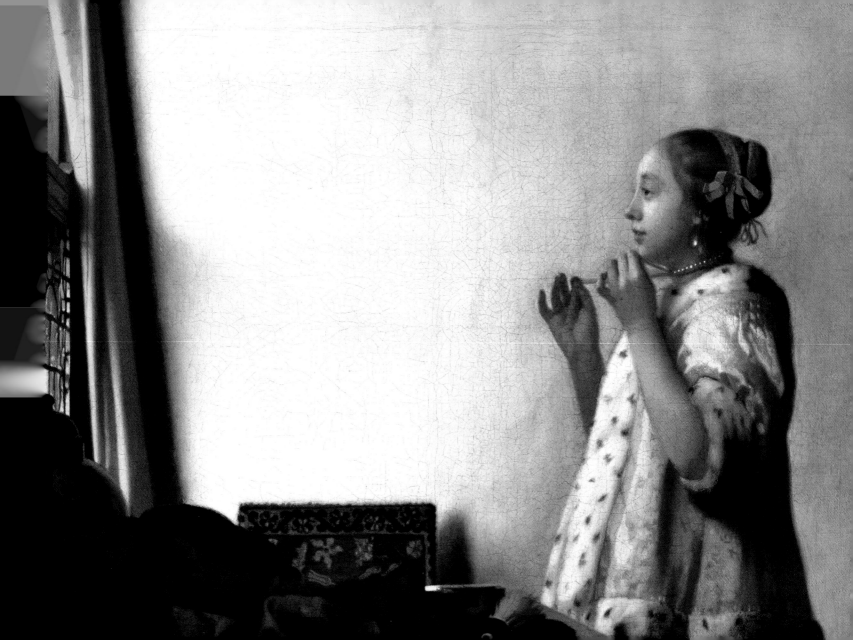

Today we are searching for things in nature that are hidden behind the veil of appearance... We look for and paint this inner, spiritual side of nature.

Franz Marc

Three Horses, 1913
Franz Marc
Nationalgalerie, Staatliche Museen zu Berlin

1 **2** 3 4 5 6 7 8 9 10 11 12 13 14 15 16 17 18 19 20 21 22 23 24 25 26 27 28 29 30 31

JANUARY

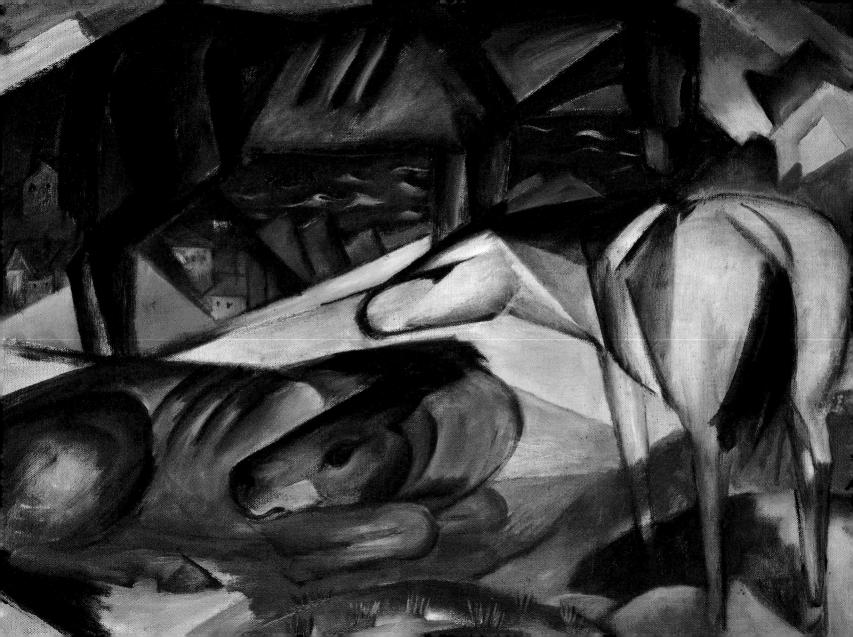

It is an old prerogative of kings
to govern everything but their passions.

Charles Dickens

Zeus in the Form of a Bull Abducting Europa,
High-classical period
Italy
Antikensammlung, Staatliche Museen zu Berlin

1 2 **3** 4 5 6 7 8 9 10 11 12 13 14 15 16 17 18 19 20 21 22 23 24 25 26 27 28 29 30 31

JANUARY

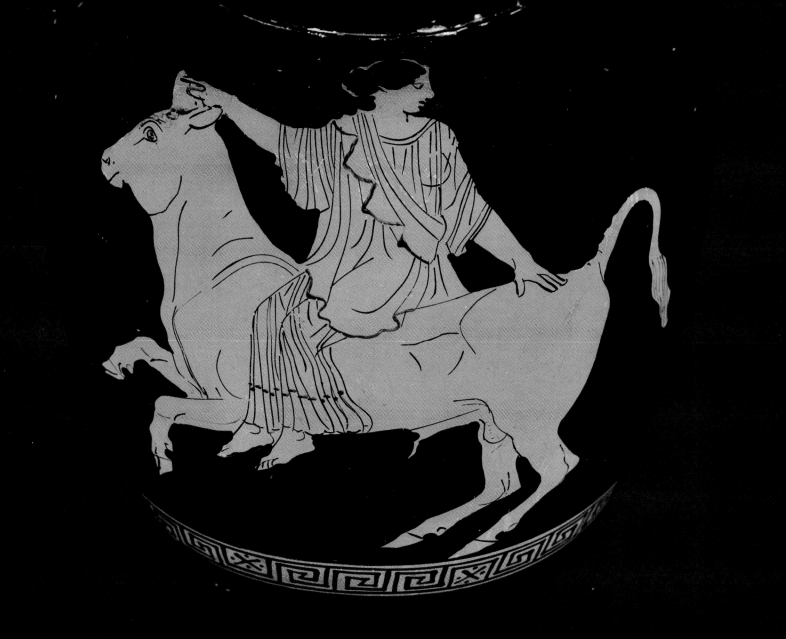

Through music the passions enjoy themselves.

Friedrich Nietzsche

The Three Minstrels, 1616–1620
Diego Rodriguez de Silva y Velázquez
Gemäldegalerie, Staatliche Museen zu Berlin

1 2 3 **4** 5 6 7 8 9 10 11 12 13 14 15 16 17 18 19 20 21 22 23 24 25 26 27 28 29 30 31

JANUARY

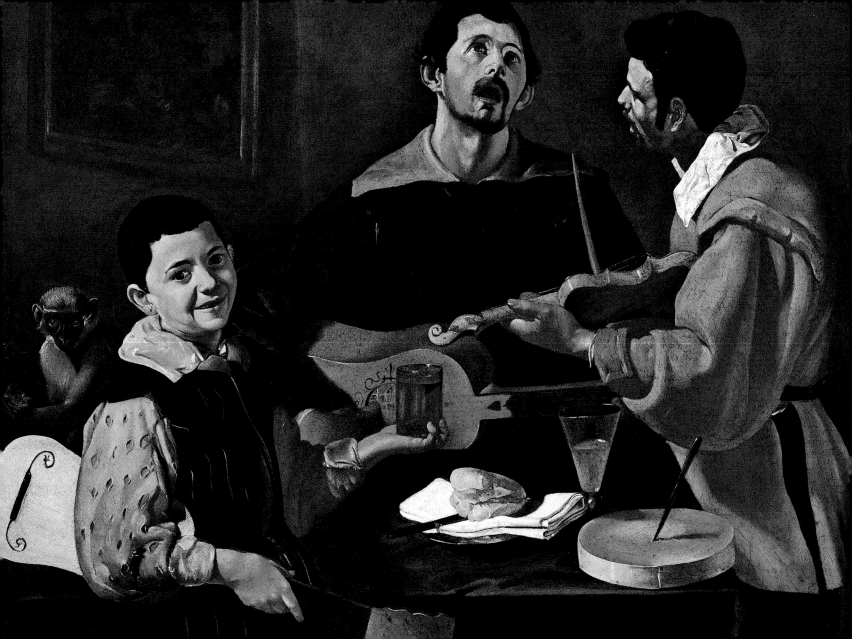

If indeed you must be candid,
be candid beautifully.

Kahlil Gibran

Marcelle Lender, late 19th century
Henri de Toulouse- Lautrec
Kupferstichkabinett, Staatliche Museen zu Berlin

1 2 3 4 **5** 6 7 8 9 10 11 12 13 14 15 16 17 18 19 20 21 22 23 24 25 26 27 28 29 30 31

JANUARY

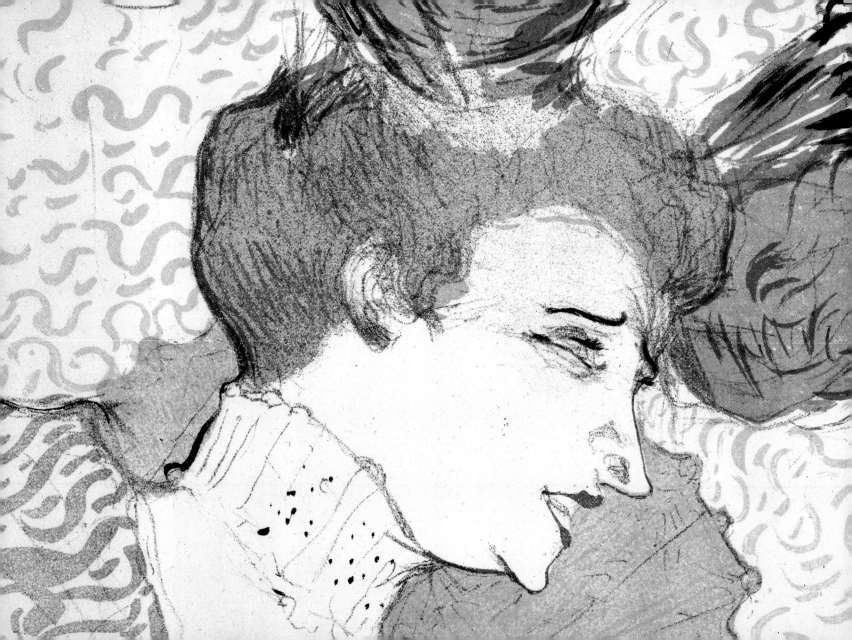

An adventurous child,
thanks to the gods.

HORACE

Adoration of the Magi (Monforte Altarpiece), *c.* 1470
Hugo van der Goes
Gemäldegalerie, Staatliche Museen zu Berlin

1 2 3 4 5 **6** 7 8 9 10 11 12 13 14 15 16 17 18 19 20 21 22 23 24 25 26 27 28 29 30 31

JANUARY

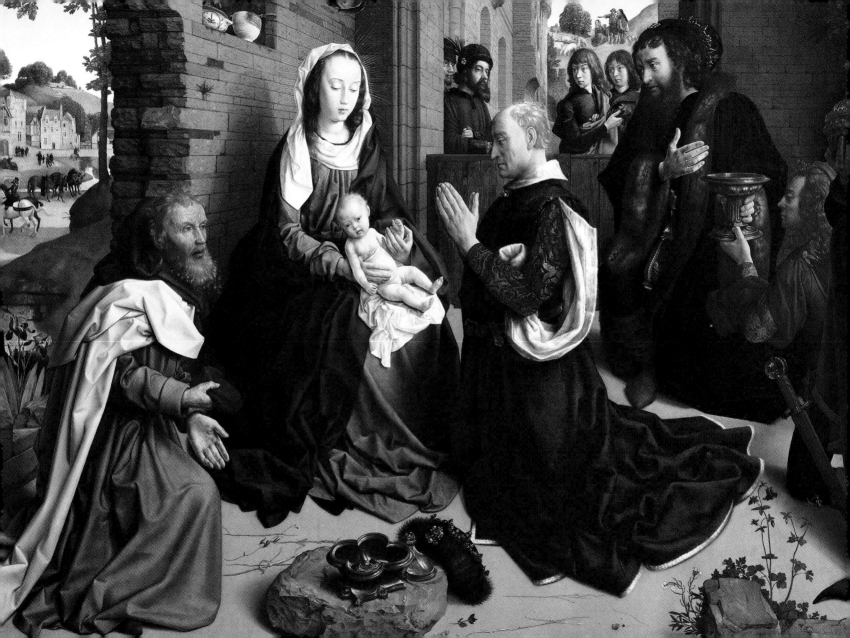

Through winter-time we call on spring,
And through the spring on summer call,
And when abounding hedges ring
Declare that winter's best of all…

WILLIAM BUTLER YEATS

Skaters on the Y in Front of the Paalhuis and the Nieuwe Brug in Amsterdam, *c.* 1660

Johannes Beerstraten
Gemäldegalerie, Staatliche Museen zu Berlin

1 2 3 4 5 6 **7** 8 9 10 11 12 13 14 15 16 17 18 19 20 21 22 23 24 25 26 27 28 29 30 31

JANUARY

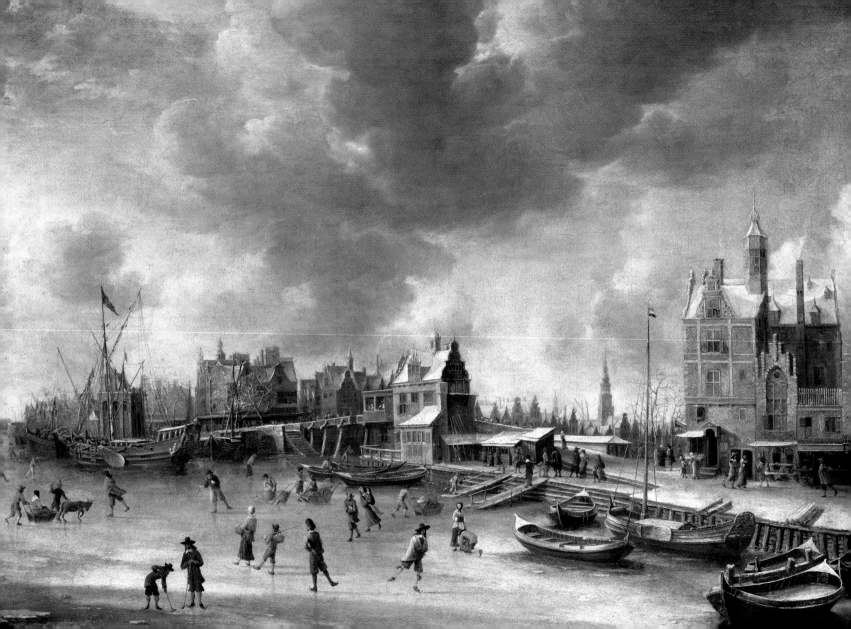

Painting is the grandchild of nature.

REMBRANDT HARMENSZ VAN RIJN

The Snail, 1650
Rembrandt Harmensz van Rijn
Kupferstichkabinett, Staatliche Museen zu Berlin

1 2 3 4 5 6 7 **8** 9 10 11 12 13 14 15 16 17 18 19 20 21 22 23 24 25 26 27 28 29 30 31

JANUARY

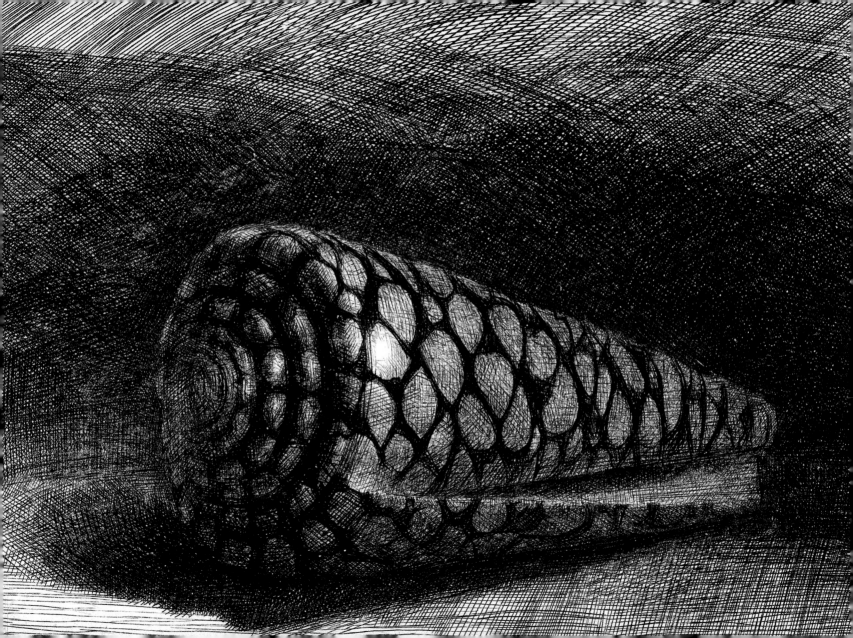

Love seeketh not itself to please,
Nor for itself hath any care,
But for another gives its ease,
And builds a Heaven in Hell's despair.

WILLIAM BLAKE

Caressing Couple, 1300–1340
Miniature
Kunstbibliothek, Staatliche Museen zu Berlin

1 2 3 4 5 6 7 8 **9** 10 11 12 13 14 15 16 17 18 19 20 21 22 23 24 25 26 27 28 29 30 31

JANUARY

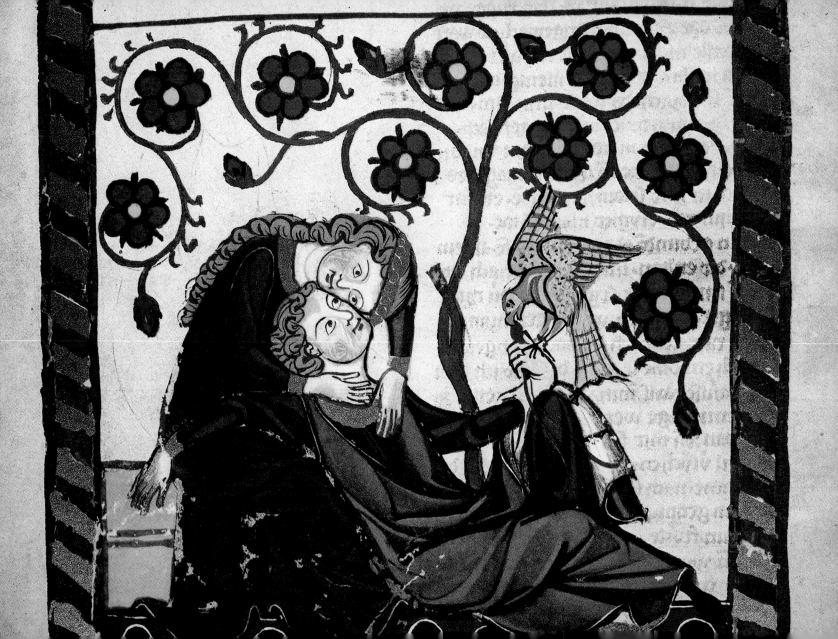

Middle age is the time when a man is always thinking that in a week or two he will feel as good as ever.

DON MARQUIS

Portrait of an Elderly Man, *c.* 1492
Luca Signorelli
Gemäldegalerie, Staatliche Museen zu Berlin

1 2 3 4 5 6 7 8 9 **10** 11 12 13 14 15 16 17 18 19 20 21 22 23 24 25 26 27 28 29 30 31

JANUARY

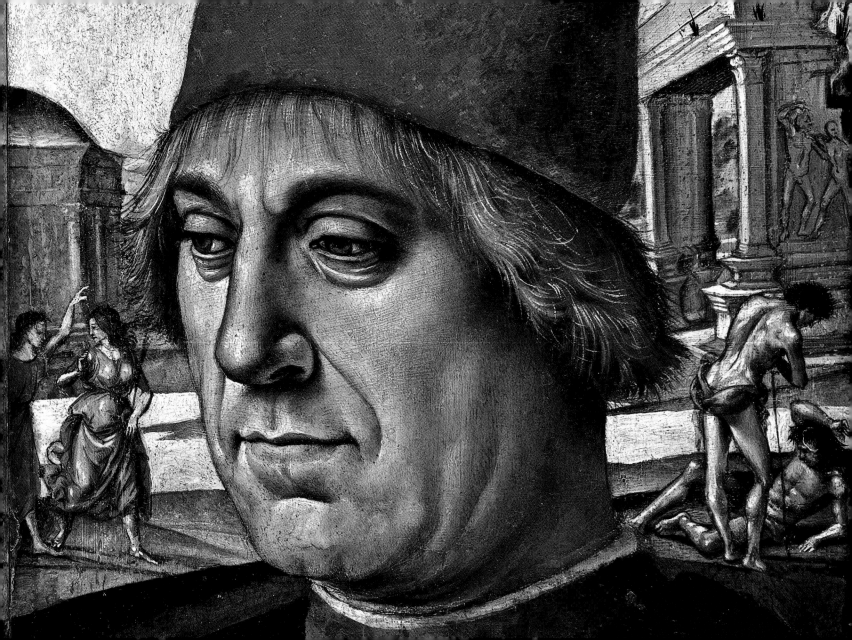

Woman, nude, is the blue sky.
Clouds and garments are an obstacle to
contemplation. Beauty and infinity
would be gazed upon unveiled.

VICTOR HUGO

Fränzi Reclining, 1910
Erich Heckel
Kupferstichkabinett, Staatliche Museen zu Berlin

1 2 3 4 5 6 7 8 9 10 **11** 12 13 14 15 16 17 18 19 20 21 22 23 24 25 26 27 28 29 30 31

JANUARY

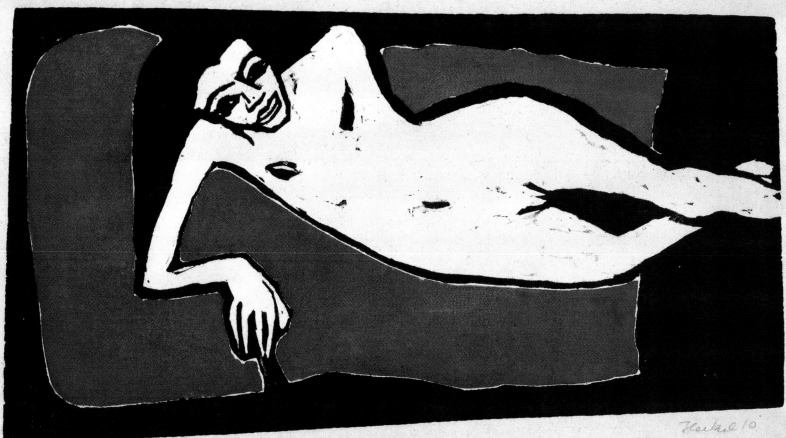

Wänti liegend
Hand Mude

Heckel 10

A forest bird never wants a cage.

<small>Henrik Ibsen</small>

Decoration in the form of a bird, painted wood carving,
19th century
Malaysia
Ethnologisches Museum, Staatliche Museen zu Berlin

1 2 3 4 5 6 7 8 9 10 11 **12** 13 14 15 16 17 18 19 20 21 22 23 24 25 26 27 28 29 30 31

JANUARY

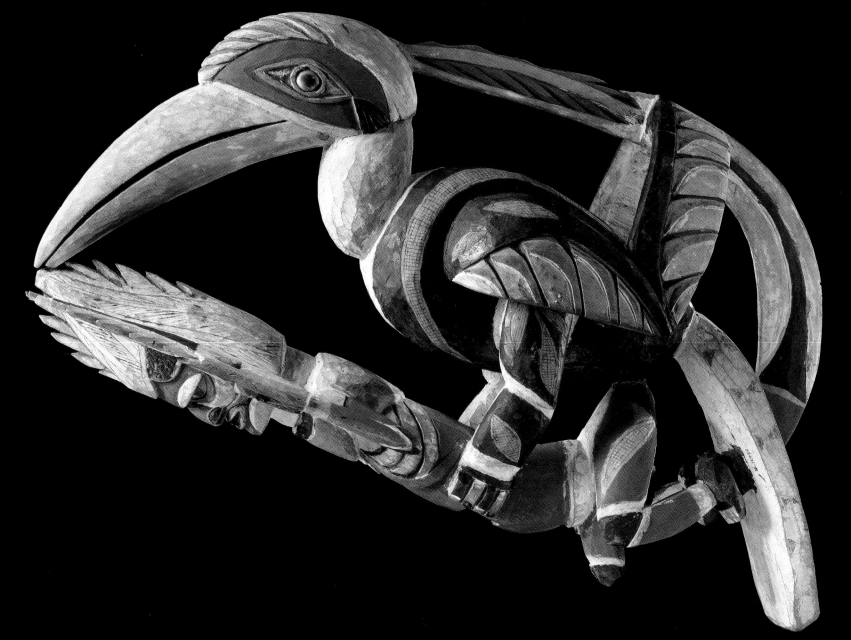

The real voyage of discovery consists not in seeking new landscapes, but in having new eyes.

MARCEL PROUST

Sétubal in 1547, 1592

Theodor de Bry

Kunstbibliothek, Staatliche Museen zu Berlin

1 2 3 4 5 6 7 8 9 10 11 12 **13** 14 15 16 17 18 19 20 21 22 23 24 25 26 27 28 29 30 31

JANUARY

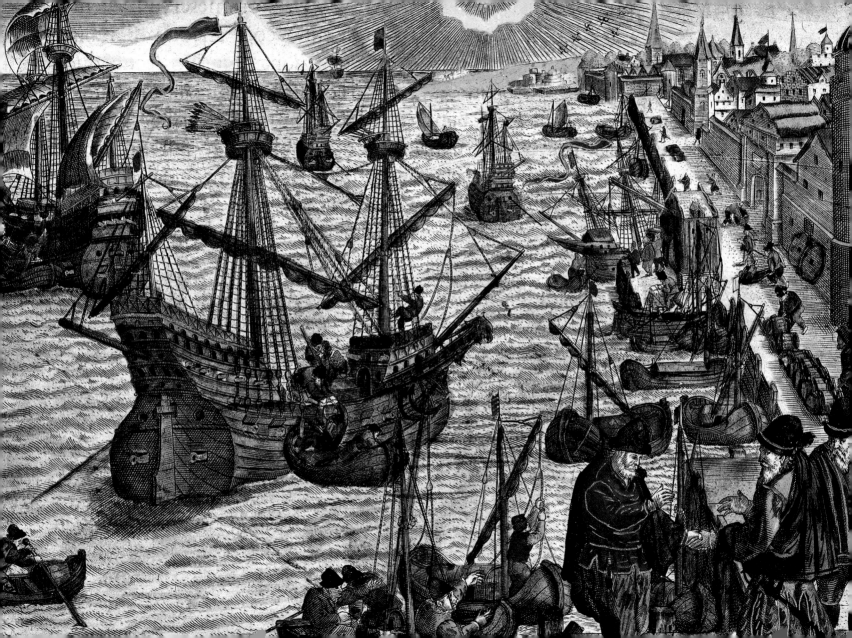

Not to hope for things to last forever,
is what the year teaches and even the
hour which snatches a nice day away.

HORACE

Still Life with Rummer and Silver Bowl, 17th century
Pieter Claesz
Gemäldegalerie, Staatliche Museen zu Berlin

1 2 3 4 5 6 7 8 9 10 11 12 13 **14** 15 16 17 18 19 20 21 22 23 24 25 26 27 28 29 30 31

JANUARY

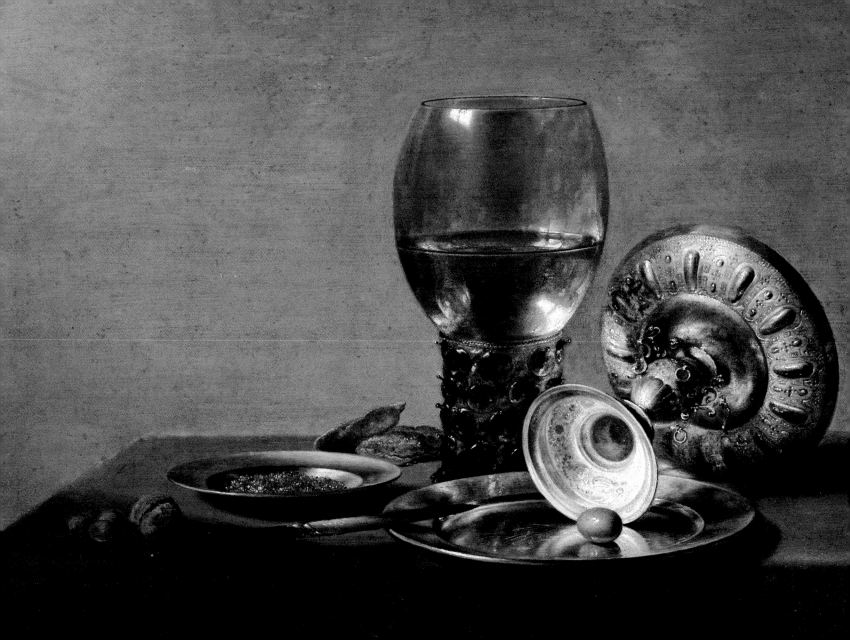

*No great artist ever sees things
as they really are. If he did,
he would cease to be an artist.*

Oscar Wilde

Brushstrokes, 1996
Sol LeWitt
Kupferstichkabinett, Staatliche Museen zu Berlin

1 2 3 4 5 6 7 8 9 10 11 12 13 14 **15** 16 17 18 19 20 21 22 23 24 25 26 27 28 29 30 31

January

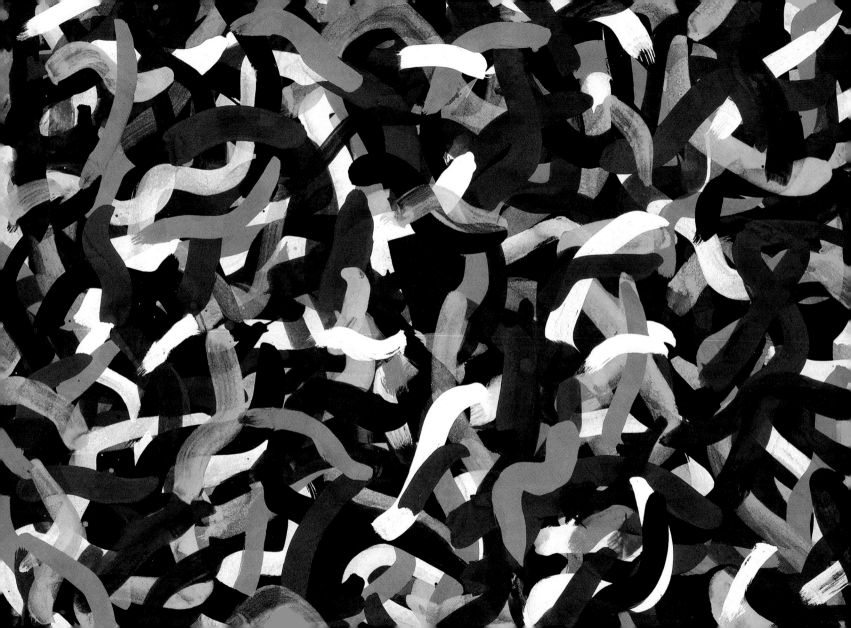

My delight and thy delight
Walking, like two angels white,
In the gardens of the night.

ROBERT BRIDGES

Relief depicting a king and a queen, so-called Walk in the Garden, *c.* 1351–1334 B. C.

Egypt

Ägyptisches Museum und Papyrussammlung, Staatliche Museen zu Berlin

1 2 3 4 5 6 7 8 9 10 11 12 13 14 15 **16** 17 18 19 20 21 22 23 24 25 26 27 28 29 30 31

JANUARY

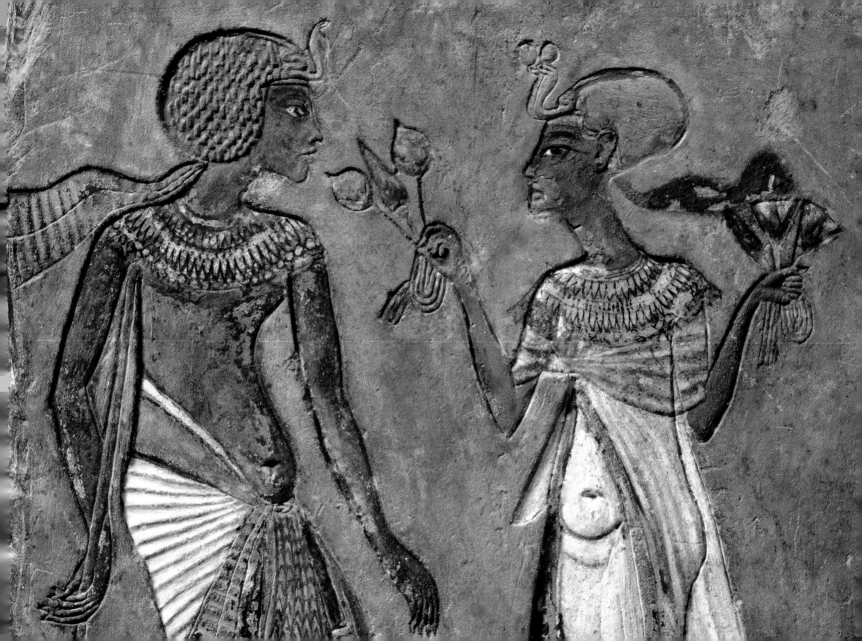

It is not bright colors but good drawing that makes figures beautiful.

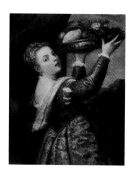

Girl with Fruit Bowl, *c.* 1555
Titian
Gemäldegalerie, Staatliche Museen zu Berlin

1 2 3 4 5 6 7 8 9 10 11 12 13 14 15 16 **17** 18 19 20 21 22 23 24 25 26 27 28 29 30 31

JANUARY

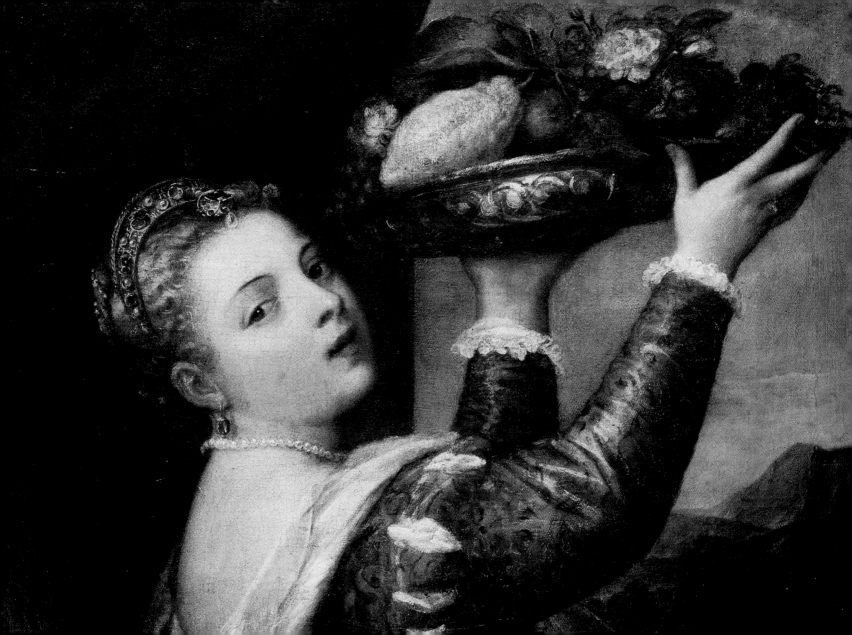

Venice once was dear,
The pleasant place of all festivity,
The revel of the earth,
the masque of Italy.

Lord Byron

The Molo in Front of the Doge's Palace, *c.* 1730
Canaletto (Giovanni Antonio Canal)
Gemäldegalerie, Staatliche Museen zu Berlin

1 2 3 4 5 6 7 8 9 10 11 12 13 14 15 16 17 **18** 19 20 21 22 23 24 25 26 27 28 29 30 31

JANUARY

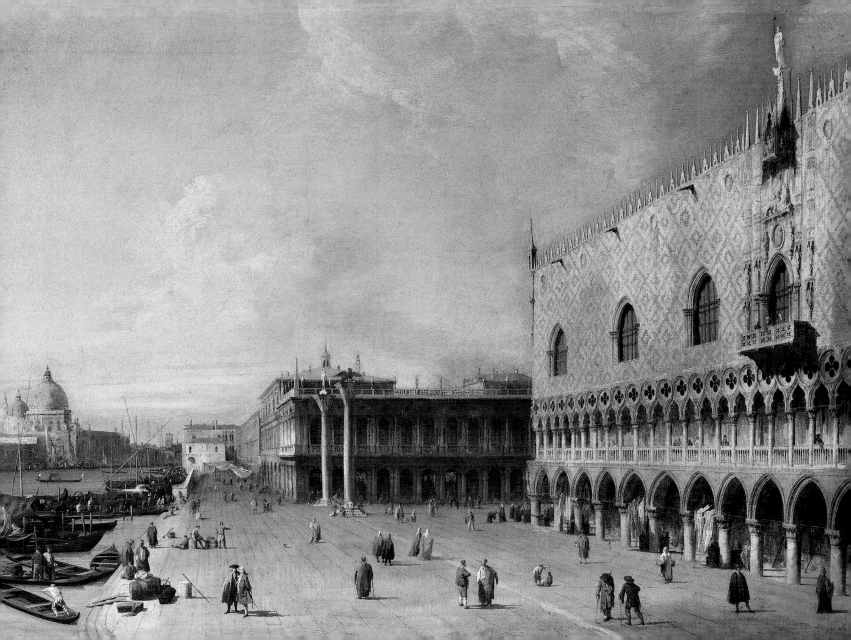

I don't say everything,
but I paint everything.

Pablo Picasso

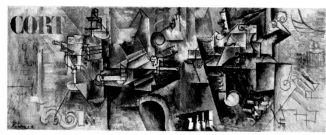

Bottle, Absinth Glass, Whistle, Violin and Clarinet on Top of a Piano, *c.* 1911/12

Pablo Picasso

Museum Berggruen, Nationalgalerie, Staatliche Museen zu Berlin

1 2 3 4 5 6 7 8 9 10 11 12 13 14 15 16 17 18 **19** 20 21 22 23 24 25 26 27 28 29 30 31

JANUARY

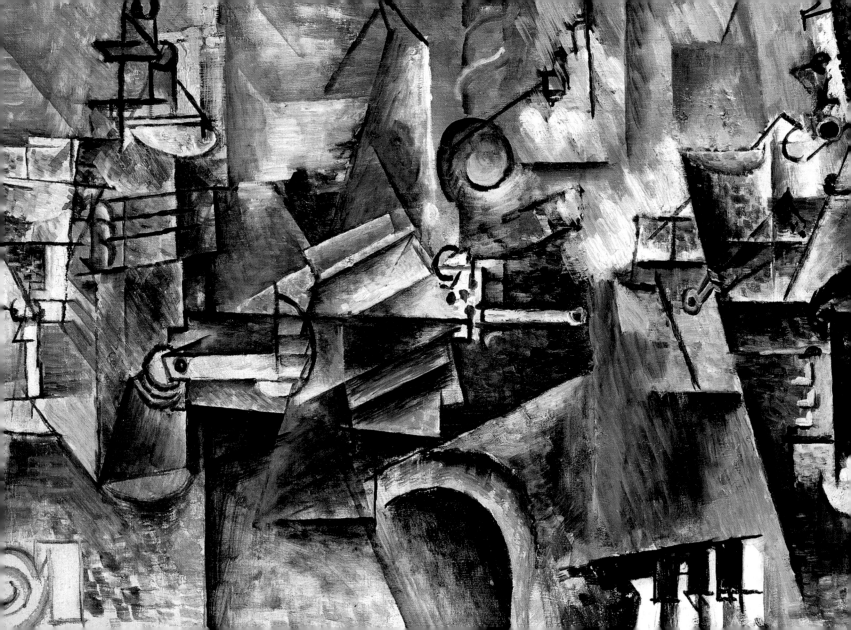

The more elevated a culture, the richer its language. The number of words and their combinations depends directly on a sum of conceptions and ideas; without the latter there can be no understandings, no definitions, and, as a result, no reason to enrich a language.

Anton Pavlovich Chekhov

Cuneiform writing board, 2600 B. C.
Fara
Vorderasiatisches Museum, Staatliche Museen zu Berlin

1 2 3 4 5 6 7 8 9 10 11 12 13 14 15 16 17 18 19 **20** 21 22 23 24 25 26 27 28 29 30 31

JANUARY

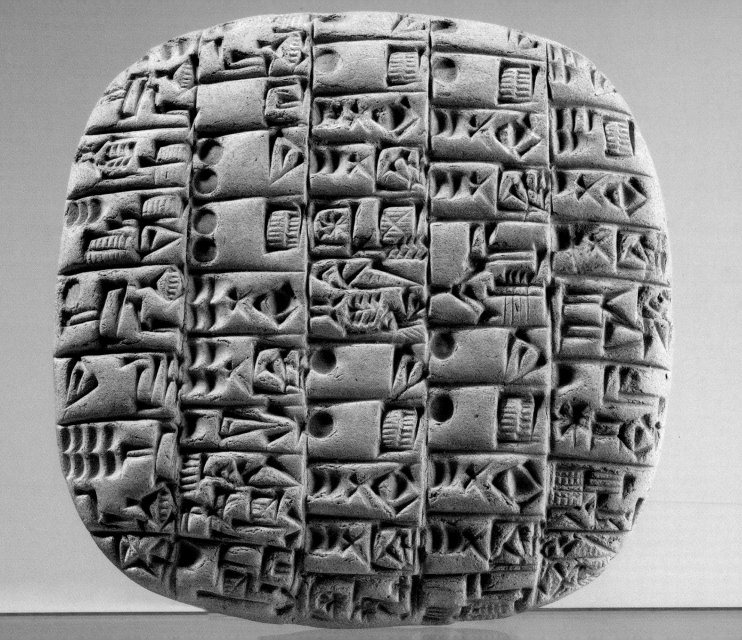

*He that does good for good's sake
seeks neither paradise nor reward,
but he is sure of both in the end.*

William Penn

The Lost Knight, 1816
Carl Philipp Fohr
Nationalgalerie, Staatliche Museen zu Berlin

1 2 3 4 5 6 7 8 9 10 11 12 13 14 15 16 17 18 19 20 **21** 22 23 24 25 26 27 28 29 30 31

JANUARY

This is the month, and this the happy morn,
Wherein the Son of heav'n's eternal King,
Of wedded Maid and Virgin Mother born,
Our great redemption from above did bring.

JOHN MILTON

Enthroned Madonna and Child with Saints Peter, Romuald, Benedict and Paul, *c.* 1595–1597
Giovanni Battista Cima
Gemäldegalerie, Staatliche Museen zu Berlin

1 2 3 4 5 6 7 8 9 10 11 12 13 14 15 16 17 18 19 20 21 **22** 23 24 25 26 27 28 29 30 31

JANUARY

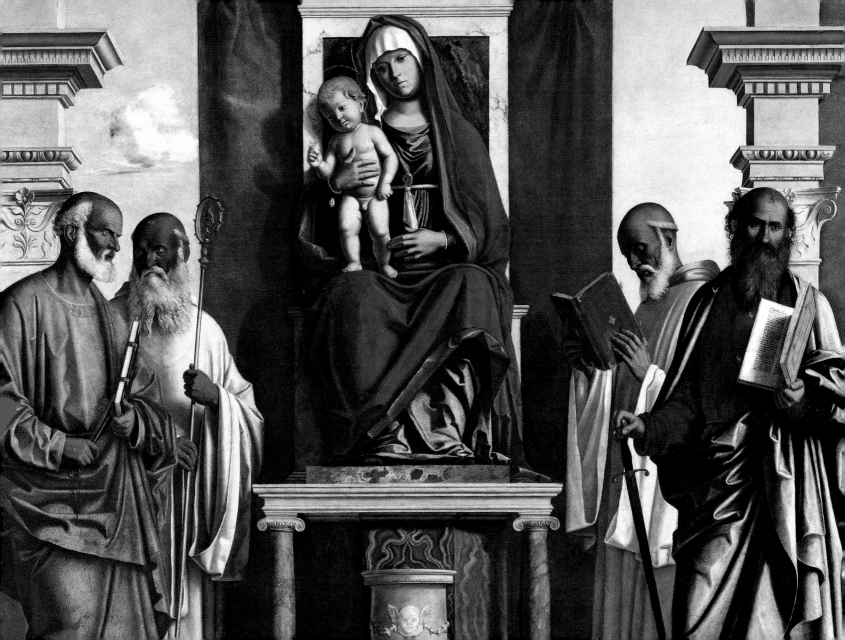

He who paints must be able to see an object in its uniform tone, in its whole magic. All paintings created this way are the mirror of the soul in harmony.

AUGUST MACKE

The Artist's Wife, 1912
August Macke
Nationalgalerie, Staatliche Museen zu Berlin

1 2 3 4 5 6 7 8 9 10 11 12 13 14 15 16 17 18 19 20 21 22 **23** 24 25 26 27 28 29 30 31

JANUARY

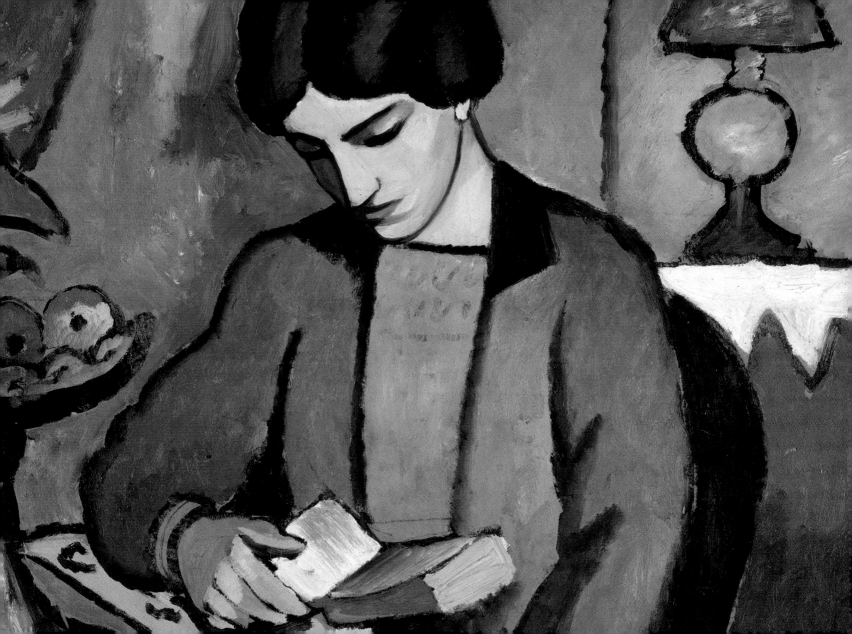

Hath not the morning dawned with added light?
And shall not evening call another star
Out of the infinite regions of the night,
To mark this day in Heaven?

HENRY TIMROD

The Cockcrow, *c.* 1700
India
Museum für Islamische Kunst, Staatliche Museen zu Berlin

1 2 3 4 5 6 7 8 9 10 11 12 13 14 15 16 17 18 19 20 21 22 23 **24** 25 26 27 28 29 30 31

JANUARY

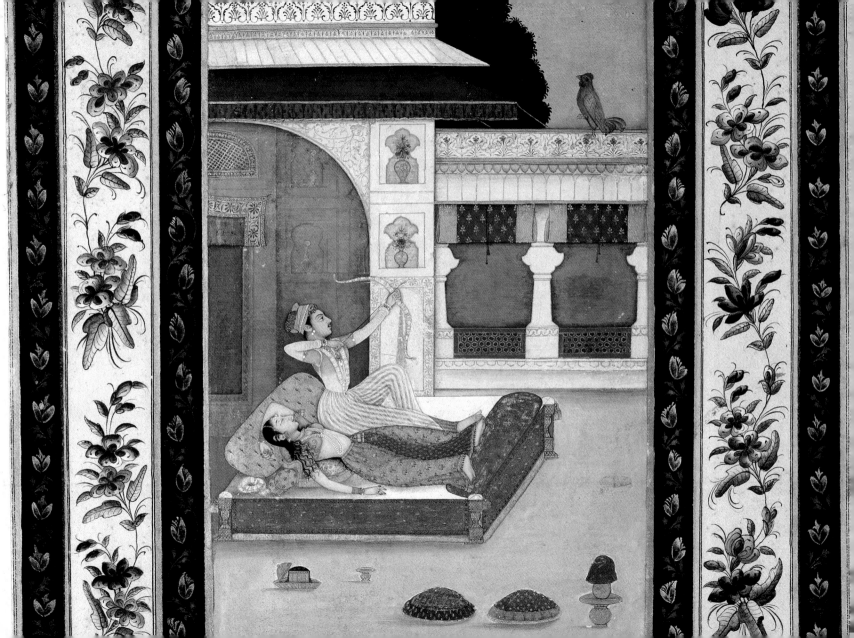

Insects are born from the sun.
They are the sun's kisses.

ALEXANDER SCRIABIN

Winged dung beetle, gold with inscription,
664–425 B. C.
Egypt
Ägyptisches Museum und Papyrussammlung, Staatliche Museen zu Berlin

1 2 3 4 5 6 7 8 9 10 11 12 13 14 15 16 17 18 19 20 21 22 23 24 **25** 26 27 28 29 30 31

JANUARY

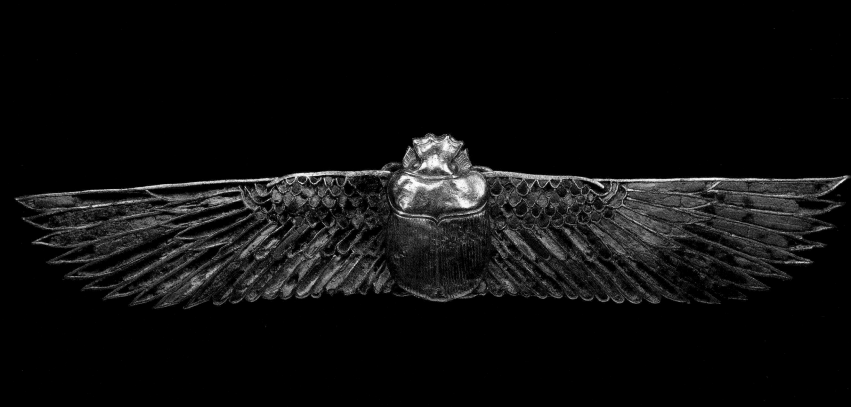

Baptism: a regeneration, the initiation into a new state.

<small>Georgе Eliot</small>

The Baptism, 17th century
Jan van Steen
Gemäldegalerie, Staatliche Museen zu Berlin

1 2 3 4 5 6 7 8 9 10 11 12 13 14 15 16 17 18 19 20 21 22 23 24 25 **26** 27 28 29 30 31

JANUARY

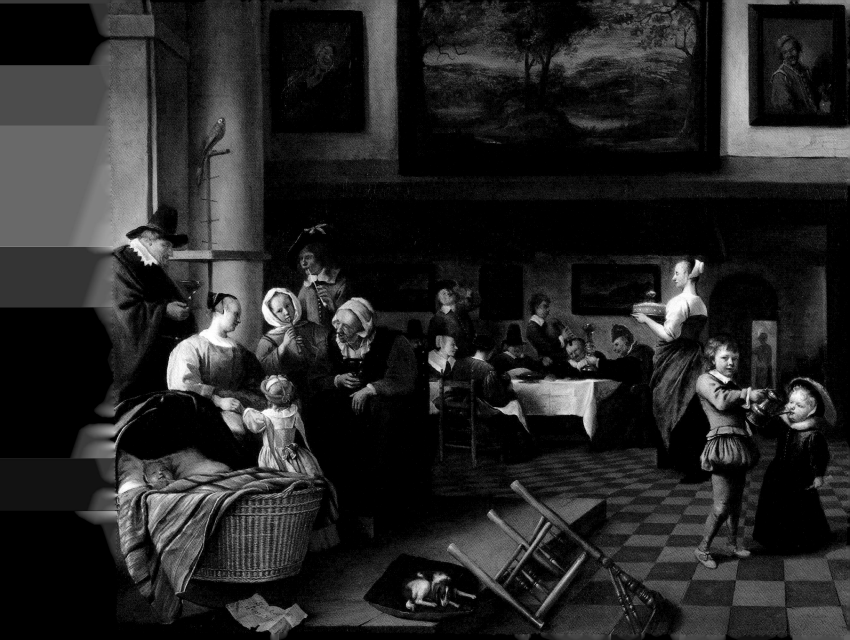

Fear not, we are of the nature of the lion, and cannot descend to the destruction of mice and such small beasts.

ELIZABETH I OF ENGLAND

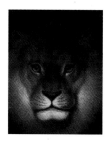

Lion's Head, 1818
Franz Krüger
Kupferstichkabinett, Staatliche Museen zu Berlin

1 2 3 4 5 6 7 8 9 10 11 12 13 14 15 16 17 18 19 20 21 22 23 24 25 26 **27** 28 29 30 31

JANUARY

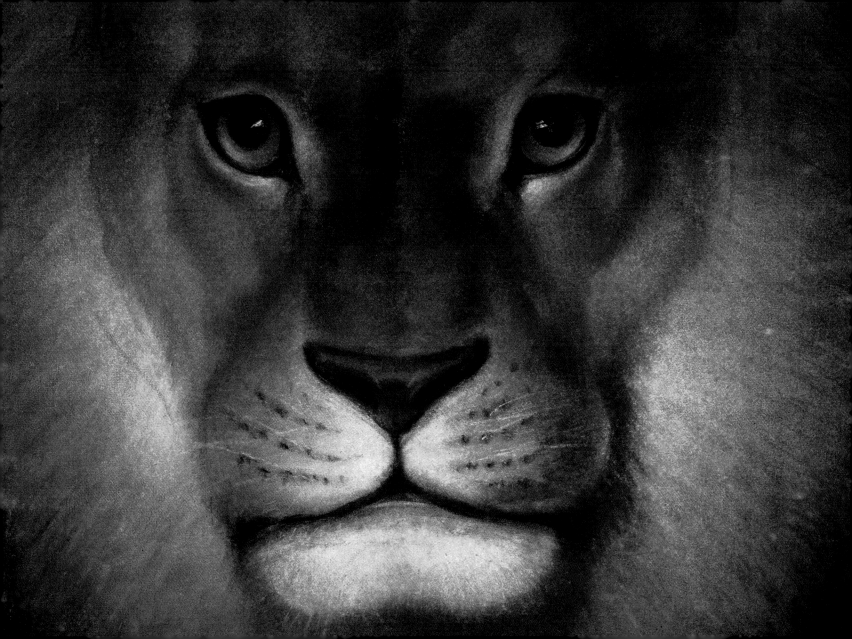

Poetry lifts the veil from the hidden beauty of the world, and makes familiar objects be as if they were not familiar.

PERCY BYSSHE SHELLEY

The Room with a Balcony, 1845
Adolph von Menzel
Nationalgalerie, Staatliche Museen zu Berlin

1 2 3 4 5 6 7 8 9 10 11 12 13 14 15 16 17 18 19 20 21 22 23 24 25 26 27 **28** 29 30 31

JANUARY

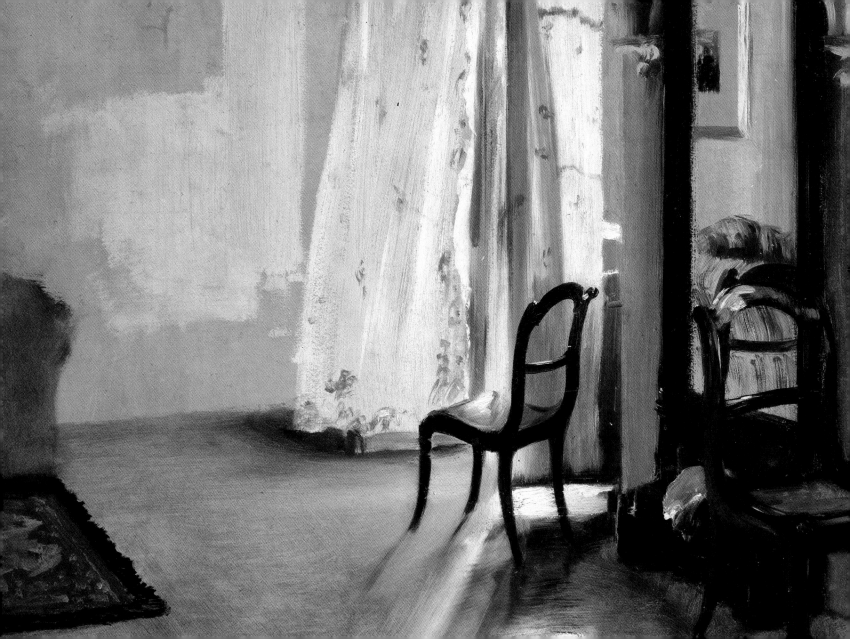

I am out to introduce a psychic shock into my painting, one that is always motivated by pictorial reasoning: that is to say, a fourth dimension.

MARC CHAGALL

Circus Dream, *c.* 1939/40
Marc Chagall
Nationalgalerie, Staatliche Museen zu Berlin

1 2 3 4 5 6 7 8 9 10 11 12 13 14 15 16 17 18 19 20 21 22 23 24 25 26 27 28 **29** 30 31

JANUARY

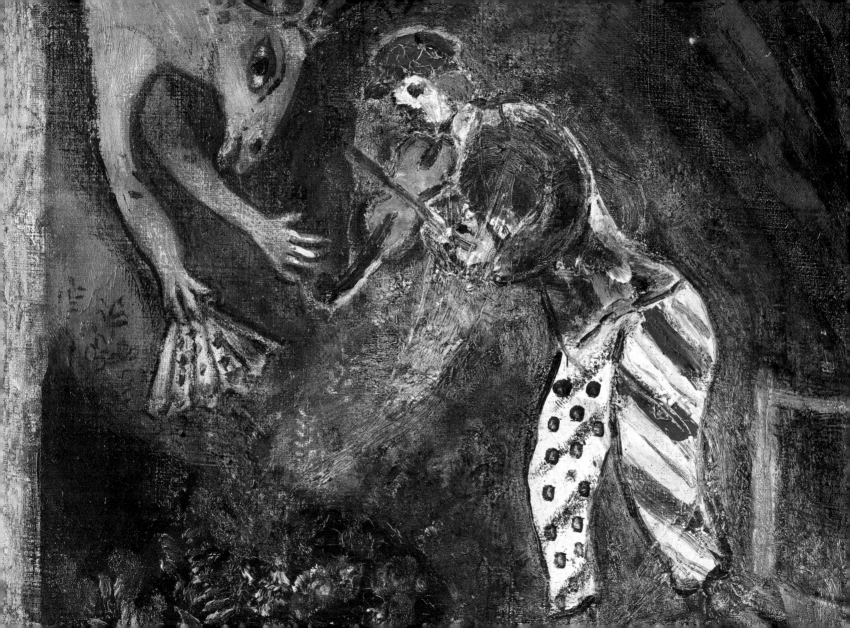

I feel within me
A peace above all earthly dignities,
A still and quiet conscience.

WILLIAM SHAKESPEARE

Rest on the Flight into Egypt, c. 1520
Joachim de Patenier
Gemäldegalerie, Staatliche Museen zu Berlin

1 2 3 4 5 6 7 8 9 10 11 12 13 14 15 16 17 18 19 20 21 22 23 24 25 26 27 28 29 **30** 31

JANUARY

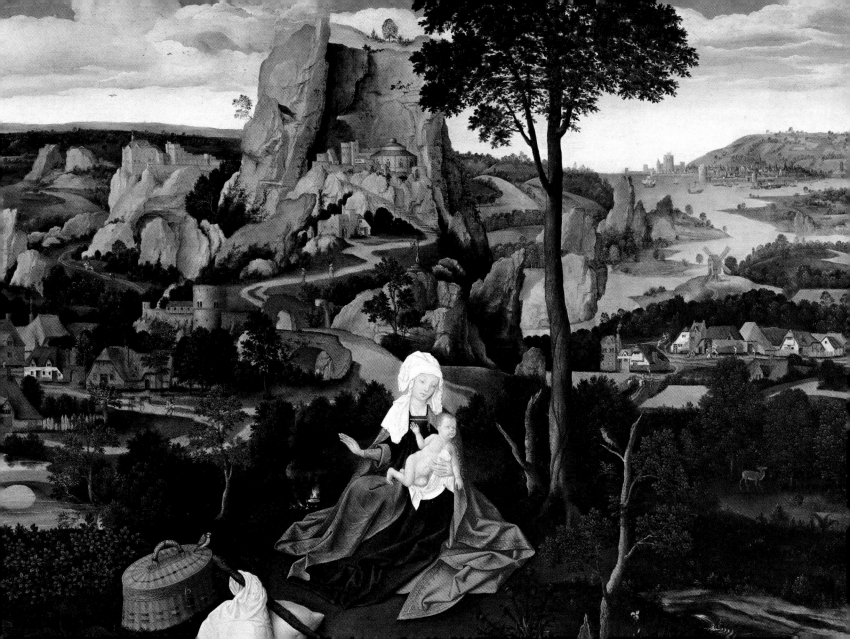

Each touch, taken pure from the palette,
remains pure upon the canvas.

Still Life, 1883
Paul Signac
Nationalgalerie, Staatliche Museen zu Berlin

1 2 3 4 5 6 7 8 9 10 11 12 13 14 15 16 17 18 19 20 21 22 23 24 25 26 27 28 29 30 **31**

JANUARY

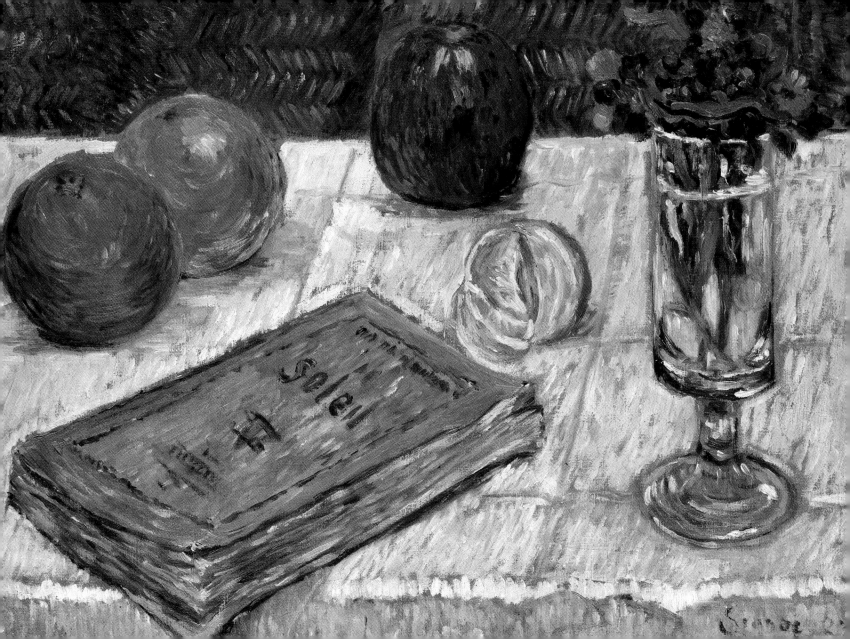

He who teaches children learns more than they do.

After School, 1841
Ferdinand Georg Waldmüller
Nationalgalerie, Staatliche Museen zu Berlin

1 2 3 4 5 6 7 8 9 10 11 12 13 14 15 16 17 18 19 20 21 22 23 24 25 26 27 28/29

FEBRUARY

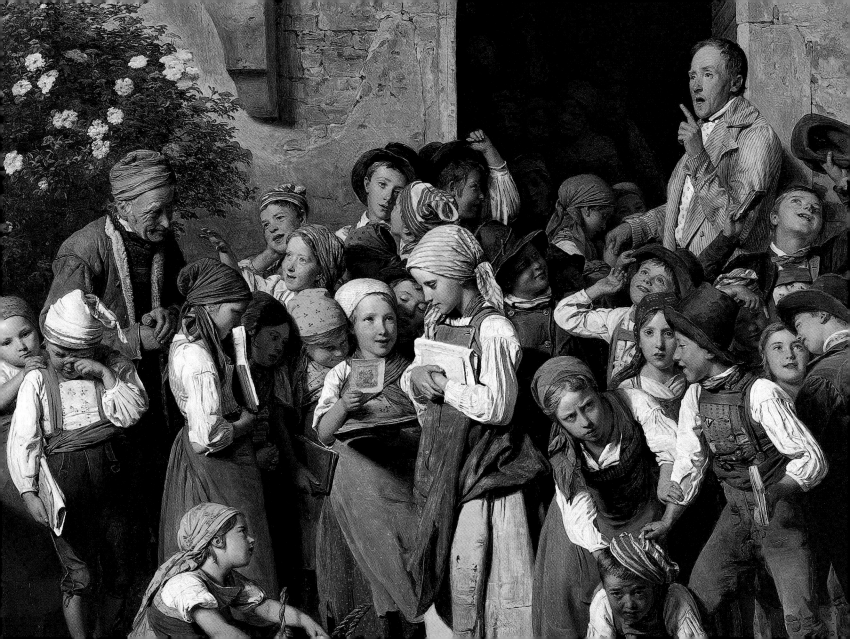

Valor is stability, not of legs and arms, but of courage and the soul.

<small>MICHEL DE MONTAIGNE</small>

Saint Michael as Conqueror of Satan, *c.* 1750
Ignatz Günther
Skulpturensammlung und Museum für Byzantinische Kunst, Staatliche Museen zu Berlin

1 2 3 4 5 6 7 8 9 10 11 12 13 14 15 16 17 18 19 20 21 22 23 24 25 26 27 28/29

FEBRUARY

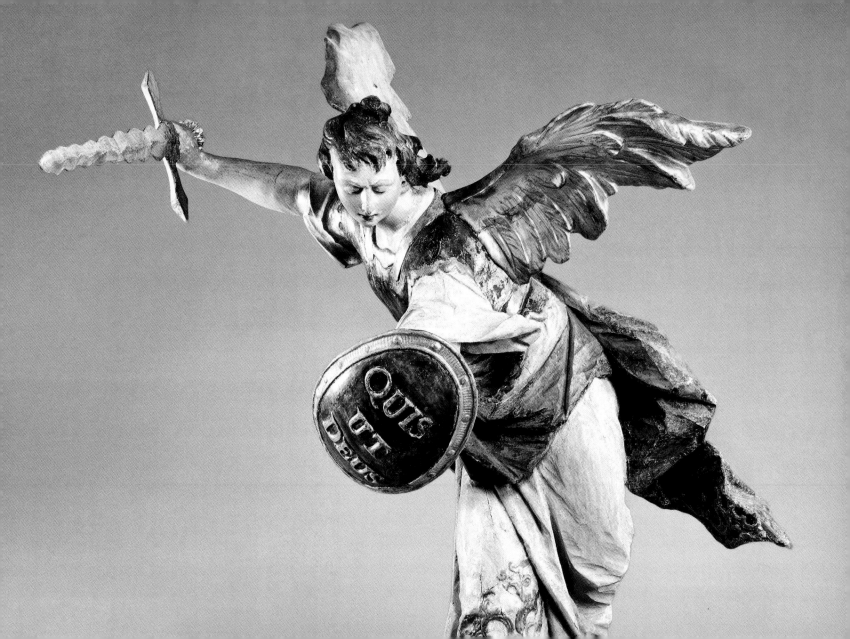

Who sees the human face correctly:
the photographer, the mirror,
or the painter?

PABLO PICASSO

Mummy portrait, late 2nd century A. D.
Egypt
Ägyptisches Museum und Papyrussammlung, Staatliche Museen zu Berlin

1 2 **3** 4 5 6 7 8 9 10 11 12 13 14 15 16 17 18 19 20 21 22 23 24 25 26 27 28/29

FEBRUARY

Reading is merely a surrogate for thinking for yourself; it means letting someone else direct your thoughts.

<small>Arthur Schopenhauer</small>

Madonna and Child
Fra Filippo Lippi
Gemäldegalerie, Staatliche Museen zu Berlin

1 2 3 **4** 5 6 7 8 9 10 11 12 13 14 15 16 17 18 19 20 21 22 23 24 25 26 27 28/29

FEBRUARY

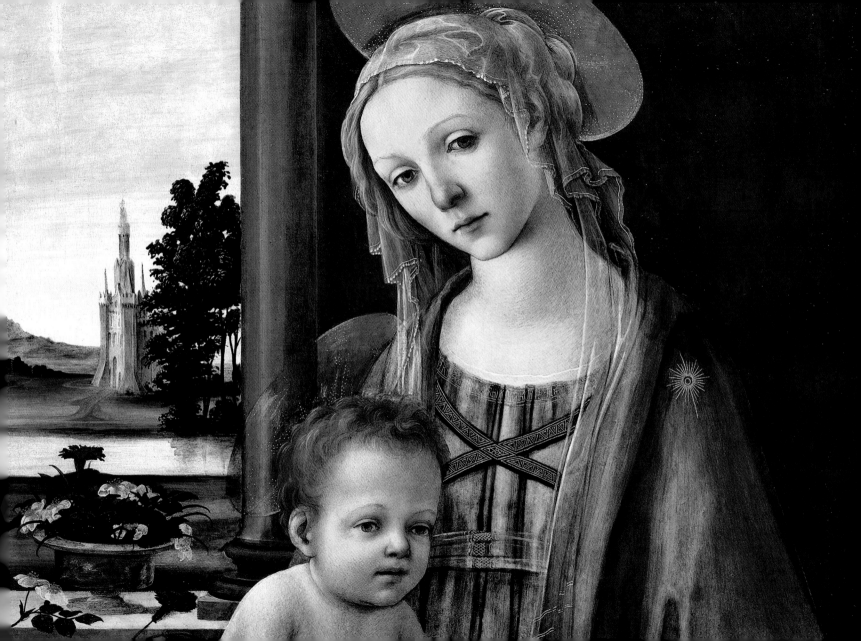

*Nature is thoroughly mediate. It is made to serve.
It receives the dominion of man as meekly as the
ass on which the Saviour rode. It offers all its
kingdoms to man as the raw material which he
may mould into what is useful. Man is never
weary of working it up.*

Ralph Waldo Emerson

Riders at the Tegernsee, 1832
*Wilhelm von Kobell
Nationalgalerie, Staatliche Museen zu Berlin*

1 2 3 4 **5** 6 7 8 9 10 11 12 13 14 15 16 17 18 19 20 21 22 23 24 25 26 27 28/29

FEBRUARY

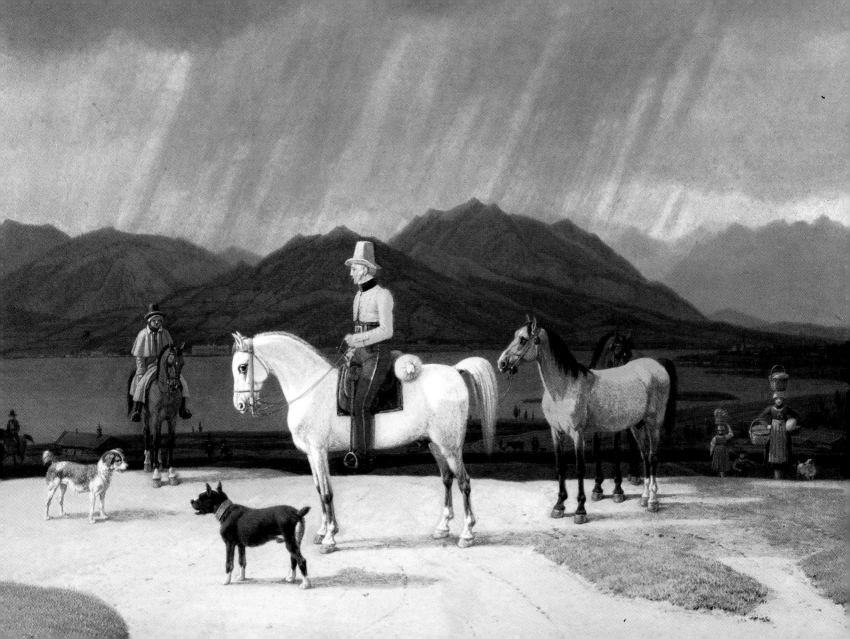

I dreamed as I wandered by the way,
Bare Winter suddenly was changed to Spring,
And gentle odours led my steps astray,
Mixed with a sound of murmuring
Along a shelving bank of turf, which lay
Under a copse, and hardly dared to fling
Its green arms round the bosom of the stream,
But kissed it and then fled, as thou mightst in dream.

PERCY BYSSHE SHELLEY

The Sound of Water, 1930
Kaburagi Kiyokata
Museum für Asiatische Kunst, Staatliche Museen zu Berlin

1 2 3 4 5 **6** 7 8 9 10 11 12 13 14 15 16 17 18 19 20 21 22 23 24 25 26 27 28/29

FEBRUARY

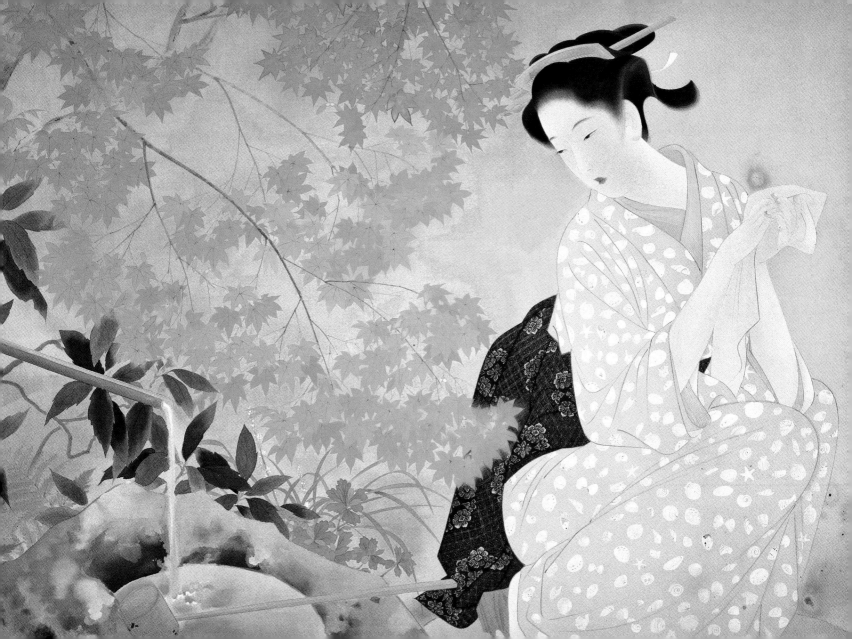

There is all Africa, and her prodigies in us; we are that bold and adventurous piece of nature.

Sir Thomas Browne

Three power figures (Zinkondi Tatu), 19th century
Congo Basin
Ethnologisches Museum, Staatliche Museen zu Berlin

7

1 2 3 4 5 6 8 9 10 11 12 13 14 15 16 17 18 19 20 21 22 23 24 25 26 27 28/29

FEBRUARY

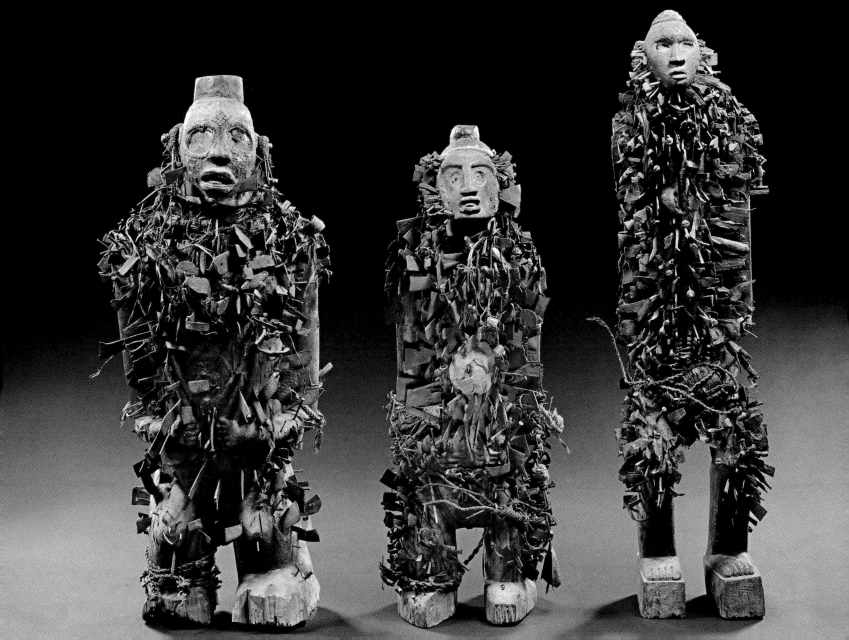

Travel broadens the mind.

Englishmen in the Campagna, *c.* 1845
Carl Spitzweg
Nationalgalerie, Staatliche Museen zu Berlin

1 2 3 4 5 6 7 **8** 9 10 11 12 13 14 15 16 17 18 19 20 21 22 23 24 25 26 27 28/29

FEBRUARY

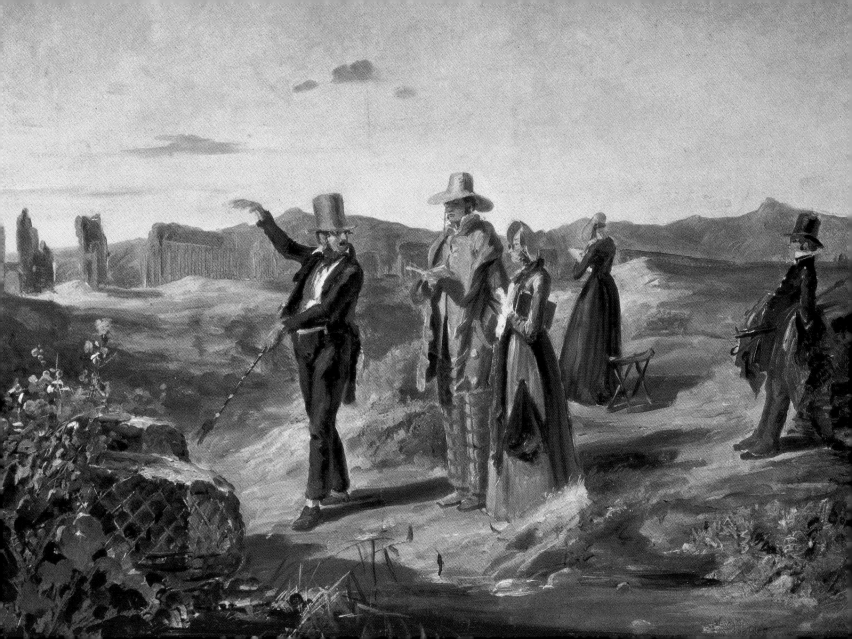

The aim of art is to represent not the outward appearance of things, but their inward significance.

ARISTOTLE

Parrot mosaic, 159–138 B. C.
Pergamon/Turkey
Antikensammlung, Staatliche Museen zu Berlin

9

1 2 3 4 5 6 7 8 9 10 11 12 13 14 15 16 17 18 19 20 21 22 23 24 25 26 27 28/29

FEBRUARY

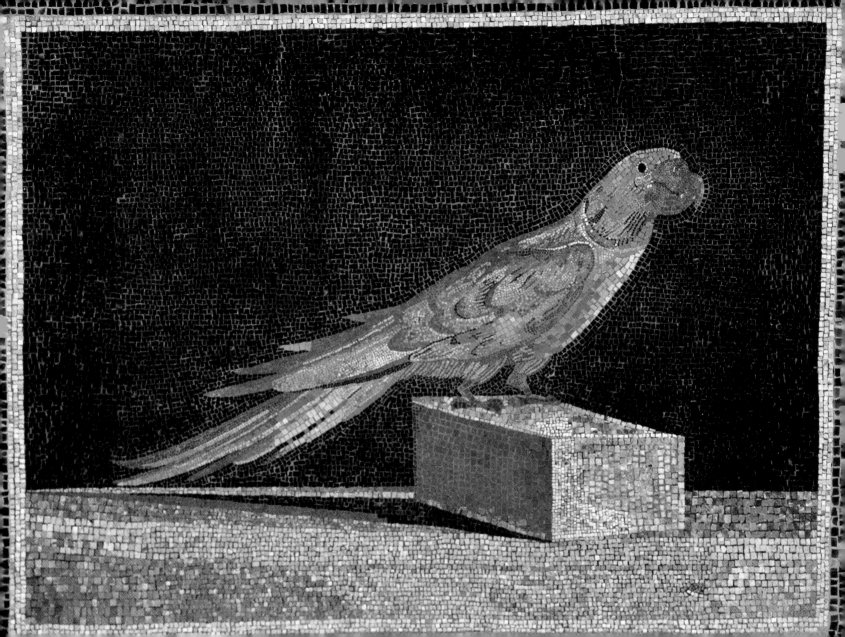

A woman is only a woman,
but a good cigar is a smoke.

RUDYARD KIPLING

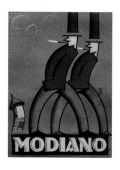

Advertising poster for Modiano cigars, 1928
after a design by Aladár Richter
Kunstbibliothek, Staatliche Museen zu Berlin

1 2 3 4 5 6 7 8 9 **10** 11 12 13 14 15 16 17 18 19 20 21 22 23 24 25 26 27 28/29

FEBRUARY

Jesters do oft prove prophets.

WILLIAM SHAKESPEARE

Carnival Jesters, early 17th century
Willem Cornelisz Duyster
Gemäldegalerie, Staatliche Museen zu Berlin

1 2 3 4 5 6 7 8 9 10 **11** 12 13 14 15 16 17 18 19 20 21 22 23 24 25 26 27 28/29

FEBRUARY

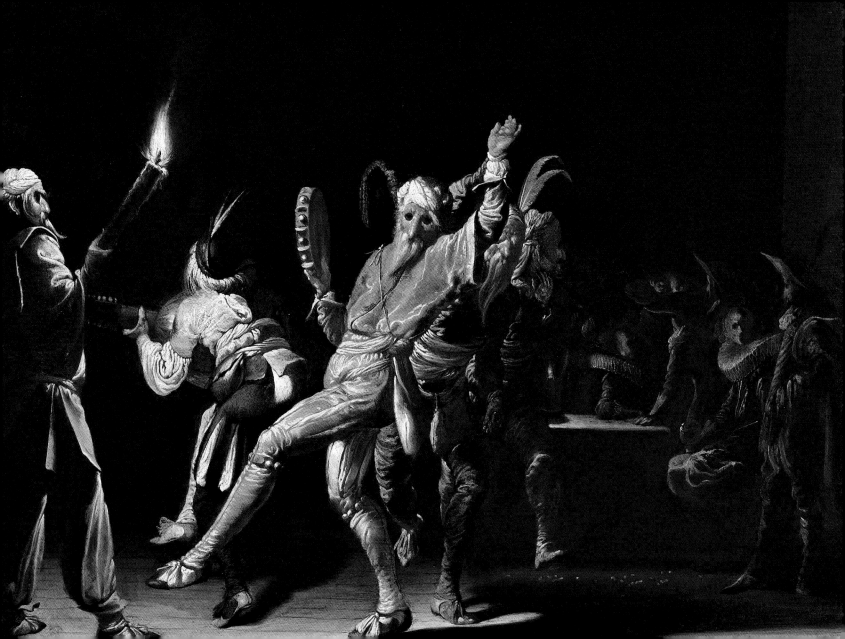

Practice what you know,
and it will help to make clear
what now you do not know.

Rembrandt Harmensz van Rijn

Triumph of Mordecai, 1641
Rembrandt Harmensz van Rijn
Kupferstichkabinett, Staatliche Museen zu Berlin

1 2 3 4 5 6 7 8 9 10 11 **12** 13 14 15 16 17 18 19 20 21 22 23 24 25 26 27 28/29

FEBRUARY

The wind of heaven is that which blows between a horse's ears.

Horse with holes in the legs, clay sculpture, 1st century B. C.
Vorderasiatisches Museum, Staatliche Museen zu Berlin

1 2 3 4 5 6 7 8 9 10 11 12 **13** 14 15 16 17 18 19 20 21 22 23 24 25 26 27 28/29

FEBRUARY

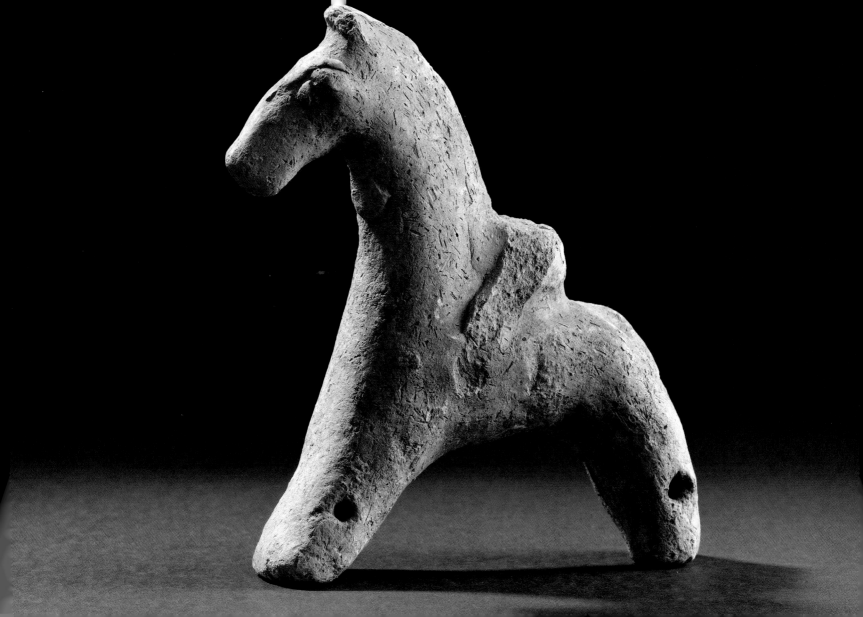

Pharaoh gave Joseph the name Zaphenath-Paneah and gave him Asenath daughter of Potiphera, priest of On, to be his wife. And Joseph went throughout the land of Egypt.

Genesis 41:45

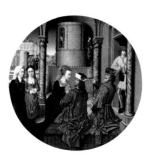

Joseph's Encounter with Asenath, the Daughter of Potiphera, the Priest of On, 14th or 15th century

Master of the Joseph Sequence

Gemäldegalerie, Staatliche Museen zu Berlin

1 2 3 4 5 6 7 8 9 10 11 12 13 **14** 15 16 17 18 19 20 21 22 23 24 25 26 27 28/29

FEBRUARY

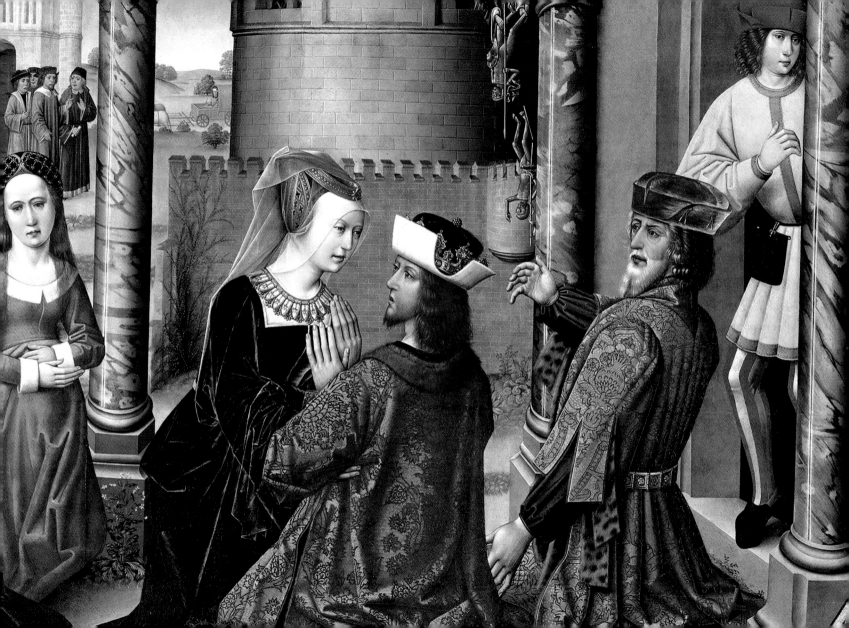

*Mid pleasures and palaces
though we may roam,
Be it ever so humble,
there's no place like home.*

JOHN HOWARD PAYNE

Country House in Rueil, 1882
Edouard Manet
Nationalgalerie, Staatliche Museen zu Berlin

1 2 3 4 5 6 7 8 9 10 11 12 13 14 **15** 16 17 18 19 20 21 22 23 24 25 26 27 28/29

FEBRUARY

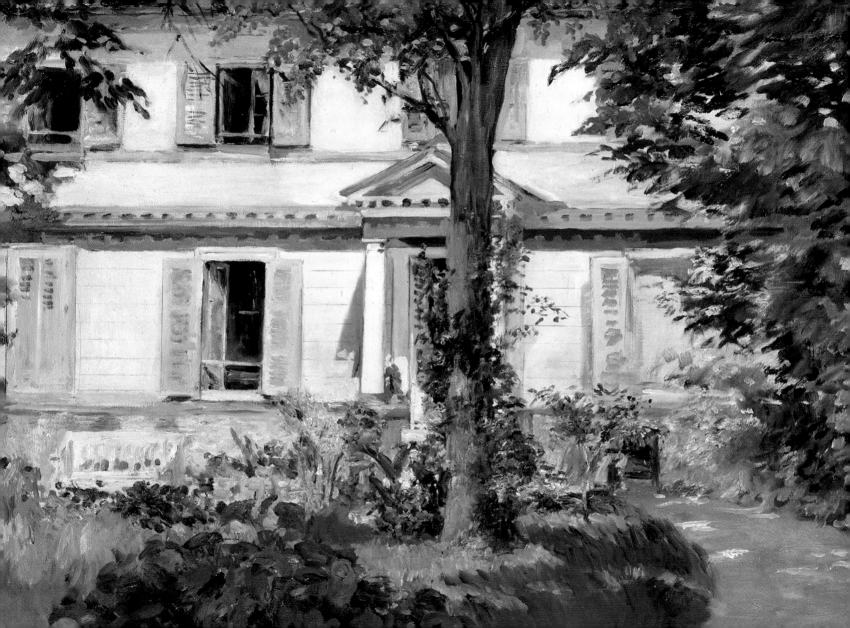

*The perception of beauty
is a moral test.*

Henry David Thoreau

Silk fabric design, 17th century
Osmanian Empire
Kunstgewerbemuseum, Staatliche Museen zu Berlin

1 2 3 4 5 6 7 8 9 10 11 12 13 14 15 **16** 17 18 19 20 21 22 23 24 25 26 27 28/29

FEBRUARY

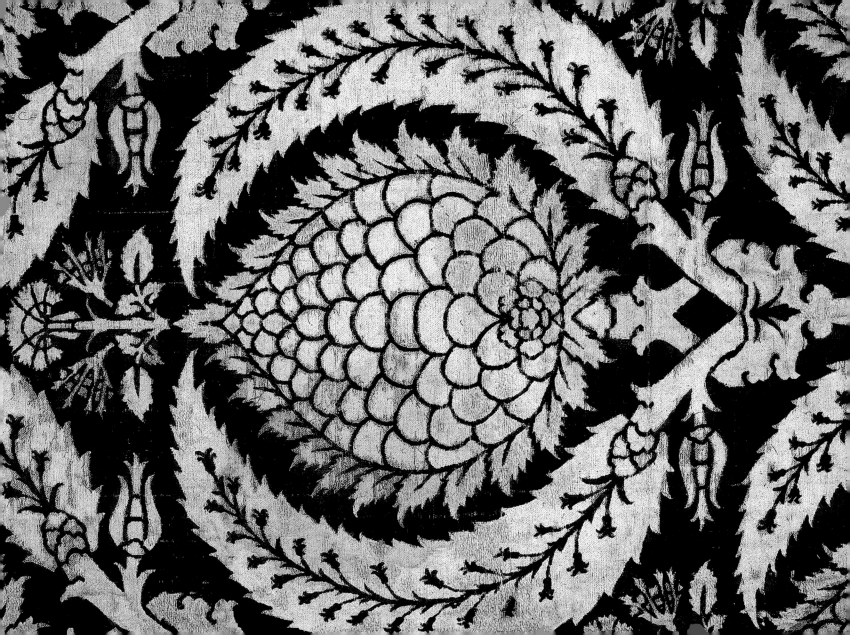

We cannot command Nature,
except by obeying her.

FRANCIS BACON

Fruit Study
Franz Horny
Kupferstichkabinett, Staatliche Museen zu Berlin

1 2 3 4 5 6 7 8 9 10 11 12 13 14 15 16 **17** 18 19 20 21 22 23 24 25 26 27 28/29

FEBRUARY

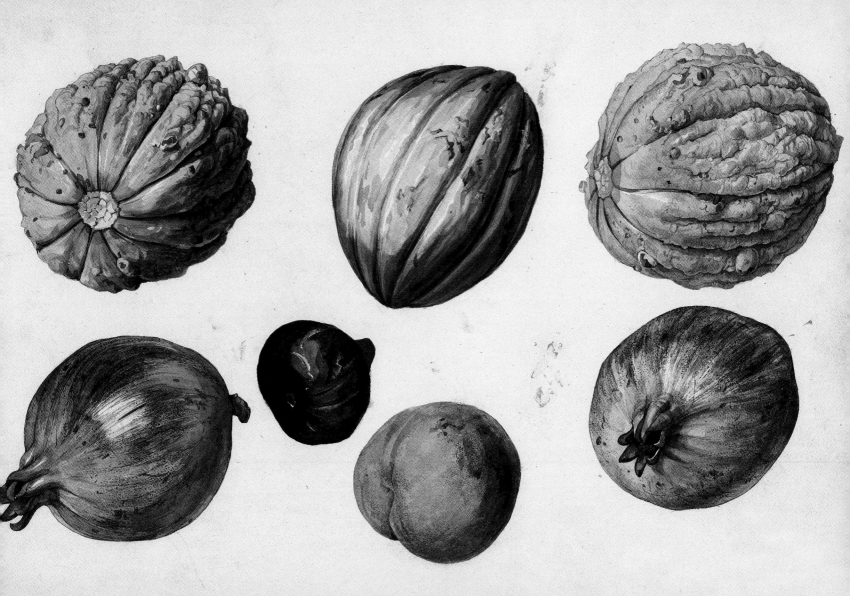

The sea hath no king but God alone.

Dante Gabriel Rossetti

Sea Piece (Sea/Sea), 1970
Gerhard Richter
Nationalgalerie, Staatliche Museen zu Berlin

1 2 3 4 5 6 7 8 9 10 11 12 13 14 15 16 17 **18** 19 20 21 22 23 24 25 26 27 28/29

FEBRUARY

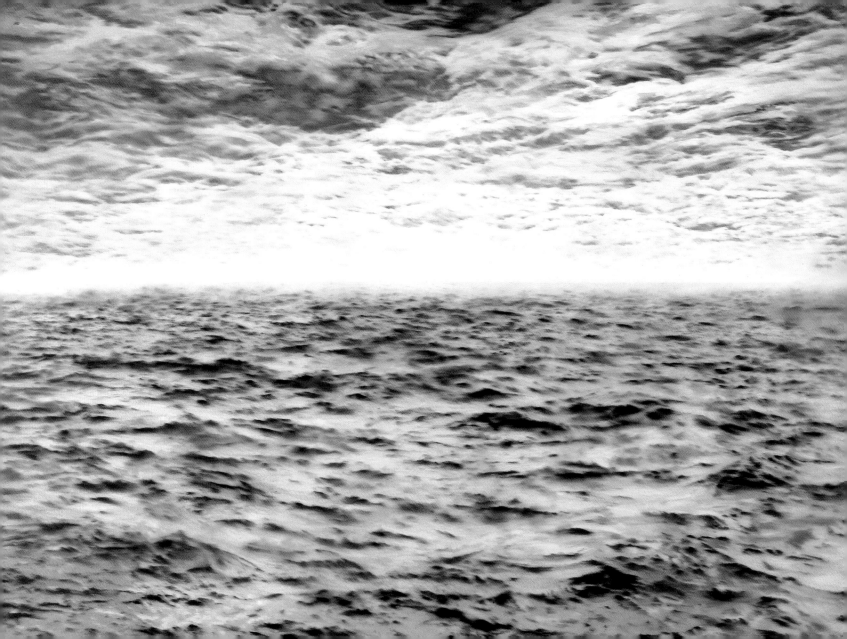

There are tricks in every trade.

The Sales Agreement
Quentin Massys
Gemäldegalerie, Staatliche Museen zu Berlin

1 2 3 4 5 6 7 8 9 10 11 12 13 14 15 16 17 18 **19** 20 21 22 23 24 25 26 27 28/29

FEBRUARY

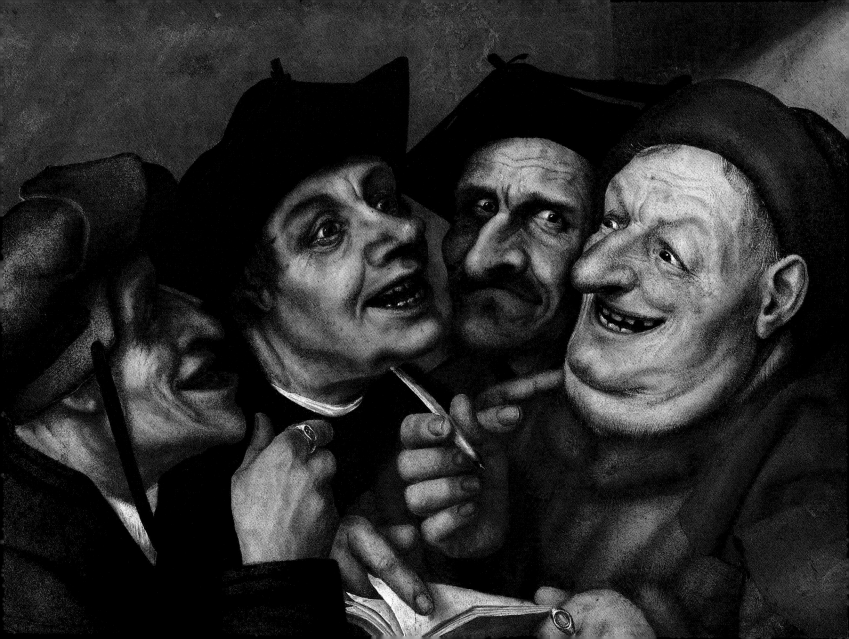

I am interested in the creation of space through color contrasts rather than through simple shading of light and dark.

AUGUST MACKE

Girl with Horse and Donkey, 1914

August Macke

Kupferstichkabinett, Staatliche Museen zu Berlin

1 2 3 4 5 6 7 8 9 10 11 12 13 14 15 16 17 18 19 **20** 21 22 23 24 25 26 27 28/29

FEBRUARY

Art has something to do with the achievement of stillness in the midst of chaos. A stillness which characterizes prayer, too, and the eye of the storm . . . an arrest of attention in the midst of distraction.

GEORGE PLIMPTON

Roger and Angelica, *c.* 1910
Odilon Redon
Sammlung Scharf-Gerstenberg, Staatliche Museen zu Berlin

1 2 3 4 5 6 7 8 9 10 11 12 13 14 15 16 17 18 19 20 **21** 22 23 24 25 26 27 28/29

FEBRUARY

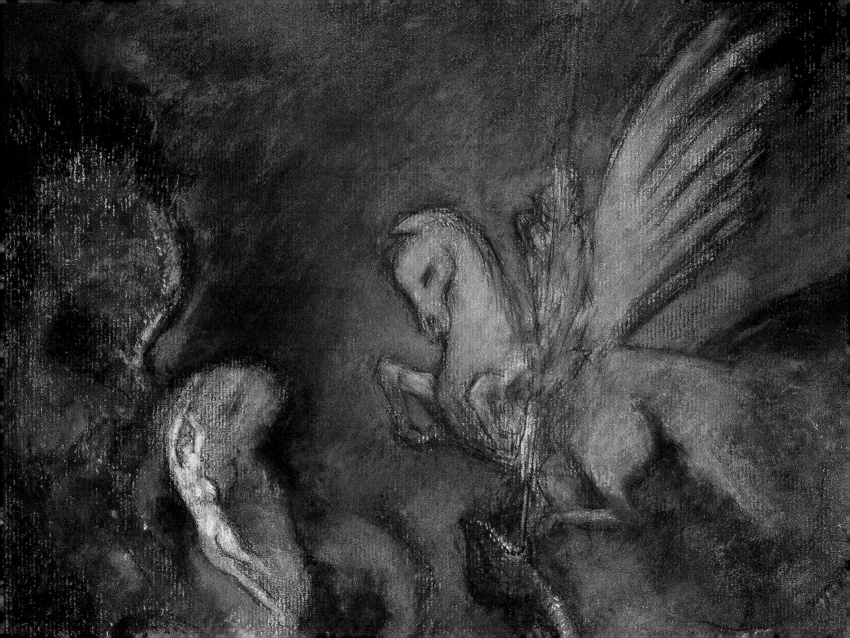

*Every portrait that is painted
with feeling is a portrait of the artist,
not of the sitter.*

<small>OSCAR WILDE</small>

Portrait of Mrs. Isabel Styler-Tas (Melancholy), 1945
Salvador Dalí
Nationalgalerie, Staatliche Museen zu Berlin

1 2 3 4 5 6 7 8 9 10 11 12 13 14 15 16 17 18 19 20 21 **22** 23 24 25 26 27 28/29

FEBRUARY

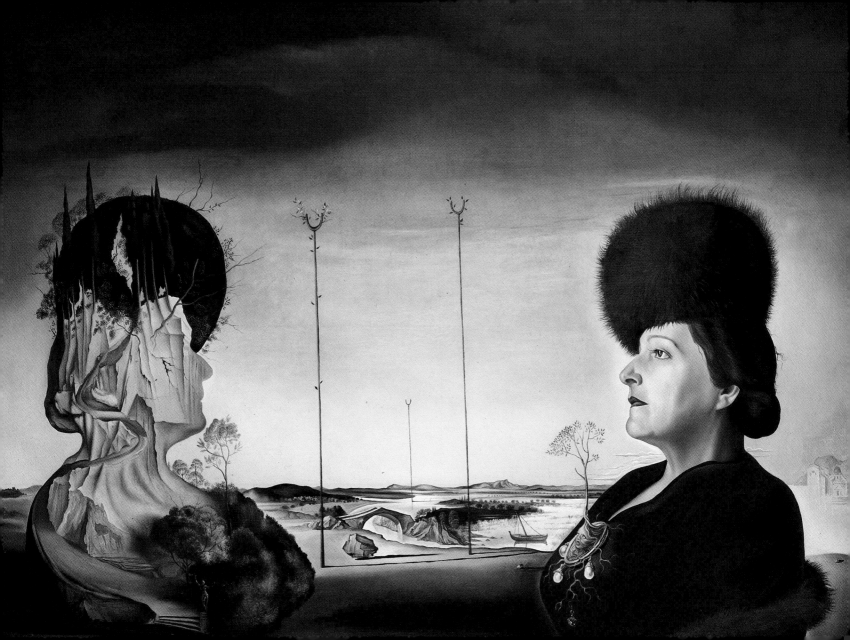

And in the end, it's not the years
in your life that count.
It's the life in your years.

ABRAHAM LINCOLN

The Fountain of Youth, 1546
Lucas Cranach the Elder
Gemäldegalerie, Staatliche Museen zu Berlin

1 2 3 4 5 6 7 8 9 10 11 12 13 14 15 16 17 18 19 20 21 22 23 24 25 26 27 28/29

FEBRUARY

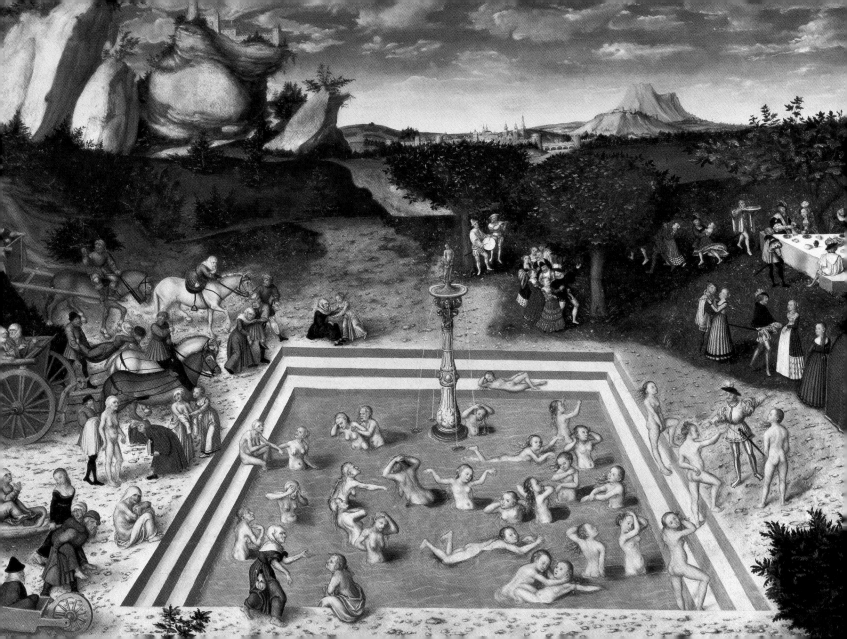

*Unless we place our religion
and our treasure in the same thing,
religion will always be sacrificed.*

<small>EPICTETUS</small>

**Relic purse from the treasure of the St. Dionysius Monastery
in Enger near Herford,** third quarter of the 8th century A. D.

Kunstgewerbemuseum, Staatliche Museen zu Berlin

1 2 3 4 5 6 7 8 9 10 11 12 13 14 15 16 17 18 19 20 21 22 23 **24** 25 26 27 28/29

FEBRUARY

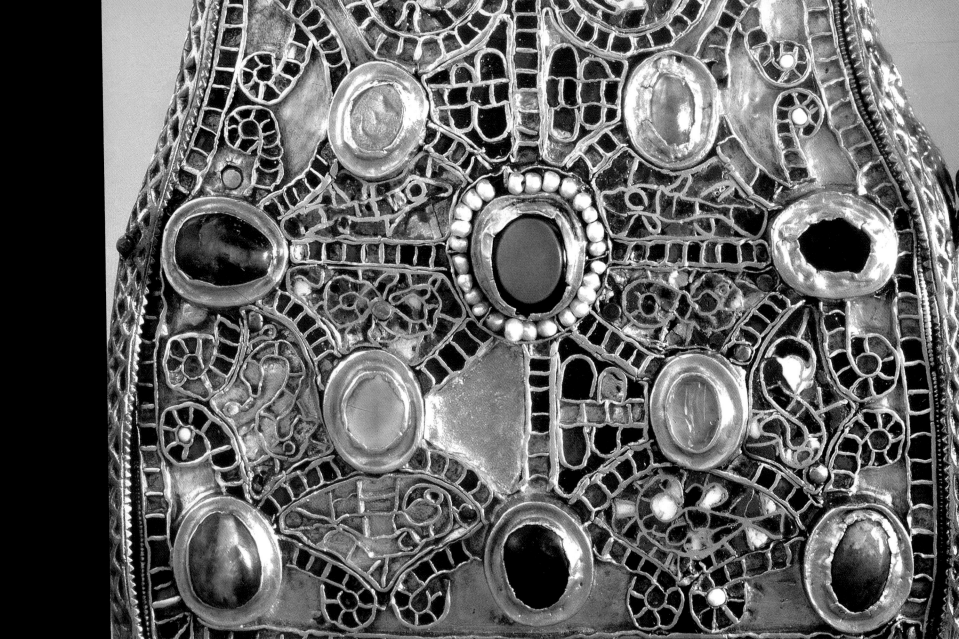

There is no must in art because art is free.

WASSILY KANDINSKY

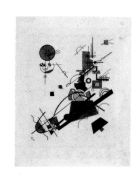

Joyful Arising, 1923
Wassily Kandinsky
Kupferstichkabinett, Staatliche Museen zu Berlin

1 2 3 4 5 6 7 8 9 10 11 12 13 14 15 16 17 18 19 20 21 22 23 24 **25** 26 27 28/29

FEBRUARY

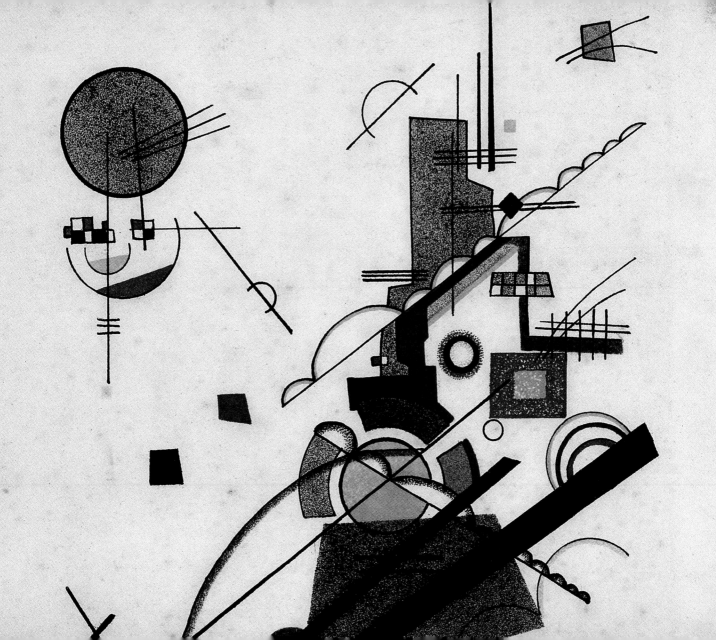

Those who have courage to love should have courage to suffer.

ANTHONY TROLLOPE

An Engagement
Michele da Verona
Gemäldegalerie, Staatliche Museen zu Berlin

1 2 3 4 5 6 7 8 9 10 11 12 13 14 15 16 17 18 19 20 21 22 23 24 25 **26** 27 28/29

FEBRUARY

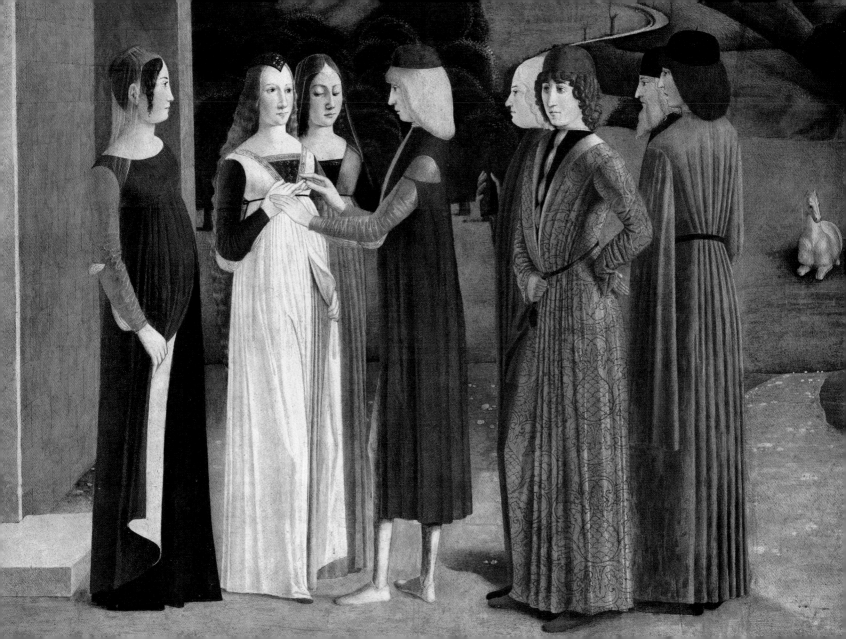

Ave Maria! 'tis the hour of prayer!
Ave Maria! 'tis the hour of love!

Isaac Watts

Virgin of the Protecting Cloak from Ravensburg, 1480
Michel Erhart
Skulpturensammlung und Museum für Byzantinische Kunst, Staatliche Museen zu Berlin

1 2 3 4 5 6 7 8 9 10 11 12 13 14 15 16 17 18 19 20 21 22 23 24 25 26 **27** 28/29

FEBRUARY

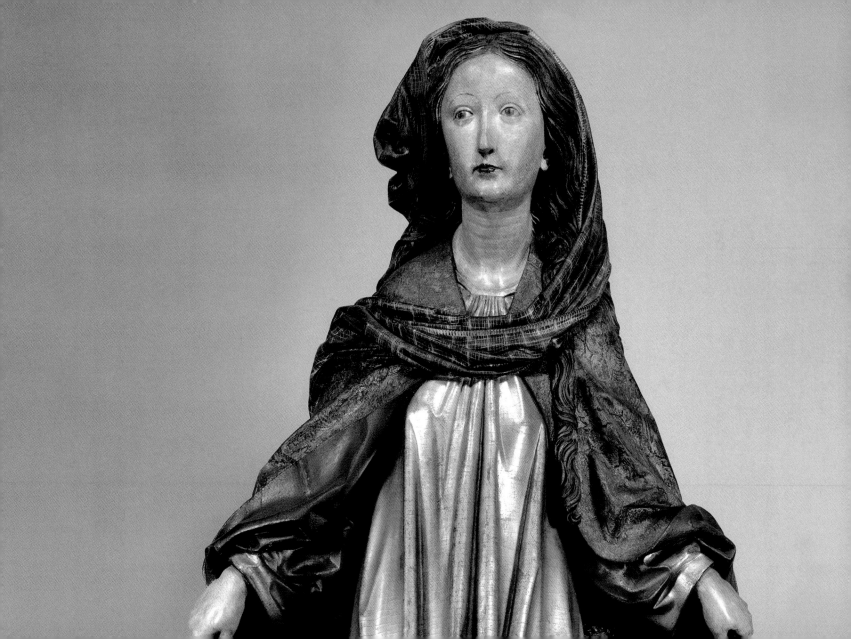

> *Art does not reproduce the visible;*
> *rather, it makes visible.*

PAUL KLEE

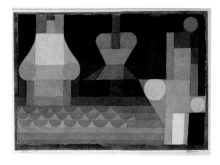

Sluices, 1922
Paul Klee
Museum Berggruen, Nationalgalerie, Staatliche Museen zu Berlin

1 2 3 4 5 6 7 8 9 10 11 12 13 14 15 16 17 18 19 20 21 22 23 24 25 26 27 **28/29**

FEBRUARY

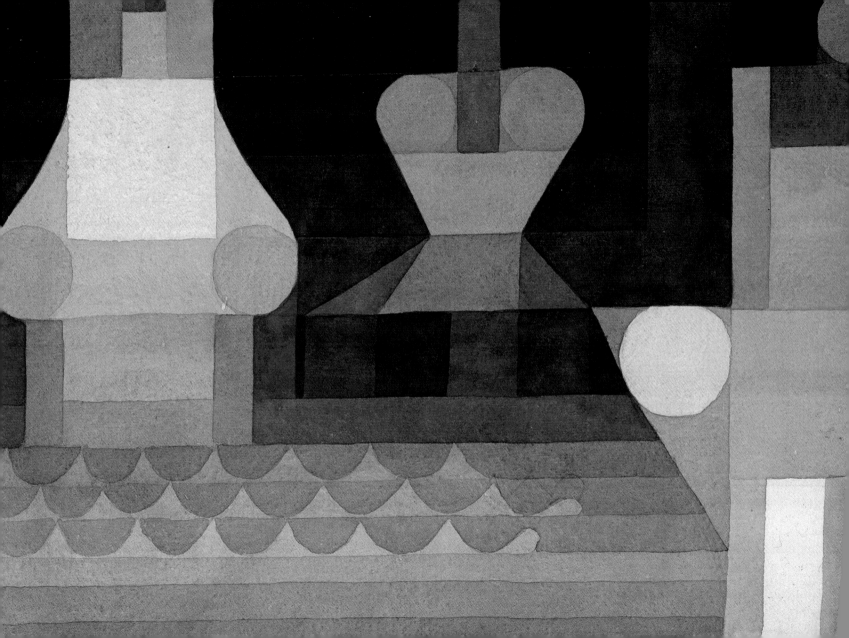

And in the sweetness of friendship let there be laughter and the sharing of pleasures.

Kahlil Gibran

Life on the Ice at Sundown in Amsterdam, early 17th century
Hendrick Avercamp
Kupferstichkabinett, Staatliche Museen zu Berlin

1 2 3 4 5 6 7 8 9 10 11 12 13 14 15 16 17 18 19 20 21 22 23 24 25 26 27 28 29 30 31

MARCH

Love and war are the same thing, and stratagems and policy are as allowable in the one as in the other.

MIGUEL DE CERVANTES

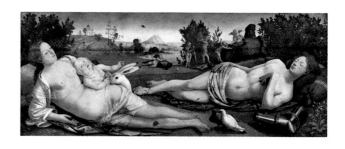

Venus, Mars and Cupid, *c.* 1505
Piero di Cosimo
Gemäldegalerie, Staatliche Museen zu Berlin

1 **2** 3 4 5 6 7 8 9 10 11 12 13 14 15 16 17 18 19 20 21 22 23 24 25 26 27 28 29 30 31

MARCH

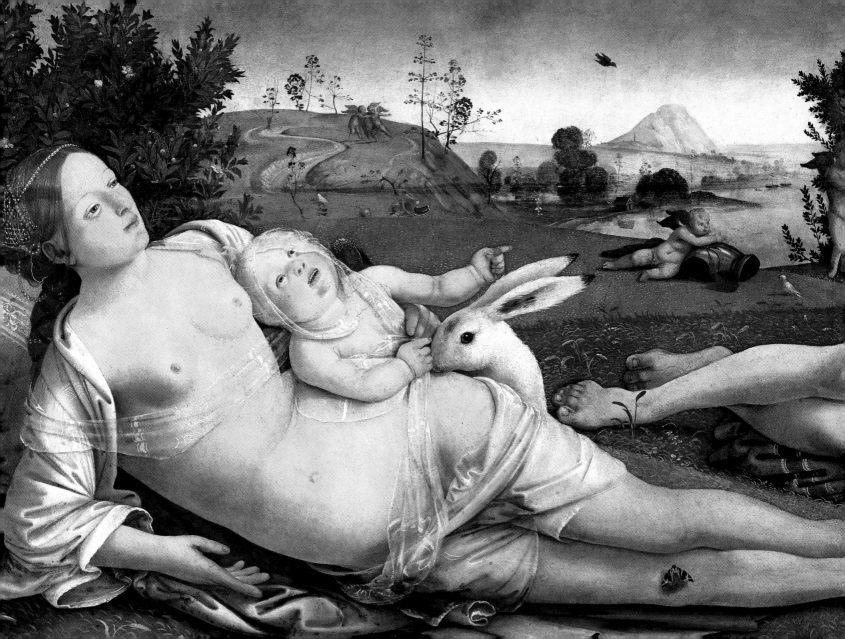

It took me 40 years to find out that painting is not sculpture.

Paul Cézanne

Still Life with Fruit and Dishes, *c.* 1871/72
Paul Cézanne
Nationalgalerie, Staatliche Museen zu Berlin

1 2 **3** 4 5 6 7 8 9 10 11 12 13 14 15 16 17 18 19 20 21 22 23 24 25 26 27 28 29 30 31

MARCH

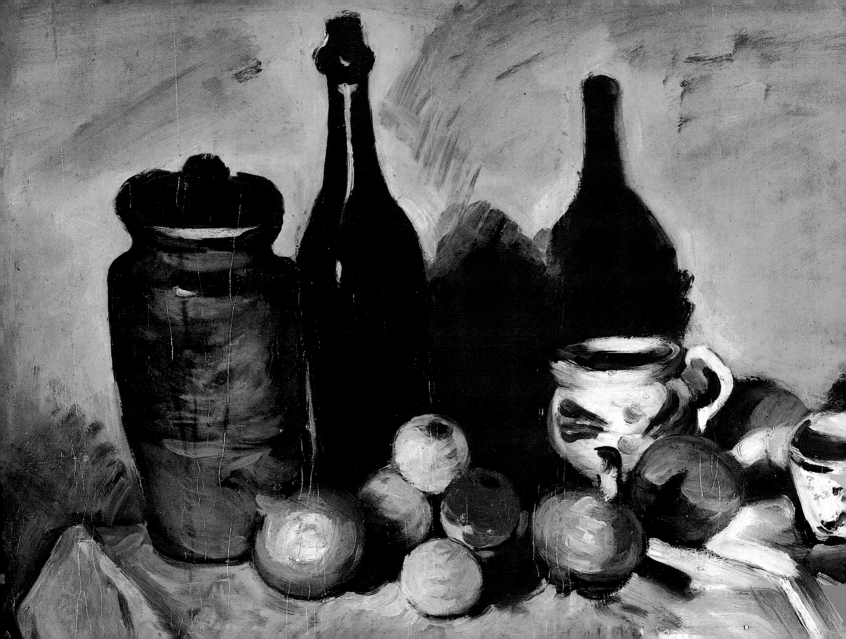

Children are the hands by which we take hold of heaven.

HENRY WARD BEECHER

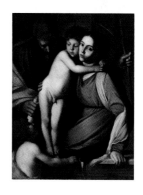

The Holy Family with John the Baptist as a Child
Caravaggio (Copy)
Gemäldegalerie, Staatliche Museen zu Berlin

1 2 3 **4** 5 6 7 8 9 10 11 12 13 14 15 16 17 18 19 20 21 22 23 24 25 26 27 28 29 30 31

MARCH

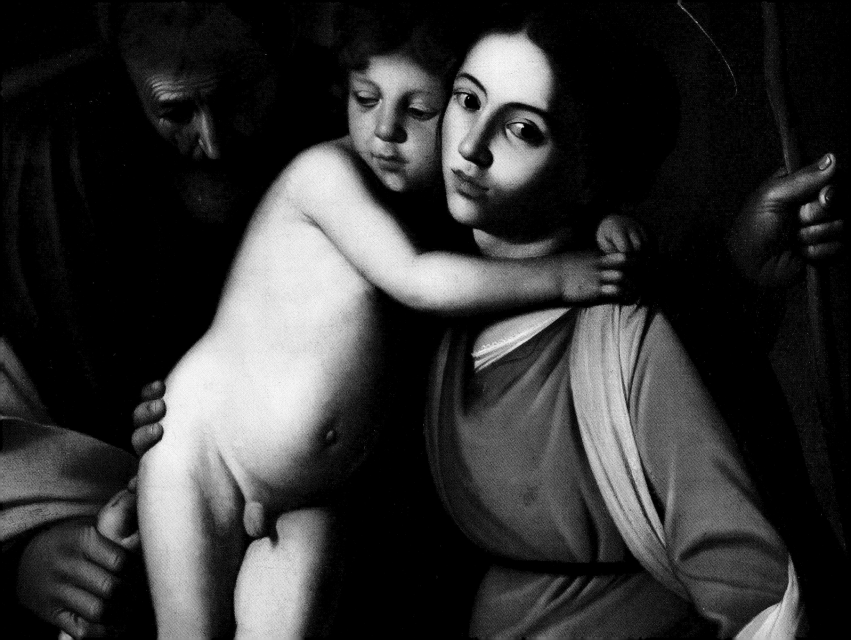

The winds blew, and beat upon that house; and it fell not: for it was founded upon a rock.

MATTHEW 7:25

Gothic Cathedral on a Rock Beside the Sea, 1815
Karl Friedrich Schinkel
Nationalgalerie, Staatliche Museen zu Berlin

1 2 3 4 **5** 6 7 8 9 10 11 12 13 14 15 16 17 18 19 20 21 22 23 24 25 26 27 28 29 30 31

MARCH

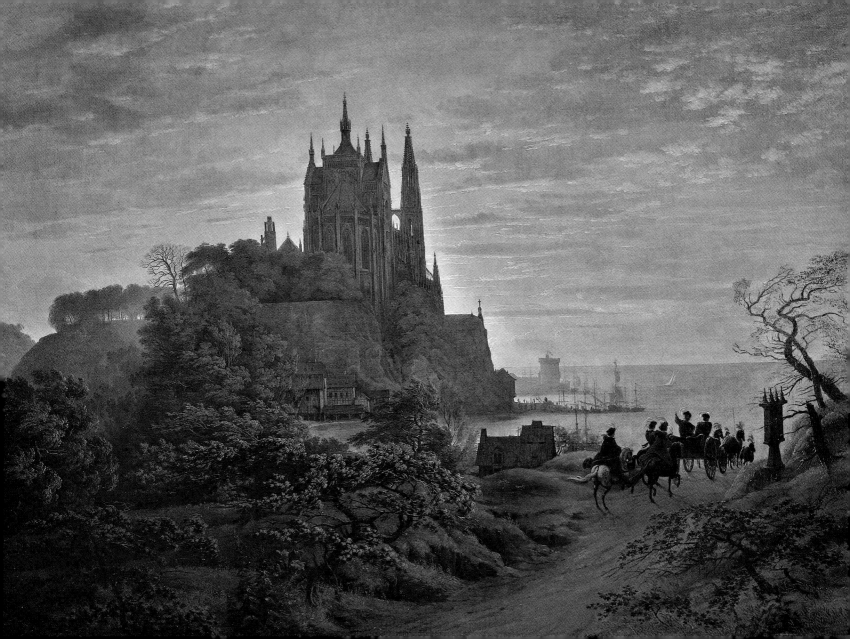

A dog trusts his master's might.

CHINESE PROVERB

Two ridge ornaments (dogs of Fo) on curved roof tiles, 1368–1644
China
Museum für Asiatische Kunst, Staatliche Museen zu Berlin

6

1 2 3 4 5 6 7 8 9 10 11 12 13 14 15 16 17 18 19 20 21 22 23 24 25 26 27 28 29 30 31

MARCH

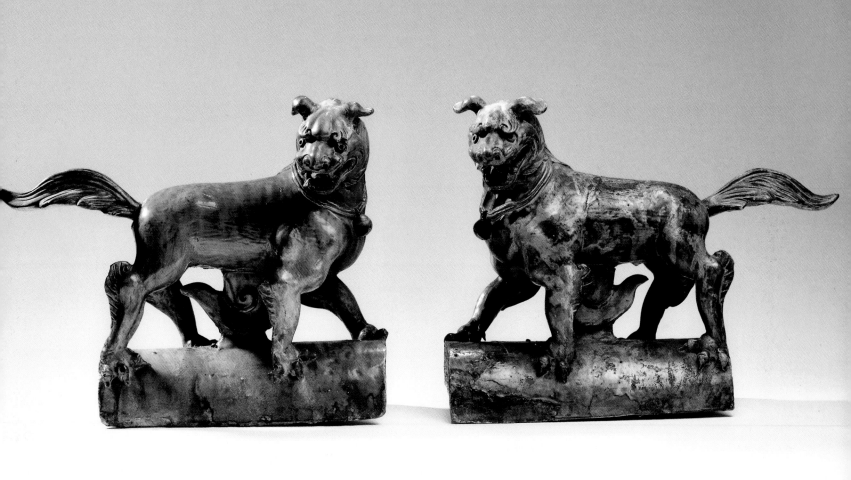

*My soul can find no staircase to heaven
unless it be through earth's loveliness.*

Michelangelo

Capuchin Stairs in Salzburg, 19th century
Adolph von Menzel
Kupferstichkabinett, Staatliche Museen zu Berlin

1 2 3 4 5 6 **7** 8 9 10 11 12 13 14 15 16 17 18 19 20 21 22 23 24 25 26 27 28 29 30 31

MARCH

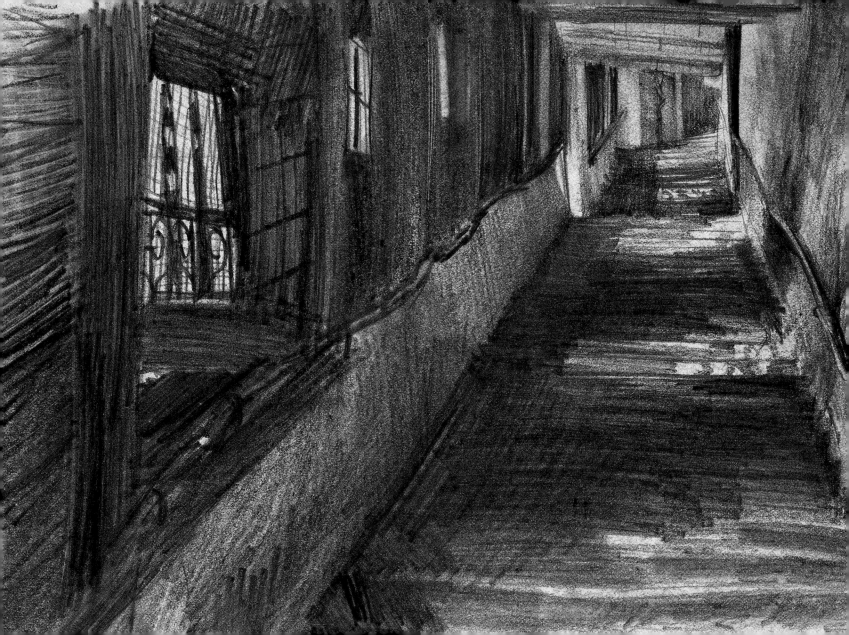

The rich man in his castle,
The poor man at his gate,
God made them, high or lowly,
And ordered their estate.

Cecil Frances Alexander

Park Landscape with Castle, 1589
Hans Bol
Gemäldegalerie, Staatliche Museen zu Berlin

1 2 3 4 5 6 7 **8** 9 10 11 12 13 14 15 16 17 18 19 20 21 22 23 24 25 26 27 28 29 30 31

MARCH

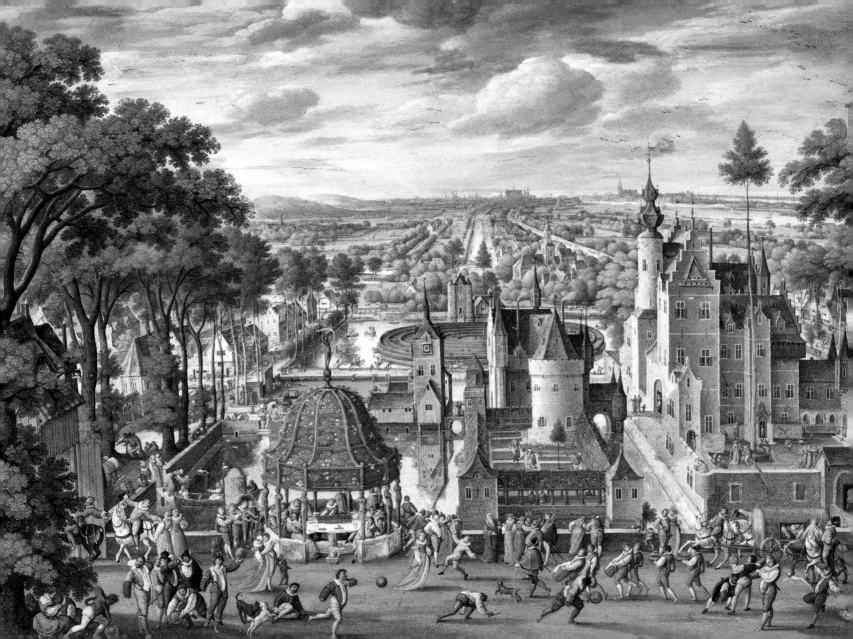

Cowards die many times before their deaths; the valiant never taste of death but once.

<small>WILLIAM SHAKESPEARE</small>

Saint George and the Dragon, 15th century
Belbello da Pavia
Kupferstichkabinett, Staatliche Museen zu Berlin

1 2 3 4 5 6 7 8 **9** 10 11 12 13 14 15 16 17 18 19 20 21 22 23 24 25 26 27 28 29 30 31

MARCH

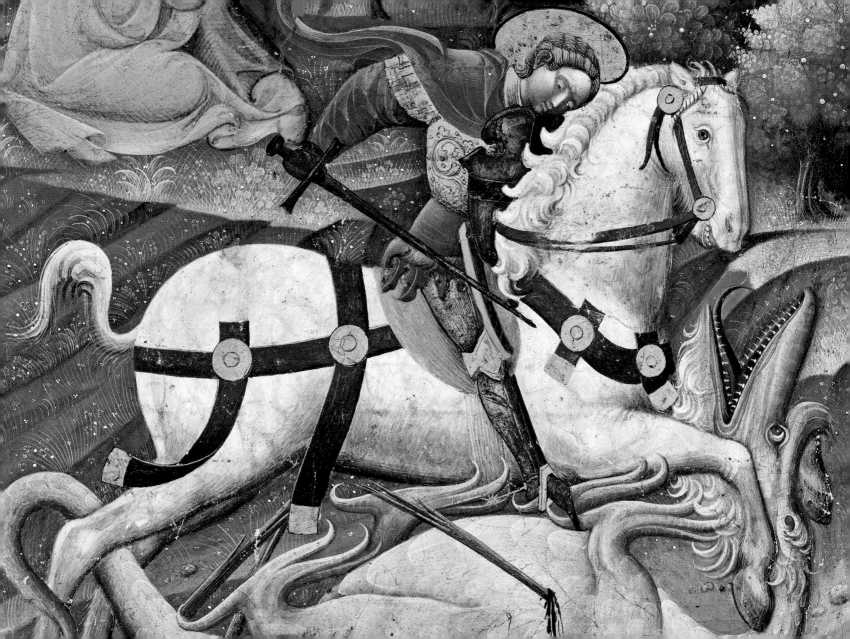

Science is organized knowledge.
Wisdom is organized life.

IMMANUEL KANT

Young Man Sharpening a Pencil, 1737
Jean-Baptiste Siméon Chardin
Gemäldegalerie, Staatliche Museen zu Berlin

1 2 3 4 5 6 7 8 9 **10** 11 12 13 14 15 16 17 18 19 20 21 22 23 24 25 26 27 28 29 30 31

MARCH

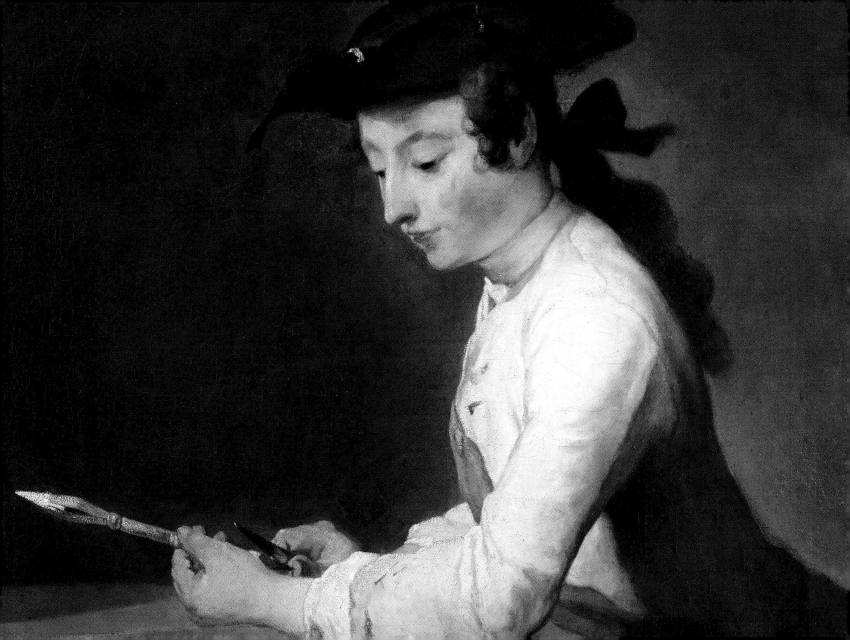

*Innocence most often is a good fortune
and not a virtue.*

Anatole France

Wall frieze inlay in the form of a calf, clay relief, *c.* 2600 B. C.
Uruk
Vorderasiatisches Museum, Staatliche Museen zu Berlin

1 2 3 4 5 6 7 8 9 10 **11** 12 13 14 15 16 17 18 19 20 21 22 23 24 25 26 27 28 29 30 31

MARCH

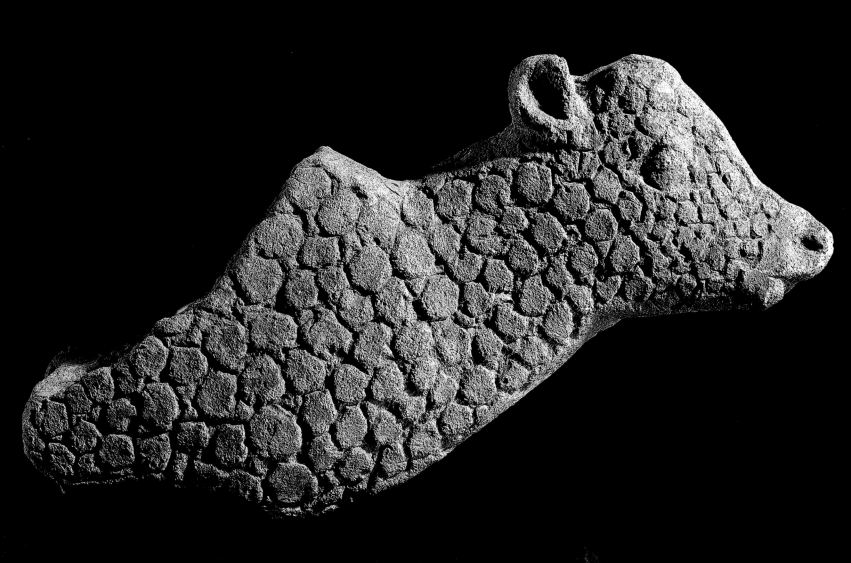

The chess-board is the world; the pieces are the phenomena of the universe; the rules of the game are what we call the laws of Nature. The player on the other side is hidden from us. We know that his play is always fair, just, and patient. But also we know, to our cost, that he never overlooks a mistake, or makes the smallest allowance for ignorance.

THOMAS HENRY HUXLEY

Two Chess-players, *c.* 1540
Paris Paschalinus Bordone
Gemäldegalerie, Staatliche Museen zu Berlin

1 2 3 4 5 6 7 8 9 10 11 **12** 13 14 15 16 17 18 19 20 21 22 23 24 25 26 27 28 29 30 31

MARCH

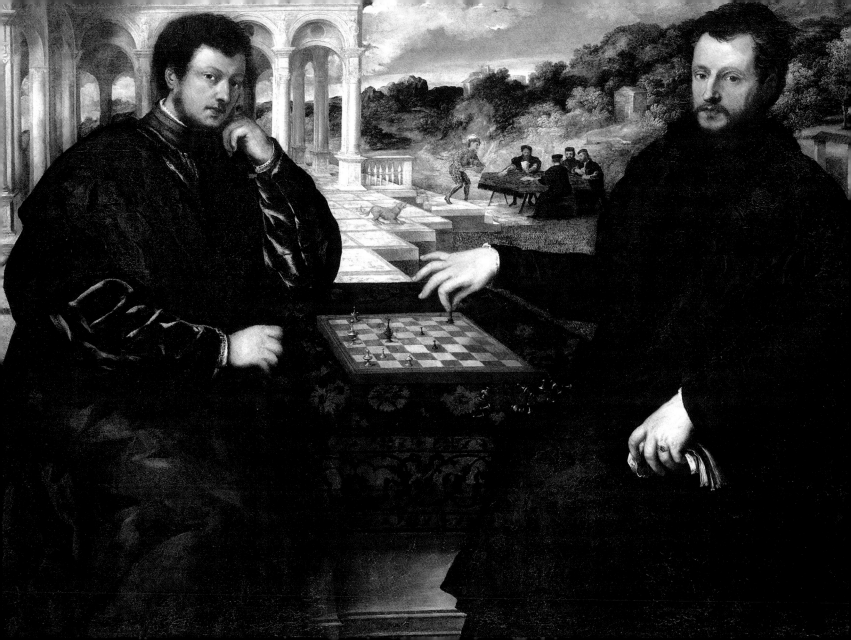

The more we study art,
the less we care for nature.

OSCAR WILDE

Two Weasels
Albrecht Dürer
Kupferstichkabinett, Staatliche Museen zu Berlin

1 2 3 4 5 6 7 8 9 10 11 12 **13** 14 15 16 17 18 19 20 21 22 23 24 25 26 27 28 29 30 31

MARCH

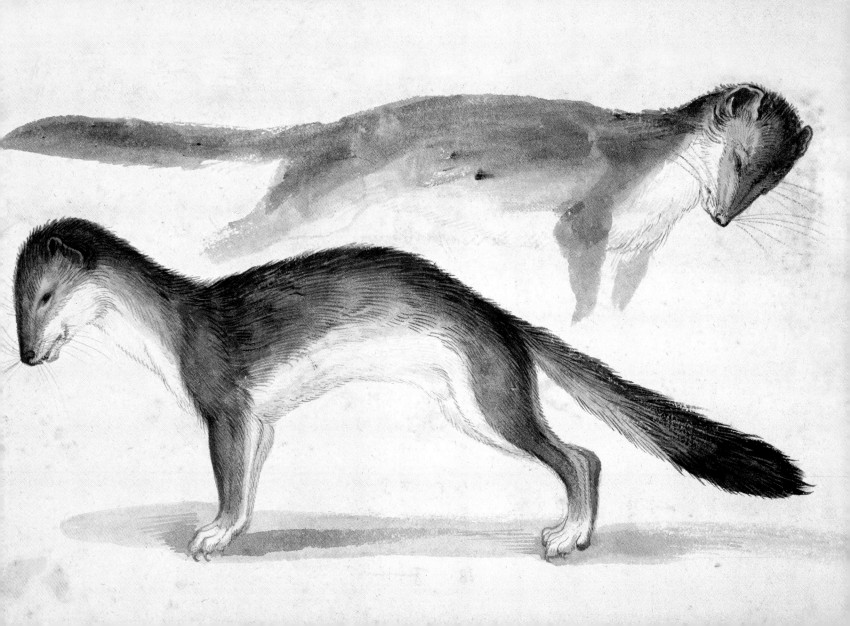

For the Christ Child who comes
is the Master of all;
No palace too great,
no cottage too small.

PHILLIPS BROOKS

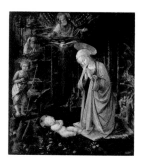

**The Madonna Adoring Christ with John the Baptist and
Saint Bernard,** *c.* 1459
Fra Filippo Lippi
Gemäldegalerie, Staatliche Museen zu Berlin

1 2 3 4 5 6 7 8 9 10 11 12 13 **14** 15 16 17 18 19 20 21 22 23 24 25 26 27 28 29 30 31

MARCH

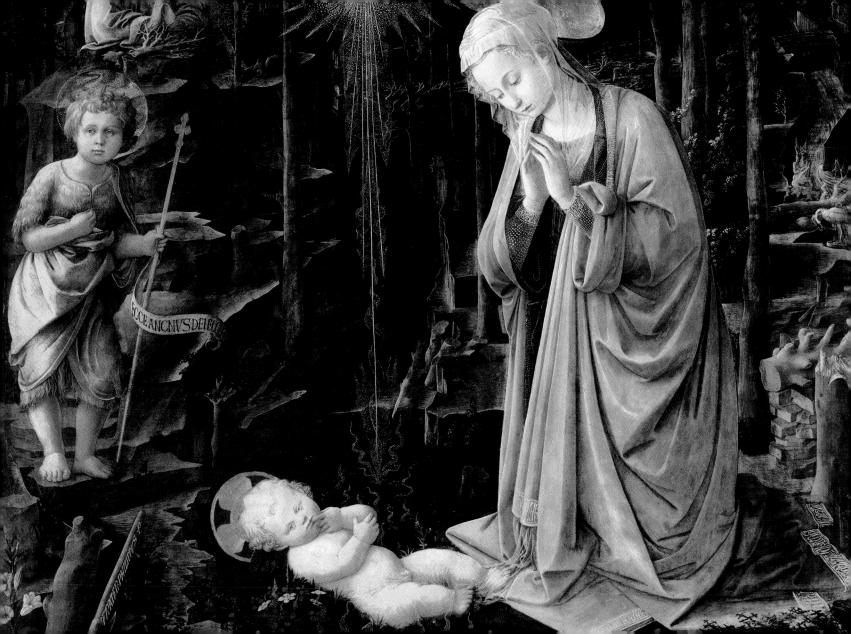

Consider the past and you shall know the future.

Cylinder seal of Adad, *c.* 9th century B. C.
Old Babylonian Empire
Vorderasiatisches Museum, Staatliche Museen zu Berlin

1 2 3 4 5 6 7 8 9 10 11 12 13 14 **15** 16 17 18 19 20 21 22 23 24 25 26 27 28 29 30 31

MARCH

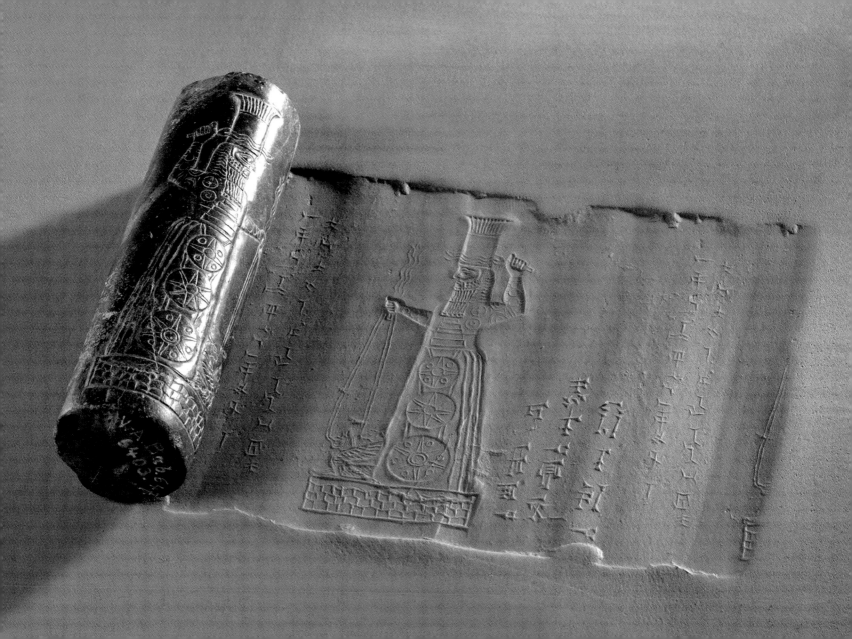

Culture is roughly anything we do and the monkeys don't.

Two Chained Monkeys, 1562
Pieter Bruegel the Elder
Gemäldegalerie, Staatliche Museen zu Berlin

1 2 3 4 5 6 7 8 9 10 11 12 13 14 15 **16** 17 18 19 20 21 22 23 24 25 26 27 28 29 30 31

MARCH

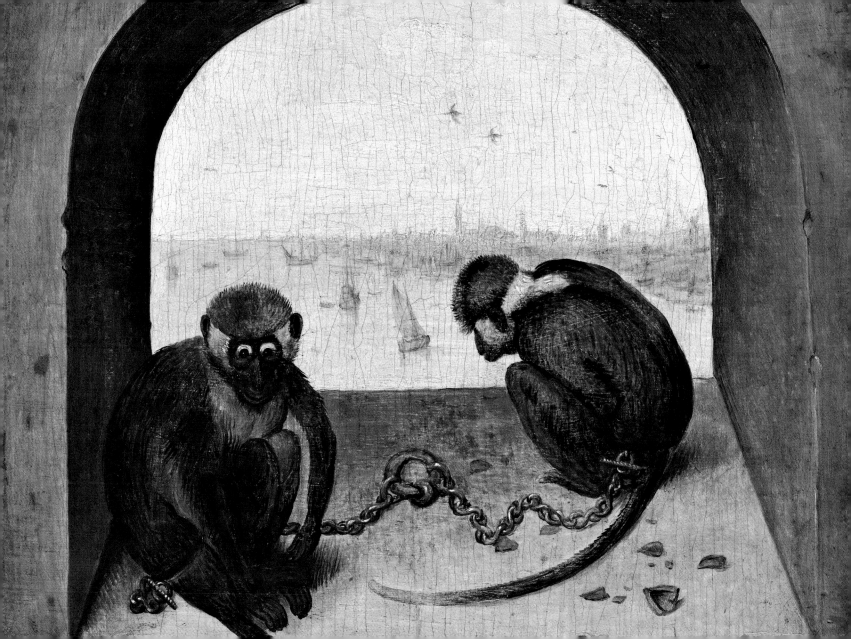

I thought I alone suffered, but suffering is everywhere. When I went on the housetop I saw its fire in every home.

<small>FARID</small>

Martyrdom of Saint Sebastian, *c.* 1525
Monogrammist IP
Skulpturensammlung und Museum für Byzantinische Kunst, Staatliche Museen zu Berlin

1 2 3 4 5 6 7 8 9 10 11 12 13 14 15 16 **17** 18 19 20 21 22 23 24 25 26 27 28 29 30 31

MARCH

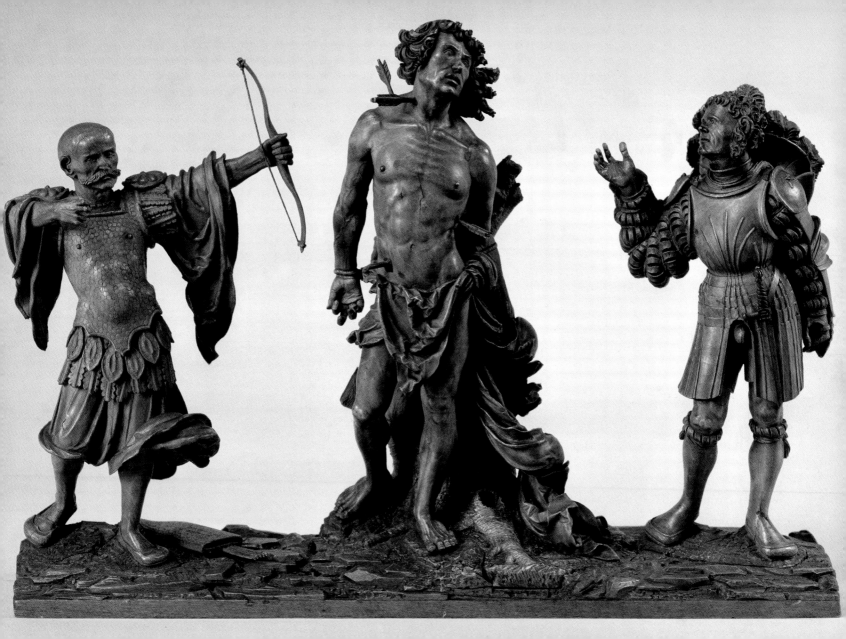

A painting requires a little mystery,
some vagueness, some fantasy.
When you always make your meaning
perfectly plain you end up boring people.

EDGAR DEGAS

Amusement, *c.* 1884
Edgar Degas
Nationalgalerie, Staatliche Museen zu Berlin

1 2 3 4 5 6 7 8 9 10 11 12 13 14 15 16 17 **18** 19 20 21 22 23 24 25 26 27 28 29 30 31

MARCH

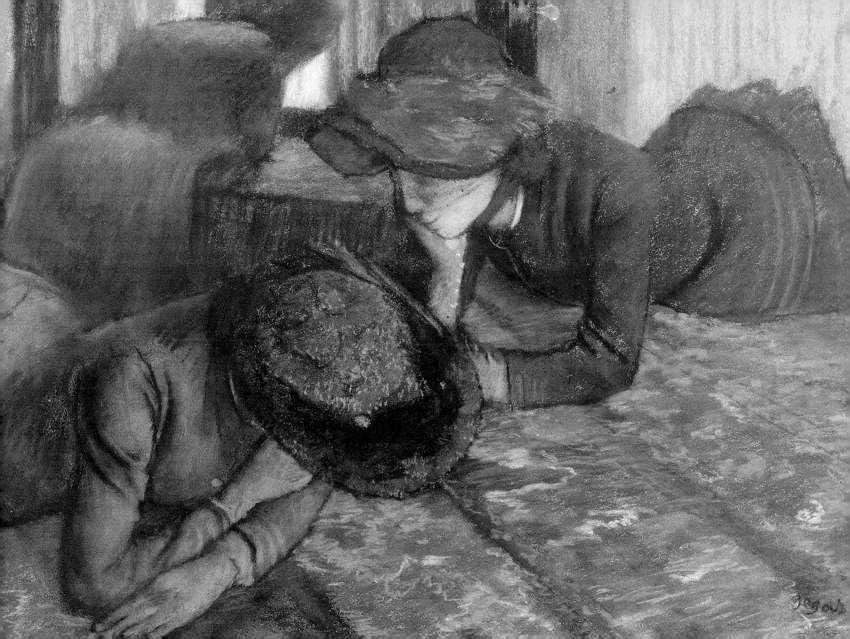

Beauty is momentary in the mind—
The fitful tracing of a portal;
But in the flesh it is immortal.
The body dies; the body's beauty lives.

WALLACE STEVENS

Portrait of a Woman with Bonnet, *c.* 1435
Rogier van der Weyden
Gemäldegalerie, Staatliche Museen zu Berlin

1 2 3 4 5 6 7 8 9 10 11 12 13 14 15 16 17 18 **19** 20 21 22 23 24 25 26 27 28 29 30 31

MARCH

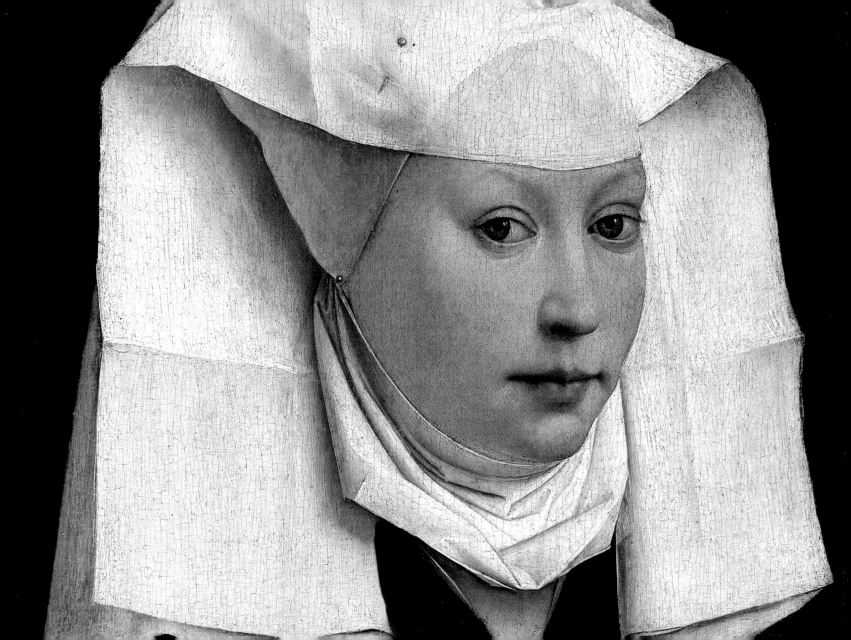

Art *always serves beauty, and beauty is*
the joy of possessing form, and form is
the key to organic life since no living
thing can exist without it.

BORIS PASTERNAK

Shell Landscape, 1928
Max Ernst
Nationalgalerie, Staatliche Museen zu Berlin

1 2 3 4 5 6 7 8 9 10 11 12 13 14 15 16 17 18 19 **20** 21 22 23 24 25 26 27 28 29 30 31

MARCH

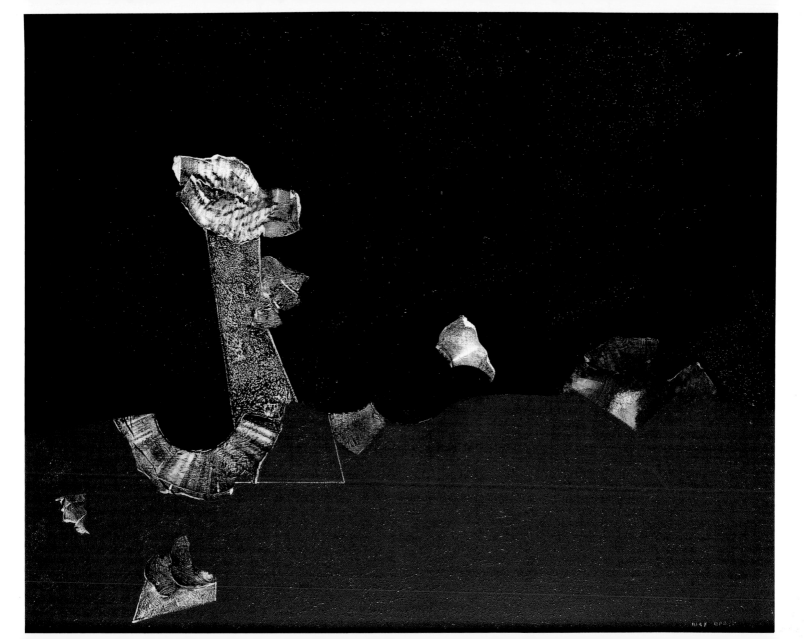

Don't waste life in doubts and fears.
Spend yourself on the work before you,
well assured that the right performance
of this hour's duties will be the best
preparation for the hours and ages that
will follow it.

RALPH WALDO EMERSON

Shoe Repair Shop, 1881/82
Max Liebermann
Nationalgalerie, Staatliche Museen zu Berlin

1 2 3 4 5 6 7 8 9 10 11 12 13 14 15 16 17 18 19 20 **21** 22 23 24 25 26 27 28 29 30 31

MARCH

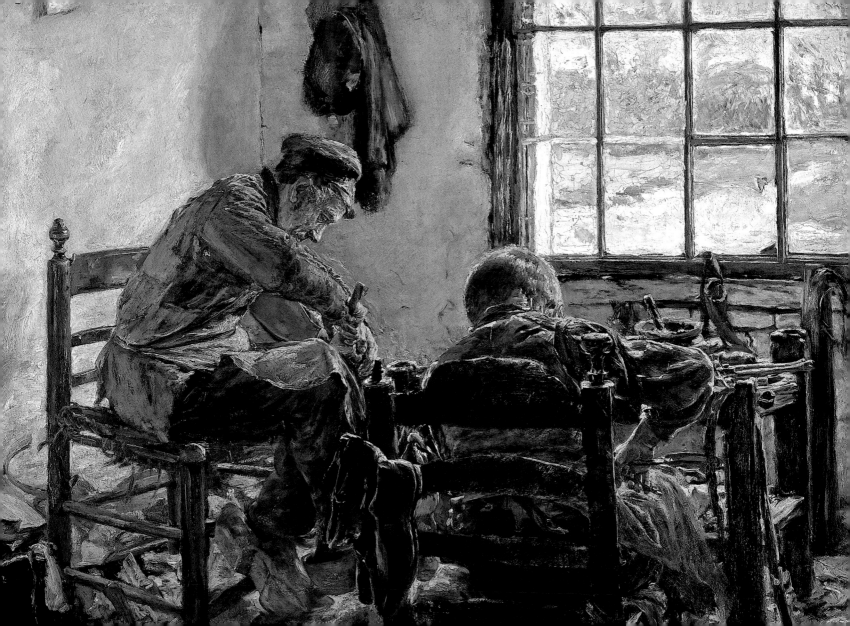

A noble craft, but somehow a most melancholy! All noble things are touched with that.

HERMAN MELVILLE

Melancholia I, 1514
Albrecht Dürer
Kupferstichkabinett, Staatliche Museen zu Berlin

1 2 3 4 5 6 7 8 9 10 11 12 13 14 15 16 17 18 19 20 21 **22** 23 24 25 26 27 28 29 30 31

MARCH

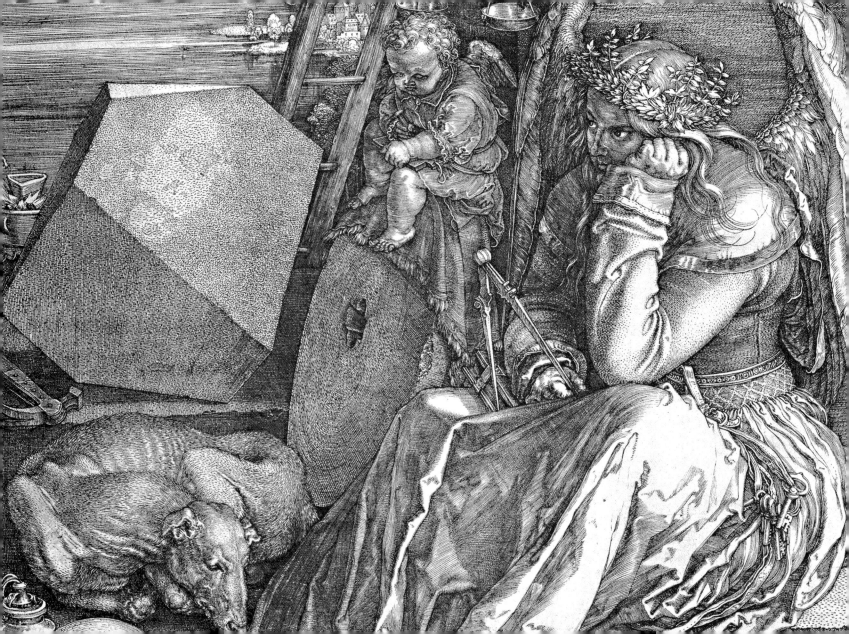

Of small coral about hire arm she bar
A peire of bedes, gauded al with grene,
And tereon heng a brooch of gold ful sheene,
On which her first write crowned A,
And after Amor vincit omnia.

GEOFFREY CHAUCER

Venus and Cupid, 1742
François Boucher
Gemäldegalerie, Property of the Kaiser Friedrich-Museums-Verein, Staatliche Museen zu Berlin

1 2 3 4 5 6 7 8 9 10 11 12 13 14 15 16 17 18 19 20 21 22 **23** 24 25 26 27 28 29 30 31

MARCH

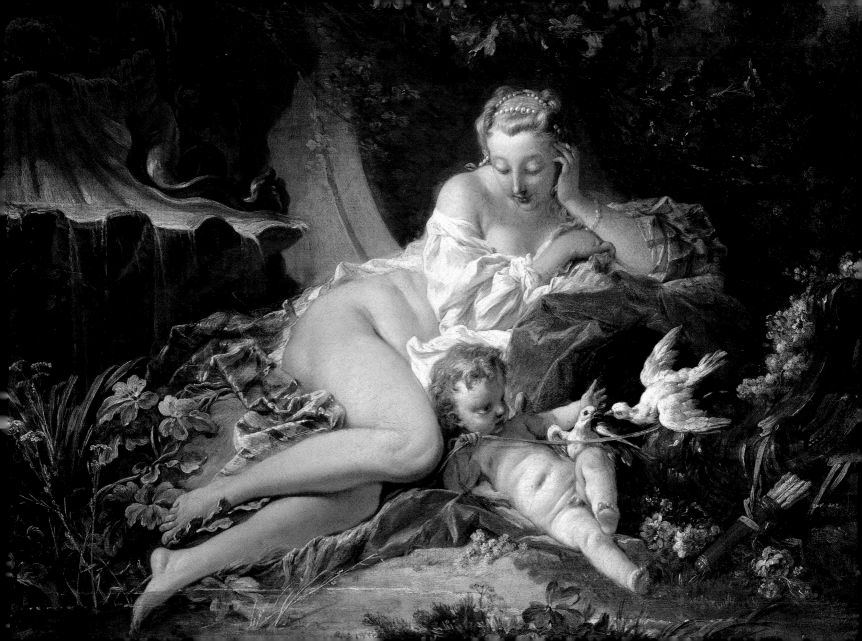

*True proportions make the beauty
of architecture.*

Lord Shaftesbury

View of the Temple of Vesta, early 19th century
Karl Friedrich Schinkel
Kupferstichkabinett, Staatliche Museen zu Berlin

1 2 3 4 5 6 7 8 9 10 11 12 13 14 15 16 17 18 19 20 21 22 23 **24** 25 26 27 28 29 30 31

MARCH

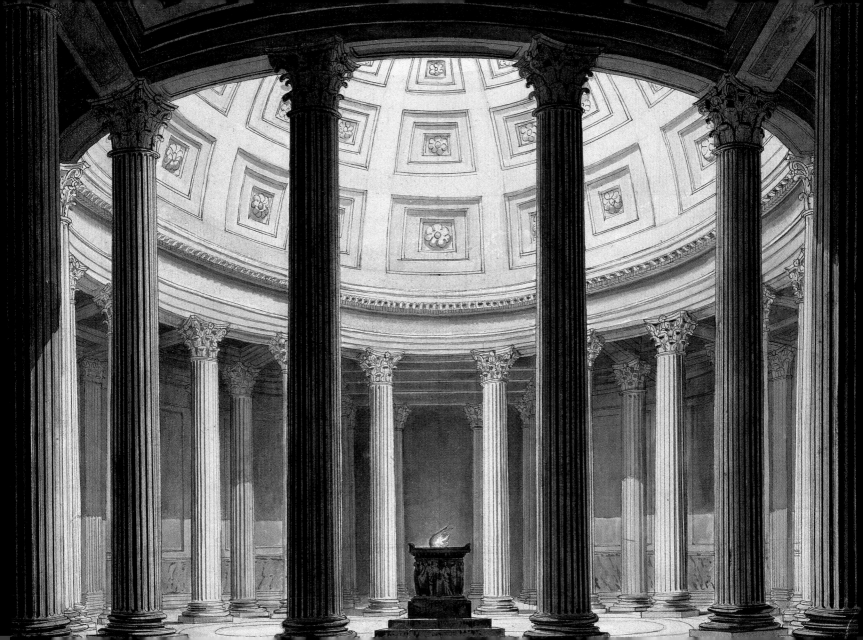

All great art has come from mutilated egos.

CAMILLE PAGLIA

Hommage à Goya, *c.* 1895
Odilon Redon
Sammlung Scharf-Gerstenberg, Staatliche Museen zu Berlin

1 2 3 4 5 6 7 8 9 10 11 12 13 14 15 16 17 18 19 20 21 22 23 24 **25** 26 27 28 29 30 31

MARCH

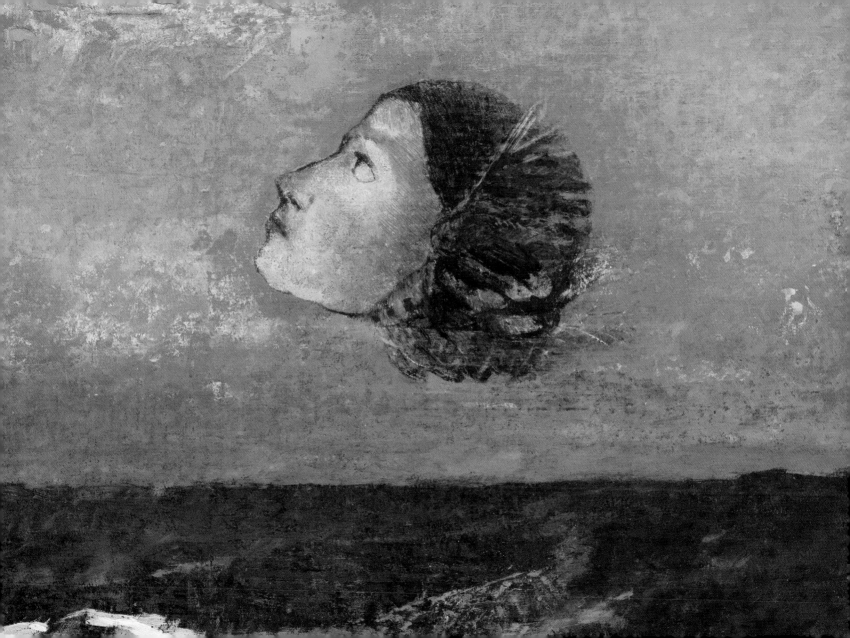

Ever charming, ever new,
When will the landscape tire the view?

JOHN DYER

Inn Valley Landscape, 1910
Lovis Corinth
Nationalgalerie, Staatliche Museen zu Berlin

1 2 3 4 5 6 7 8 9 10 11 12 13 14 15 16 17 18 19 20 21 22 23 24 25 **26** 27 28 29 30 31

MARCH

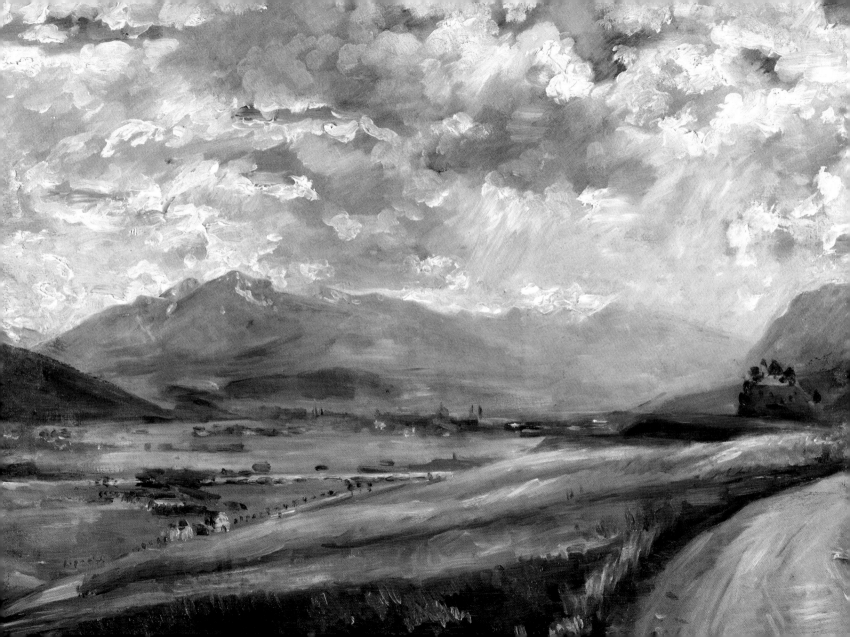

There are two cardinal human sins from which all others derive: impatience and indolence. Perhaps there is only one cardinal sin: impatience. Because of impatience we were driven out of Paradise; because of impatience we cannot return.

Adam and Eve in Paradise (The Fall of Man), 1533
Lucas Cranach the Elder
Gemäldegalerie, Staatliche Museen zu Berlin

1 2 3 4 5 6 7 8 9 10 11 12 13 14 15 16 17 18 19 20 21 22 23 24 25 26 **27** 28 29 30 31

MARCH

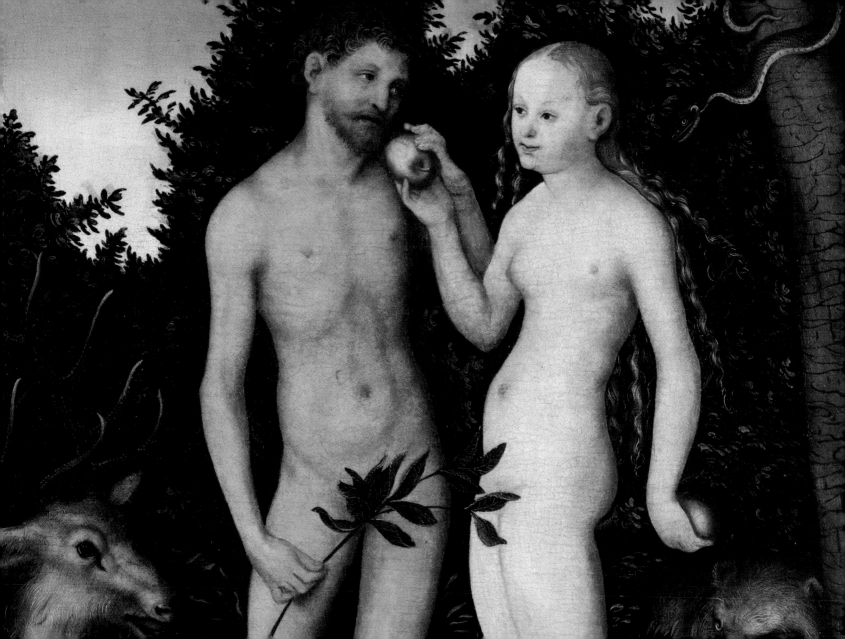

He that has one eye is a prince among those that have none.

THOMAS FULLER

Prince Dara Shikuh and His Son with a Parade of Elephants,
17th century
Museum für Islamische Kunst, Staatliche Museen zu Berlin

1 2 3 4 5 6 7 8 9 10 11 12 13 14 15 16 17 18 19 20 21 22 23 24 25 26 27 **28** 29 30 31

MARCH

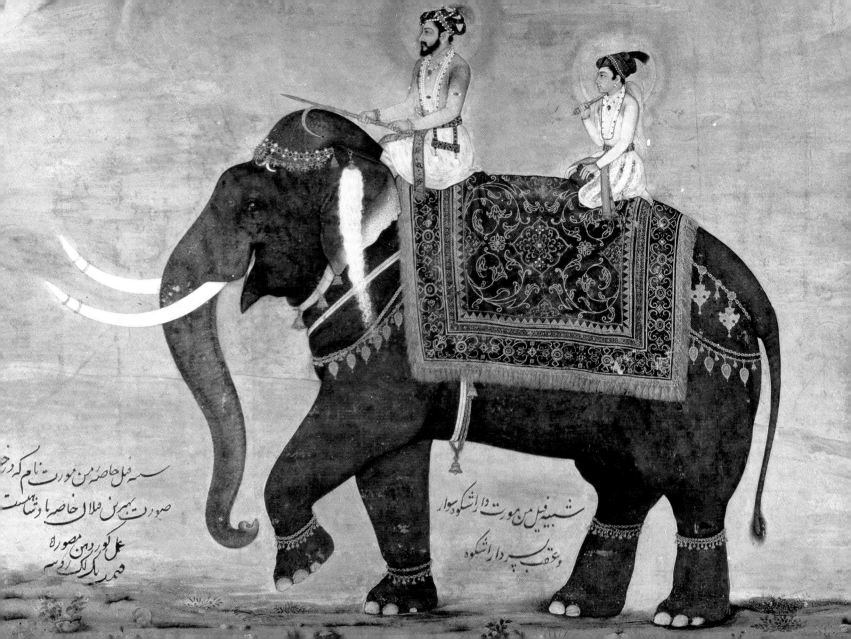

There are good marriages, but no delightful ones.

Seated figure of the Der-semeji and his wife, *c.* 2500 B. C.
Egypt
Ägyptisches Museum und Papyrussammlung, Staatliche Museen zu Berlin

1 2 3 4 5 6 7 8 9 10 11 12 13 14 15 16 17 18 19 20 21 22 23 24 25 26 27 28 **29** 30 31

MARCH

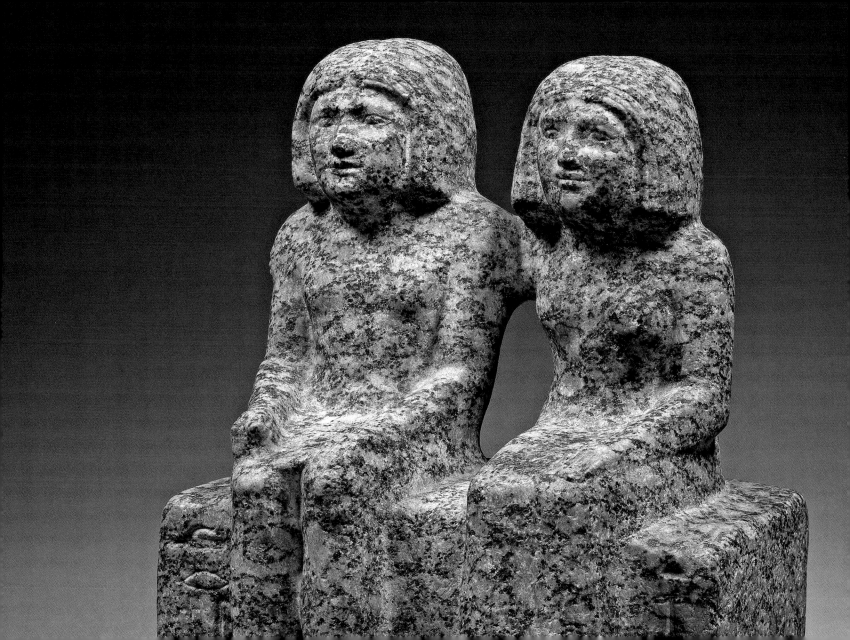

There is a land of pure delight,
Where saints immortal reign.

Isaac Watts

Landscape with Saint Christopher
Orazio Gentileschi
Gemäldegalerie, Staatliche Museen zu Berlin

1 2 3 4 5 6 7 8 9 10 11 12 13 14 15 16 17 18 19 20 21 22 23 24 25 26 27 28 29 **30** 31

MARCH

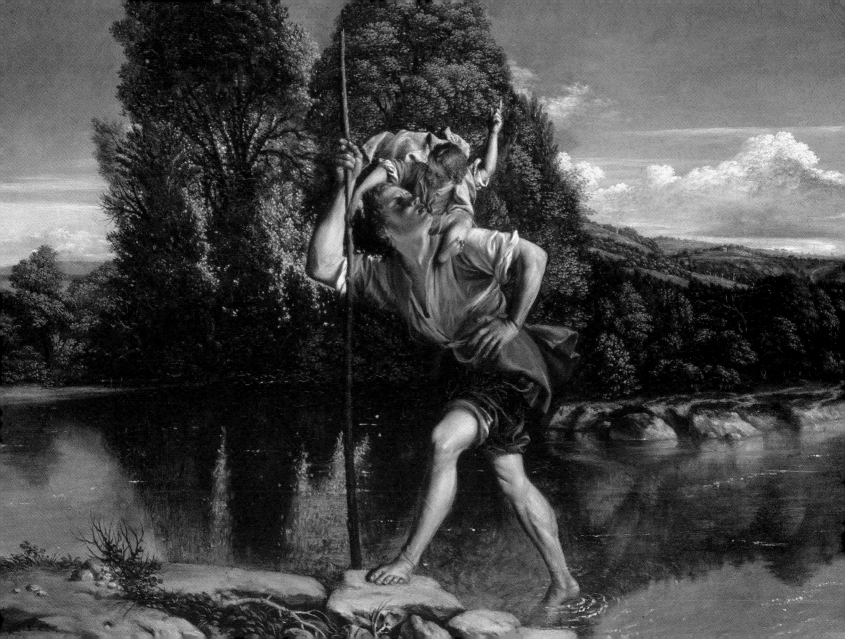

The true meaning of religion is thus not simply morality, but morality touched by emotion.

<small>MATTHEW ARNOLD</small>

Virgin and Child (Madonna Colonna), *c.* 1508
Raphael
Gemäldegalerie, Staatliche Museen zu Berlin

1 2 3 4 5 6 7 8 9 10 11 12 13 14 15 16 17 18 19 20 21 22 23 24 25 26 27 28 29 30 31

MARCH

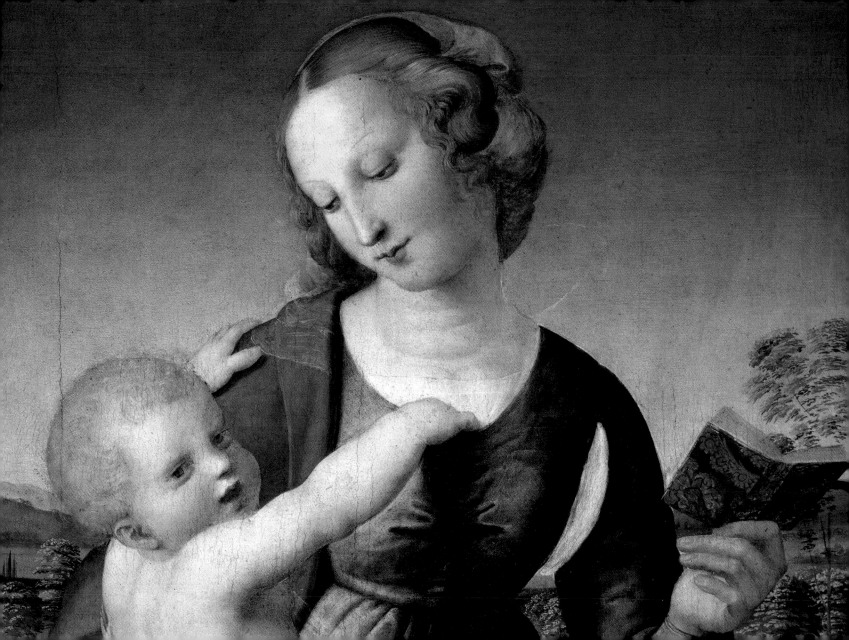

Earth's crammed with heaven,
And every common bush afire with God;
And only he who sees takes off his shoes;
The rest sit round it and pluck blackberries.

ELIZABETH BARRETT BROWNING

Summer Day, *c.* 1921/22
Otto Mueller
Nationalgalerie, Staatliche Museen zu Berlin

1 2 3 4 5 6 7 8 9 10 11 12 13 14 15 16 17 18 19 20 21 22 23 24 25 26 27 28 29 30

APRIL

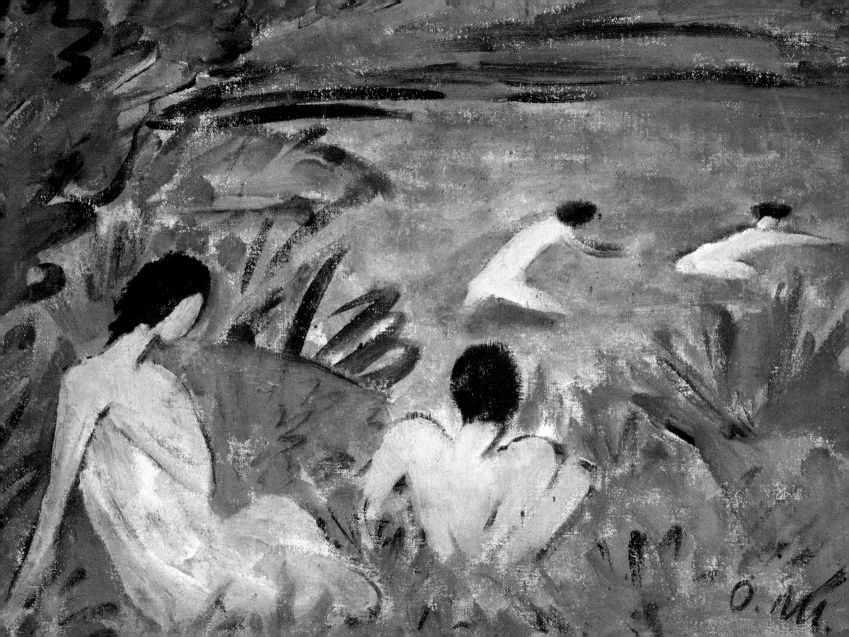

Mary said to the angel,
"How can this be, since I am a virgin?"

<small>LUKE 1:34</small>

Madonna with Two Adoring Angels, *c.* 1450
Luca della Robbia
Skulpturensammlung und Museum für Byzantinische Kunst, Staatliche Museen zu Berlin

1 2 3 4 5 6 7 8 9 10 11 12 13 14 15 16 17 18 19 20 21 22 23 24 25 26 27 28 29 30

APRIL

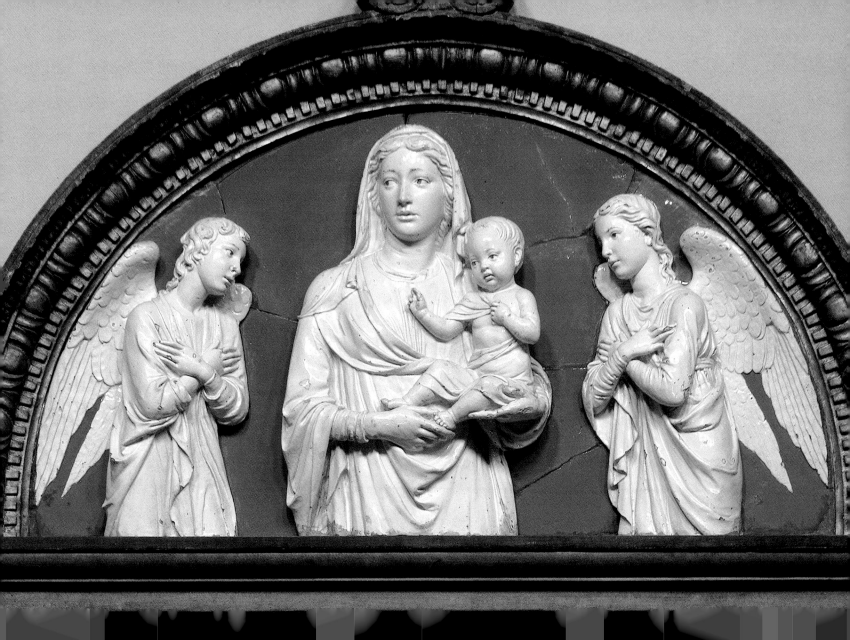

Spring is come home with her world-wandering feet. And all things are made young with desires.

FRANCIS THOMPSON

Springtime Mood, 18th century
Bundi
Museum für Asiatische Kunst, Staatliche Museen zu Berlin

1 2 **3** 4 5 6 7 8 9 10 11 12 13 14 15 16 17 18 19 20 21 22 23 24 25 26 27 28 29 30

APRIL

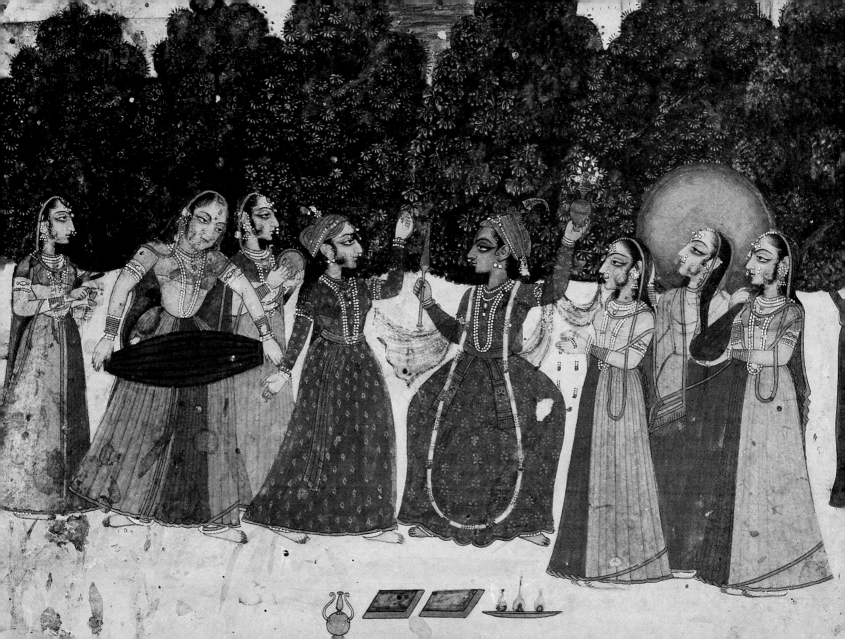

Love conquers all things:
let us too give in to Love.

Virgil

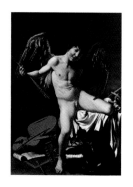

Victorious Cupid (Omnia vincit Amor), 1602
Michelangelo Merisi da Caravaggio
Gemäldegalerie, Staatliche Museen zu Berlin

1 2 3 **4** 5 6 7 8 9 10 11 12 13 14 15 16 17 18 19 20 21 22 23 24 25 26 27 28 29 30

APRIL

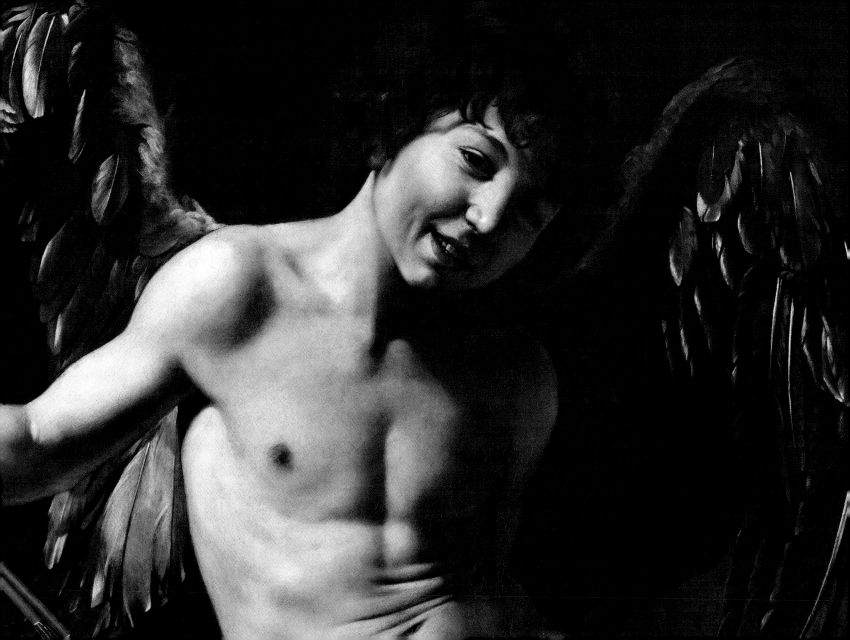

Somebody has said, that a king may make a nobleman but he cannot make a gentleman.

Edmund Burke

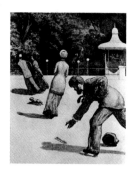

Paraphrase on the Finding of a Glove, Dedicated to the Woman that Lost it, series of 10 quill and ink drawings, Number 2: Action, 1878
Max Klinger
Sammlung Scharf-Gerstenberg, Staatliche Museen zu Berlin

1 2 3 4 **5** 6 7 8 9 10 11 12 13 14 15 16 17 18 19 20 21 22 23 24 25 26 27 28 29 30

APRIL

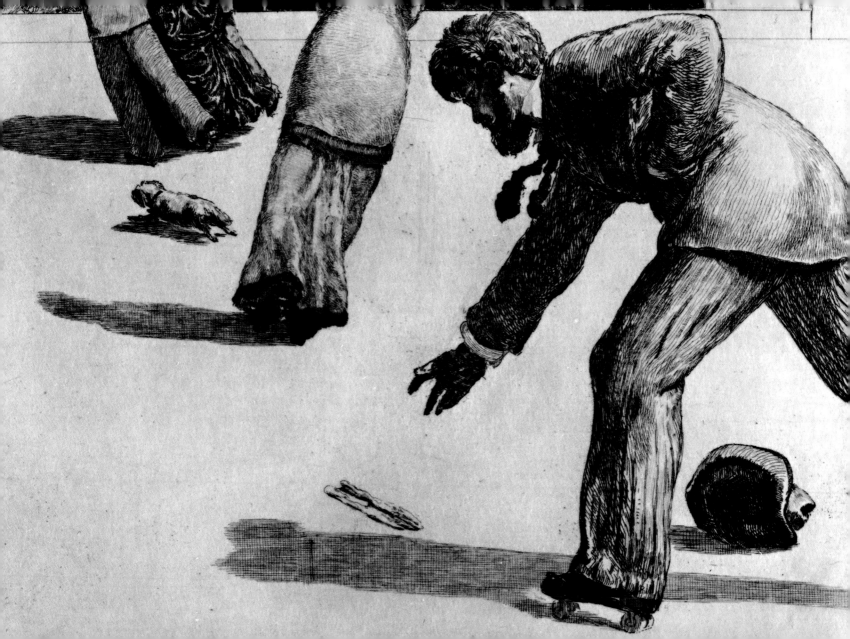

Look round and round upon this bare bleak plain, and see even here, upon a winter's day, how beautiful the shadows are!

CHARLES DICKENS

Snow, 1988
Alex Katz
Nationalgalerie, Staatliche Museen zu Berlin

1 2 3 4 5 **6** 7 8 9 10 11 12 13 14 15 16 17 18 19 20 21 22 23 24 25 26 27 28 29 30

APRIL

The childhood shows the man as morning shows the day.

JOHN MILTON

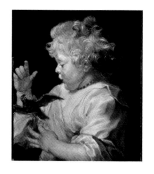

Child with a Bird, *c.* 1629/30
Peter Paul Rubens
Gemäldegalerie, Staatliche Museen zu Berlin

1 2 3 4 5 6 **7** 8 9 10 11 12 13 14 15 16 17 18 19 20 21 22 23 24 25 26 27 28 29 30

APRIL

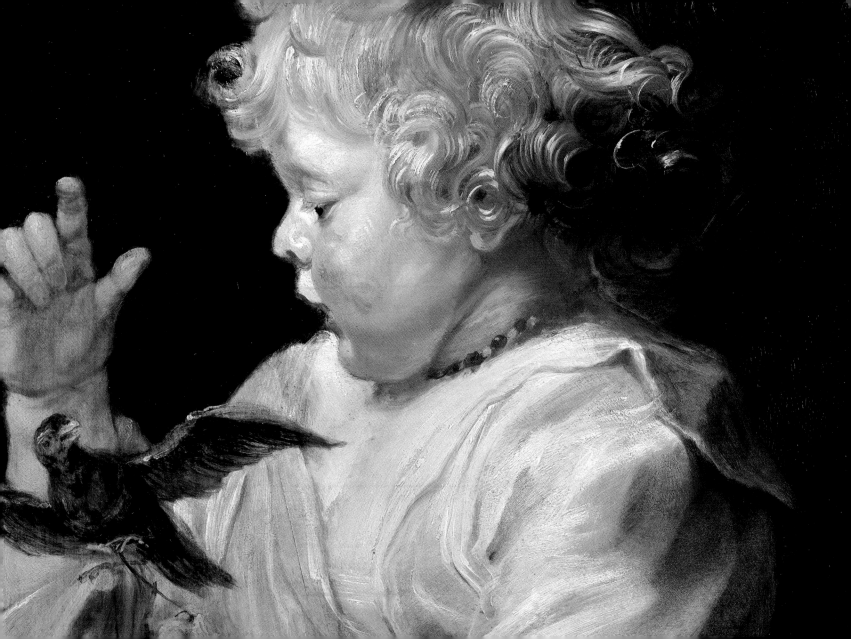

Paradise is our native country,
and we in this world be as exiles
and strangers.

RICHARD GREENHAM

Set for the Opera Nurmahal by Gaspare Spontini,
early 19th century
Karl Friedrich Schinkel
Kupferstichkabinett, Staatliche Museen zu Berlin

1 2 3 4 5 6 7 **8** 9 10 11 12 13 14 15 16 17 18 19 20 21 22 23 24 25 26 27 28 29 30

APRIL

If the artist is not also a craftsman,
the artist is nothing, but calamity.

JOHANN WOLFGANG VON GOETHE

Lusterbowl, fritware pottery, end of the 12th century A. D.
Syria
Museum für Islamische Kunst, Staatliche Museen zu Berlin

1 2 3 4 5 6 7 8 **9** 10 11 12 13 14 15 16 17 18 19 20 21 22 23 24 25 26 27 28 29 30

APRIL

Adam was but human—this explains it all. He did not want the apple for the apple's sake; he wanted it only because it was forbidden.

MARK TWAIN

Still Life with Apples
Carl Schuch
Nationalgalerie, Staatliche Museen zu Berlin

1 2 3 4 5 6 7 8 9 **10** 11 12 13 14 15 16 17 18 19 20 21 22 23 24 25 26 27 28 29 30

APRIL

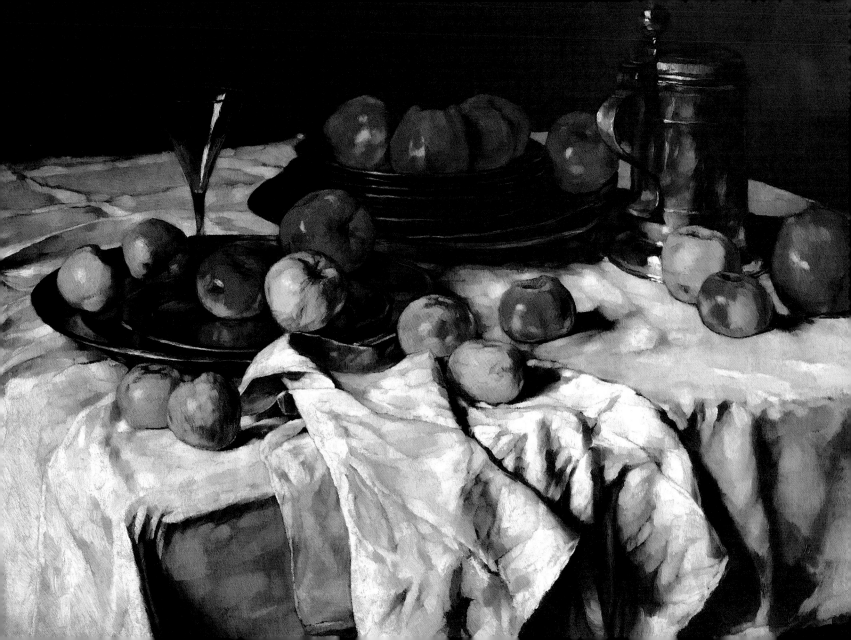

Man's life is well compared to a feast,
Furnished with choice of all variety;
To it comes Time; and as a bidden guest
He sets him down, in pomp and majesty;
The three-fold age of man the waiters be.
Then with and earthen voider (made of clay)
Comes death, and takes the table clean away.

RICHARD BARNFIELD

Sappho's Death, *c.* 1872
Gustave Moreau
Sammlung Scharf-Gerstenberg, Staatliche Museen zu Berlin

1 2 3 4 5 6 7 8 9 10 **11** 12 13 14 15 16 17 18 19 20 21 22 23 24 25 26 27 28 29 30

APRIL

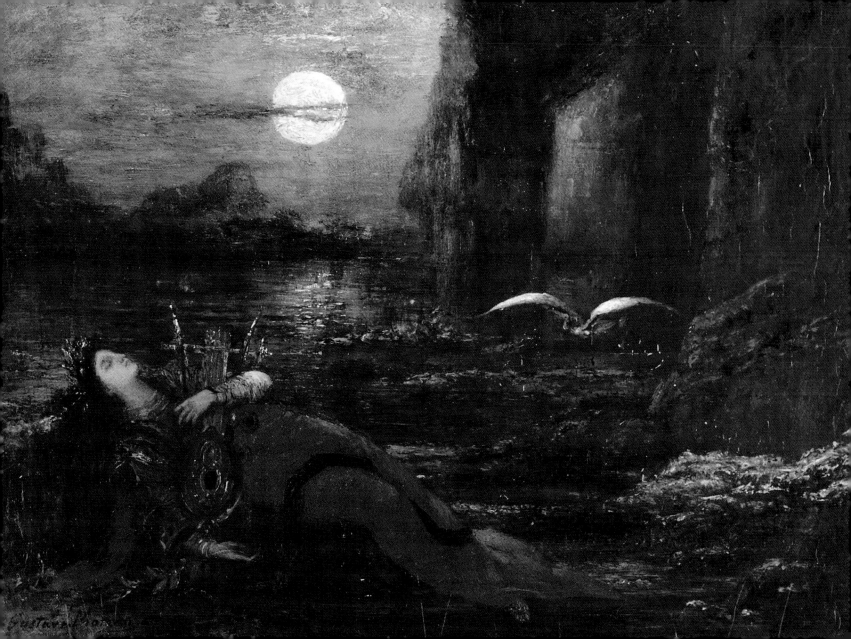

Who have been chosen according to the foreknowledge of God the Father, through the sanctifying work of the Spirit, for obedience to Jesus Christ and sprinkling by his blood: Grace and peace be yours in abundance.

1 PETER 1:2

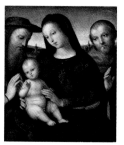

Madonna and the Christ Child Blessing with Saints Jerome and Francis, *c.* 1502
Raphael
Gemäldegalerie, Staatliche Museen zu Berlin

1 2 3 4 5 6 7 8 9 10 11 **12** 13 14 15 16 17 18 19 20 21 22 23 24 25 26 27 28 29 30

APRIL

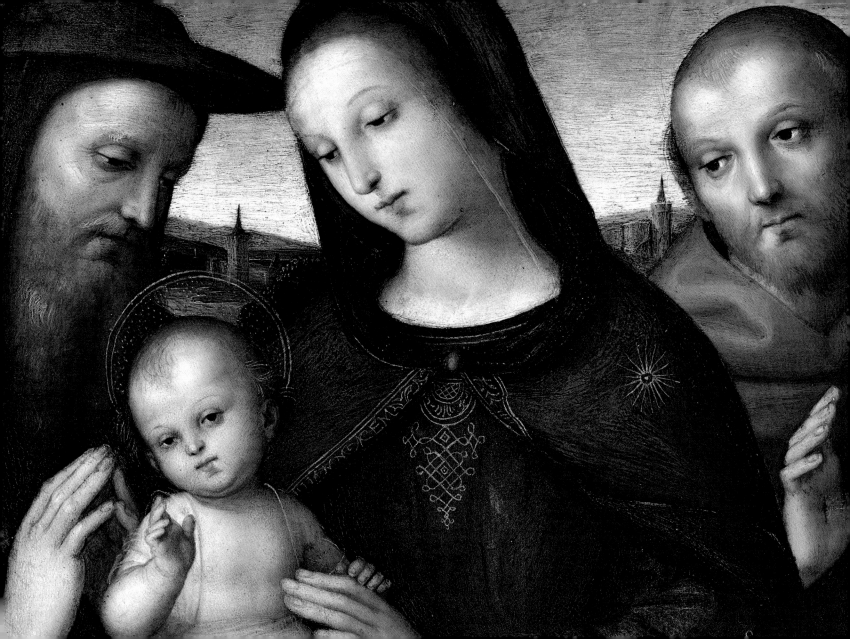

*Believe each day that has dawned
is your last.*

Football, beginning of the 19th century
Katsushika Hokusai
Museum für Asiatische Kunst, Staatliche Museen zu Berlin

1 2 3 4 5 6 7 8 9 10 11 12 **13** 14 15 16 17 18 19 20 21 22 23 24 25 26 27 28 29 30

APRIL

Government is a contrivance of human wisdom to provide for human wants. Men have a right that these wants should be provided for by this wisdom.

EDMUND BURKE

Head of a statue of King Amasis, 570–526 B. C.
Sais/Egypt
Ägyptisches Museum und Papyrussammlung, Staatliche Museen zu Berlin

1 2 3 4 5 6 7 8 9 10 11 12 13 **14** 15 16 17 18 19 20 21 22 23 24 25 26 27 28 29 30

APRIL

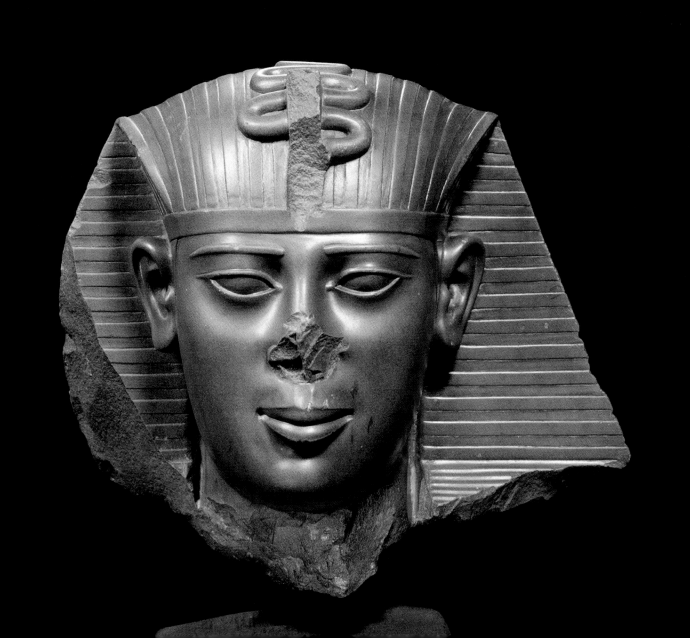

If only we could pull out our brain and use only our eyes.

PABLO PICASSO

Woman Lying Down with a Bouquet of Flowers, 1958
Pablo Picasso
Nationalgalerie, Staatliche Museen zu Berlin

1 2 3 4 5 6 7 8 9 10 11 12 13 14 **15** 16 17 18 19 20 21 22 23 24 25 26 27 28 29 30

APRIL

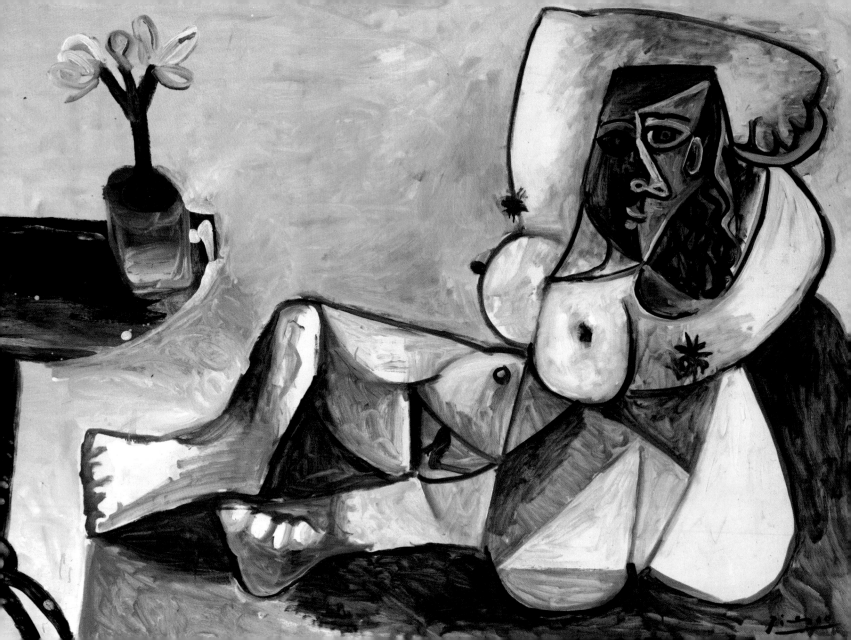

There is nothing like the fun of having brothers, if there is no rivalry.

PUNJABI PROVERB

Joseph Sold by his Brothers to the Ishmaelites/The Brothers Presenting Joseph's Bloody Garment to their Father
Master of the Joseph Sequence
Gemäldegalerie, Staatliche Museen zu Berlin

1 2 3 4 5 6 7 8 9 10 11 12 13 14 15 **16** 17 18 19 20 21 22 23 24 25 26 27 28 29 30

APRIL

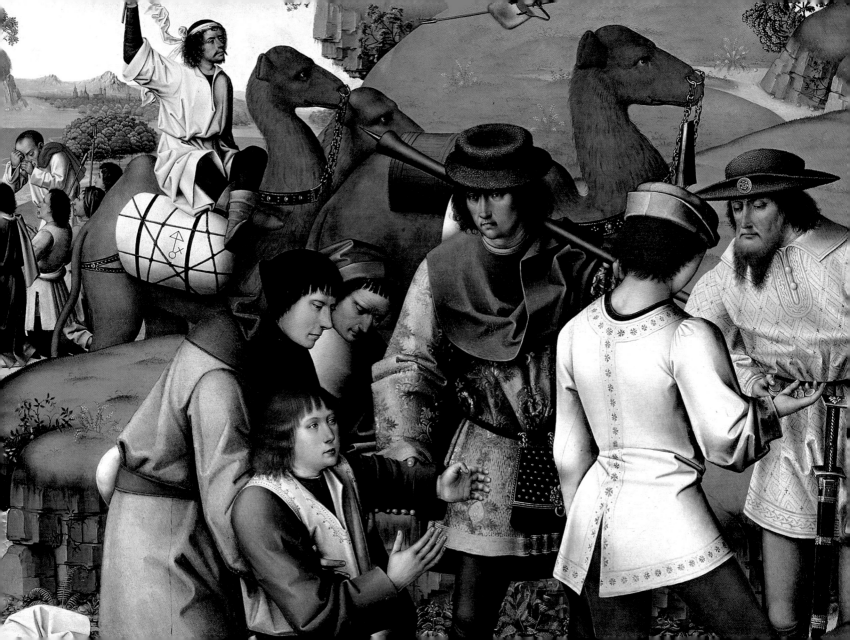

The only paradise is paradise lost.

Adam and Eve, 1504
Albrecht Dürer
Kupferstichkabinett, Staatliche Museen zu Berlin

1 2 3 4 5 6 7 8 9 10 11 12 13 14 15 16 **17** 18 19 20 21 22 23 24 25 26 27 28 29 30

APRIL

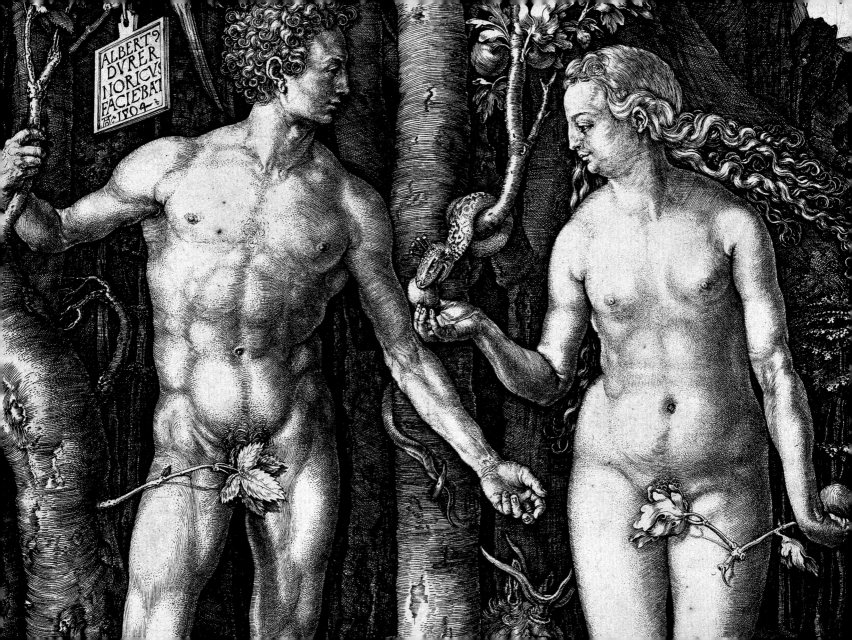

ALBERT9
DVRER
NORICV5
FACIEBAT
1504

Treat nature in terms of the cylinder, the sphere, the cone, all in perspective.

<small>PAUL CÉZANNE</small>

Still Life with Flowers and Fruit, *c.* 1888–1890
Paul Cézanne
Nationalgalerie, Staatliche Museen zu Berlin

1 2 3 4 5 6 7 8 9 10 11 12 13 14 15 16 17 **18** 19 20 21 22 23 24 25 26 27 28 29 30

APRIL

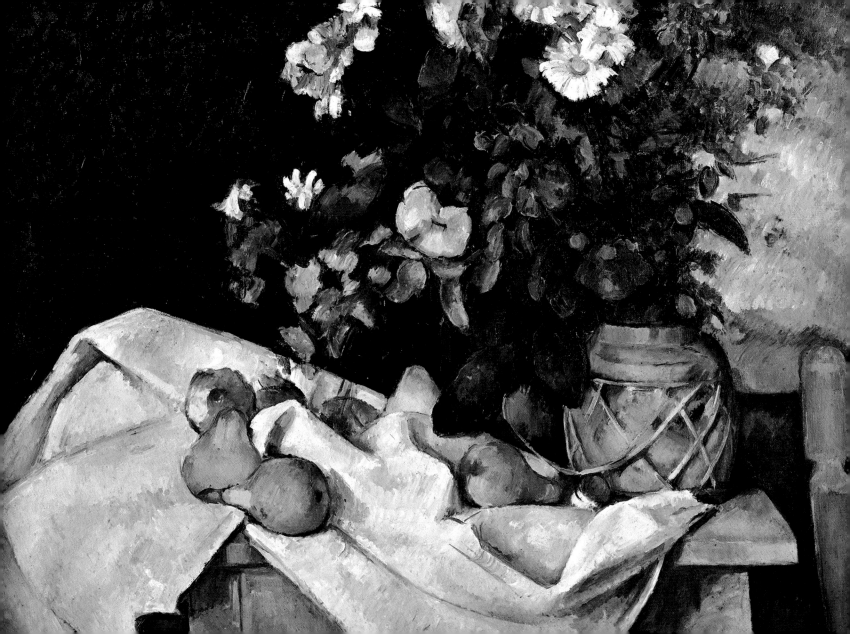

A man is wise with the wisdom of his time only, and ignorant with its ignorance.

Henry David Thoreau

Ugolino Martelli, 1540
Agnolo Bronzino
Gemäldegalerie, Staatliche Museen zu Berlin

1 2 3 4 5 6 7 8 9 10 11 12 13 14 15 16 17 18 **19** 20 21 22 23 24 25 26 27 28 29 30

APRIL

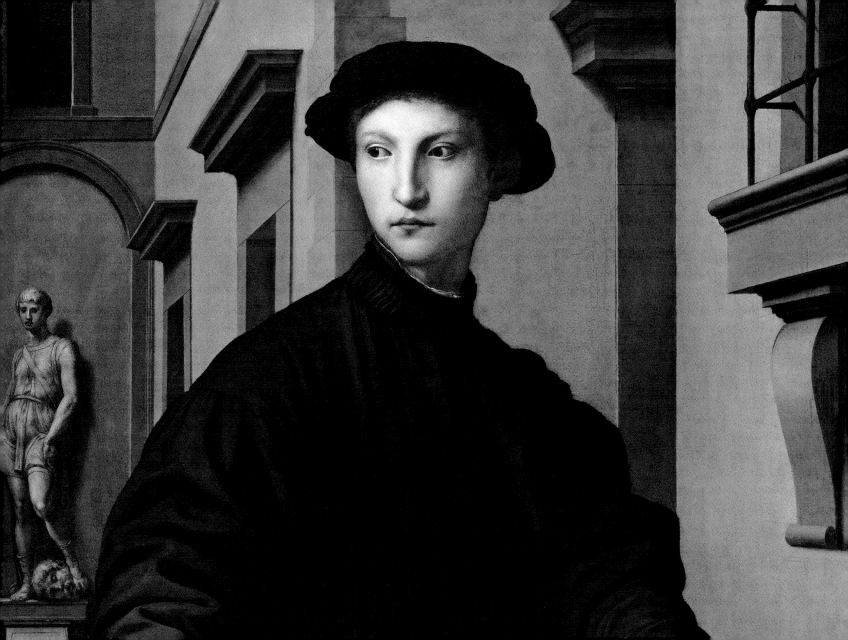

Music has charms to soothe a savage breast,
To soften rocks, or bend a knotted oak.

WILLIAM CONGREVE

Landscape with Orpheus and the Animals, 1611
Roelant Savery
Gemäldegalerie, Staatliche Museen zu Berlin

1 2 3 4 5 6 7 8 9 10 11 12 13 14 15 16 17 18 19 **20** 21 22 23 24 25 26 27 28 29 30

APRIL

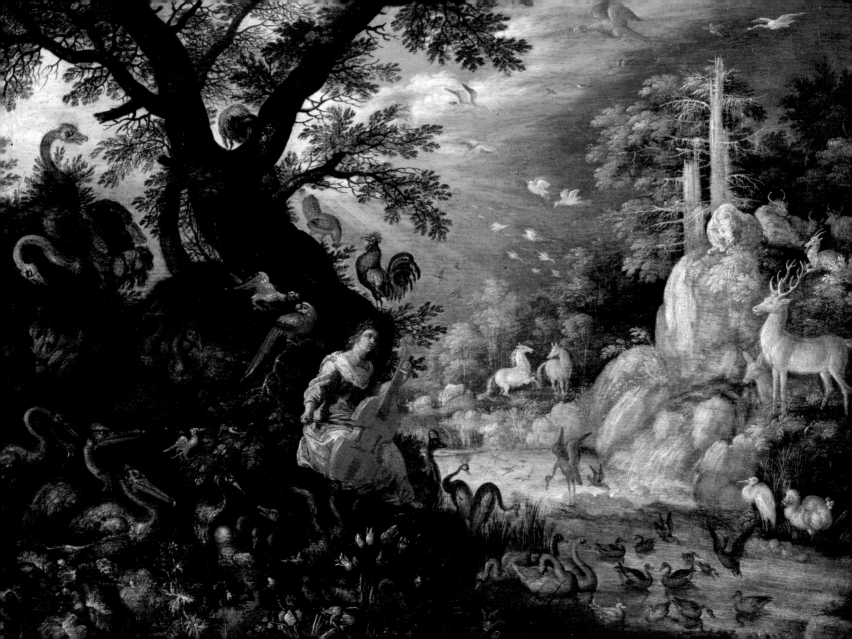

Where are the forms the sculptor's
soul hath seized?
In him alone. Can nature show as fair?

<small>LORD BYRON</small>

Head of Akhenaten, 1351–1334 B. C.
Amarna/Egypt
Ägyptisches Museum und Papyrussammlung, Staatliche Museen zu Berlin

1 2 3 4 5 6 7 8 9 10 11 12 13 14 15 16 17 18 19 20 **21** 22 23 24 25 26 27 28 29 30

APRIL

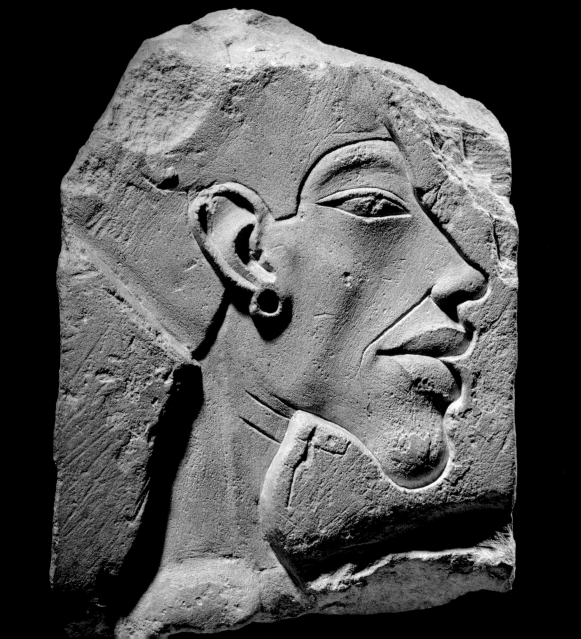

All that we are is the result of what we have thought.

BUDDHA

The Great Metaphysician, 1924–1926
Giorgio di Chirico
Nationalgalerie, Staatliche Museen zu Berlin

1 2 3 4 5 6 7 8 9 10 11 12 13 14 15 16 17 18 19 20 21 **22** 23 24 25 26 27 28 29 30

APRIL

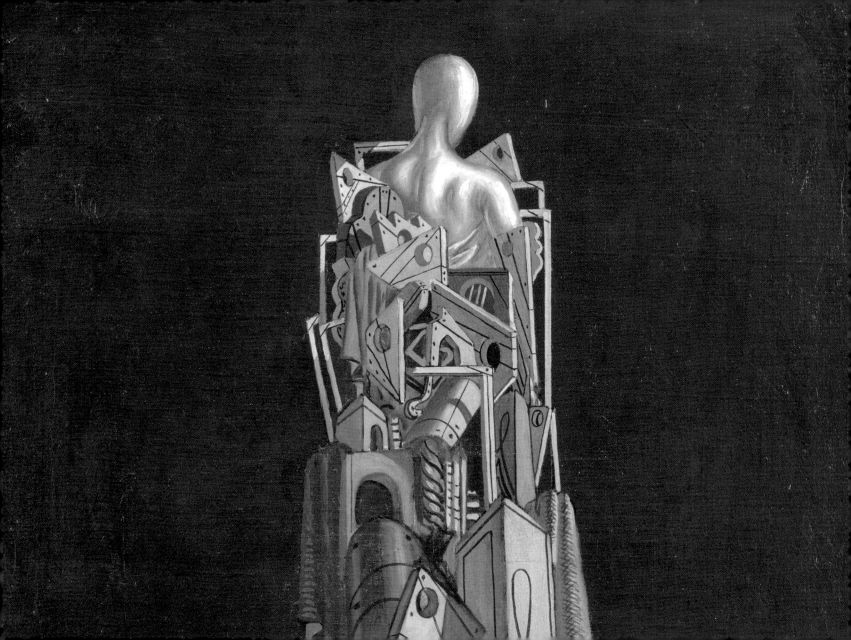

There's something in a flying horse,
There's something in a huge balloon;
But through the clouds I'll never float
Until I have a little Boat,
Shaped like the crescent moon.

WILLIAM WORDSWORTH

Boat with crew, 3700–3200 B. C.
Egypt
Ägyptisches Museum und Papyrussammlung, Staatliche Museen zu Berlin

1 2 3 4 5 6 7 8 9 10 11 12 13 14 15 16 17 18 19 20 21 22 **23** 24 25 26 27 28 29 30

APRIL

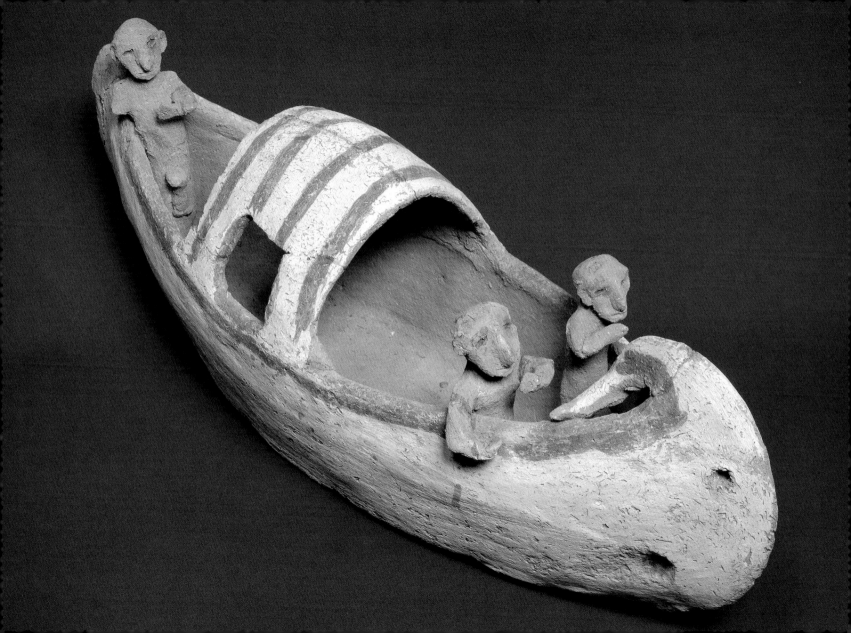

A fool and his money are soon parted.

German and English coins from the Treasury of Klein-Roschaden, hidden at the end of the 10th century, found 1886

Münzkabinett, Staatliche Museen zu Berlin

1 2 3 4 5 6 7 8 9 10 11 12 13 14 15 16 17 18 19 20 21 22 23 **24** 25 26 27 28 29 30

APRIL

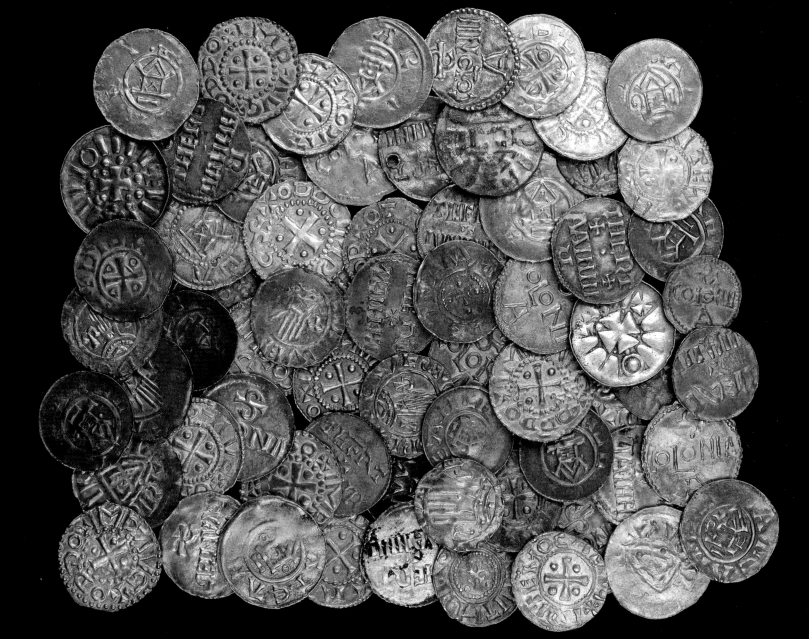

Whither, O splendid ship,
thy white sails crowding,
Leaning across the bosom
of the urgent West.

ROBERT BRIDGES

Royal English Ship under Sail, *c.* 1680
published by Pierre Mortier, Amsterdam
Kunstbibliothek, Staatliche Museen zu Berlin

1 2 3 4 5 6 7 8 9 10 11 12 13 14 15 16 17 18 19 20 21 22 23 24 **25** 26 27 28 29 30

APRIL

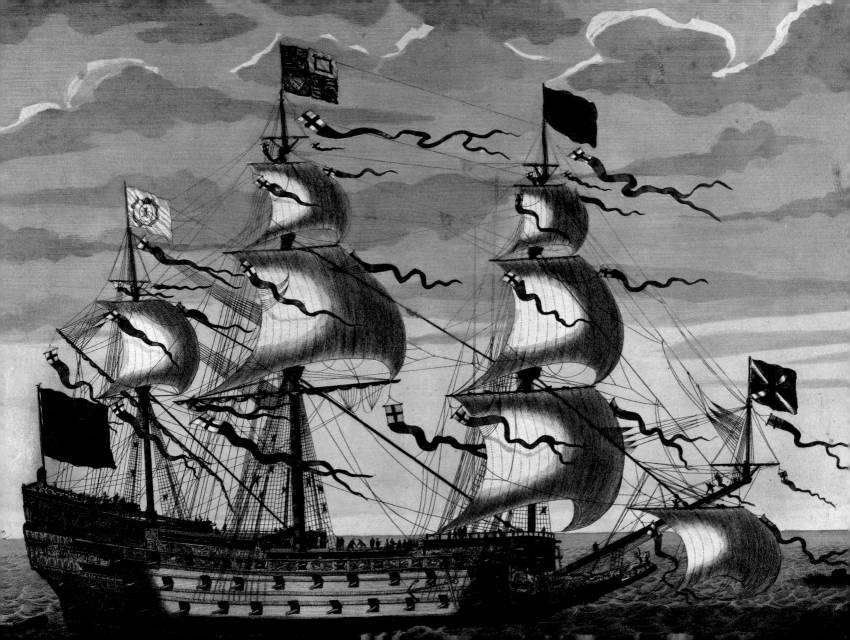

Rose of all Roses, Rose of all the World!
You, too, have come where the dim tides are hurled
Upon the wharves of sorrow, and heard ring
The bell that calls us on; the sweet far thing.

WILLIAM BUTLER YEATS

Rose from Frankfurt, *c.* 1610
Georg Flegel
Kupferstichkabinett, Staatliche Museen zu Berlin

1 2 3 4 5 6 7 8 9 10 11 12 13 14 15 16 17 18 19 20 21 22 23 24 25 **26** 27 28 29 30

APRIL

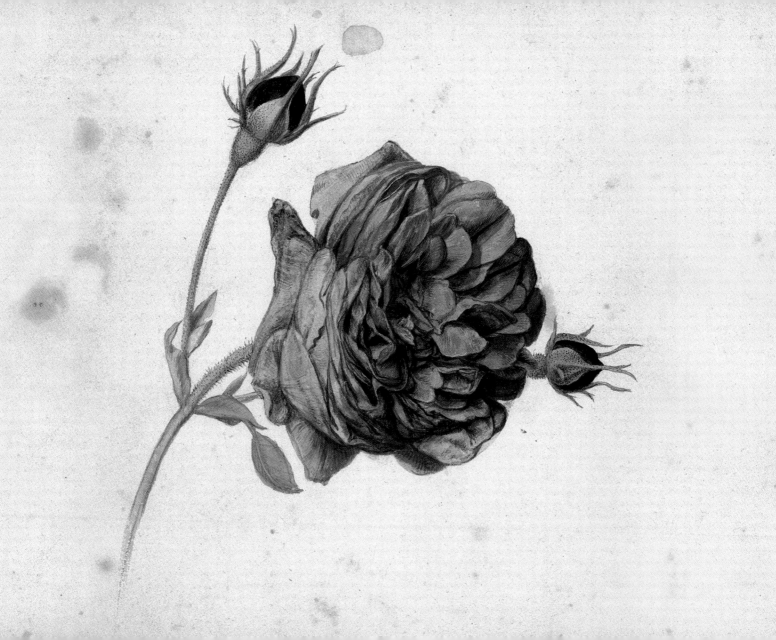

All tragedies are finish'd by a death,
All comedies are ended by marriage.

<small>LORD BYRON</small>

The French Comedy, after 1716
Jean-Antoine Watteau
Gemäldegalerie, Staatliche Museen zu Berlin

1 2 3 4 5 6 7 8 9 10 11 12 13 14 15 16 17 18 19 20 21 22 23 24 25 26 **27** 28 29 30

APRIL

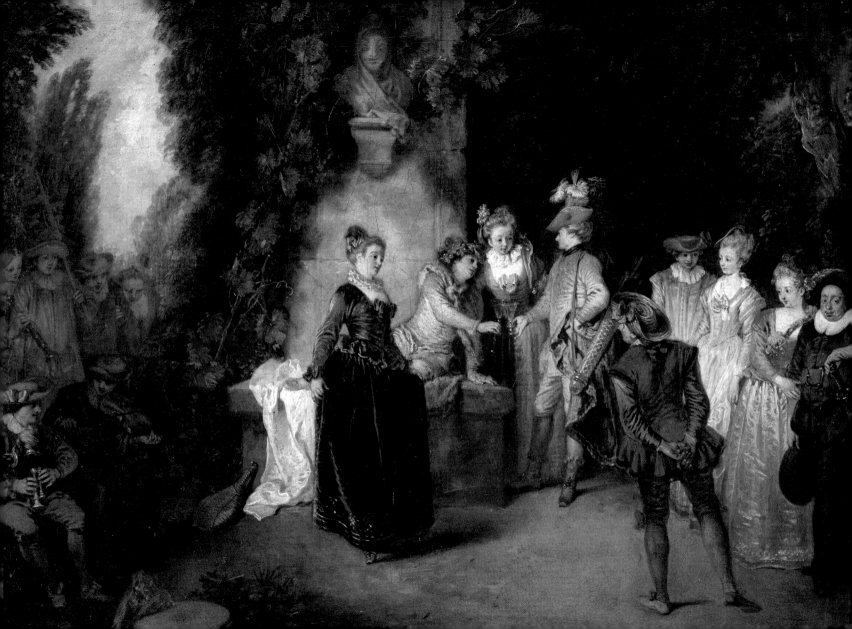

Fear an ignorant man more than a lion.

Lion's Head, 18th century
Adolph von Menzel
Kupferstichkabinett, Staatliche Museen zu Berlin

1 2 3 4 5 6 7 8 9 10 11 12 13 14 15 16 17 18 19 20 21 22 23 24 25 26 27 **28** 29 30

APRIL

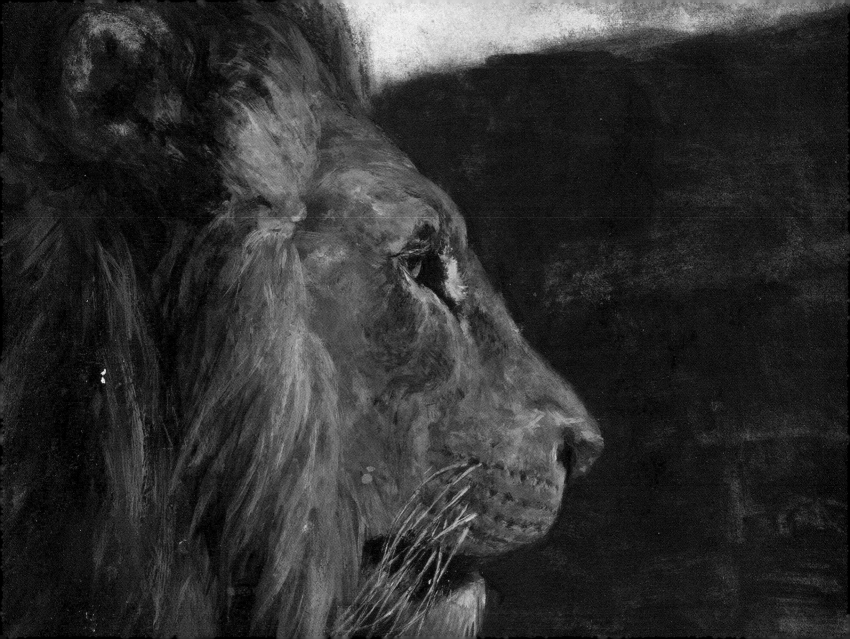

*Oh Gods, grant me this in return
for my piety.*

CATULLUS

Side of an ushebti-box of the Sched-es-en-Mut, 1550–1070 B. C.
Egypt
Ägyptisches Museum und Papyrussammlung, Staatliche Museen Berlin

1 2 3 4 5 6 7 8 9 10 11 12 13 14 15 16 17 18 19 20 21 22 23 24 25 26 27 28 **29** 30

APRIL

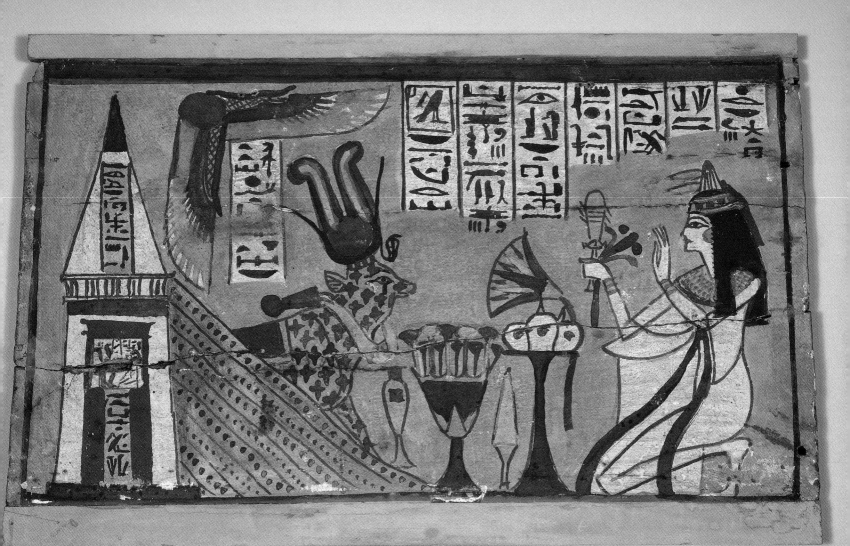

I have always tried to hide my efforts and wished my works to have the light joyousness of springtime which never lets anyone suspect the labors it has cost me.

Henri Matisse

The Codomas, from Jazz, plate XI, 1947
Henri Matisse
Kupferstichkabinett, Staatliche Museen zu Berlin

1 2 3 4 5 6 7 8 9 10 11 12 13 14 15 16 17 18 19 20 21 22 23 24 25 26 27 28 29 **30**

APRIL

Praise to the Holiest in the height,
And in the depth be praise;
In all his words most wonderful,
Most sure in all his ways.

CARDINAL NEWMAN

Figure of an Apis-bull, after 650 B. C.
Egypt
Ägyptisches Museum und Papyrussammlung, Staatliche Museen zu Berlin

1 2 3 4 5 6 7 8 9 10 11 12 13 14 15 16 17 18 19 20 21 22 23 24 25 26 27 28 29 30 31

MAY

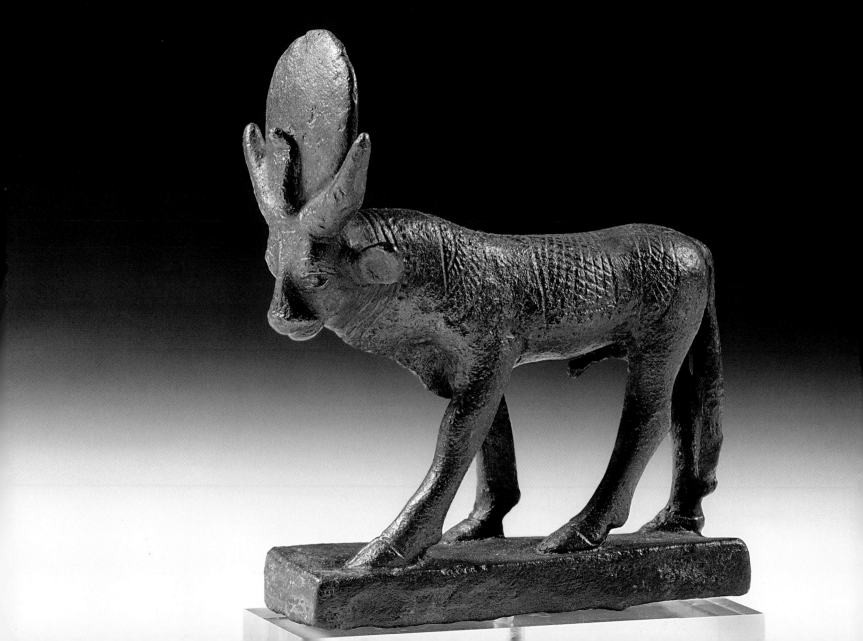

Shall I compare thee to a summer's day?
Thou art more lovely and more temperate:
Rough winds do shake the darling buds of may,
And summer's lease hath all too short a date.

WILLIAM SHAKESPEARE

Summer, 1874
Claude Monet
Nationalgalerie, Staatliche Museen zu Berlin

1 2 3 4 5 6 7 8 9 10 11 12 13 14 15 16 17 18 19 20 21 22 23 24 25 26 27 28 29 30 31

MAY

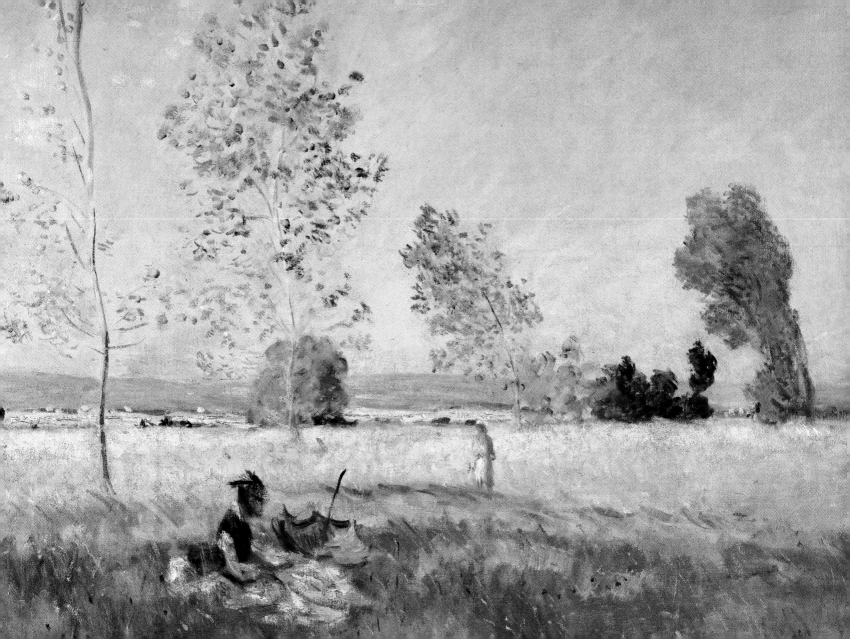

Love in her sunny eyes does basking play;
Love walks the pleasant mazes of her hair;
Love does on both her lips for ever stray;
And sows and reaps a thousand kisses there.
In all her outward parts Love's always seen;
But, oh, he never went within.

Abraham Cowley

Persian textile (detail), 1846
Museum für Islamische Kunst, Staatliche Museen zu Berlin

3

1 2 3 4 5 6 7 8 9 10 11 12 13 14 15 16 17 18 19 20 21 22 23 24 25 26 27 28 29 30 31

MAY

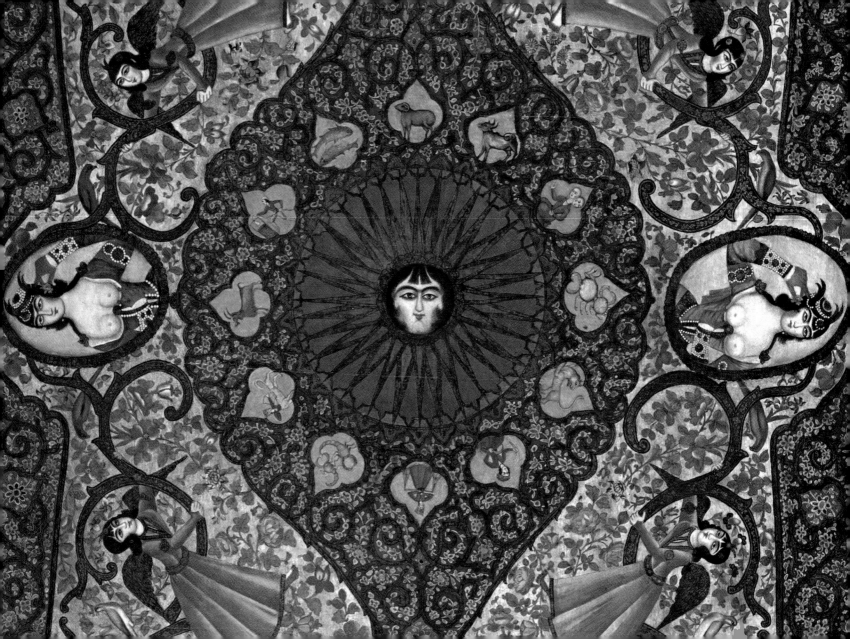

*The best things in life are nearest:
Breath in your nostrils, light in your
eyes, flowers at your feet, duties at your
hand, the path of right just before you.*

ROBERT LOUIS STEVENSON

Paradise, 1650
*Jan Brueghel the Younger
Gemäldegalerie, Staatliche Museen zu Berlin*

1 2 3 **4** 5 6 7 8 9 10 11 12 13 14 15 16 17 18 19 20 21 22 23 24 25 26 27 28 29 30 31

MAY

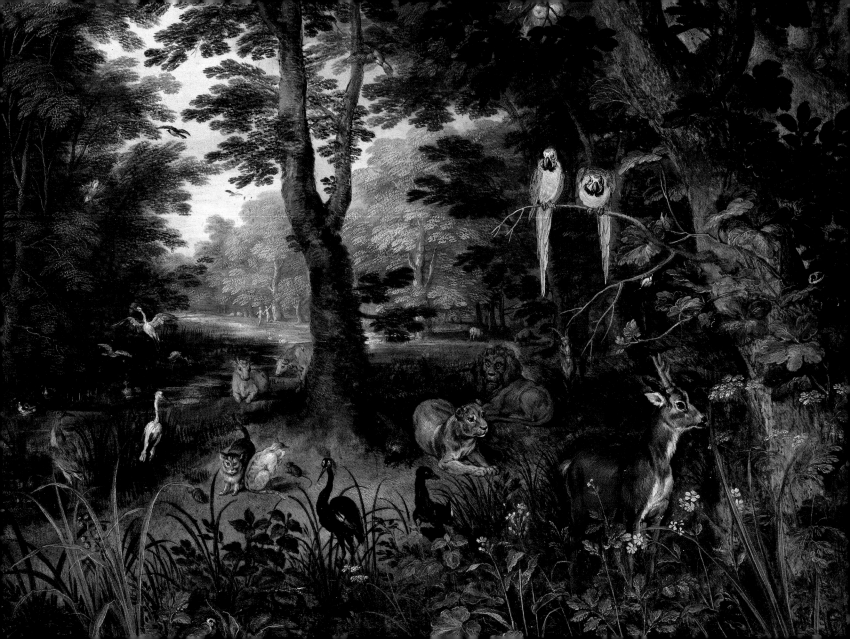

I think your whole life shows in your face and you should be proud of that.

LAUREN BACALL

Giuliano de Medici, 1478
Sandro Botticelli
Gemäldegalerie, Staatliche Museen zu Berlin

1 2 3 4 **5** 6 7 8 9 10 11 12 13 14 15 16 17 18 19 20 21 22 23 24 25 26 27 28 29 30 31

MAY

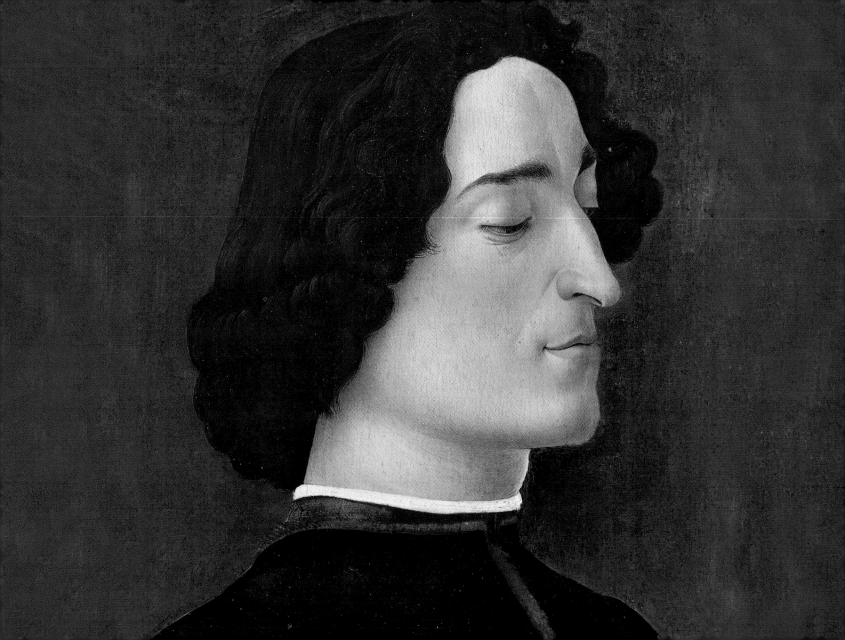

Education is what most people receive,
many pass on, and few have.

KARL KRAUS

"Dogs à la mode", *c.* 1815
Kunstbibliothek, Staatliche Museen zu Berlin

1 2 3 4 5 **6** 7 8 9 10 11 12 13 14 15 16 17 18 19 20 21 22 23 24 25 26 27 28 29 30 31

MAY

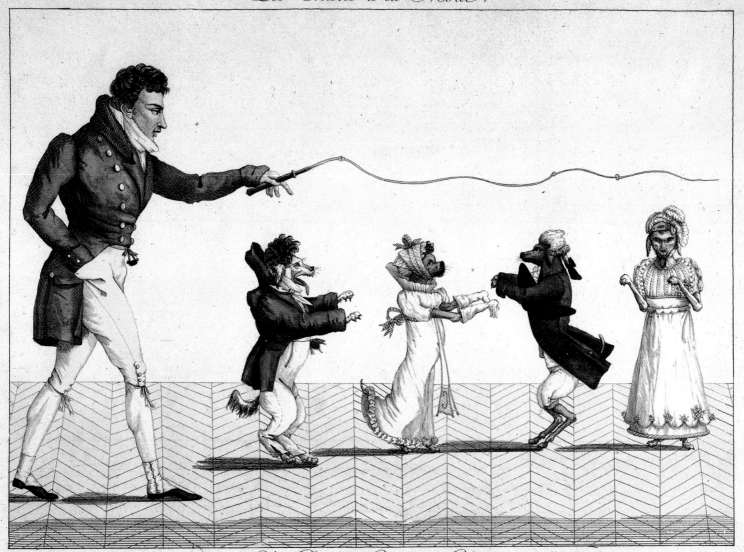

Le Bon Genre, N⁰. 35.

Truth will come to light;
murder cannot be hid long.

WILLIAM SHAKESPEARE

Medea and the Peliades, Roman copy after a Greek original
from 420–410 B. C.
Antikensammlung, Staatliche Museen zu Berlin

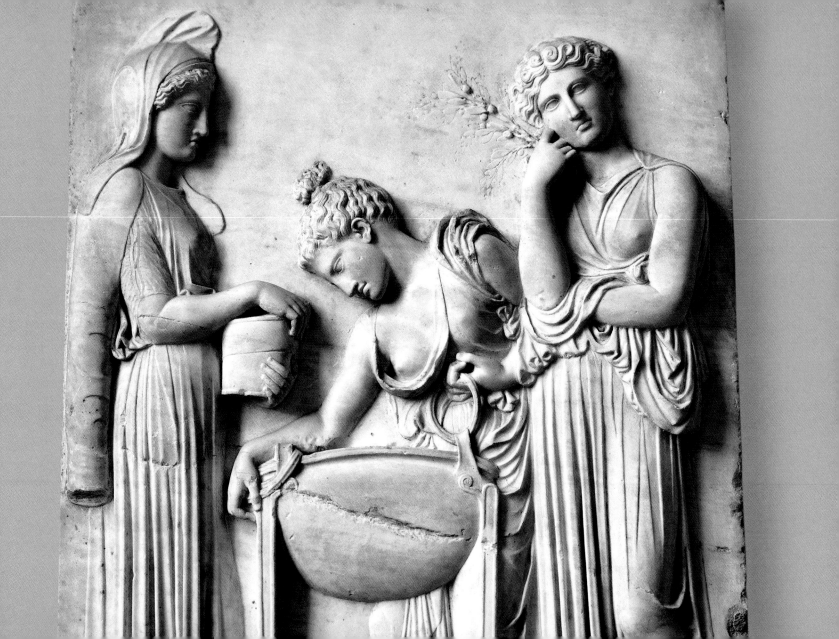

What is a country without rabbits?
They are among the most simple and
indigenous animal products; of the very
hue and substance of Nature.

Henry David Thoreau

Rabbit Lying Down, with Coat of Arms, 1587
Hans Hoffmann
Kupferstichkabinett, Staatliche Museen zu Berlin

8

1 2 3 4 5 6 7 8 9 10 11 12 13 14 15 16 17 18 19 20 21 22 23 24 25 26 27 28 29 30 31

MAY

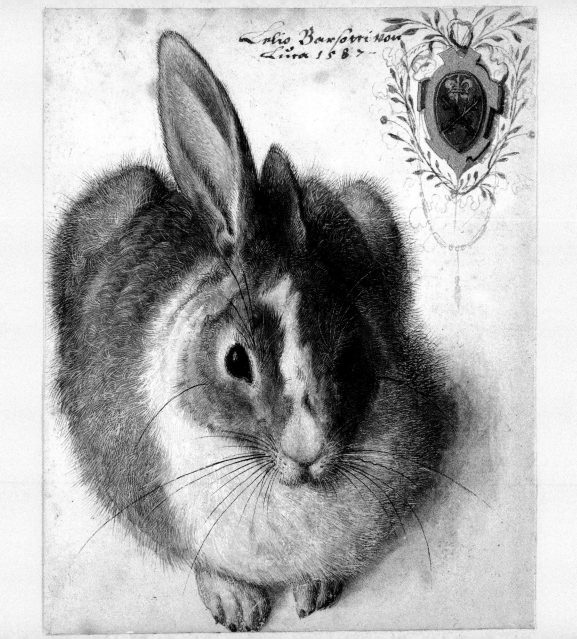

All forms of beauty contain an element of the eternal and an element of the transitory.

<small>CHARLES BAUDELAIRE</small>

Bust of Nefertiti, 1351–1334 B. C.
Amarna/Egypt
Ägyptisches Museum und Papyrussammlung, Staatliche Museen zu Berlin

1 2 3 4 5 6 7 8 **9** 10 11 12 13 14 15 16 17 18 19 20 21 22 23 24 25 26 27 28 29 30 31

MAY

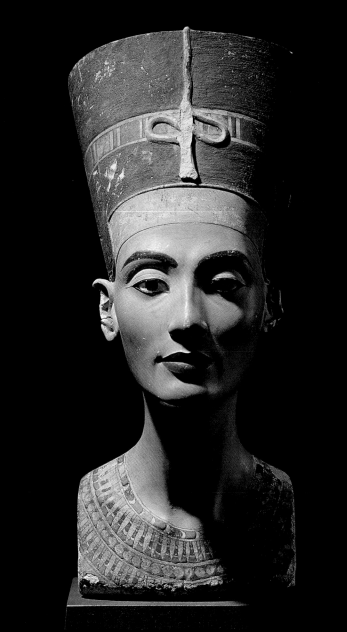

When strength is yoked with justice,
where is a mightier pair than they?

Aeschylus

Saint Barbara Argues with Her Father, 15th century

Simon Marmion

Kupferstichkabinett, Staatliche Museen zu Berlin

1 2 3 4 5 6 7 8 9 **10** 11 12 13 14 15 16 17 18 19 20 21 22 23 24 25 26 27 28 29 30 31

May

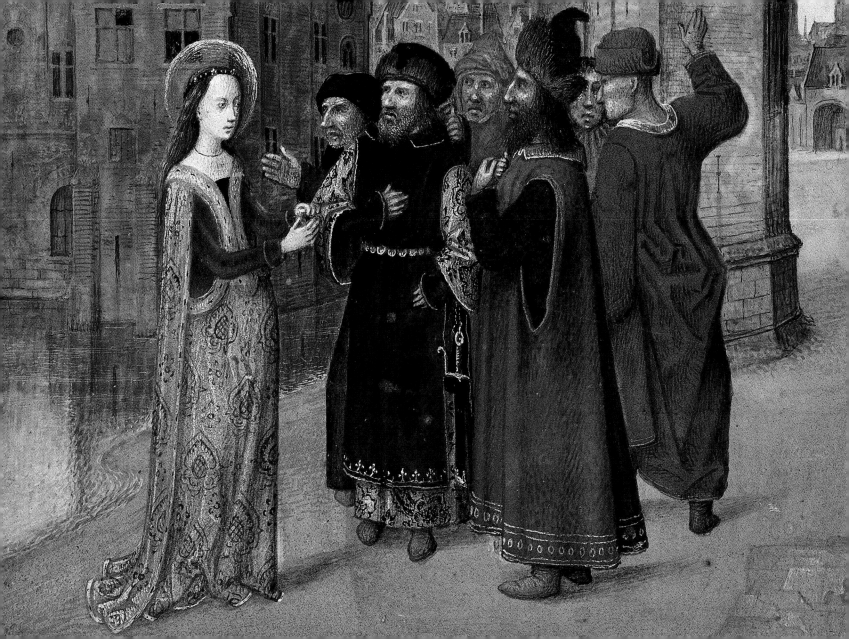

The reading of good books is like a conversation with the best men of past centuries—in fact like a prepared conversation, in which they reveal only the best of their thoughts.

René Descartes

The Reading, 1953
Pablo Picasso
Museum Berggruen, Nationalgalerie, Staatliche Museen zu Berlin

1 2 3 4 5 6 7 8 9 10 **11** 12 13 14 15 16 17 18 19 20 21 22 23 24 25 26 27 28 29 30 31

MAY

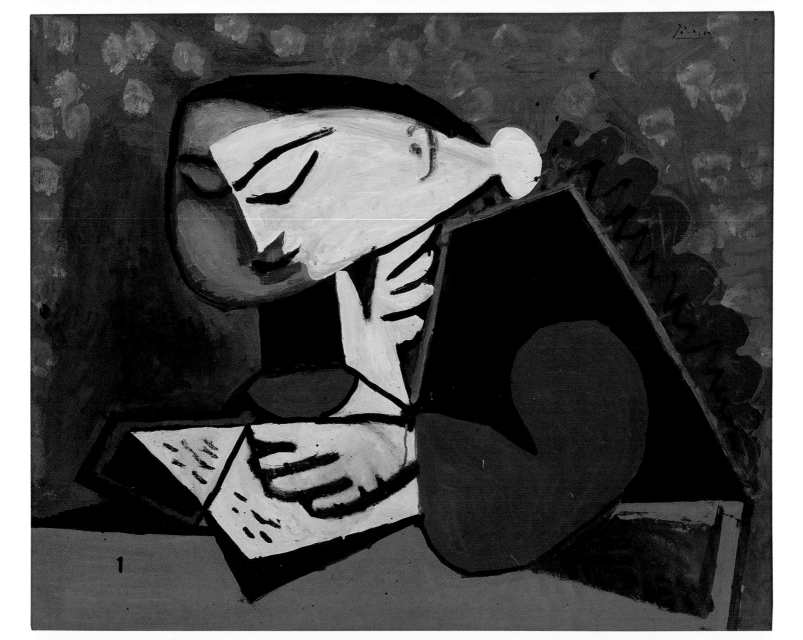

It was a soft, reposeful summer landscape, as lovely as a dream, and as lonesome as Sunday.

<small>MARK TWAIN</small>

Blooming Chestnut Tree, 1881
Pierre-Auguste Renoir
Nationalgalerie, Staatliche Museen zu Berlin

1 2 3 4 5 6 7 8 9 10 11 **12** 13 14 15 16 17 18 19 20 21 22 23 24 25 26 27 28 29 30 31

MAY

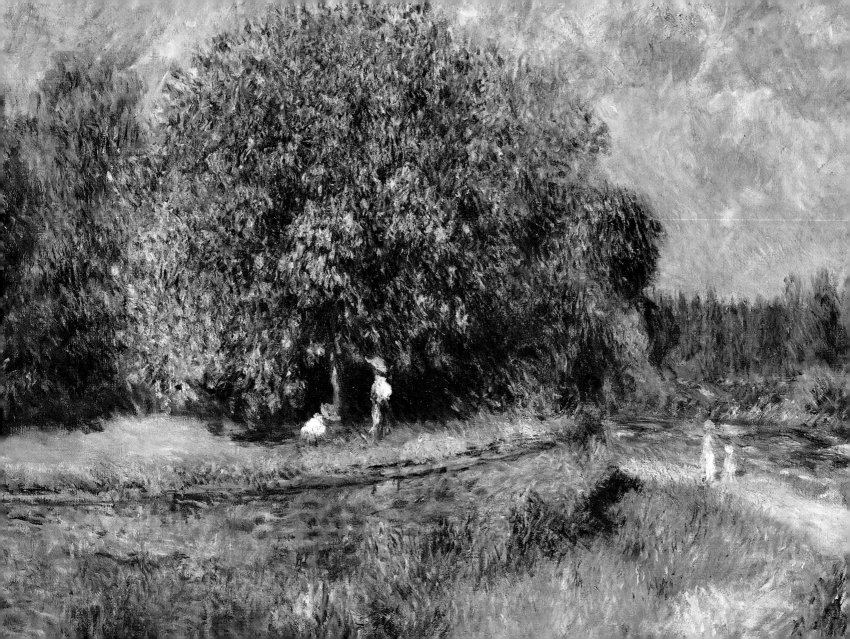

All the world's a stage,
And all the men and women
merely players.

WILLIAM SHAKESPEARE

Shadow Puppets, *c.* 1975–1978
Greece
Museum Europäischer Kulturen, Staatliche Museen zu Berlin

1 2 3 4 5 6 7 8 9 10 11 12 **13** 14 15 16 17 18 19 20 21 22 23 24 25 26 27 28 29 30 31

MAY

Riches are valuable at all times, and to all men; because they always purchase pleasures, such as men are accustomed to, and desire: Nor can any thing restrain or regulate the love of money, but a sense of honour and virtue; which, if it be not nearly equal at all times, will naturally abound most in ages of knowledge and refinement.

DAVID HUME

The Merchant Georg Gisze, 1532
Hans Holbein the Younger
Gemäldegalerie, Staatliche Museen zu Berlin

1 2 3 4 5 6 7 8 9 10 11 12 13 **14** 15 16 17 18 19 20 21 22 23 24 25 26 27 28 29 30 31

MAY

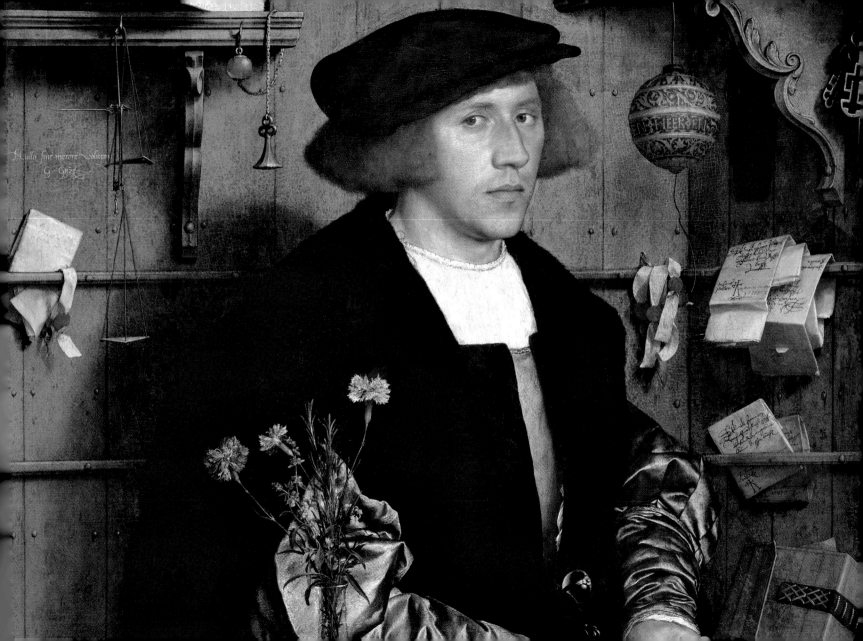

The purpose of art is the lifelong
construction of a state of wonder.

GLENN GOULD

Goddess of the Amlash Culture, *c.* 1000 B. C.
Iran
Museum für Vor- und Frühgeschichte, Staatliche Museen zu Berlin

1 2 3 4 5 6 7 8 9 10 11 12 13 14 **15** 16 17 18 19 20 21 22 23 24 25 26 27 28 29 30 31

MAY

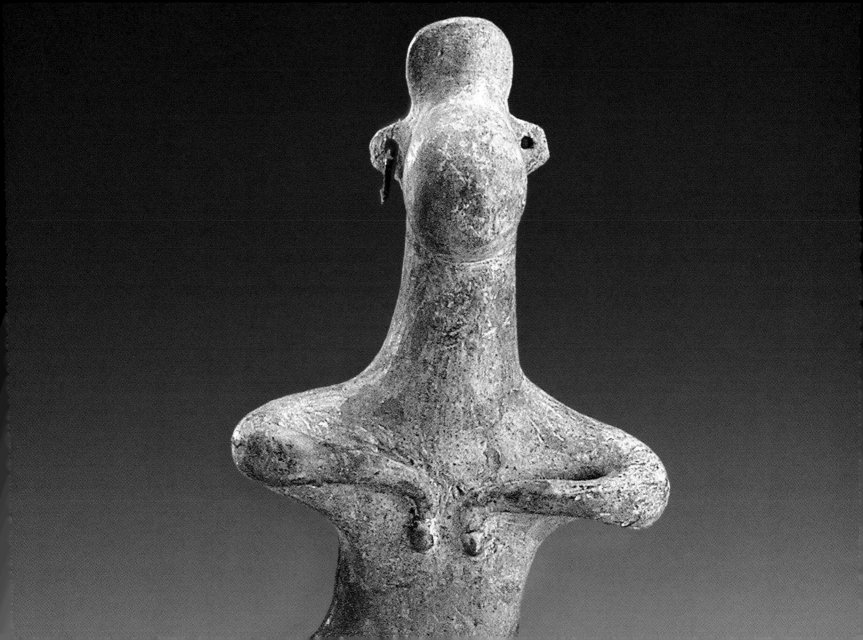

If poetry comes not as naturally as the leaves to a tree it had better not come at all.

JOHN KEATS

Yellow Town Church I, 1927
Lyonel Feininger
Nationalgalerie, Staatliche Museen zu Berlin

1 2 3 4 5 6 7 8 9 10 11 12 13 14 15 **16** 17 18 19 20 21 22 23 24 25 26 27 28 29 30 31

MAY

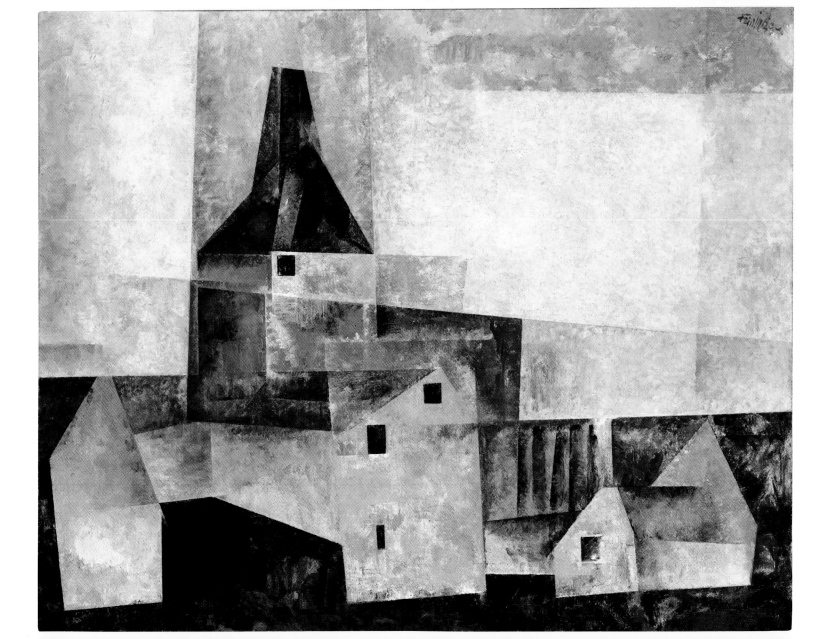

Can anything be so elegant as to have few wants, and to serve them one's self?

RALPH WALDO EMERSON

Farmer Couple Eating Peas, *c.* 1620–1625
Georges de La Tour
Gemäldegalerie, Staatliche Museen zu Berlin

1 2 3 4 5 6 7 8 9 10 11 12 13 14 15 16 **17** 18 19 20 21 22 23 24 25 26 27 28 29 30 31

MAY

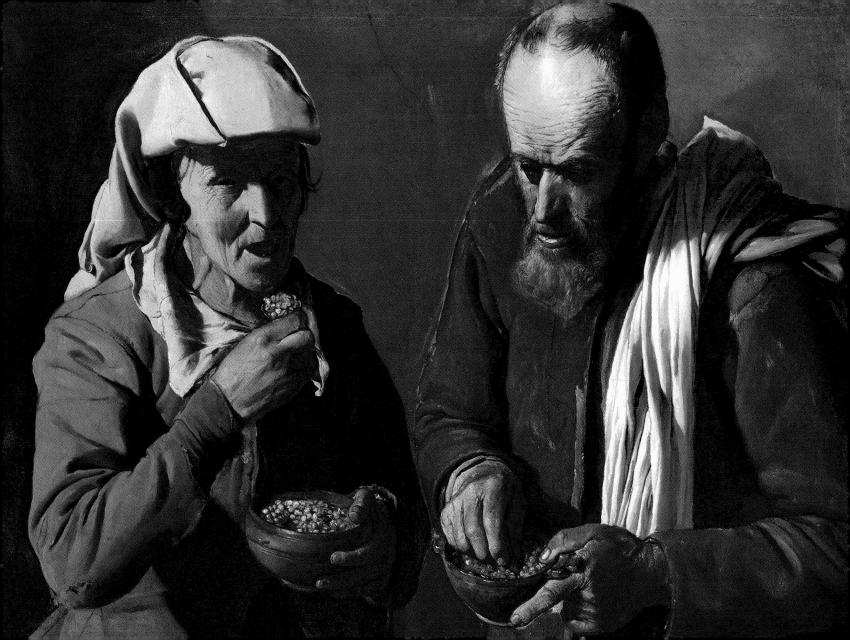

By mere burial man arrives not at bliss; and in the future life, throughout its whole infinite range, they will seek for happiness as vainly as they sought it here, who seek it in aught else than that which so closely surrounds them here—the Infinite.

Johann Gottlieb Fichte

Burial Procession, papyrus, 323–30 B. C.
Egypt
Ägyptisches Museum und Papyrussammlung, Staatliche Museen zu Berlin

1 2 3 4 5 6 7 8 9 10 11 12 13 14 15 16 17 **18** 19 20 21 22 23 24 25 26 27 28 29 30 31

MAY

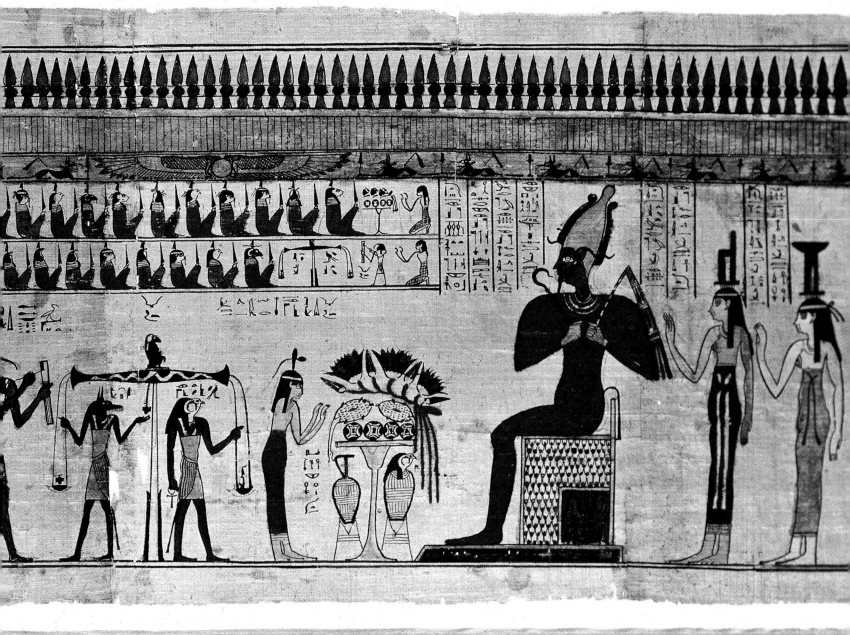

How wonderful is Death,
Death and his brother Sleep!

PERCY BYSSHE SHELLEY

Sleeping Youth, 15th century
Andrea del Verrocchio
Skulpturensammlung und Museum für Byzantinische Kunst, Staatliche Museen zu Berlin

1 2 3 4 5 6 7 8 9 10 11 12 13 14 15 16 17 18 **19** 20 21 22 23 24 25 26 27 28 29 30 31

MAY

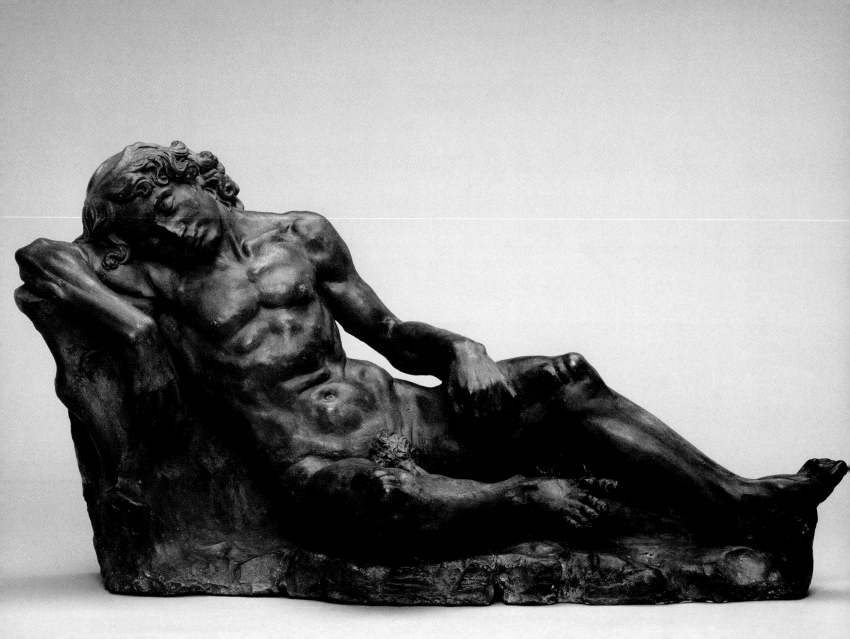

If men could learn from history, what lessons it might teach us! But passion and party blind our eyes, and the light which experience gives is a lantern on the stern, which shines only on the waves behind us.

SAMUEL TAYLOR COLERIDGE

Gathering in the Open Air
Jean-Antoine Watteau
Gemäldegalerie, Staatliche Museen zu Berlin

1 2 3 4 5 6 7 8 9 10 11 12 13 14 15 16 17 18 19 **20** 21 22 23 24 25 26 27 28 29 30 31

MAY

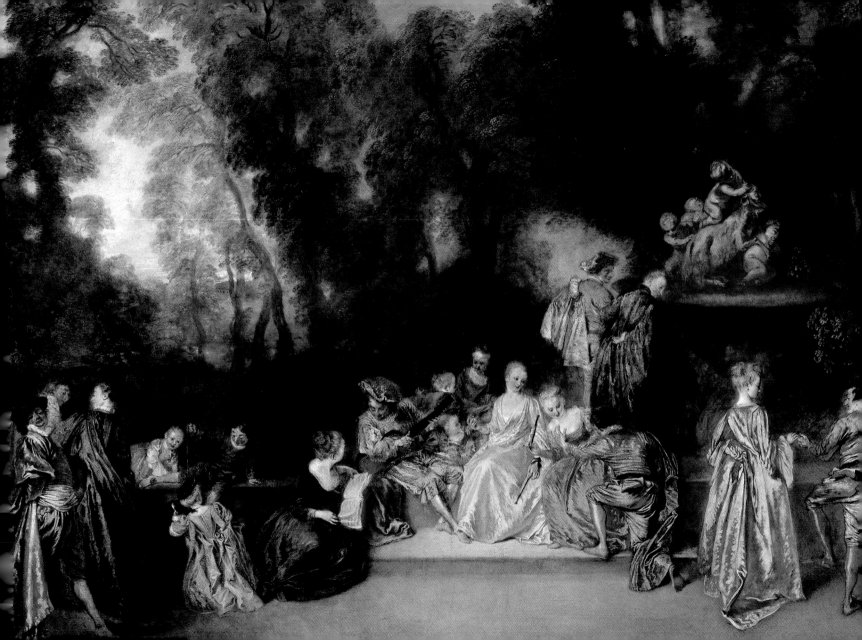

*There is but one temple in the universe
and that is the body of man.*

Novalis

Study of a Foot, late 17th or early 18th century
Pier Leone Ghezzi
Kupferstichkabinett, Staatliche Museen zu Berlin

1 2 3 4 5 6 7 8 9 10 11 12 13 14 15 16 17 18 19 20 **21** 22 23 24 25 26 27 28 29 30 31

May

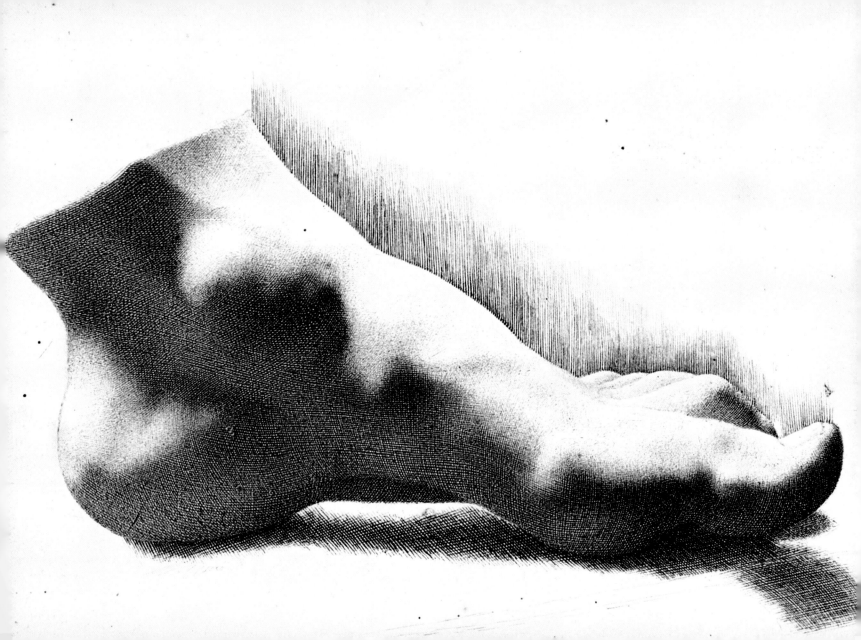

Difficulties are meant to rouse, not discourage. The human spirit is to grow strong by conflict.

WILLIAM ELLERY CHANNING

Breach of the Muider Dike During the Storm Flood on the Night of March 5ᵗʰ, 1651, *c.* 1651/52

Jan Asselijn
Gemäldegalerie, Staatliche Museen zu Berlin

1 2 3 4 5 6 7 8 9 10 11 12 13 14 15 16 17 18 19 20 21 **22** 23 24 25 26 27 28 29 30 31

MAY

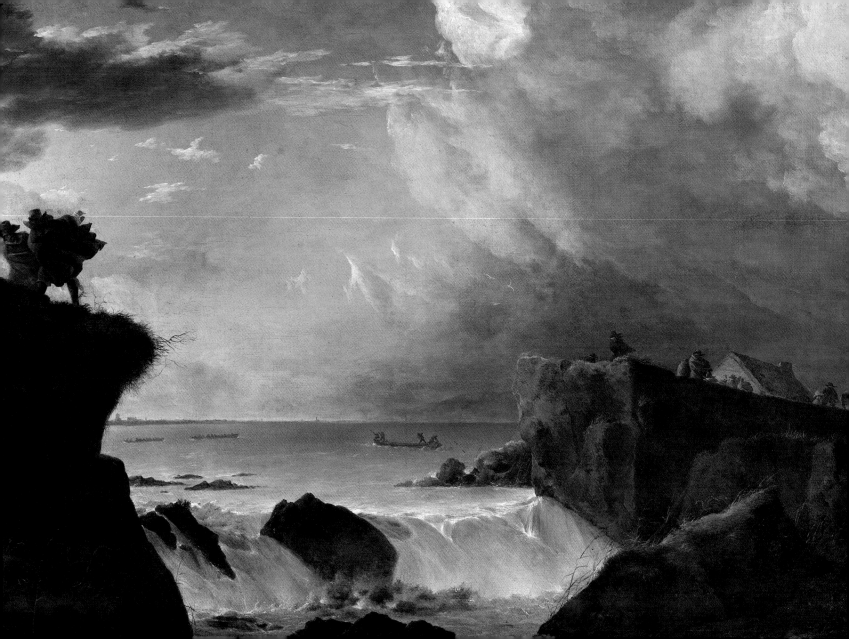

Wealth should not be seized,
but the god-given is much better.

HESIOD

Head of the shepherd-god Pan, silver coin, c. 410 B. C.
Catania/Sicily
Münzkabinett, Staatliche Museen zu Berlin

1 2 3 4 5 6 7 8 9 10 11 12 13 14 15 16 17 18 19 20 21 22 **23** 24 25 26 27 28 29 30 31

MAY

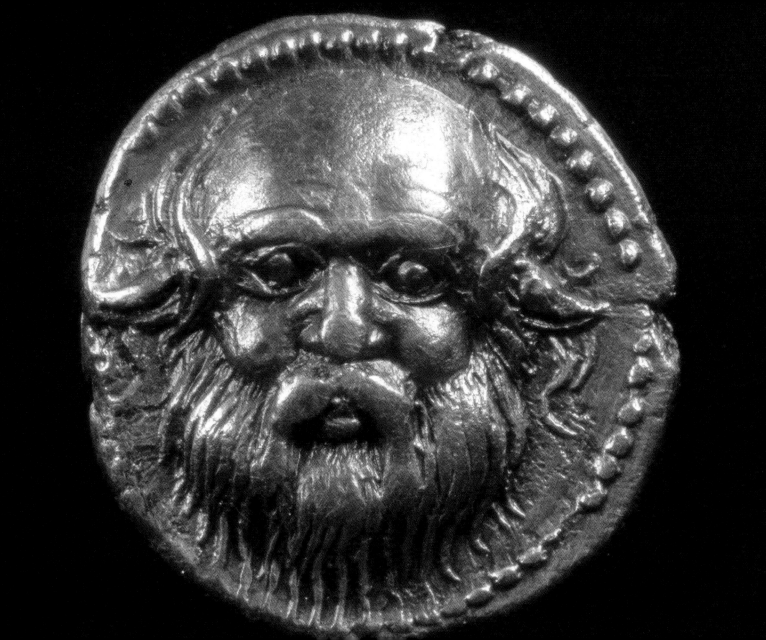

It is not enough to know your craft—you have to have feeling. Science is all very well, but for us imagination is worth far more.

EDOUARD MANET

In the Winter Garden (Dans la serre), 1879
Edouard Manet
Nationalgalerie, Staatliche Museen zu Berlin

1 2 3 4 5 6 7 8 9 10 11 12 13 14 15 16 17 18 19 20 21 22 23 **24** 25 26 27 28 29 30 31

MAY

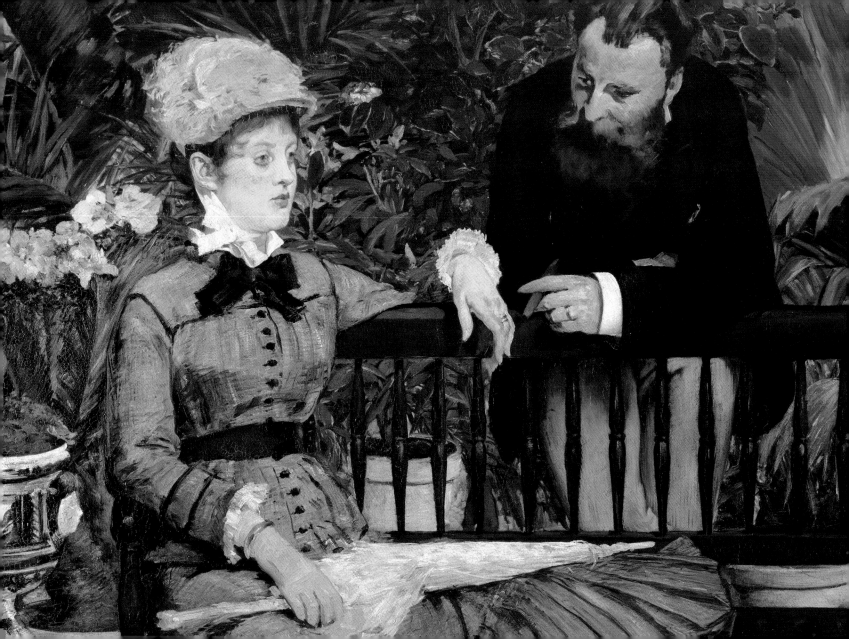

The Sin, *c.* 1912

Franz von Stuck

Nationalgalerie, Staatliche Museen zu Berlin

Pleasure is the bait of sin.

<small>PLATO</small>

1 2 3 4 5 6 7 8 9 10 11 12 13 14 15 16 17 18 19 20 21 22 23 24 **25** 26 27 28 29 30 31

MAY

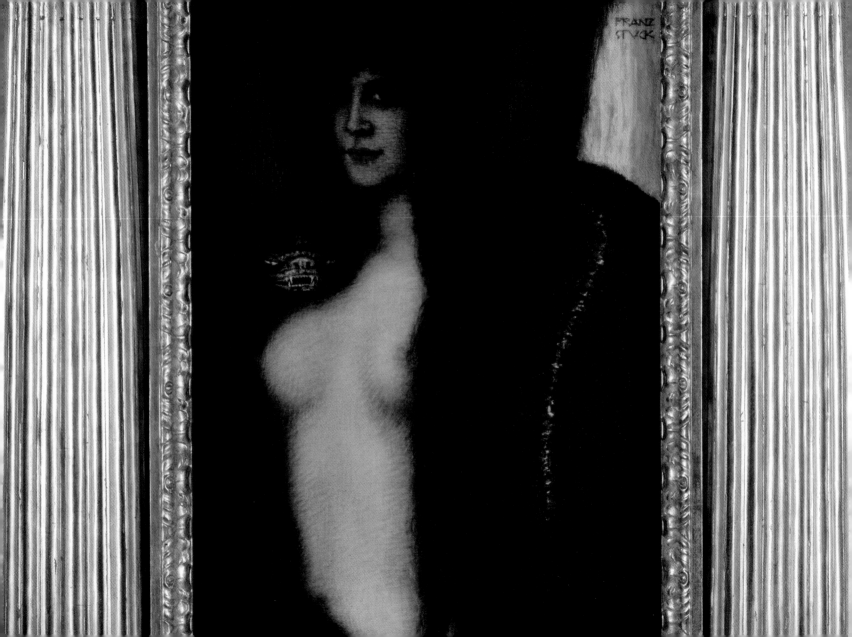

Live each season as it passes; breathe the air, drink the drink, taste the fruit, and resign yourself to the influences of each.

Henry David Thoreau

Building Site with Willows, 1846
Adolph von Menzel
Nationalgalerie, Staatliche Museen zu Berlin

1 2 3 4 5 6 7 8 9 10 11 12 13 14 15 16 17 18 19 20 21 22 23 24 25 **26** 27 28 29 30 31

MAY

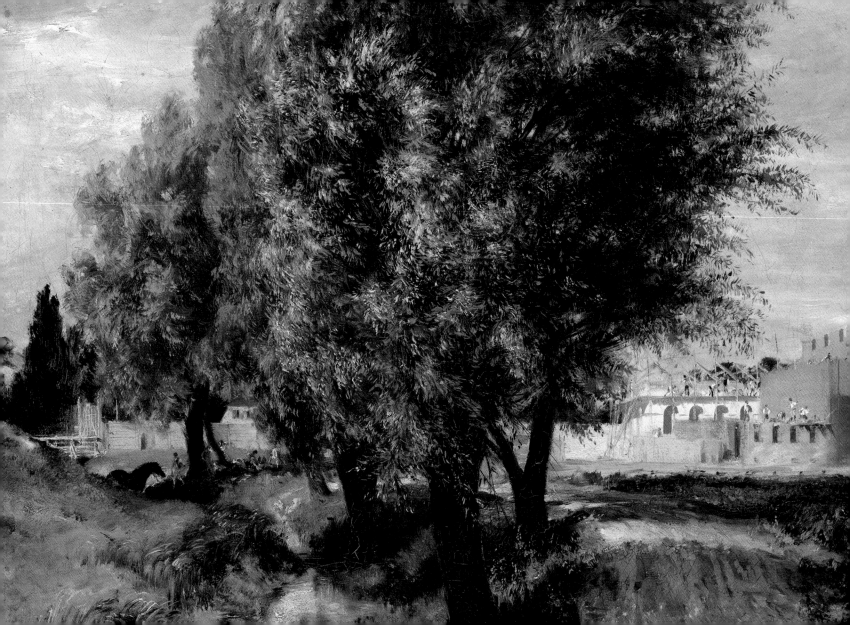

Virtue and genuine graces in themselves speak what no words can utter.

WILLIAM SHAKESPEARE

Venus in a Mussel Chariot, 1884/85

Max Klinger
Nationalgalerie, Staatliche Museen zu Berlin

1 2 3 4 5 6 7 8 9 10 11 12 13 14 15 16 17 18 19 20 21 22 23 24 25 26 **27** 28 29 30 31

MAY

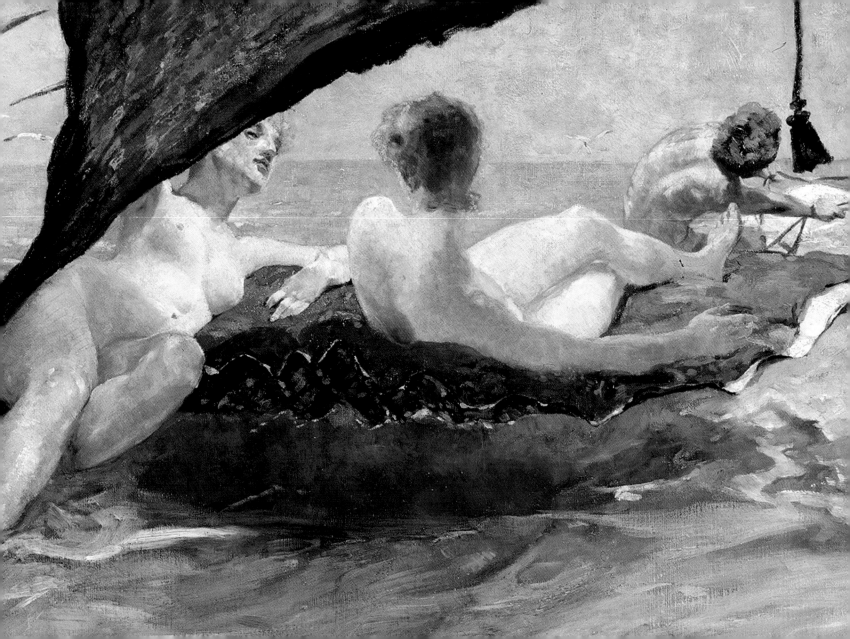

What counts most is finding new ways to get the world down in paint on my own terms.

Ciao America, 1988

Georg Baselitz

Kupferstichkabinett, Staatliche Museen zu Berlin

1 2 3 4 5 6 7 8 9 10 11 12 13 14 15 16 17 18 19 20 21 22 23 24 25 26 27 **28** 29 30 31

May

There are only two styles of portrait painting: the serious and the smirk.

CHARLES DICKENS

Self-Portrait with Saskia, 1636

Rembrandt Harmensz van Rijn

Kupferstichkabinett, Staatliche Museen zu Berlin

1 2 3 4 5 6 7 8 9 10 11 12 13 14 15 16 17 18 19 20 21 22 23 24 25 26 27 28 **29** 30 31

MAY

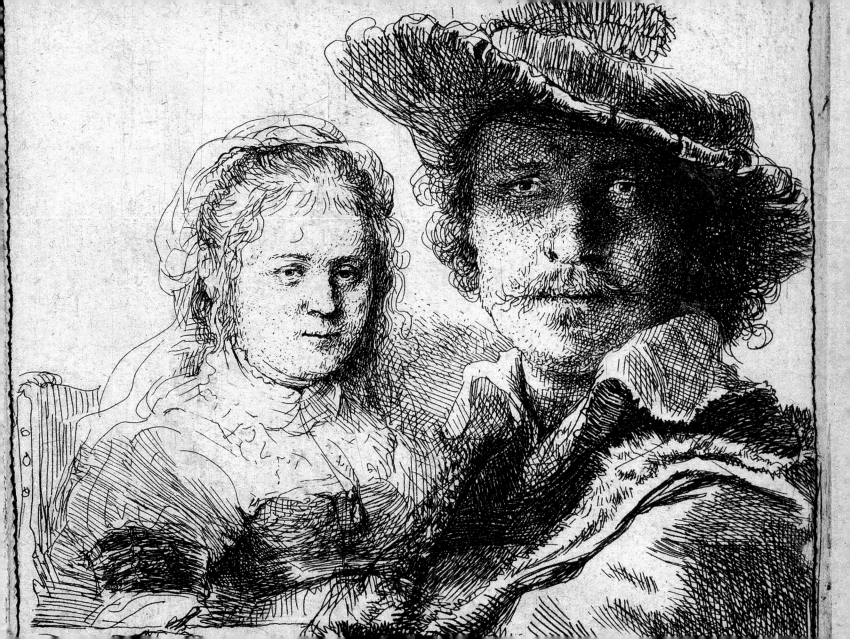

We know by experience itself, that...
we find out but a short way, by long
wandering.

Roger Ascham

The Wanderer. Studies on the Pacing Buddha, 1890–1895
Odilon Redon
Sammlung Scharf-Gerstenberg, Staatliche Museen zu Berlin

1 2 3 4 5 6 7 8 9 10 11 12 13 14 15 16 17 18 19 20 21 22 23 24 25 26 27 28 29 **30** 31

May

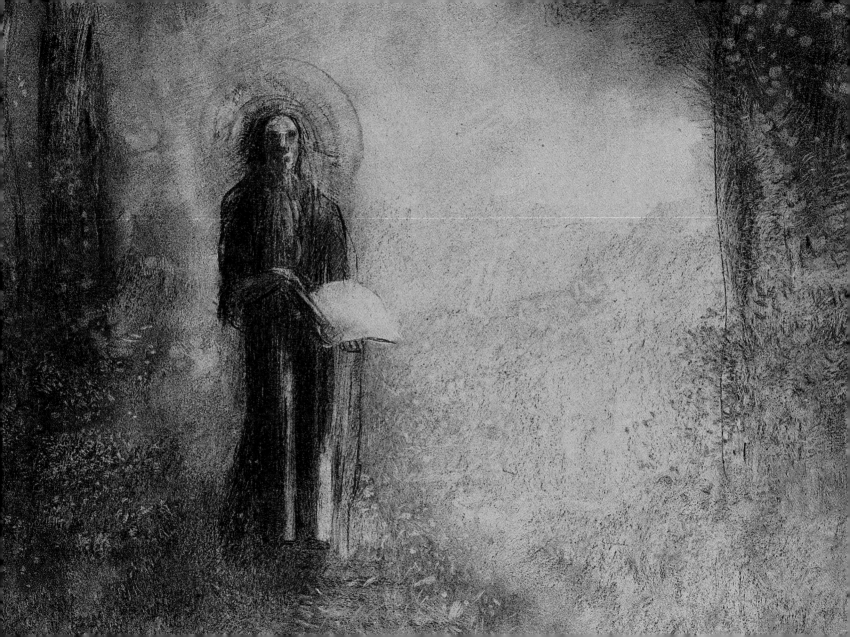

Blue, darkly, deeply, beautifully blue.

Robert Southey

Blue demon, 8th-9th century
Central Asia
Museum für Asiatische Kunst, Staatliche Museen zu Berlin

1 2 3 4 5 6 7 8 9 10 11 12 13 14 15 16 17 18 19 20 21 22 23 24 25 26 27 28 29 30 **31**

MAY

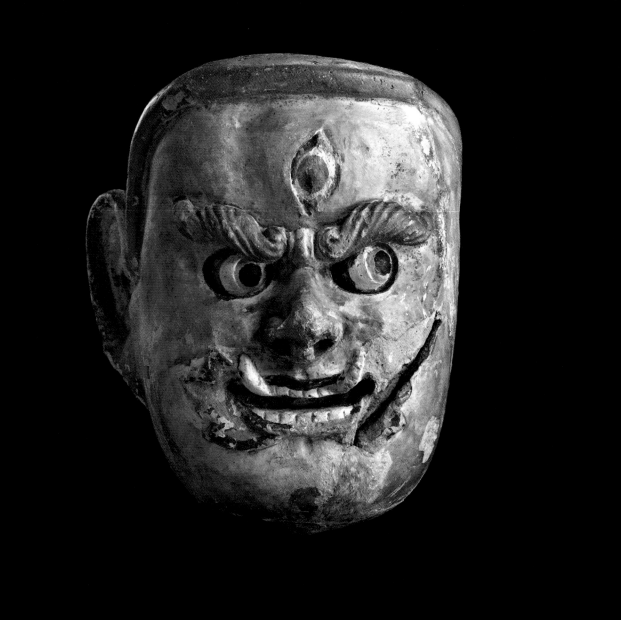

Music is a moral law. It gives soul to the universe, wings to the mind, flight to the imagination, and charm and gaiety to life and to everything.

PLATO

Writing console, Neuwied, 1779
David Roentgen
Kunstgewerbemuseum, Staatliche Museen zu Berlin

1 2 3 4 5 6 7 8 9 10 11 12 13 14 15 16 17 18 19 20 21 22 23 24 25 26 27 28 29 30

JUNE

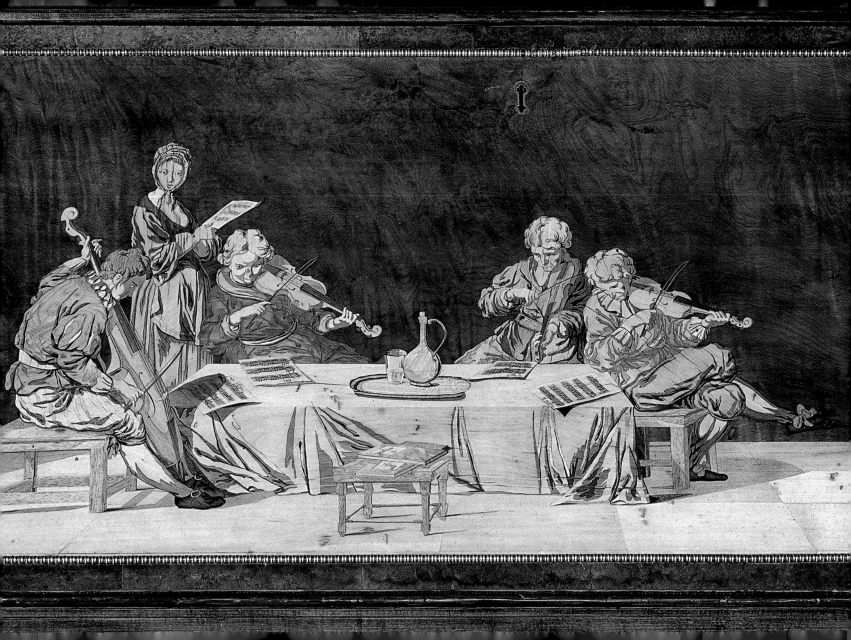

Travelling is the ruin of all happiness!
There's no looking at a building here
after seeing Italy.

Fanny Burney

Gulf of Naples with Fruit Merchants, 1822
Franz Ludwig Catel
Nationalgalerie, Staatliche Museen zu Berlin

1 2 3 4 5 6 7 8 9 10 11 12 13 14 15 16 17 18 19 20 21 22 23 24 25 26 27 28 29 30

JUNE

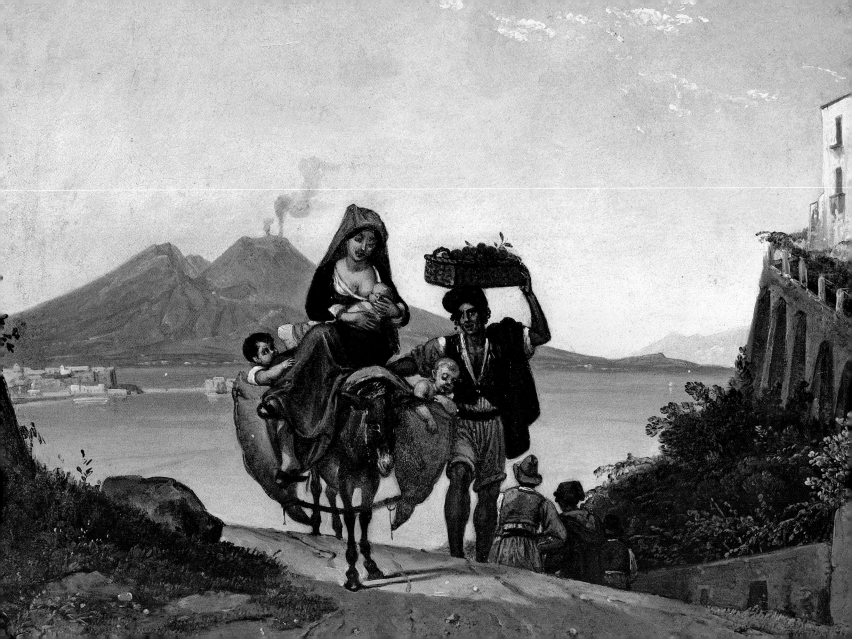

One must ask children and birds how cherries and strawberries taste.

Still Life with Cherries and Strawberries in Chinese Porcelain Bowls, 1608
Osias Beert
Gemäldegalerie, Staatliche Museen zu Berlin

Johann Wolfgang von Goethe

1 2 **3** 4 5 6 7 8 9 10 11 12 13 14 15 16 17 18 19 20 21 22 23 24 25 26 27 28 29 30

June

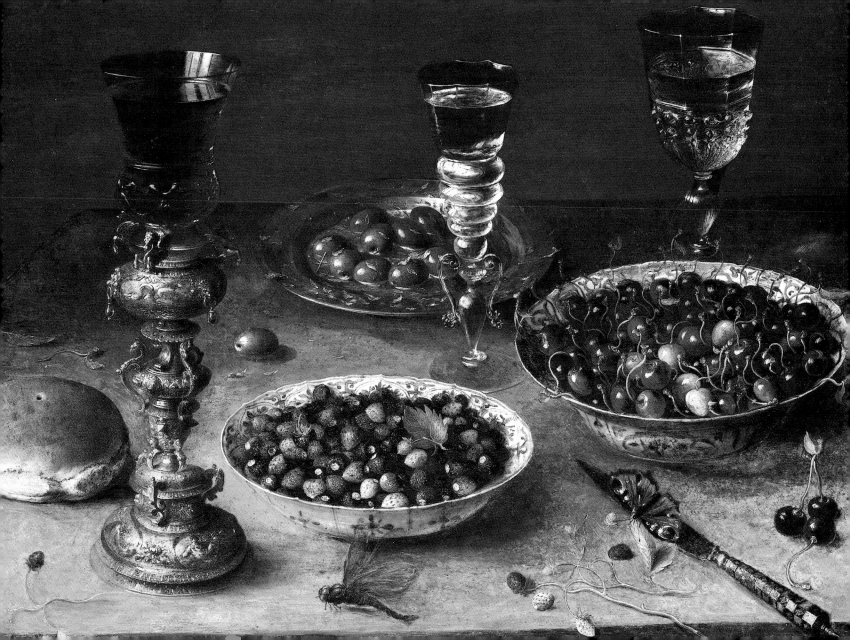

Fine art is that in which the hand, the head, and the heart of man go together.

JOHN RUSKIN

The Little Cycle, 20th century
Hannah Höch
Kupferstichkabinett, Staatliche Museen zu Berlin

4

1 2 3 5 6 7 8 9 10 11 12 13 14 15 16 17 18 19 20 21 22 23 24 25 26 27 28 29 30

JUNE

One doesn't discover new lands without consenting to lose sight of the shore for a very long time.

André Gide

The Cliffs at Etretat, 1869
Gustave Courbet
Nationalgalerie, Staatliche Museen zu Berlin

1 2 3 4 **5** 6 7 8 9 10 11 12 13 14 15 16 17 18 19 20 21 22 23 24 25 26 27 28 29 30

JUNE

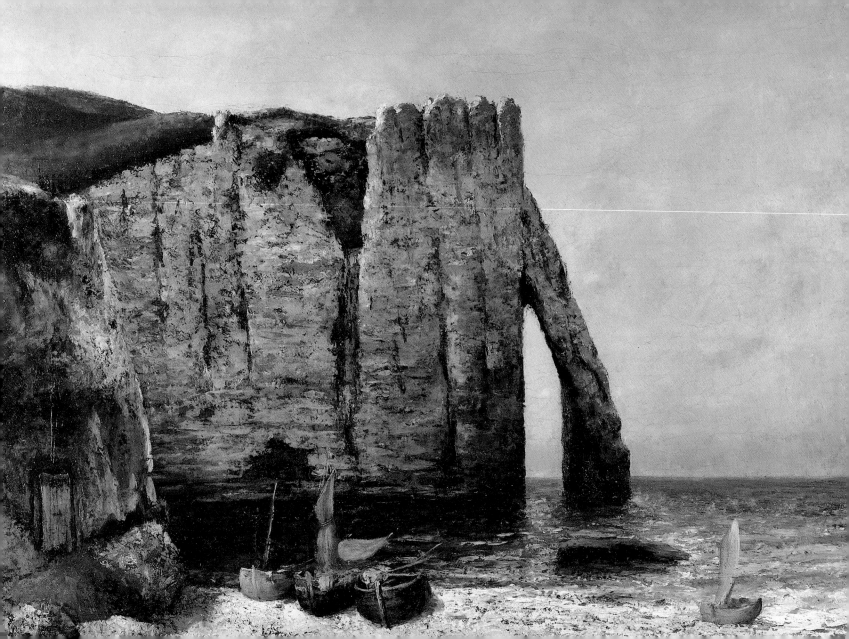

Now the young lady was beautiful of form and face, and when her father and her mother died, Mordecai took her as his own daughter.

ESTHER 2:7

Half-lenght Portrait of a Lady
Hans Baldung Grien
Kupferstichkabinett, Staatliche Museen zu Berlin

1 2 3 4 5 **6** 7 8 9 10 11 12 13 14 15 16 17 18 19 20 21 22 23 24 25 26 27 28 29 30

JUNE

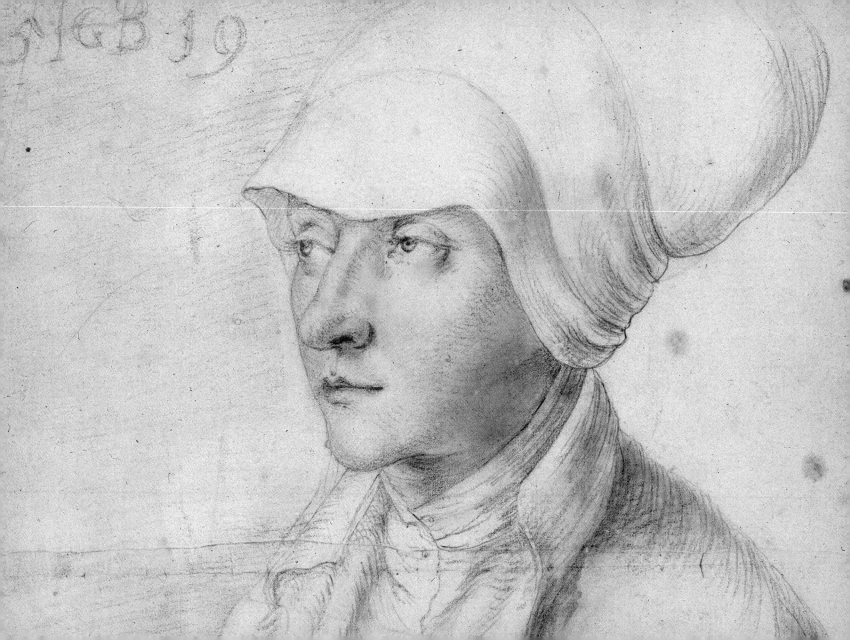

There's nothing ill can dwell in such a temple:
If the ill spirit have so fair a house,
Good things will strive to dwell with't.

WILLIAM SHAKESPEARE

The Temple of Isis in Pompeii, late 18th century
Jacob Phillip Hackert
Kupferstichkabinett, Staatliche Museen zu Berlin

1 2 3 4 5 6 **7** 8 9 10 11 12 13 14 15 16 17 18 19 20 21 22 23 24 25 26 27 28 29 30

JUNE

Family likeness has often a deep sadness in it. Nature, that great tragic dramatist, knits us together by bone and muscle.

GEORGE ELIOT

Self-Portrait with Family, 1829
Gustav Adolf Hippius
Nationalgalerie, Staatliche Museen zu Berlin

1 2 3 4 5 6 7 **8** 9 10 11 12 13 14 15 16 17 18 19 20 21 22 23 24 25 26 27 28 29 30

JUNE

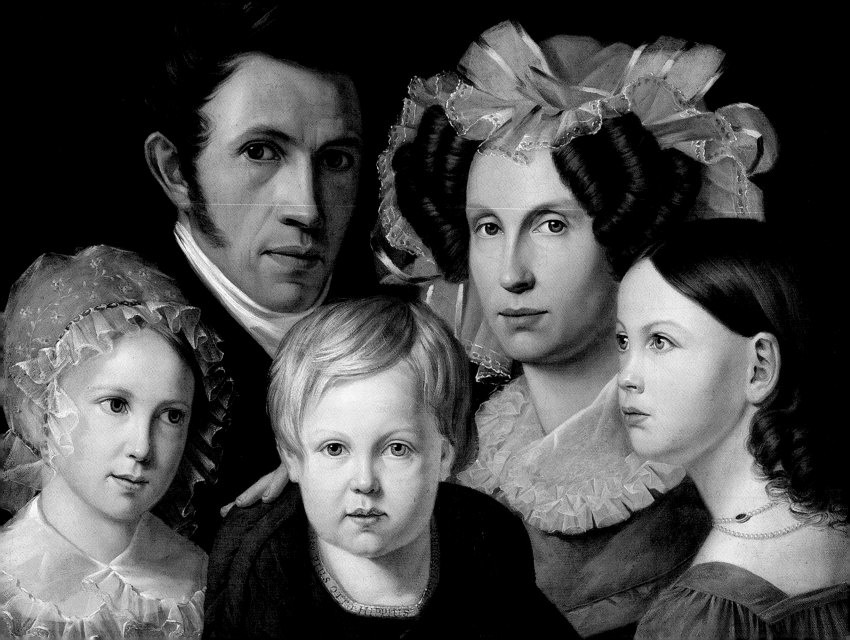

A dance is a measured pace, as a verse is a measured speech.

Francis Bacon

Cover Draft for Verve IV, No. 13, 1943
Henri Matisse
Museum Berggruen, Nationalgalerie, Staatliche Museen zu Berlin

1 2 3 4 5 6 7 8 **9** 10 11 12 13 14 15 16 17 18 19 20 21 22 23 24 25 26 27 28 29 30

JUNE

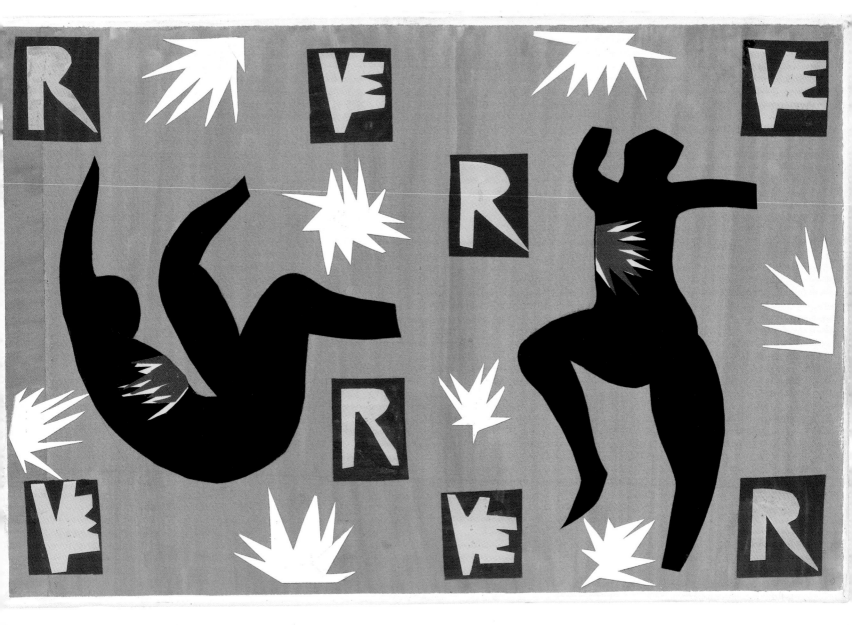

*It is for the character and preservation
of these noble fellows that I am an enthusiast;
and it is for these uncontaminated people that I
would be willing to devote the energies of my life.*

<small>GEORGE CATLIN</small>

Indians from the Tribe of the Dakota, 1854

George Catlin

Ethnologisches Museum, Staatliche Museen zu Berlin

1 2 3 4 5 6 7 8 9 **10** 11 12 13 14 15 16 17 18 19 20 21 22 23 24 25 26 27 28 29 30

JUNE

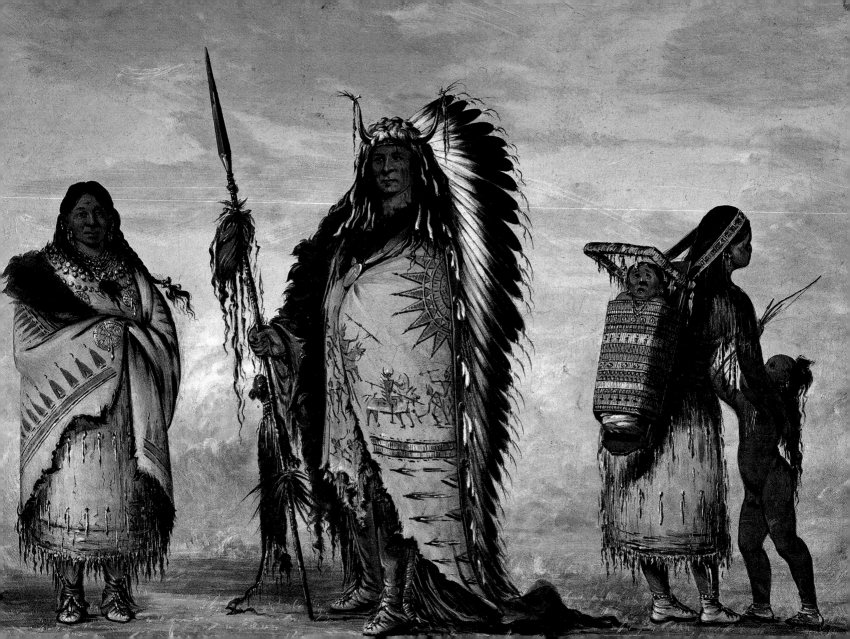

When the queen of Sheba heard about the fame of Solomon and his relation to the name of the LORD, she came to test him with hard questions.

1 KINGS 10

The Queen of Sheba in Front of King Solomon, *c.* 1435–1437
Konrad Witz
Gemäldegalerie, Staatliche Museen zu Berlin

1 2 3 4 5 6 7 8 9 10 **11** 12 13 14 15 16 17 18 19 20 21 22 23 24 25 26 27 28 29 30

JUNE

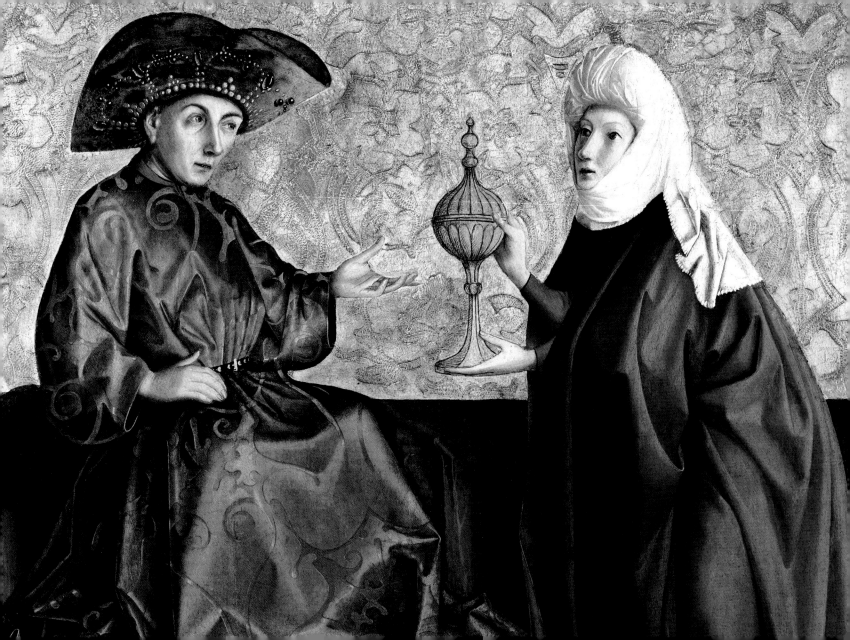

I think of what great art removes:
Hazard and death, the future and the
past.

EAVAN BOLAND

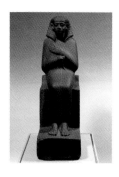

Seated figure of Chertihotep, 1976–1794 B. C.
Egypt
Ägyptisches Museum und Papyrussammlung, Staatliche Museen zu Berlin

1 2 3 4 5 6 7 8 9 10 11 **12** 13 14 15 16 17 18 19 20 21 22 23 24 25 26 27 28 29 30

JUNE

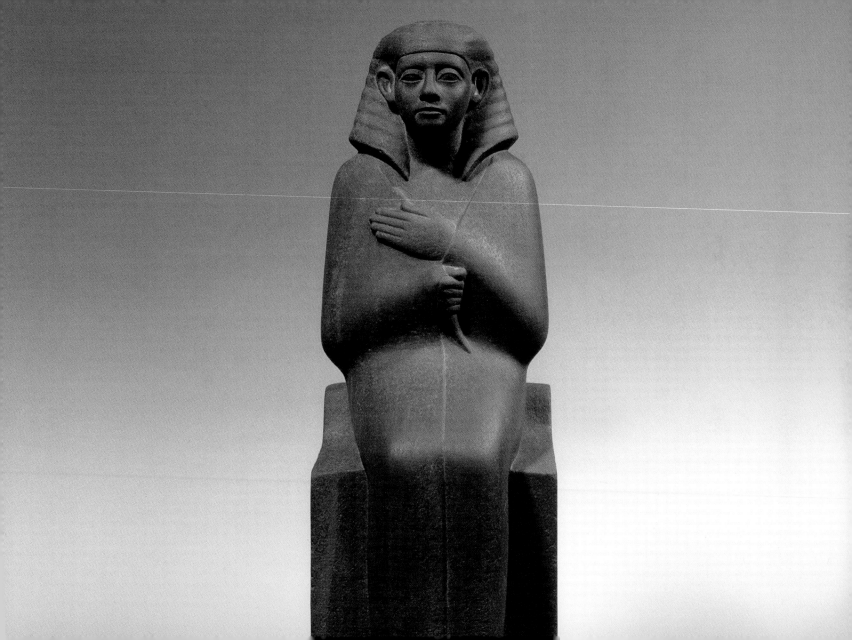

Grace is in garments, in movements, in manners.

JOSEPH JOUBERT

Cloak Study, late 15ᵗʰ or early 16ᵗʰ century
Albrecht Dürer
Kupferstichkabinett, Staatliche Museen zu Berlin

13

1 2 3 4 5 6 7 8 9 10 11 12 13 14 15 16 17 18 19 20 21 22 23 24 25 26 27 28 29 30

JUNE

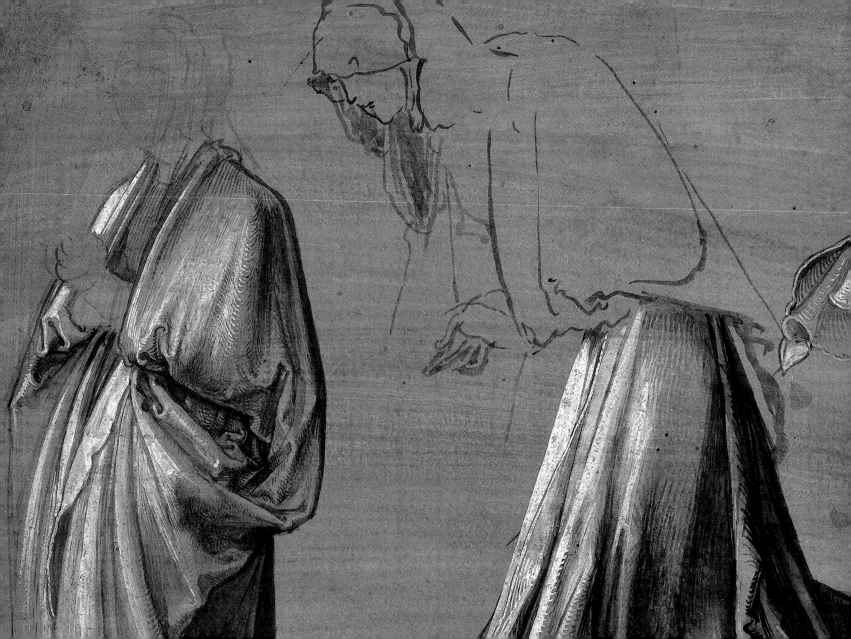

Beauty is no quality in things themselves: It exists merely in the mind which contemplates them; and each mind perceives a different beauty.

DAVID HUME

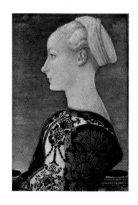

Profile Portrait of a Young Lady, *c.* 1465
Andrea del Pollaiuolo
Gemäldegalerie, Staatliche Museen zu Berlin

1 2 3 4 5 6 7 8 9 10 11 12 13 **14** 15 16 17 18 19 20 21 22 23 24 25 26 27 28 29 30

JUNE

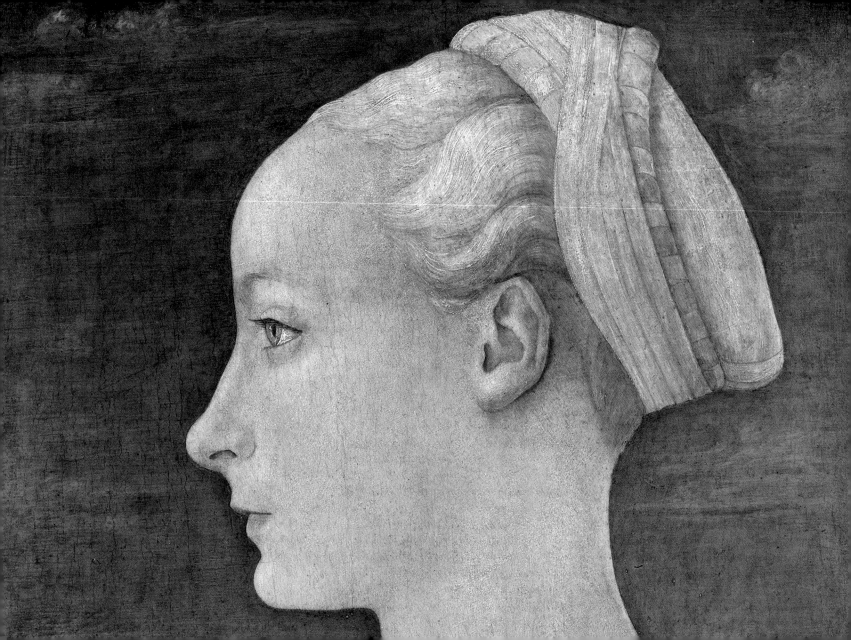

*My characters have undergone the same
process of simplification as the colors.
Now that they have been simplified,
they appear more human and alive than
if they had been represented in all their
details.*

Joan Miró

The Little Blonde in the Amusement Park, 1950

Joan Miró
Nationalgalerie, Staatliche Museen zu Berlin

1 2 3 4 5 6 7 8 9 10 11 12 13 14 **15** 16 17 18 19 20 21 22 23 24 25 26 27 28 29 30

JUNE

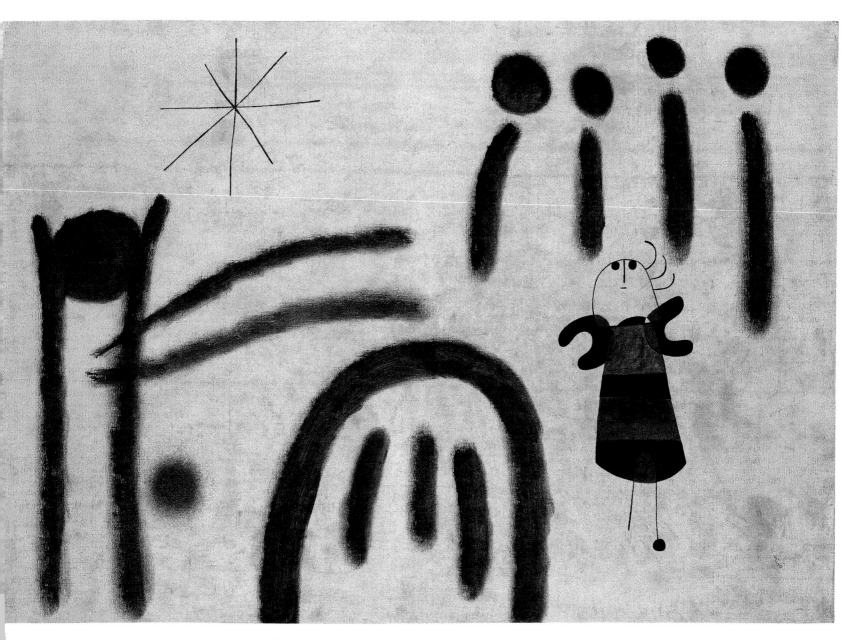

*The finest qualities of our nature,
like the bloom on fruits, can be preserved
only by the most delicate handling.*

HENRY DAVID THOREAU

Still Life with Fruit and Lobster, 17th century

Jan Davidsz de Heem

Gemäldegalerie, Staatliche Museen zu Berlin

1 2 3 4 5 6 7 8 9 10 11 12 13 14 15 **16** 17 18 19 20 21 22 23 24 25 26 27 28 29 30

JUNE

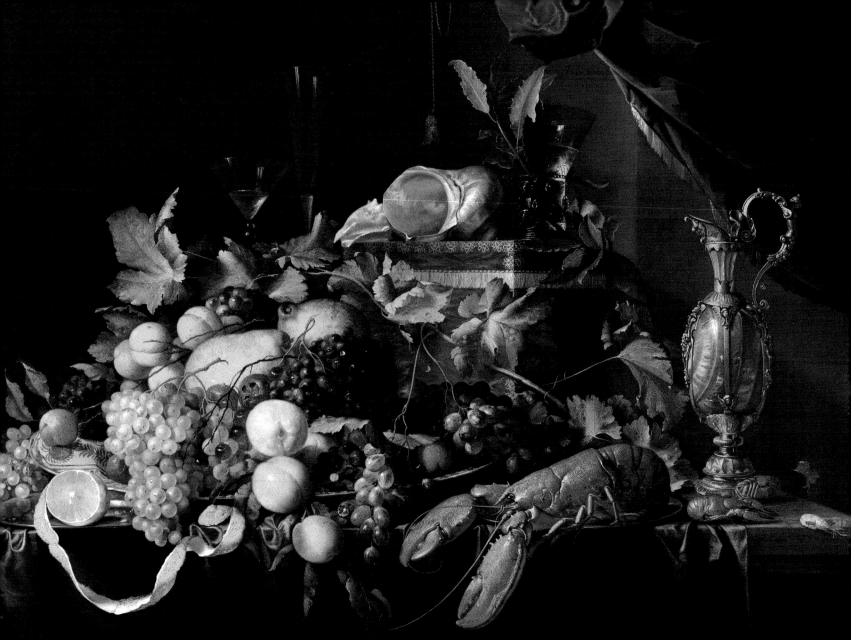

In every work of art the subject is primordial, whether the artist knows it or not. The measure of the formal qualities is only a sign of the measure of the artist's obsession with his subject; the form is always in proportion to the obsession.

ALBERTO GIACOMETTI

The Cat, 1951
Alberto Giacometti
Museum Berggruen, Nationalgalerie, Staatliche Museen zu Berlin

1 2 3 4 5 6 7 8 9 10 11 12 13 14 15 16 **17** 18 19 20 21 22 23 24 25 26 27 28 29 30

JUNE

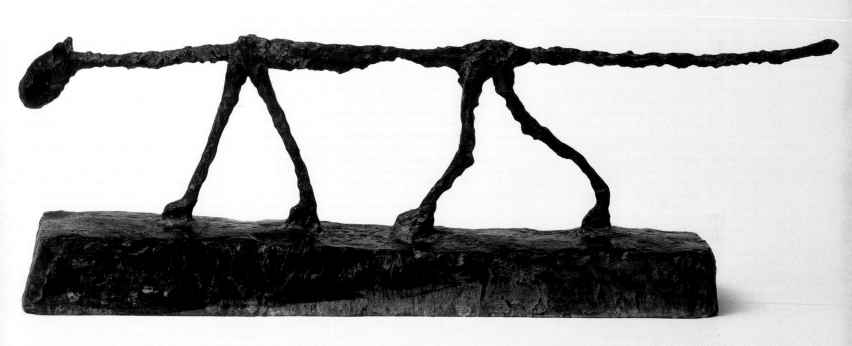

Then it happened one evening that David arose from his bed and walked on the roof of the king's house. And from the roof he saw a woman bathing, and the woman was very beautiful to behold. So David sent and inquired about the woman. And someone said, Is this not Bathsheba, the daughter of Eliam, the wife of Uriah the Hittite?

2 SAMUEL 11:2–3

Bathsheba Bathing, *c.* 1775
Sebastiano Ricci
Gemäldegalerie, Staatliche Museen zu Berlin

1 2 3 4 5 6 7 8 9 10 11 12 13 14 15 16 17 **18** 19 20 21 22 23 24 25 26 27 28 29 30

JUNE

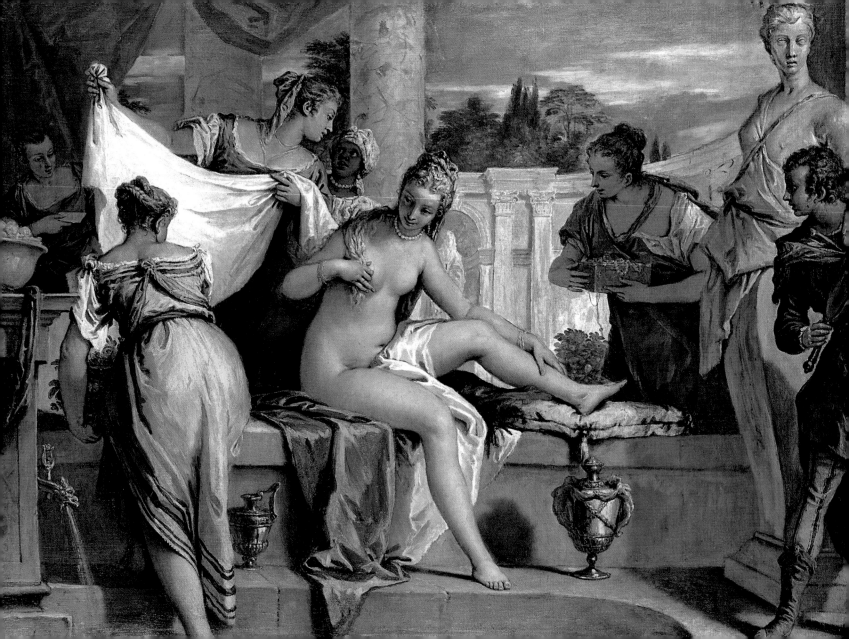

And he [Zeus] would have cast me from
the aither into the sea, out of sight,
had not Night, subduer of gods and men,
saved me.

HOMER

**Pergamon Altar (detail from the north frieze, Moire [Nyx] with
snake-entwined vessel),** second quarter of the 2nd century B. C.

Pergamon/Turkey

Antikensammlung, Staatliche Museen zu Berlin

1 2 3 4 5 6 7 8 9 10 11 12 13 14 15 16 17 18 **19** 20 21 22 23 24 25 26 27 28 29 30

JUNE

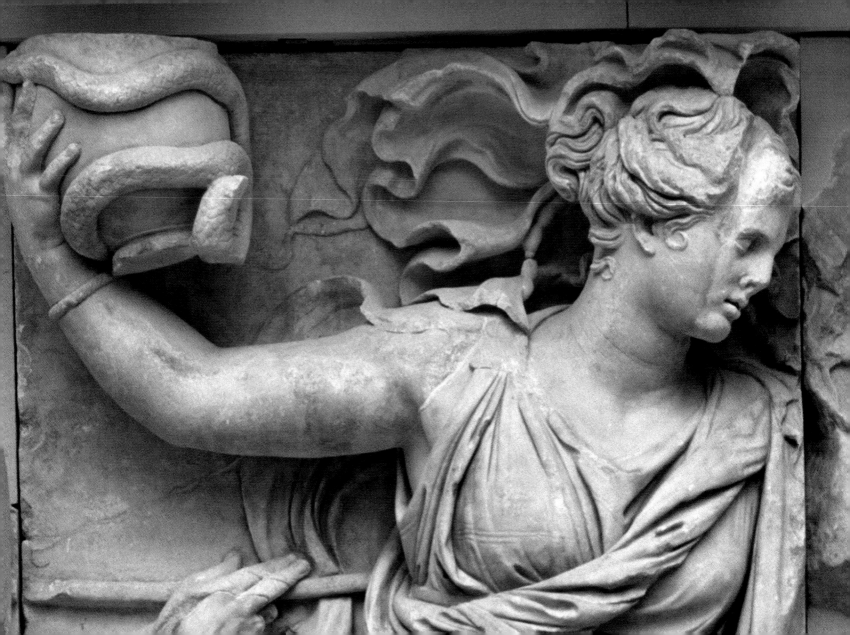

Words are pattern-like, and in their horizontality they answer my investigation into landscape. They're almost not words—they are objects that become words.

Edward Ruscha

Vanish, 1974
Edward Ruscha
Kupferstichkabinett, Staatliche Museen zu Berlin

1 2 3 4 5 6 7 8 9 10 11 12 13 14 15 16 17 18 19 **20** 21 22 23 24 25 26 27 28 29 30

JUNE

VANISH

Every painter paints himself.

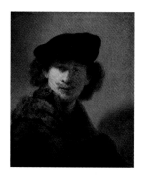

Self-Portrait with Velvet Beret and Furred Mantle, 1634
Rembrandt Harmensz van Rijn
Gemäldegalerie, Staatliche Museen zu Berlin

1 2 3 4 5 6 7 8 9 10 11 12 13 14 15 16 17 18 19 20 **21** 22 23 24 25 26 27 28 29 30

JUNE

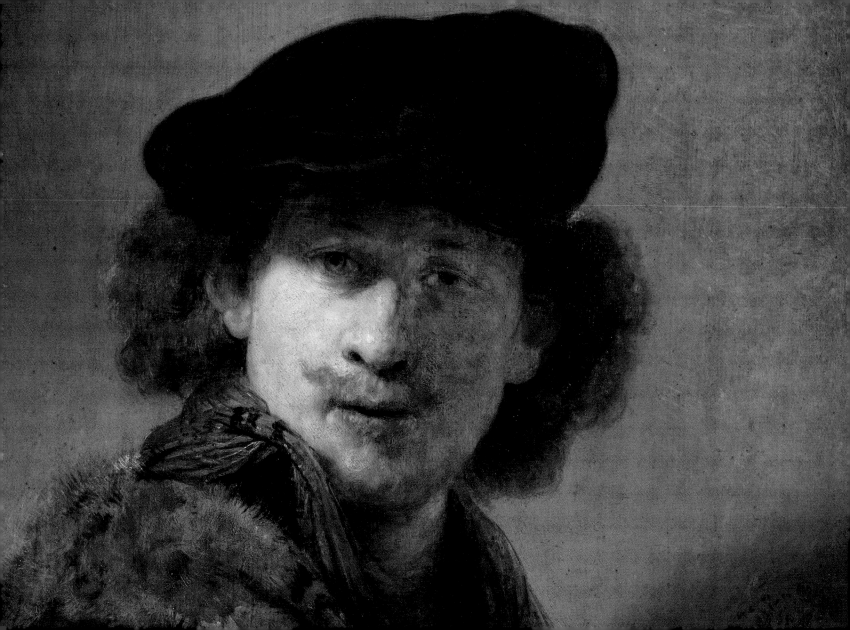

A brilliant morning shines on the old city. Its antiquities and ruins are surpassingly beautiful, with a lusty ivy gleaming in the sun, and the rich trees waving in the balmy air.

CHARLES DICKENS

Plate fragment, majolica, *c.* 1540
Kunstgewerbemuseum, Staatliche Museen zu Berlin

1 2 3 4 5 6 7 8 9 10 11 12 13 14 15 16 17 18 19 20 21 **22** 23 24 25 26 27 28 29 30

JUNE

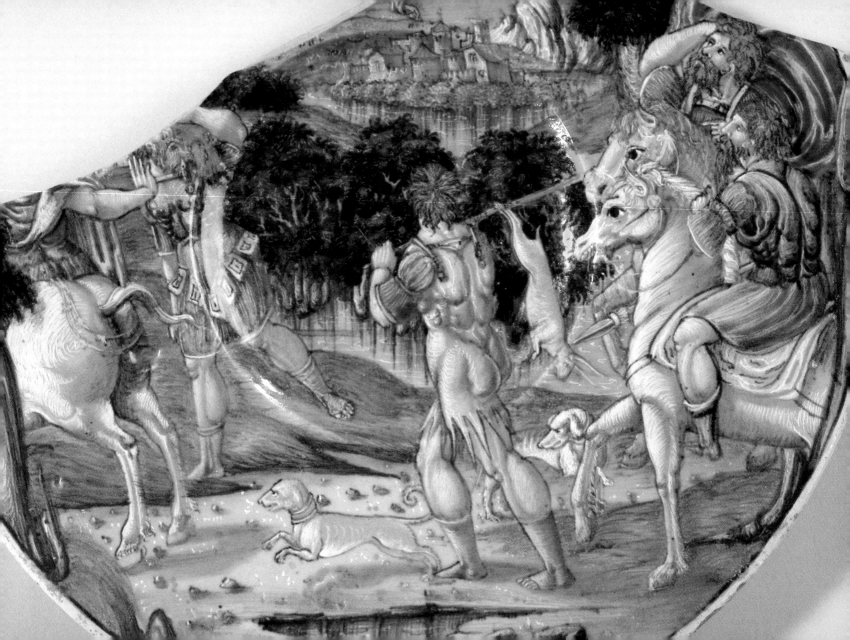

Fashions fade, style is eternal.

Yves Saint Laurent

Berlin fashion: organza dress with pleated sleeves, 1928
design by Herbert Mocho
Kunstbibliothek, Staatliche Museen zu Berlin

1 2 3 4 5 6 7 8 9 10 11 12 13 14 15 16 17 18 19 20 21 22 **23** 24 25 26 27 28 29 30

JUNE

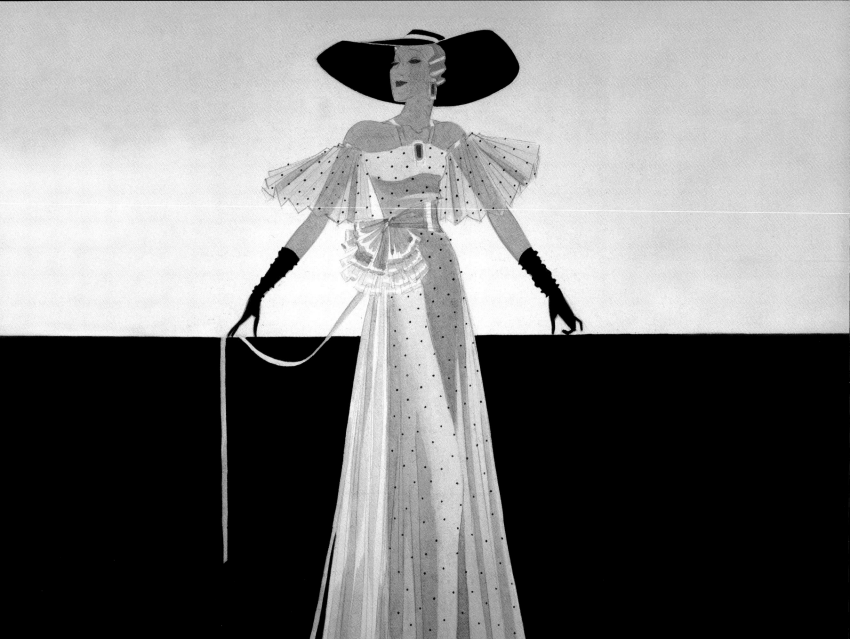

Is it not in the most absolute simplicity that real genius plies its pinions the most wonderfully?

E. T. A. HOFFMANN

Rider on a horse, 5th–4th century B. C.

Babylon

Vorderasiatisches Museum, Staatliche Museen zu Berlin

1 2 3 4 5 6 7 8 9 10 11 12 13 14 15 16 17 18 19 20 21 22 23 **24** 25 26 27 28 29 30

JUNE

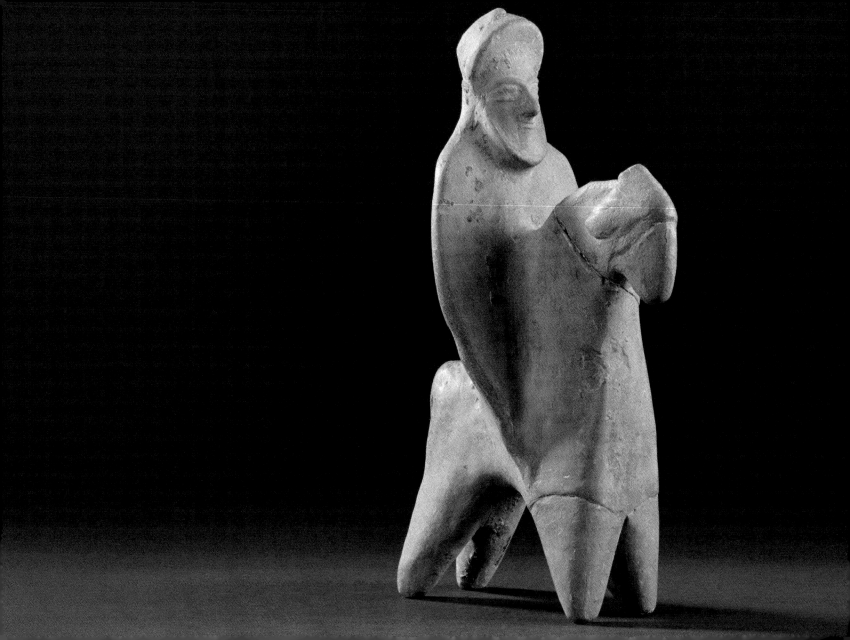

This world is a comedy to those that think, a tragedy to those that feel.

Horace Walpole

The Italian Comedy, after 1716
Jean-Antoine Watteau
Gemäldegalerie, Staatliche Museen zu Berlin

1 2 3 4 5 6 7 8 9 10 11 12 13 14 15 16 17 18 19 20 21 22 23 24 **25** 26 27 28 29 30

JUNE

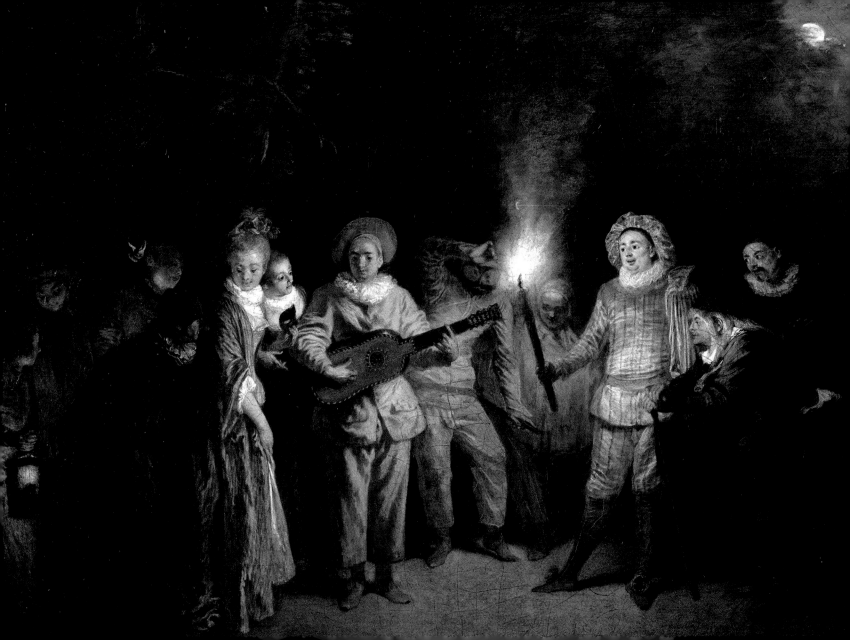

Do not try to find out—we're forbidden to know—what end the gods have in store for me, or for you.

HORACE

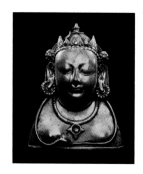

Bust of Shiva, 8th–9th century A. D.
Himachal Pradesh, Kulu or Sirmur
Museum für Asiatische Kunst, Staatliche Museen zu Berlin

1 2 3 4 5 6 7 8 9 10 11 12 13 14 15 16 17 18 19 20 21 22 23 24 25 **26** 27 28 29 30

JUNE

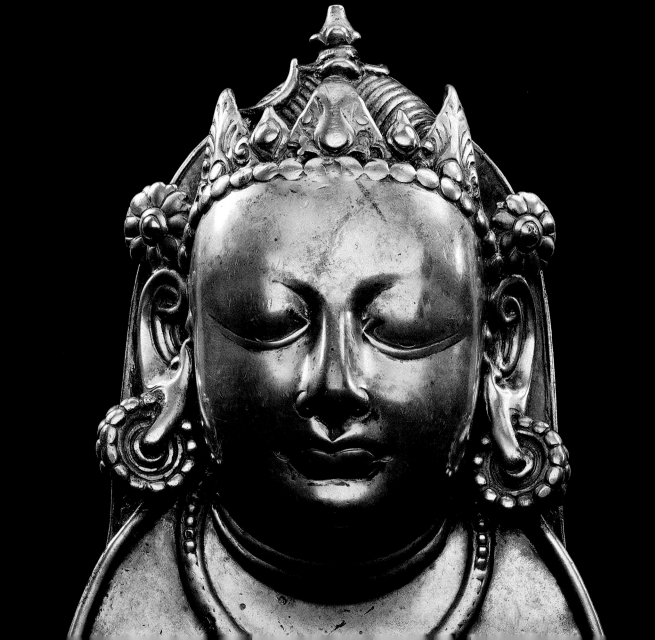

Art is unquestionably one of the purest and highest elements in human happiness. It trains the mind through the eye, and the eye through the mind. As the sun colors flowers, so does art color life.

JOHN LUBBOCK

Autumn Song, 1945
Ernst Wilhelm Nay
Kupferstichkabinett, Staatliche Museen zu Berlin

1 2 3 4 5 6 7 8 9 10 11 12 13 14 15 16 17 18 19 20 21 22 23 24 25 26 **27** 28 29 30

JUNE

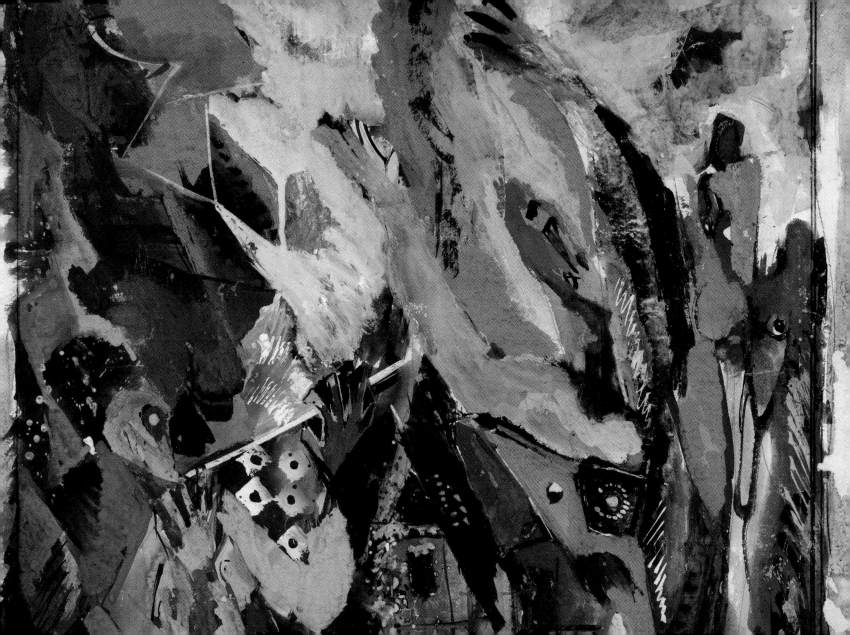

For man, as for flower and beast and bird, the supreme triumph is to be most vividly, most perfectly alive.

D. H. LAWRENCE

Relief from the Ishtar Gate, built under Nebuchadnezzar II, *c.* 580 B. C.
Babylon
Vorderasiatisches Museum, Staatliche Museen zu Berlin

1 2 3 4 5 6 7 8 9 10 11 12 13 14 15 16 17 18 19 20 21 22 23 24 25 26 27 **28** 29 30

JUNE

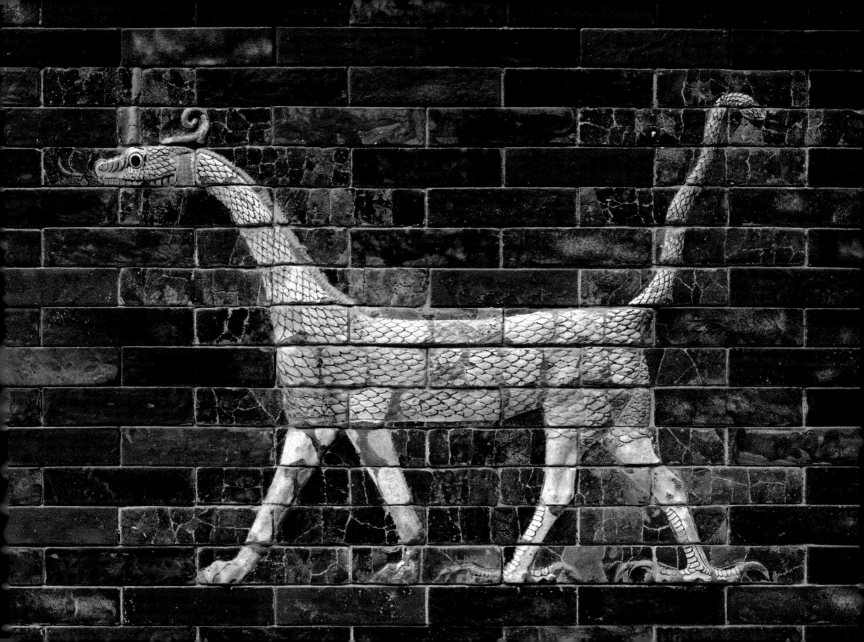

Art and Religion are, then, two roads by which men escape from circumstance to ecstasy. Between aesthetic and religious rapture there is a family alliance. Art and Religion are means to similar states of mind.

CLIVE BELL

Kai Stele, 2119–1976 B. C.
Egypt
Ägyptisches Museum und Papyrussammlung, Staatliche Museen zu Berlin

1 2 3 4 5 6 7 8 9 10 11 12 13 14 15 16 17 18 19 20 21 22 23 24 25 26 27 28 **29** 30

JUNE

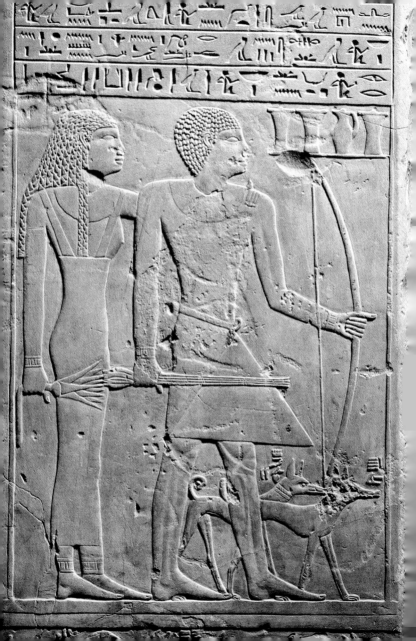

*It is the common wonder of all men,
how among so many millions of faces
there should be none alike.*

Sir Thomas Browne

Giovanni Arnolfini

Jan van Eyck
Gemäldegalerie, Staatliche Museen zu Berlin

1 2 3 4 5 6 7 8 9 10 11 12 13 14 15 16 17 18 19 20 21 22 23 24 25 26 27 28 29 **30**

JUNE

Dürer portrayed a rhinoceros covered with scales and imbricated plates; as a result this image of the rhinoceros remained constant for at least two centuries and reappeared in the books of explorers and zoologists…. One could say Dürer's rhinoce-ros is more successful at portraying, if not actual rhinoceroses, at best our cultural conception of a rhinoceros.

UMBERTO ECO

The Rhinoceros, 1515
Albrecht Dürer
Kupferstichkabinett, Staatliche Museen zu Berlin

1 2 3 4 5 6 7 8 9 10 11 12 13 14 15 16 17 18 19 20 21 22 23 24 25 26 27 28 29 30 31

JULY

Nach Christus gepurt.1513. Jar. Adi.1.May. Hat man dem grosmechtigen Kunig von Portugall Emanuell gen Lysabona pracht aus India/ein sollich lebendig Thier. Das nennen sie Rhinocerus. Das ist hye mit aller seiner gestalt Abcondertfet. Es hat ein farb wie ein gespreckelte Schildtkrot. Und ist von dicken Schalen vberlegt fast fest. Und ist in der grös als der Helfande Aber nydertrechtiger von paynen/und fast werhasstig. Es hat ein scharff starck Horn vorn auff der nasen/Das begyndt es albeg zu werzen wo es bey staynen ist. Das dosig Thier ist des Helfsants todt feyndt. Der Helffandt furcht es fast vbel/dann wo es Jn ankumbt/so laufft Jm das Thier mit dem kopff zwischen dye fordern payn/und tryst den Helffandt vnden am pauch auff vn erwürgt Jn/des mag er sich nit erwern. Dann das Thier ist also gewapent/das Jm der Helffandt nichts kan thün. Sie sagen auch das der Rhynocerus Schnell/Fraydig vnd Listig sey.

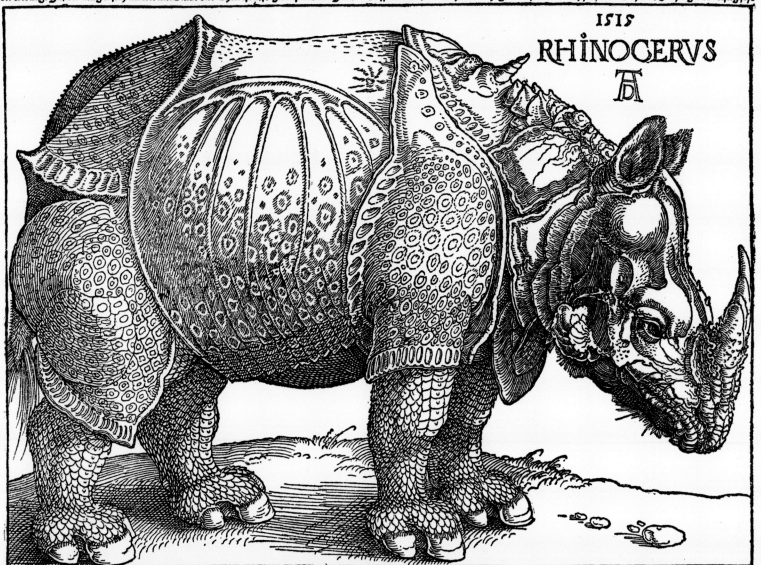

1515
RHINOCERVS

Life on board a pleasure steamer violates every moral and physical condition of healthy life except fresh air… It is a guzzling, lounging, gambling, dog's life.

GEORGE BERNARD SHAW

Schnellster Weg nach New York (The Fastest Way to New York),
1930–1933
advertising poster for the sister ships Bremen and Europa
Kunstbibliothek, Staatliche Museen zu Berlin

1 **2** 3 4 5 6 7 8 9 10 11 12 13 14 15 16 17 18 19 20 21 22 23 24 25 26 27 28 29 30 31

JULY

Art is the unceasing effort to compete with the beauty of flowers—and never succeeding.

Marc Chagall

English Iris, *c.* 1610
Georg Flegel
Kupferstichkabinett, Staatliche Museen zu Berlin

3

1 2 **3** 4 5 6 7 8 9 10 11 12 13 14 15 16 17 18 19 20 21 22 23 24 25 26 27 28 29 30 31

JULY

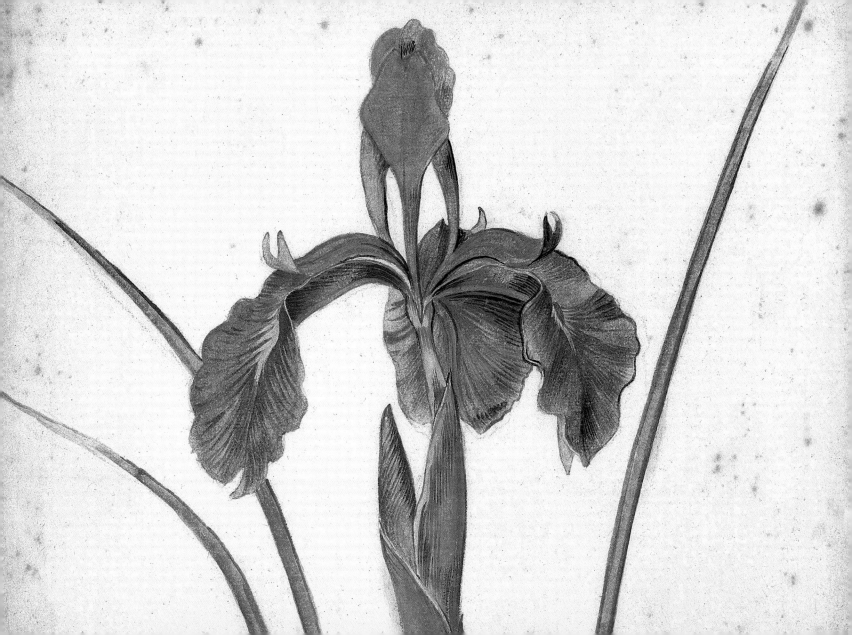

In the future everybody will be world famous for fifteen minutes.

ANDY WARHOL

Marilyn (light green, pink, yellow), 20th century
Andy Warhol
Kupferstichkabinett, Staatliche Museen zu Berlin

1 2 3 **4** 5 6 7 8 9 10 11 12 13 14 15 16 17 18 19 20 21 22 23 24 25 26 27 28 29 30 31

JULY

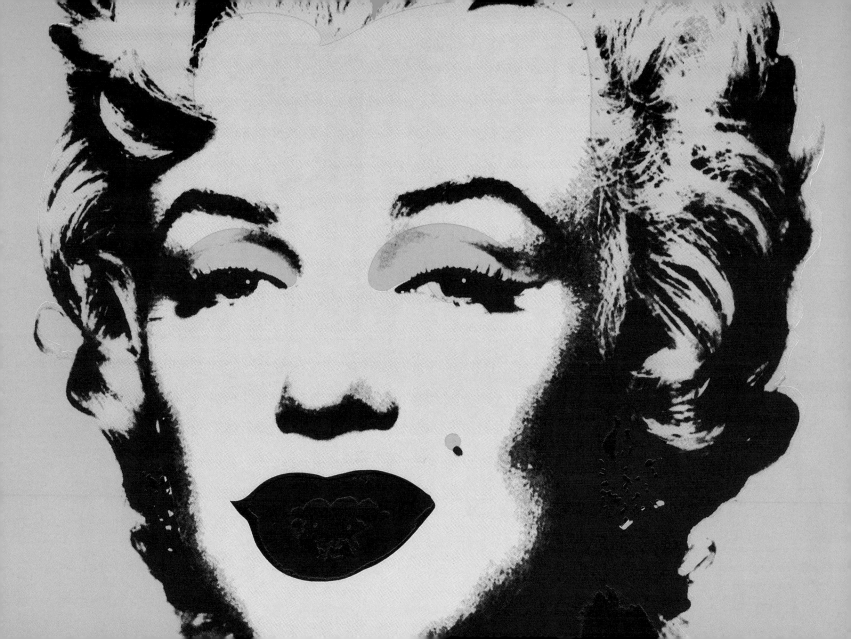

Was it a vision, or a waking dream?

JOHN KEATS

The Madonna in the Church, *c.* 1425

Jan van Eyck

Gemäldegalerie, Staatliche Museen zu Berlin

1 2 3 4 **5** 6 7 8 9 10 11 12 13 14 15 16 17 18 19 20 21 22 23 24 25 26 27 28 29 30 31

JULY

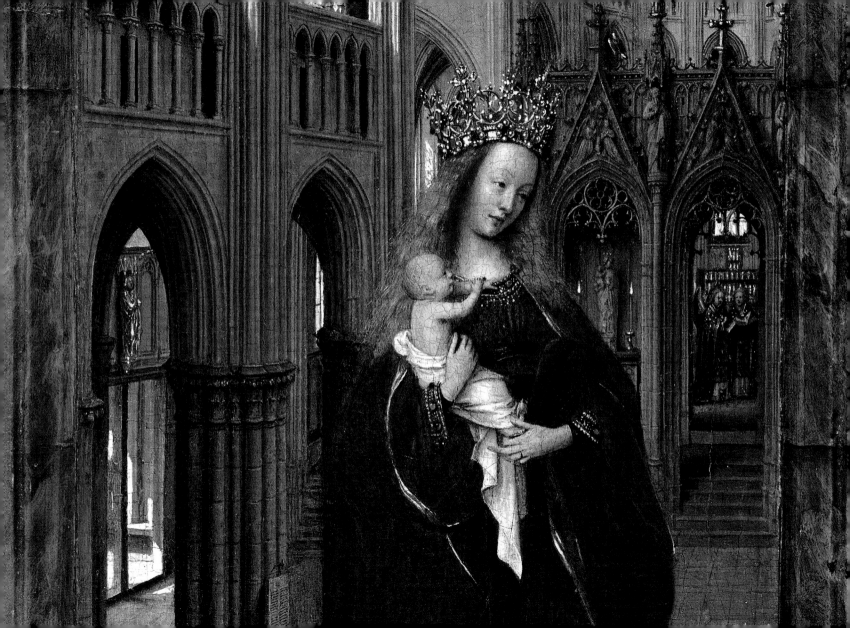

It is an unscrupulous intellect that does not pay to antiquity its due reverence.

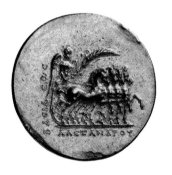

Nike in the Quadriga, gold coin's reverse,
first half of the 3rd century A. D.
Münzkabinett, Staatliche Museen zu Berlin

1 2 3 4 5 **6** 7 8 9 10 11 12 13 14 15 16 17 18 19 20 21 22 23 24 25 26 27 28 29 30 31

JULY

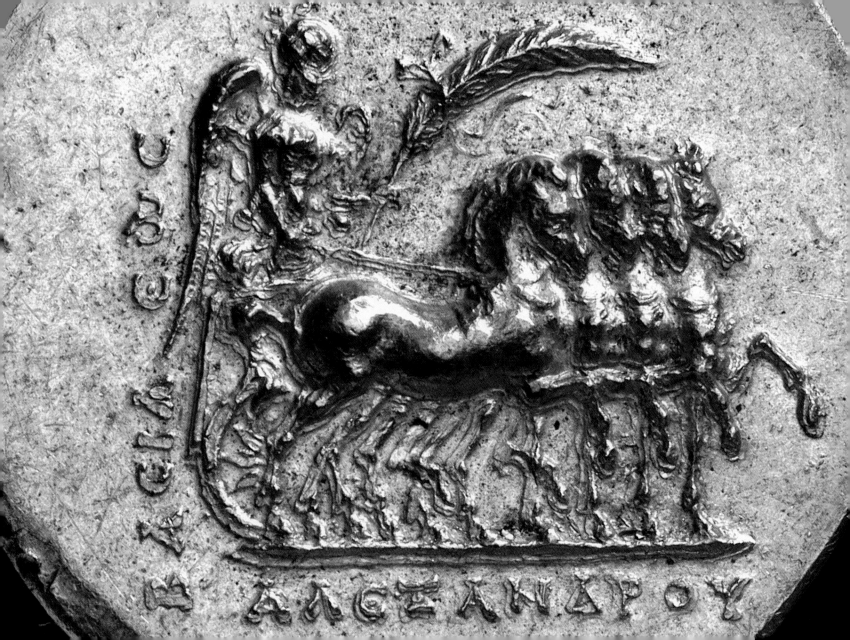

Give a man a fish and you feed him for a day. Teach a man to fish and you feed him for a lifetime.

Chinese Fish Women at Work, 1979
Chen Long
Museum für Asiatische Kunst, Staatliche Museen zu Berlin

1 2 3 4 5 6 **7** 8 9 10 11 12 13 14 15 16 17 18 19 20 21 22 23 24 25 26 27 28 29 30 31

JULY

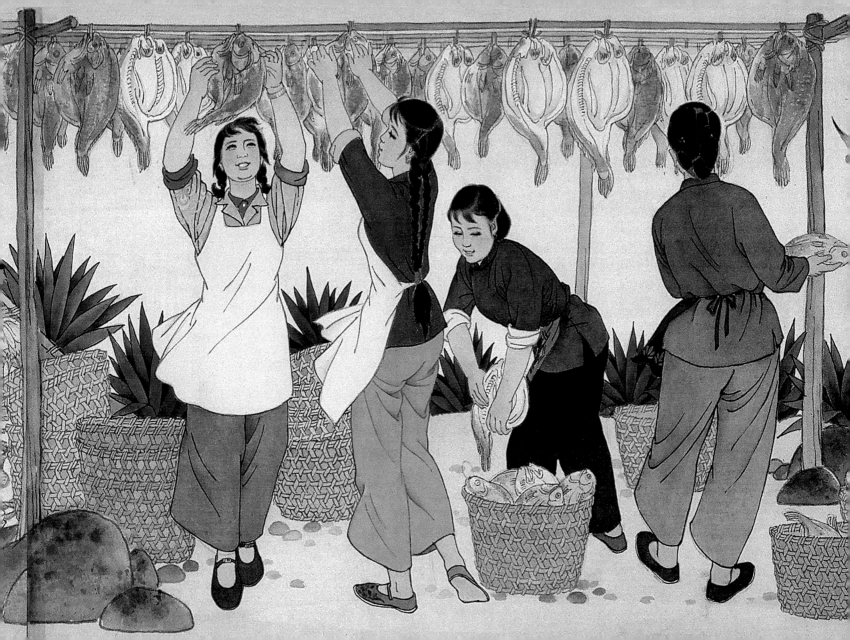

I love all beauteous things,
I seek and adore them;
God hath no better praise,
And man in his hasty days
Is honoured for them.

Buffalo mask of the Batabi, 19th century
Cameroon
Ethnologisches Museum, Staatliche Museen zu Berlin

8

1 2 3 4 5 6 7 **8** 9 10 11 12 13 14 15 16 17 18 19 20 21 22 23 24 25 26 27 28 29 30 31

JULY

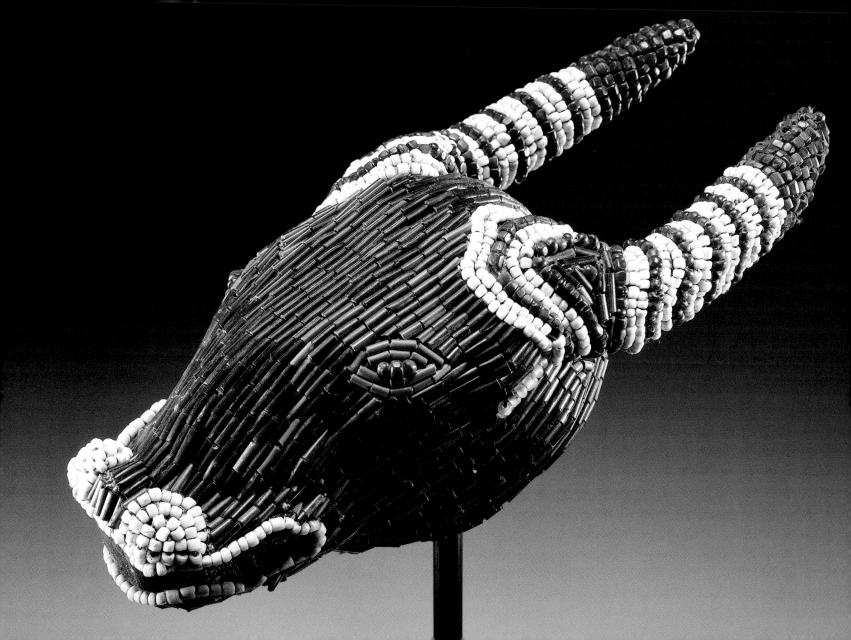

Whoever cultivates the golden mean avoids both the poverty of a hovel and the envy of a palace.

Horace

George Clive and His Family with an Indian Servant, *c.* 1765/66
Joshua Reynolds
Gemäldegalerie, Staatliche Museen zu Berlin

1 2 3 4 5 6 7 8 **9** 10 11 12 13 14 15 16 17 18 19 20 21 22 23 24 25 26 27 28 29 30 31

July

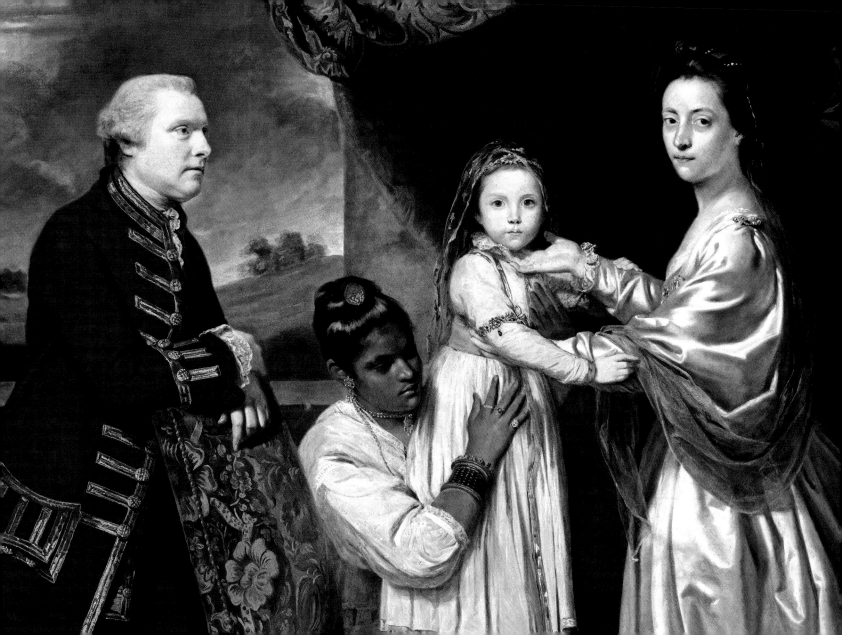

Any landscape is a condition of the spirit.

HENRI FRÉDÉRIC AMIEL

Mill on the Couleuvre at Pontoise, *c.* 1881
Paul Cézanne
Nationalgalerie, Staatliche Museen zu Berlin

1 2 3 4 5 6 7 8 9 **10** 11 12 13 14 15 16 17 18 19 20 21 22 23 24 25 26 27 28 29 30 31

JULY

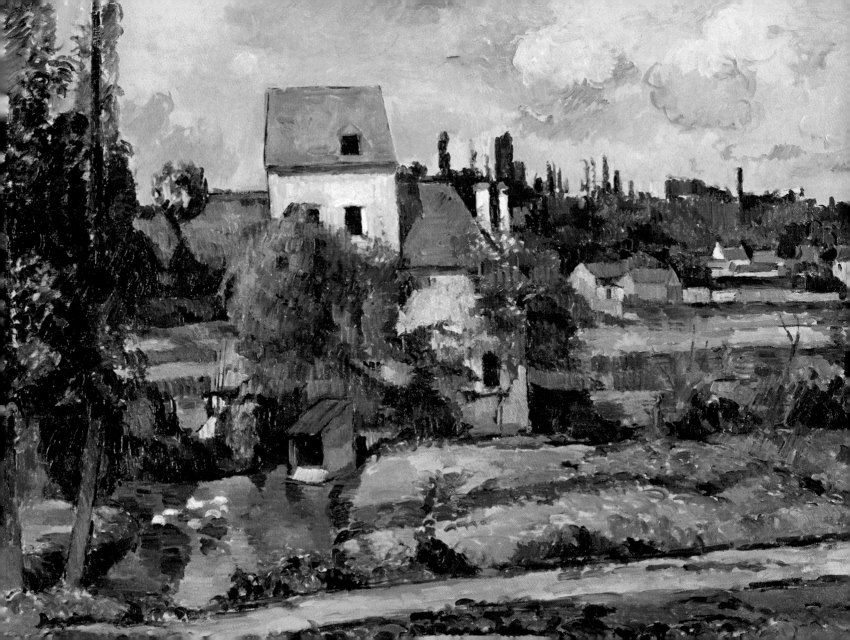

Painitng is the grandchild to nature.
It is related to God.

REMBRANDT HARMENSZ VAN RIJN

Young Woman at an Open Half-Door (Hendrickje Stoffels),
1656/57

Rembrandt Harmensz van Rijn
Gemäldegalerie, Staatliche Museen zu Berlin

1 2 3 4 5 6 7 8 9 10 **11** 12 13 14 15 16 17 18 19 20 21 22 23 24 25 26 27 28 29 30 31

JULY

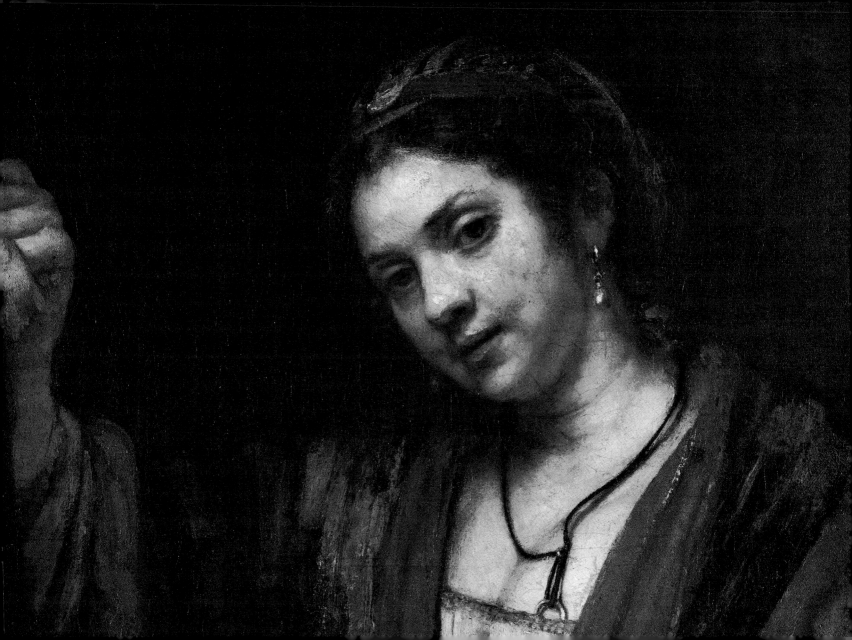

Drawing is like making an expressive gesture with the advantage of permanence.

Henri Matisse

Unmade Bed, *c. 1845*
Adolph von Menzel
Kupferstichkabinett, Staatliche Museen zu Berlin

1 2 3 4 5 6 7 8 9 10 11 **12** 13 14 15 16 17 18 19 20 21 22 23 24 25 26 27 28 29 30 31

JULY

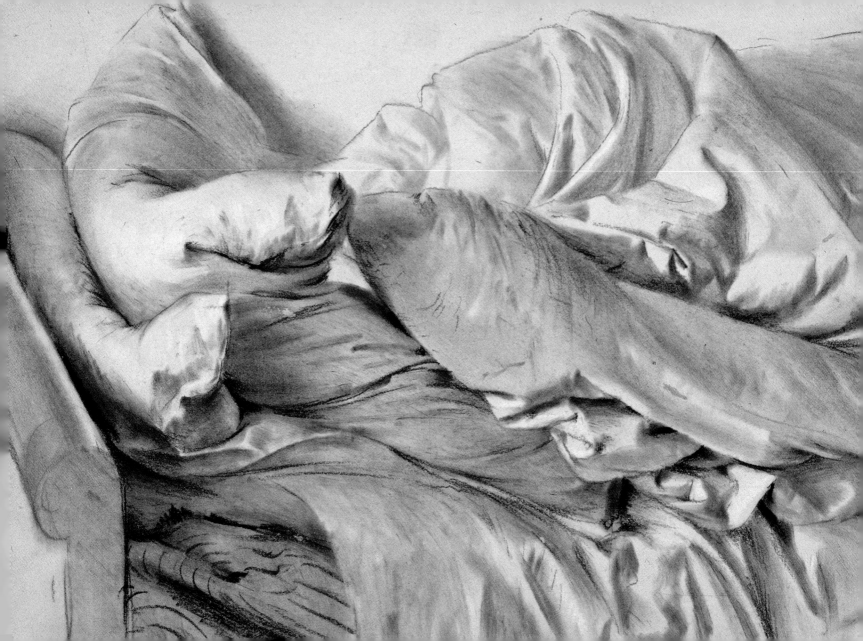

To have faith is to have wings.

J. M. BARRIE

Figurine of a Soul (Ba) Bird, gold, 664–432 B. C.
Abusir el Melque
Ägyptisches Museum und Papyrussammlung, Staatliche Museen zu Berlin

1 2 3 4 5 6 7 8 9 10 11 12 **13** 14 15 16 17 18 19 20 21 22 23 24 25 26 27 28 29 30 31

JULY

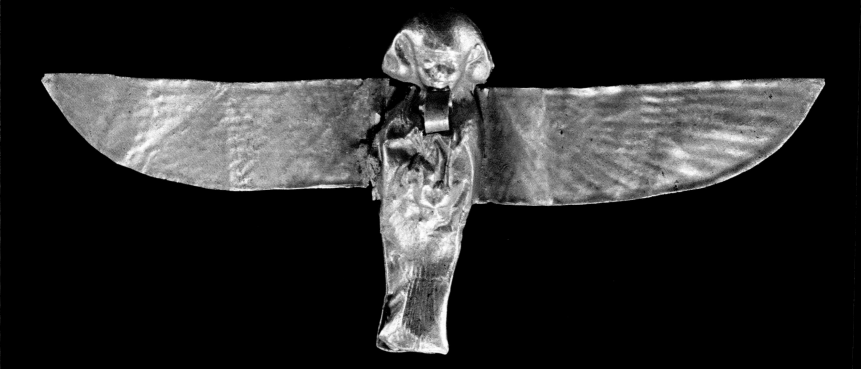

And one of the Pharisees desired him to eat with him. And he went into the house of the Pharisee and sat down to meat.

LUKE 7:36

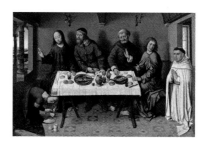

Christ in the House of the Pharisee Simon, *c.* 1460

Dieric Bouts

Gemäldegalerie, Staatliche Museen zu Berlin

1 2 3 4 5 6 7 8 9 10 11 12 13 **14** 15 16 17 18 19 20 21 22 23 24 25 26 27 28 29 30 31

JULY

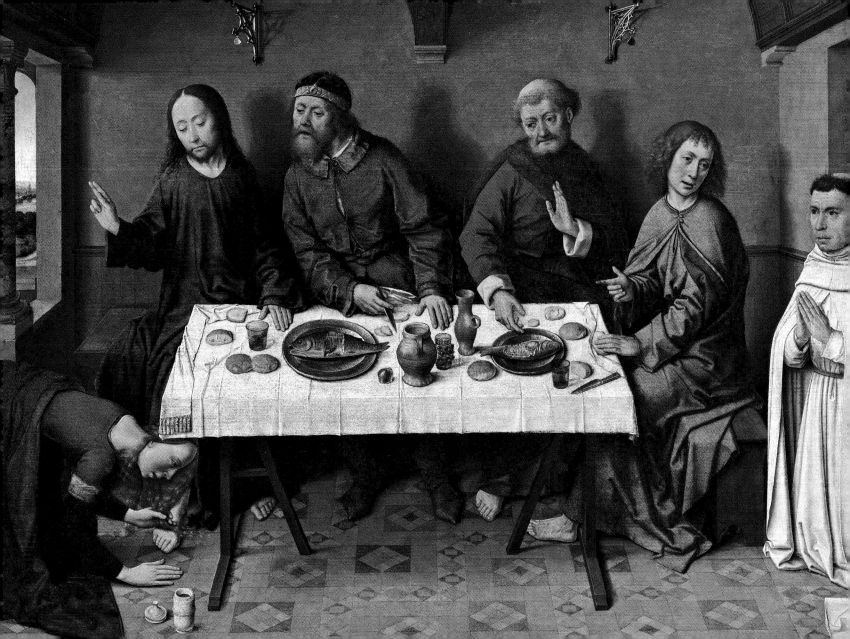

To reach a port we must sail, sometimes with the wind, and sometimes against it. But we must not drift or lie at anchor.

Oliver Wendell Holmes

Fishing Boat Setting Sail, *c.* 1680
published by Pierre Mortier, Amsterdam
Kunstbibliothek, Staatliche Museen zu Berlin

1 2 3 4 5 6 7 8 9 10 11 12 13 14 **15** 16 17 18 19 20 21 22 23 24 25 26 27 28 29 30 31

JULY

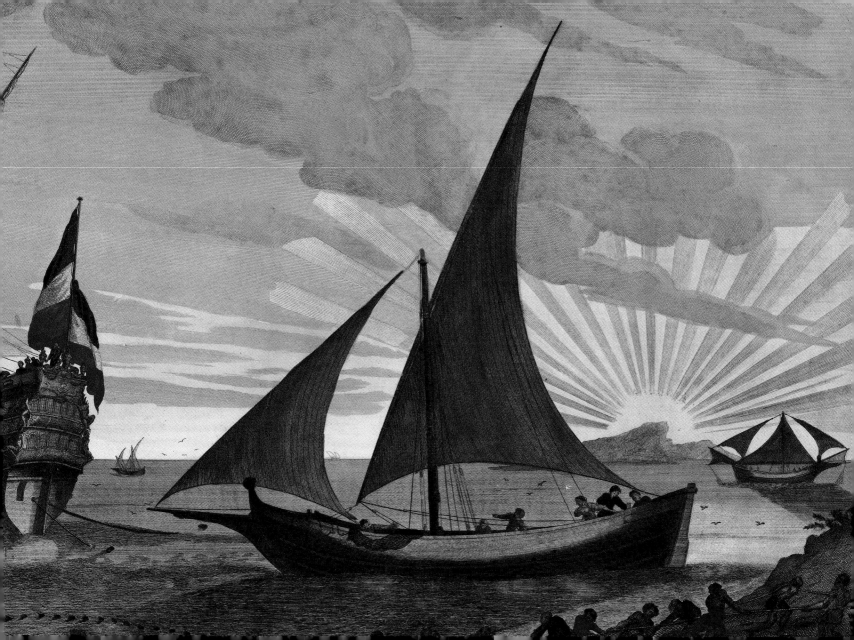

When I speak of home, I speak of
the place—where in default of a better—
those I love are gathered together;
and if that place were a gypsy's tent,
or a barn, I should call it by the same
good name notwithstanding.

CHARLES DICKENS

Encamped Gypsy Family with Children, 1926/27
Otto Mueller
Kupferstichkabinett, Staatliche Museen zu Berlin

1 2 3 4 5 6 7 8 9 10 11 12 13 14 15 **16** 17 18 19 20 21 22 23 24 25 26 27 28 29 30 31

JULY

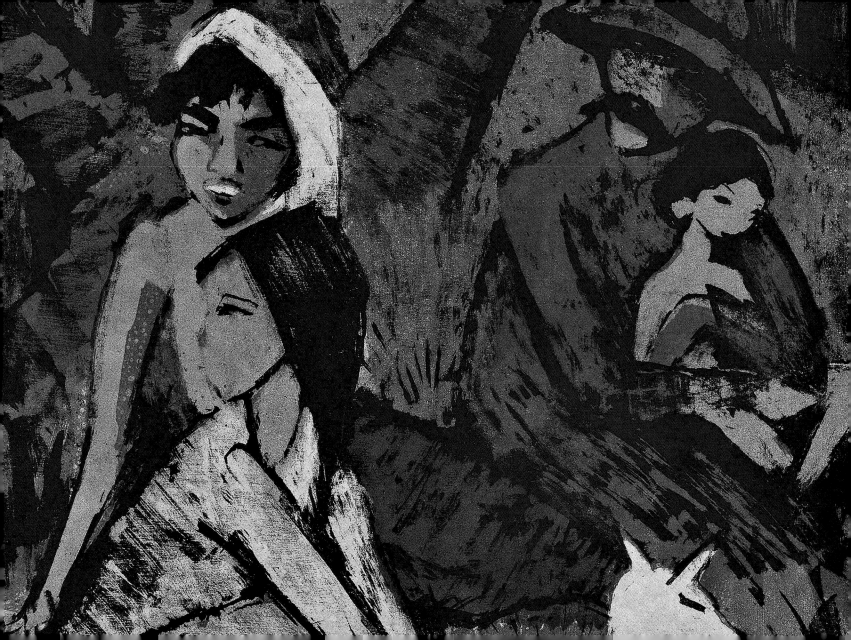

Sonya: I'm not beautiful.
Helen: You have lovely hair.
Sonya: No, when a woman isn't
beautiful, people always say,
'You have lovely eyes,
you have lovely hair.'

ANTON PAVLOVICH CHEKHOV

Head of a princess, 1351–1334 B. C.
Amarna/Egypt
Ägyptisches Museum und Papyrussammlung, Staatliche Museen zu Berlin

1 2 3 4 5 6 7 8 9 10 11 12 13 14 15 16 **17** 18 19 20 21 22 23 24 25 26 27 28 29 30 31

JULY

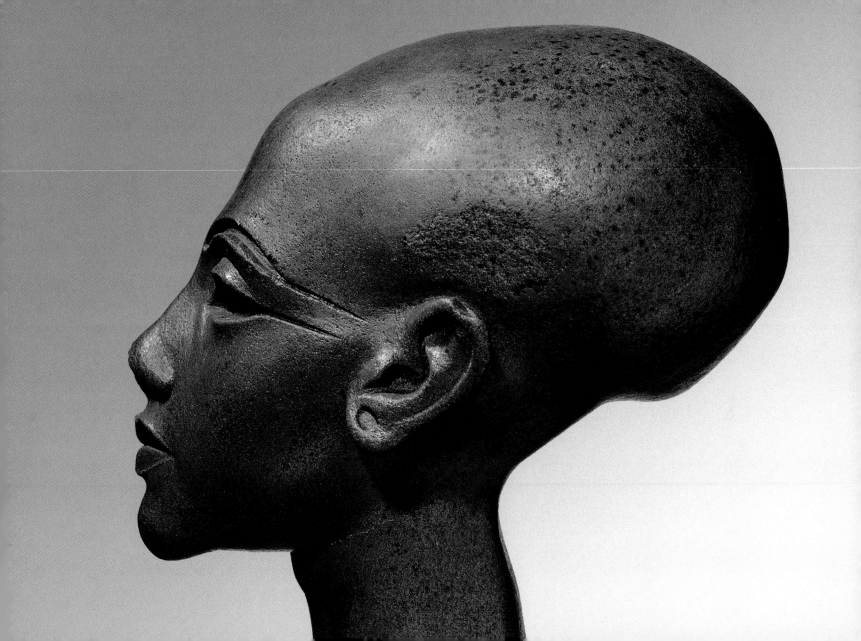

First keep the peace within yourself,
then you can also bring peace to others.

Thomas à Kempis

People from Sao Paolo, mid 19th century
Eduard Hildebrandt
Kupferstichkabinett, Staatliche Museen zu Berlin

1 2 3 4 5 6 7 8 9 10 11 12 13 14 15 16 17 **18** 19 20 21 22 23 24 25 26 27 28 29 30 31

JULY

Rio. 18__

Wonder is the beginning of wisdom.

Altar of Eilbertus, Cologne, *c.* 1150–1160

Eilbertus Master

Kunstgewerbemuseum, Staatliche Museen zu Berlin

1 2 3 4 5 6 7 8 9 10 11 12 13 14 15 16 17 18 **19** 20 21 22 23 24 25 26 27 28 29 30 31

JULY

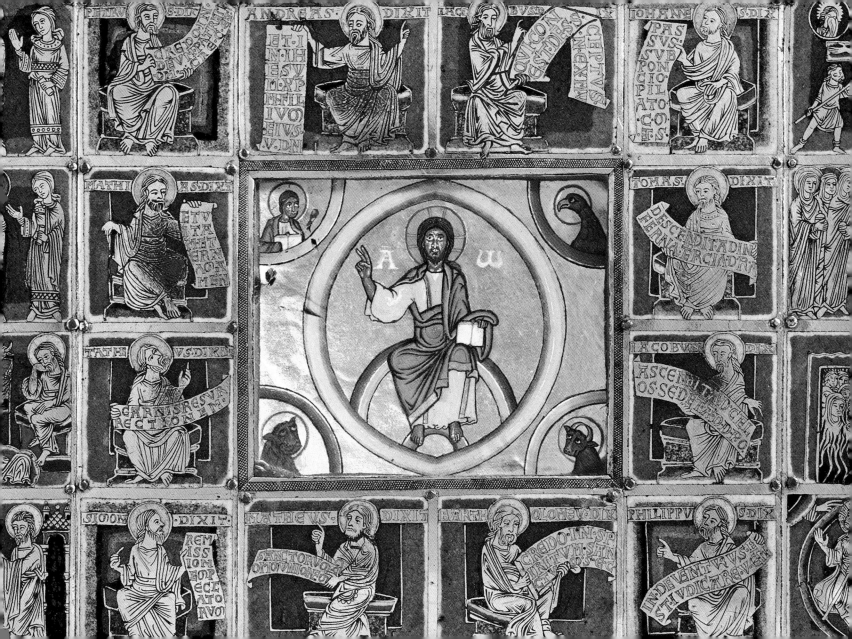

That blessed mood,
In which the burthen of the mystery,
In which the heavy and weary weight
of all this unintelligible world,
Is lightenend.

WILLIAM WORDSWORTH

Solitary Tree (Countryside in the Morning Light)
Caspar David Friedrich
Nationalgalerie, Staatliche Museen zu Berlin

1 2 3 4 5 6 7 8 9 10 11 12 13 14 15 16 17 18 19 **20** 21 22 23 24 25 26 27 28 29 30 31

JULY

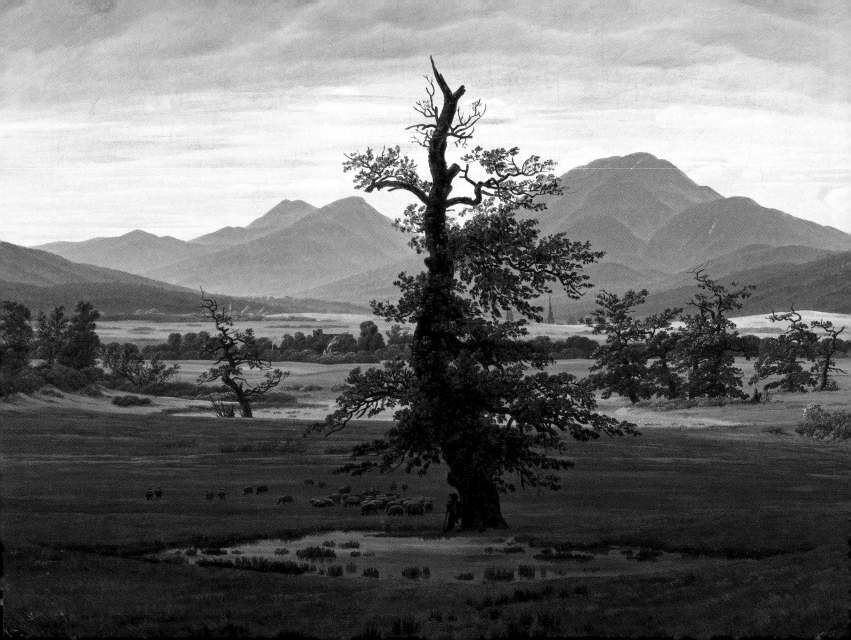

Love all, trust a few,
Do wrong to none.

WILLIAM SHAKESPEARE

Mars and Venus Surprised by Vulcan, *c.* 1548–1550
Paris Paschalinus Bordone
Gemäldegalerie, Staatliche Museen zu Berlin, Loan from the State

1 2 3 4 5 6 7 8 9 10 11 12 13 14 15 16 17 18 19 20 **21** 22 23 24 25 26 27 28 29 30 31

JULY

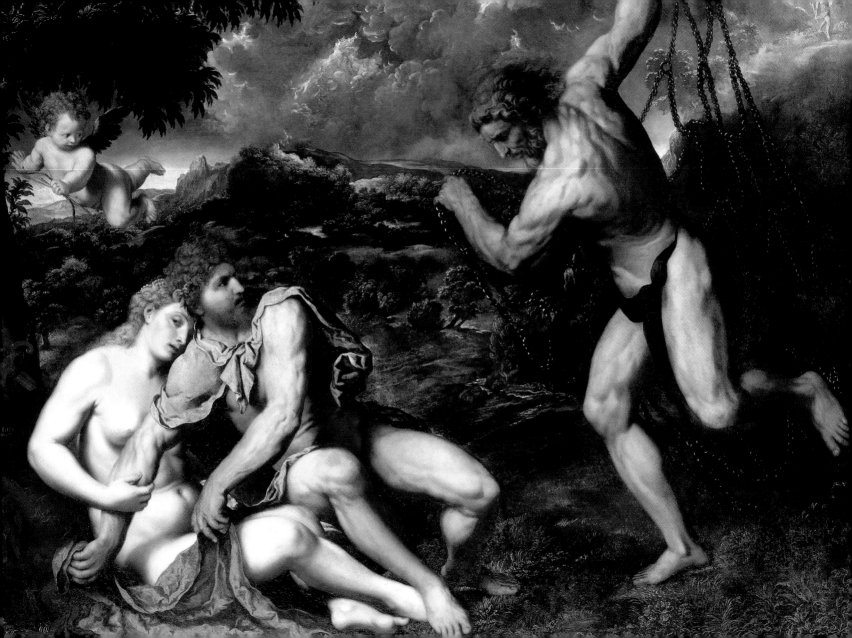

Every child is an artist.
The problem is how to remain
an artist once we grow up.

PABLO PICASSO

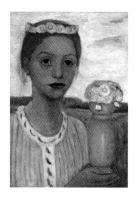

Girl with Flower Wreath, 1902/03
Paula Modersohn-Becker
Nationalgalerie, Staatliche Museen zu Berlin

1 2 3 4 5 6 7 8 9 10 11 12 13 14 15 16 17 18 19 20 21 **22** 23 24 25 26 27 28 29 30 31

JULY

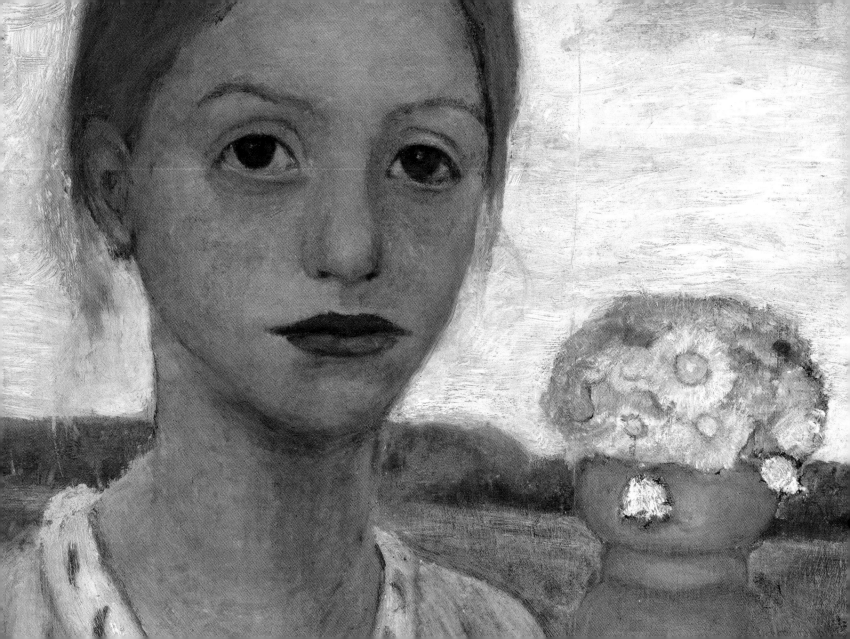

The evening advanced. The shadows lengthened. The waters of the lake grew pitchy black.

WILKIE COLLINS

Walchensee Landscape, 1925
Lovis Corinth
Kupferstichkabinett, Staatliche Museen zu Berlin

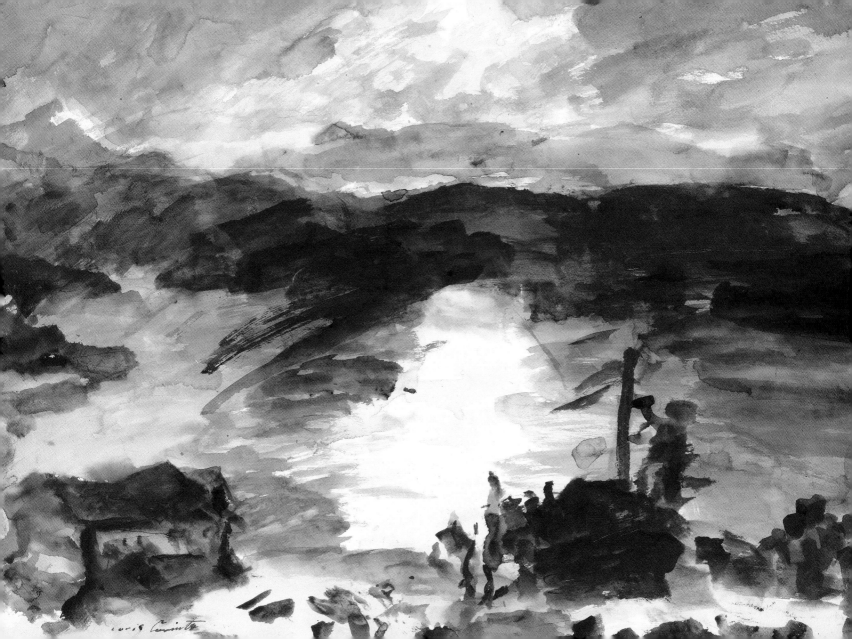

Lovis Corinth

Justice is the constant and perpetual wish to render to every one his due.

Justinian

Judgment of Paris, *c. 1529*
Doman Hering
Skulpturensammlung und Museum für Byzantinische Kunst, Staatliche Museen zu Berlin

1 2 3 4 5 6 7 8 9 10 11 12 13 14 15 16 17 18 19 20 21 22 23 **24** 25 26 27 28 29 30 31

JULY

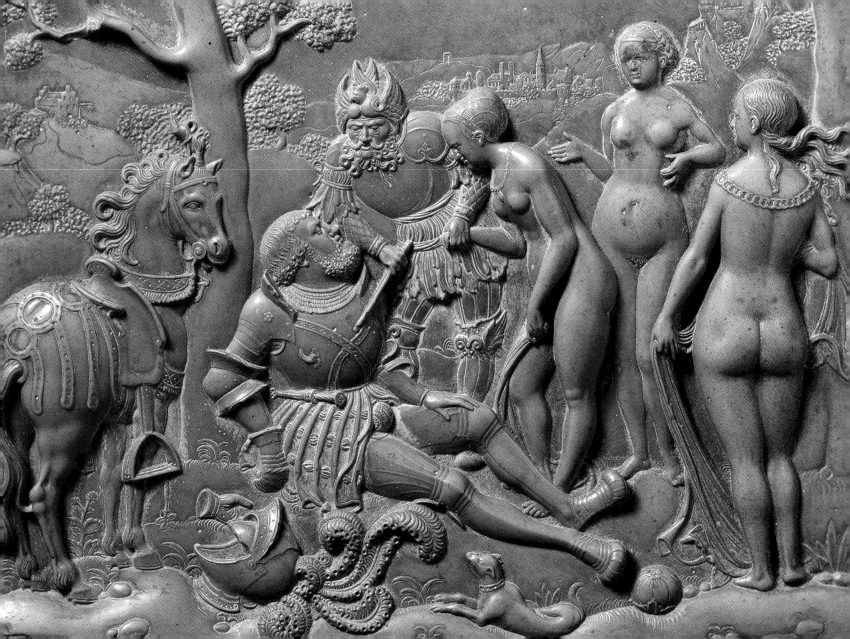

Charm is the quality in others that makes us more satisfied with ourselves.

Henri-Frédéric Amiel

Scaramouche with a Lady, Meissen, 1740/41
Johann Joachim Kändler
Kunstgewerbemuseum, Staatliche Museen zu Berlin

1 2 3 4 5 6 7 8 9 10 11 12 13 14 15 16 17 18 19 20 21 22 23 24 **25** 26 27 28 29 30 31

JULY

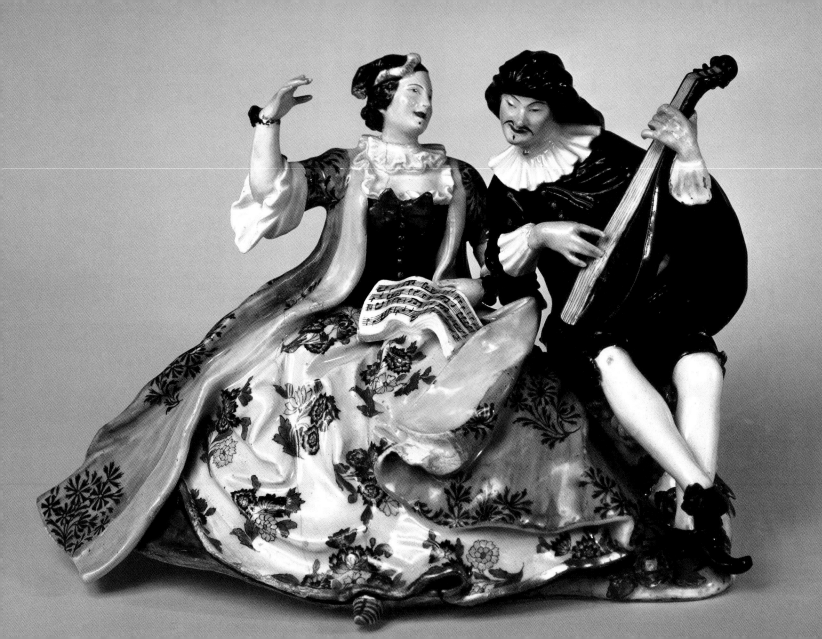

It is better to be born lucky than rich.

Golden ceremonial hat, *c.* 1000 B. C.
Museum für Vor- und Frühgeschichte, Staatliche Museen zu Berlin

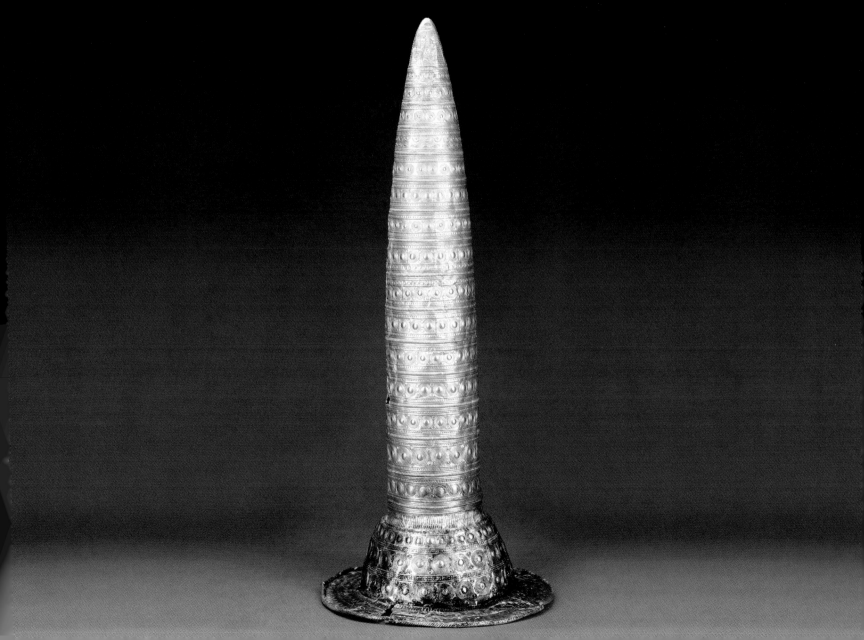

Every animal has ideas, since it has senses; it even combines those ideas to a certain degree; and it is only in degree that man differs, in this respect, from the brute.

JEAN-JACQUES ROUSSEAU

Aquamanile
Benin/Nigeria
Ethnologisches Museum, Staatliche Museen zu Berlin

1 2 3 4 5 6 7 8 9 10 11 12 13 14 15 16 17 18 19 20 21 22 23 24 25 26 **27** 28 29 30 31

JULY

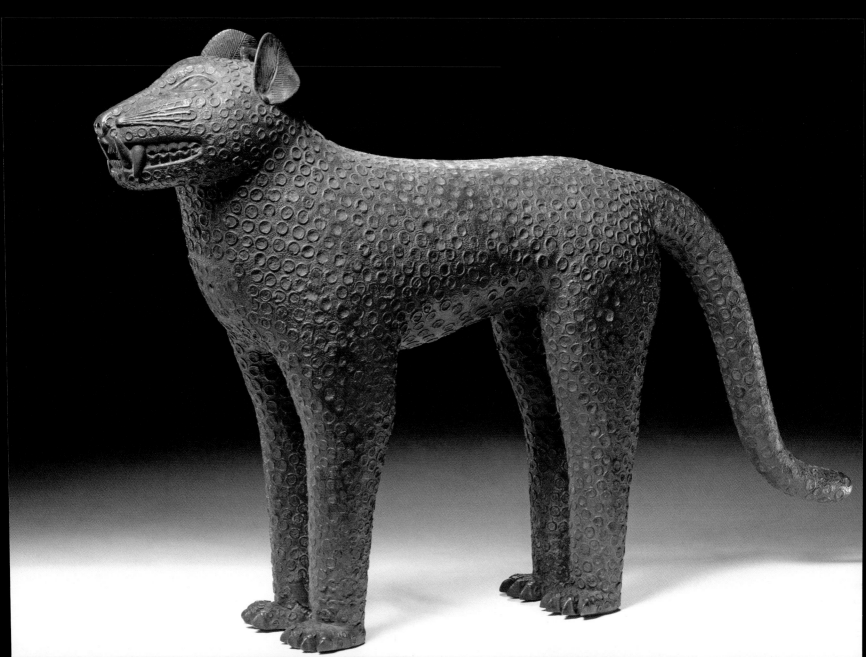

With that, I saw two Swans of goodly hue,
Come softly swimming down along the Lee;
Two fairer Birds I did never see:
The snow which doth the top of Pindus strew,
did never whiter show,
Nor did Jove himself when he a Swan
For love of Leda, whiter did appear.

EDMUND SPENSER

Leda and the Swan, *c.* 1532
Correggio
Gemäldegalerie, Staatliche Museen zu Berlin

1 2 3 4 5 6 7 8 9 10 11 12 13 14 15 16 17 18 19 20 21 22 23 24 25 26 27 28 29 30 31

JULY

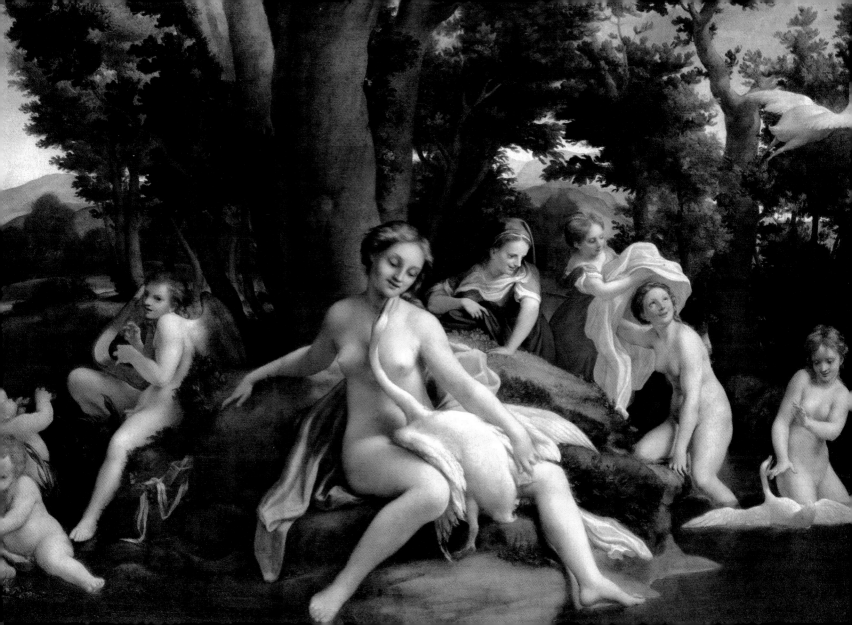

The angel said to her, "Do not be afraid, Mary, for you have found favor with God. And now, you will conceive in your womb and bear a son, and you will name him Jesus. He will be great, and will be called the Son of the Most High, and the Lord God will give to him the throne of his ancestor David. He will reign over the house of Jacob forever, and of his kingdom there will be no end."

LUKE 1:30–33

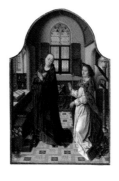

Annunciation, *c.* 1480

Aelbrecht Bouts

Gemäldegalerie, Staatliche Museen zu Berlin

1 2 3 4 5 6 7 8 9 10 11 12 13 14 15 16 17 18 19 20 21 22 23 24 25 26 27 28 **29** 30 31

JULY

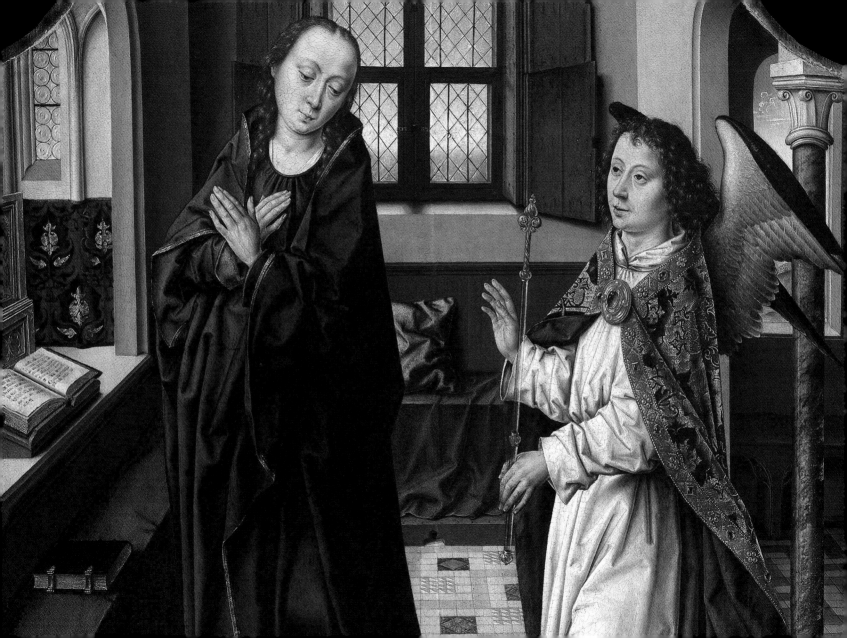

Every man's work, whether it be literature or music or pictures or architecture or anything else, is always a portrait of himself.

SAMUEL BUTLER

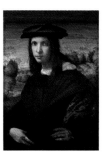

Portrait of a Young Man, early 16th century
Rosso Fiorentino
Gemäldegalerie, Staatliche Museen zu Berlin

1 2 3 4 5 6 7 8 9 10 11 12 13 14 15 16 17 18 19 20 21 22 23 24 25 26 27 28 29 **30** 31

JULY

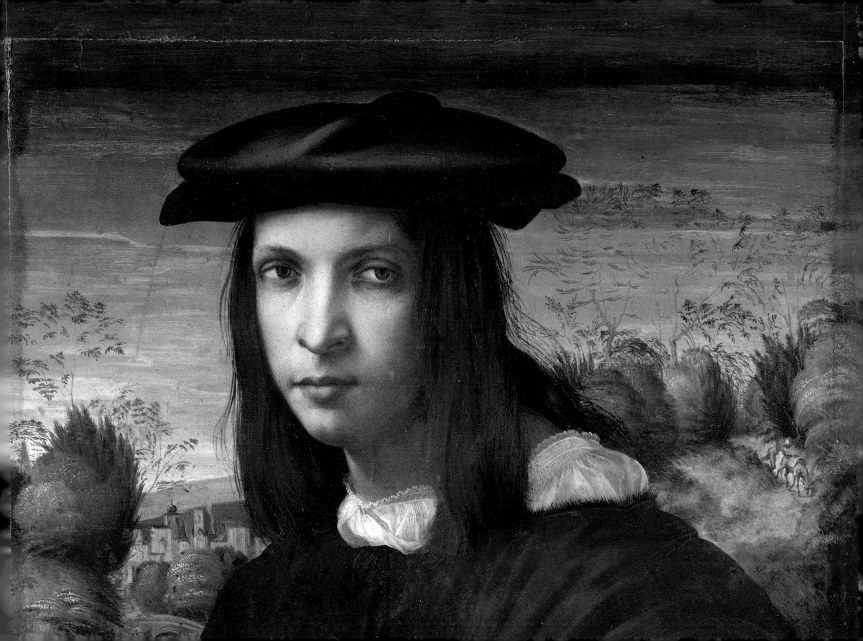

Man is a poetical animal,
and delights in fiction.

<small>WILLIAM HAZLITT</small>

Medieval City on a River, 1815
Karl Friedrich Schinkel
Nationalgalerie, Staatliche Museen zu Berlin

1 2 3 4 5 6 7 8 9 10 11 12 13 14 15 16 17 18 19 20 21 22 23 24 25 26 27 28 29 30 **31**

JULY

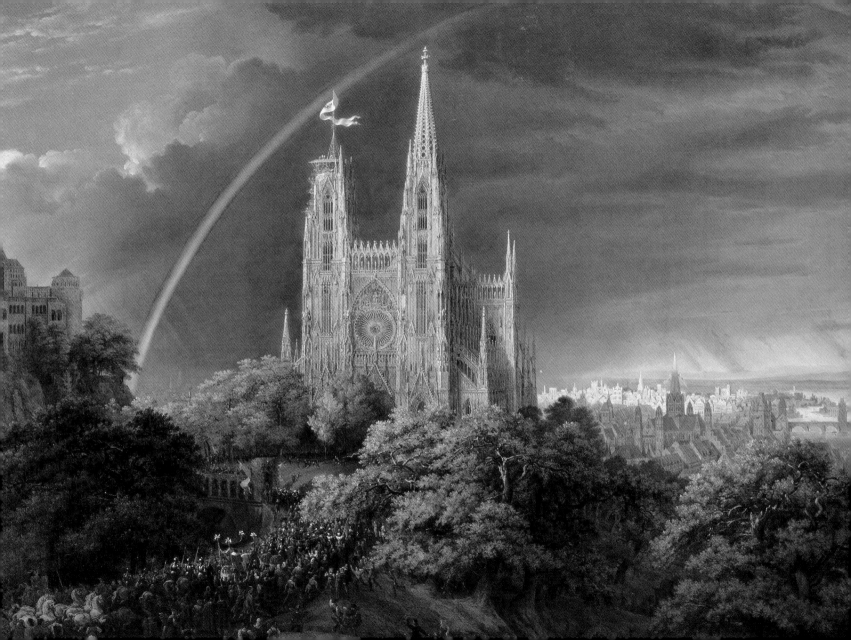

The world's great age begins anew,
The golden years return...

PERCY BYSSHE SHELLEY

Figure of goddess Bastet as a cat, 610–595 B. C.
Egypt
Ägyptisches Museum und Papyrussammlung, Staatliche Museen zu Berlin

1 2 3 4 5 6 7 8 9 10 11 12 13 14 15 16 17 18 19 20 21 22 23 24 25 26 27 28 29 30 31

AUGUST

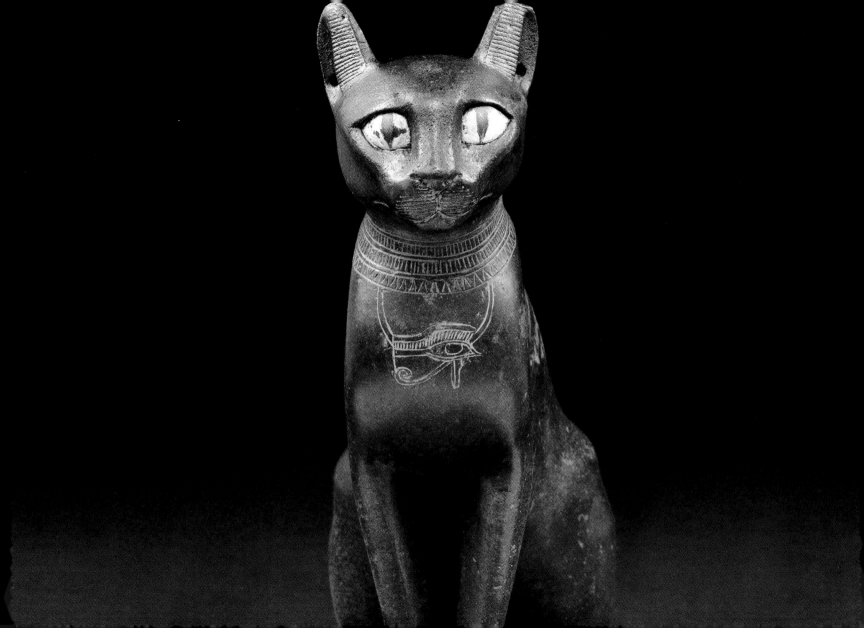

Recommend to your children virtue.
That alone can make them happy.

LUDWIG VAN BEETHOVEN

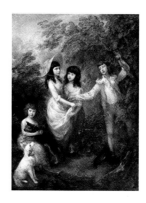

The Marsham Children, 1787
Thomas Gainsborough
Gemäldegalerie, Staatliche Museen zu Berlin

1 **2** 3 4 5 6 7 8 9 10 11 12 13 14 15 16 17 18 19 20 21 22 23 24 25 26 27 28 29 30 31

AUGUST

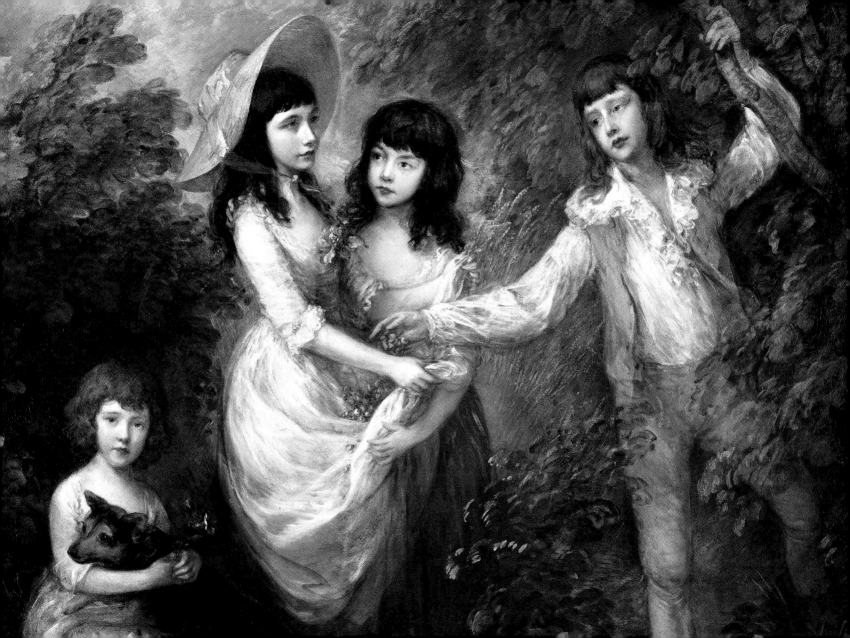

The most important thing for me is the direct observation of nature in its light-filled existence.

AUGUST MACKE

Landscape with Light Tree

August Macke

Kupferstichkabinett, Staatliche Museen zu Berlin

1 2 **3** 4 5 6 7 8 9 10 11 12 13 14 15 16 17 18 19 20 21 22 23 24 25 26 27 28 29 30 31

AUGUST

Your wealth is where your friends are.

Titus Maccius Plautus

The Fight over the Card Game, 17th century

Jan van Steen

Gemäldegalerie, Staatliche Museen zu Berlin

4

1 2 3 5 6 7 8 9 10 11 12 13 14 15 16 17 18 19 20 21 22 23 24 25 26 27 28 29 30 31

AUGUST

We have just enough religion to make us hate, but not enough to make us love one another.

JONATHAN SWIFT

The Difference Between the True Religion of Christ, and the False Idolatrous Teaching of the Antichrist, 16th century

Lucas Cranach the Younger

Kupferstichkabinett, Staatliche Museen zu Berlin

1 2 3 4 **5** 6 7 8 9 10 11 12 13 14 15 16 17 18 19 20 21 22 23 24 25 26 27 28 29 30 31

AUGUST

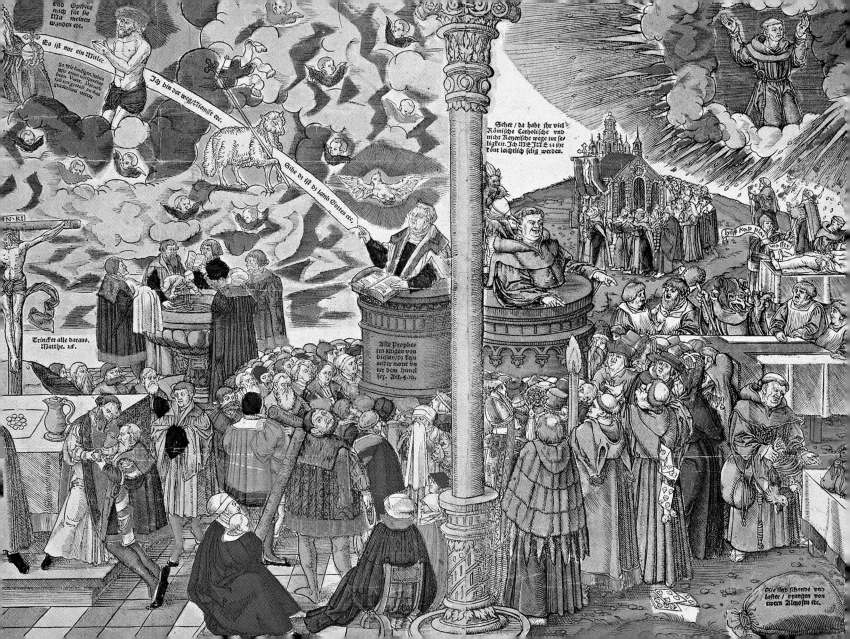

No human being, however great or powerful, was ever as free as a fish.

JOHN RUSKIN

Animal figure, 19th century

New Ireland, Melanesia

Ethnologisches Museum, Staatliche Museen zu Berlin

1 2 3 4 5 **6** 7 8 9 10 11 12 13 14 15 16 17 18 19 20 21 22 23 24 25 26 27 28 29 30 31

AUGUST

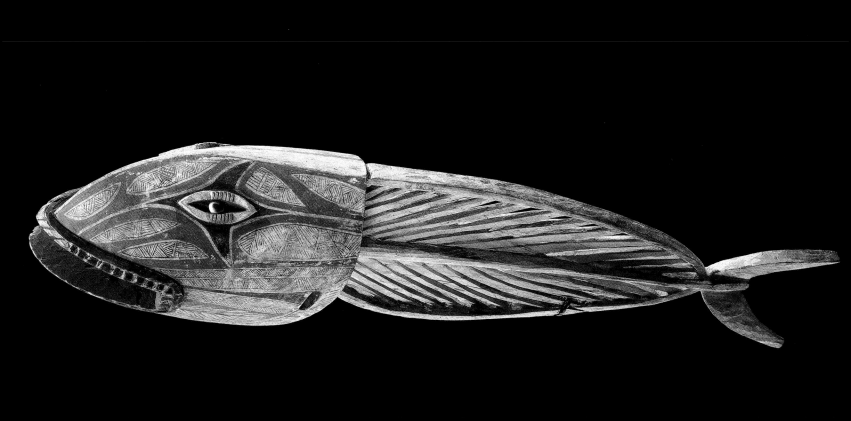

A man had given all other bliss,
And all his worldly worth for this,
To waste his whole heart in one kiss
Upon her perfect lips.

LORD ALFRED TENNYSON

Without Hesitation – Le rouge baiser, advertisement, *c.* 1957
Kunstbibliothek, Staatliche Museen zu Berlin

1 2 3 4 5 6 **7** 8 9 10 11 12 13 14 15 16 17 18 19 20 21 22 23 24 25 26 27 28 29 30 31

AUGUST

For whatever we lose (like a you or a me),
It's always our self we find in the sea.

E. E. CUMMINGS

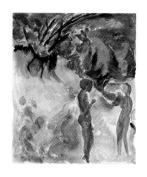

Two Nudes by the Sea, 1921
Erich Heckel
Kupferstichkabinett, Staatliche Museen zu Berlin

1 2 3 4 5 6 7 **8** 9 10 11 12 13 14 15 16 17 18 19 20 21 22 23 24 25 26 27 28 29 30 31

AUGUST

Who owns this landscape?
The millionaire who bought it
or the poacher staggering
downhill in the early morning
with a deer on his back?

NORMAN MCCAIG

Vétheuil sur Seine, 1880
Claude Monet
Nationalgalerie, Staatliche Museen zu Berlin

1 2 3 4 5 6 7 8 **9** 10 11 12 13 14 15 16 17 18 19 20 21 22 23 24 25 26 27 28 29 30 31

AUGUST

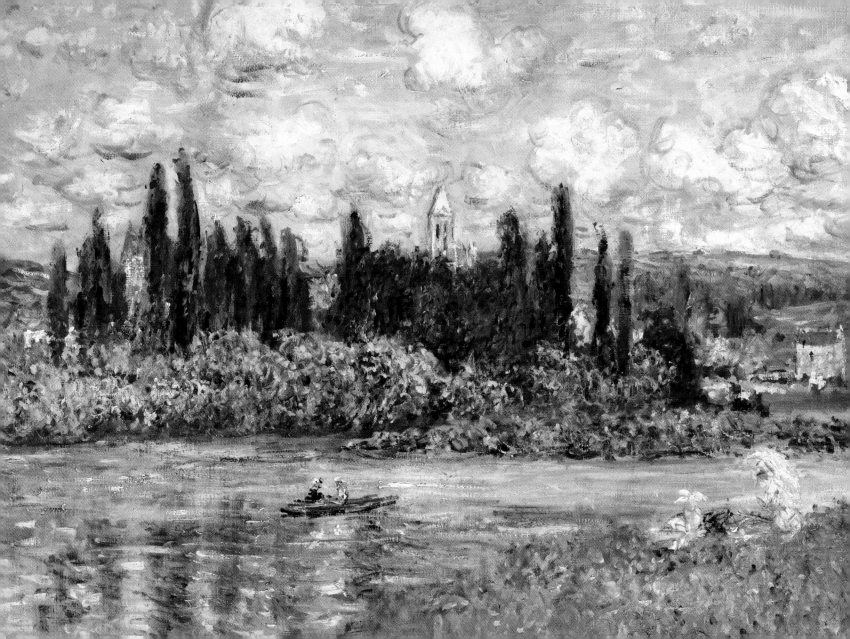

The innermost meaning of sacrifice is the annihilation of the finite just because it is finite.

Friedrich von Schlegel

Model of a sacrifice procession, wood, 1976–1794 B. C.
Egypt
Ägyptisches Museum und Papyrussammlung, Staatliche Museen zu Berlin

1 2 3 4 5 6 7 8 9 **10** 11 12 13 14 15 16 17 18 19 20 21 22 23 24 25 26 27 28 29 30 31

AUGUST

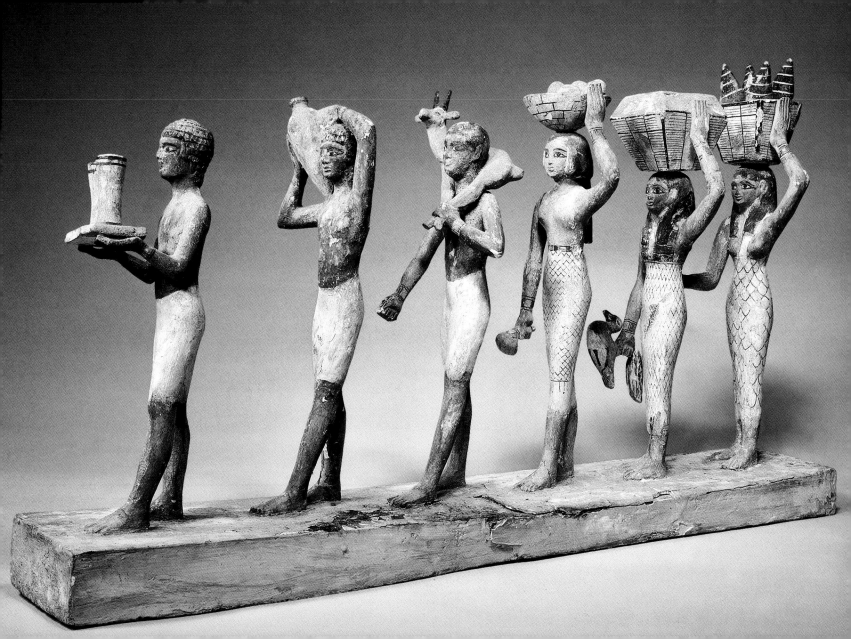

You may have tangible wealth untold;
Caskets of jewels and coffers of gold.
Richer than I you can never be,
I had a mother who read to me.

GILLIAN STRICKLAND

Woman with Child and Picture Book, early 17th century
Jacques de Gheyn
Kupferstichkabinett, Staatliche Museen zu Berlin

1 2 3 4 5 6 7 8 9 10 **11** 12 13 14 15 16 17 18 19 20 21 22 23 24 25 26 27 28 29 30 31

AUGUST

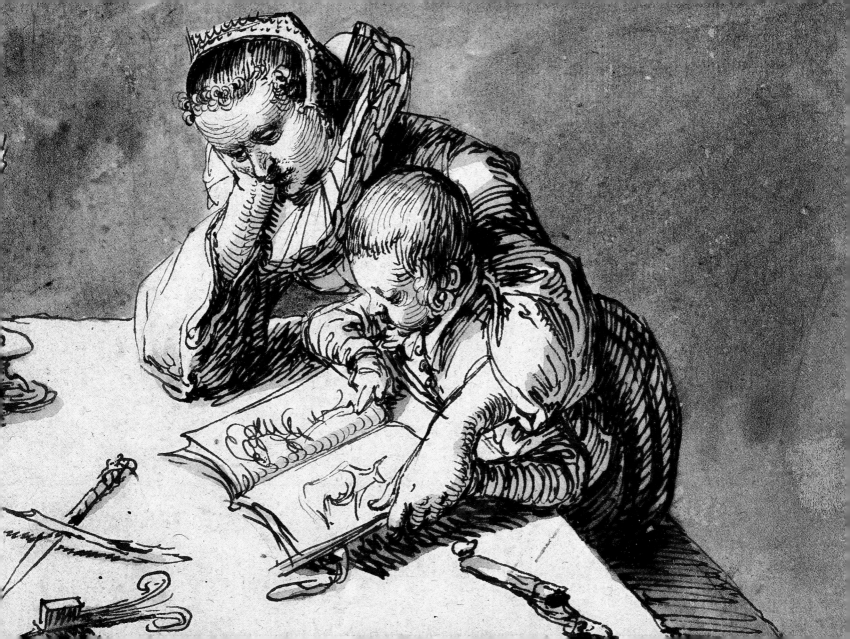

Then Mary said, "Here am I, the servant of the Lord; let it be with me according to your word." Then the angel departed from her.

LUKE 1:38

The Annunciation, early 16ᵗʰ century
Lucca School
Gemäldegalerie, Staatliche Museen zu Berlin

1 2 3 4 5 6 7 8 9 10 11 **12** 13 14 15 16 17 18 19 20 21 22 23 24 25 26 27 28 29 30 31

AUGUST

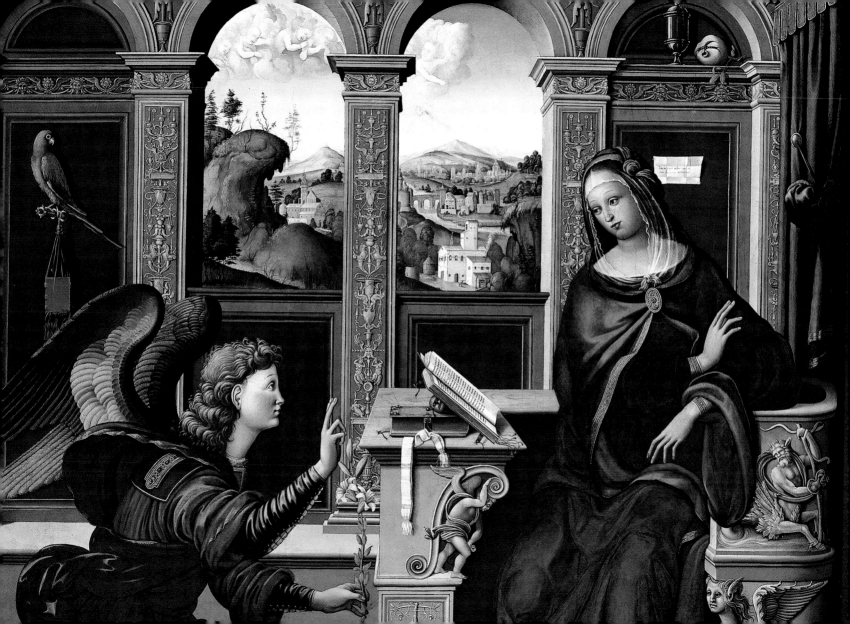

The wonderful purity of nature
at this season is a most pleasing fact…
In the bare fields and tinkling woods,
see what virtue survives.

Henry David Thoreau

The Farm
Adrian de Velde
Gemäldegalerie, Staatliche Museen zu Berlin

1 2 3 4 5 6 7 8 9 10 11 12 **13** 14 15 16 17 18 19 20 21 22 23 24 25 26 27 28 29 30 31

AUGUST

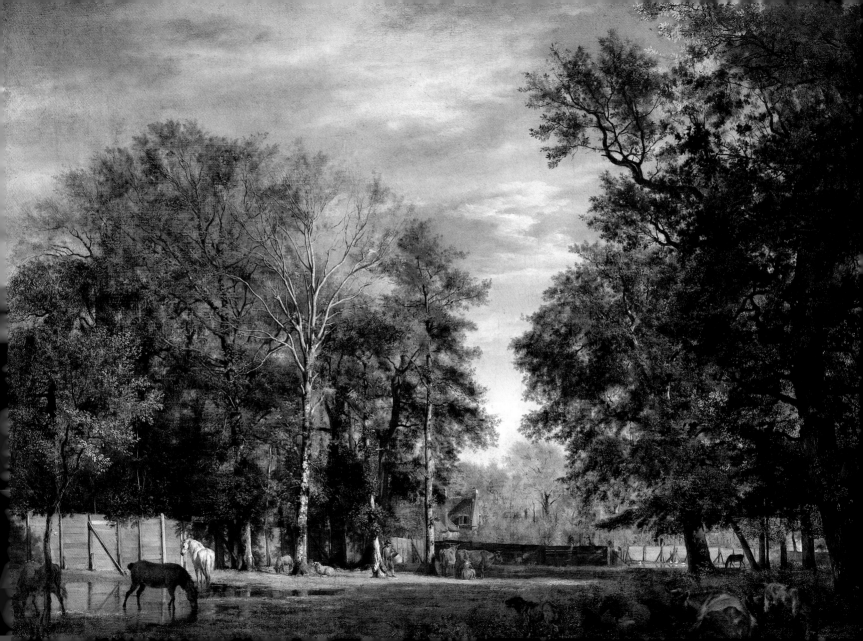

*Why shouldn't art be pretty?
There are enough unpleasant things
in the world.*

PIERRE-AUGUSTE RENOIR

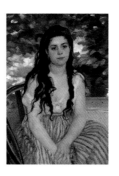

In Summer, 1868
Pierre-Auguste Renoir
Nationalgalerie, Staatliche Museen zu Berlin

1 2 3 4 5 6 7 8 9 10 11 12 13 **14** 15 16 17 18 19 20 21 22 23 24 25 26 27 28 29 30 31

AUGUST

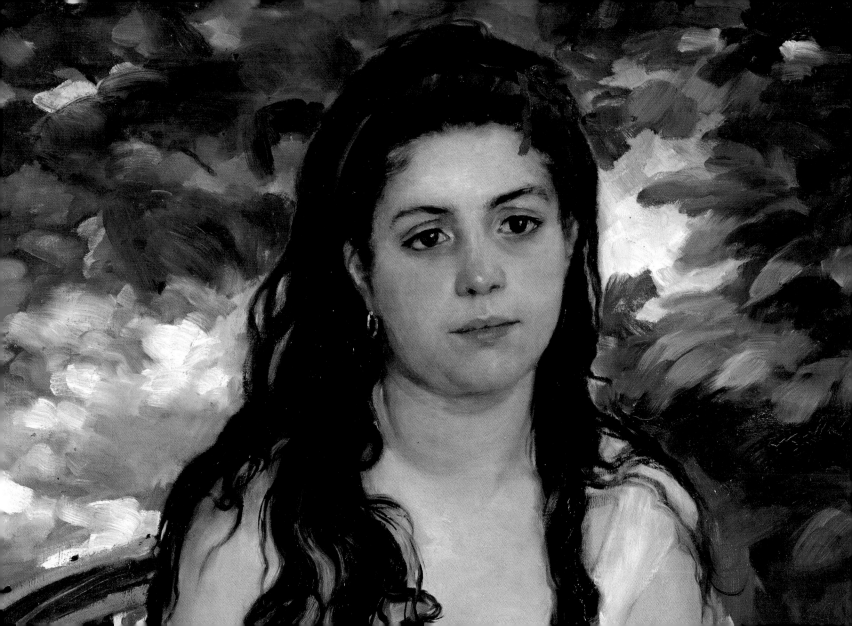

How do you know antiquity was foolish?
How do you know the present is wise?
Who made it foolish?
Who made it wise?

Fʀᴀɴçᴏɪs Rᴀʙᴇʟᴀɪs

Nereid riding on a marine animal, gold coin's reverse,
first half of the 3rd century A. D.
Macedonia
Münzkabinett, Staatliche Museen zu Berlin

1 2 3 4 5 6 7 8 9 10 11 12 13 14 **15** 16 17 18 19 20 21 22 23 24 25 26 27 28 29 30 31

AUGUST

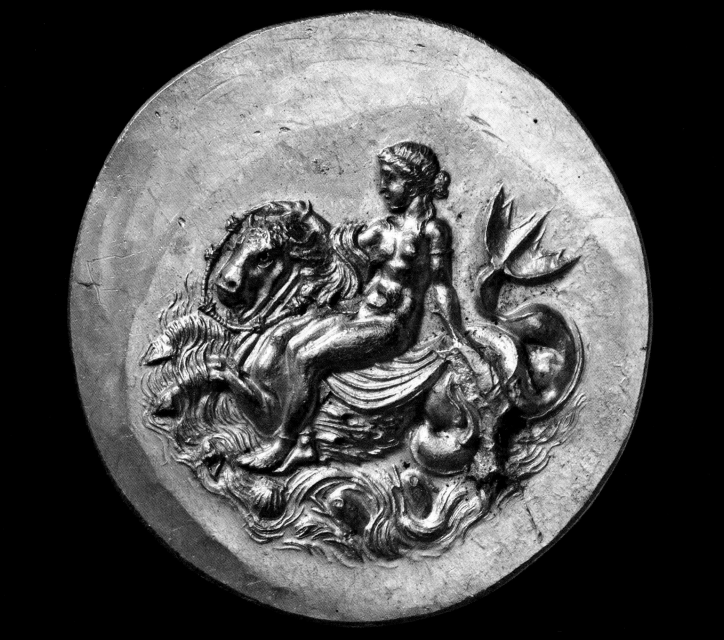

All true artists, whether they know it or not, create from a place of no-mind, from inner stillness.

Ernst Ludwig Kirchner

Bathers on the Beach, 1913
Ernst Ludwig Kirchner
Nationalgalerie, Staatliche Museen zu Berlin

1 2 3 4 5 6 7 8 9 10 11 12 13 14 15 **16** 17 18 19 20 21 22 23 24 25 26 27 28 29 30 31

AUGUST

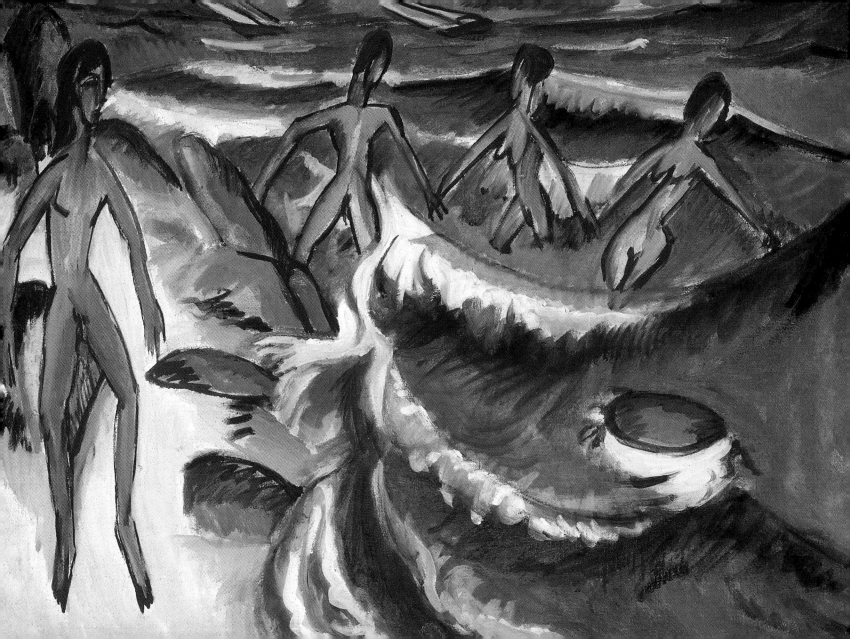

Now it is autumn and the falling fruit
And the long journey towards oblivion…
Have you built your ship of death,
O have you? O build your ship of death,
for you will need it.

D. H. LAWRENCE

Burial chamber of Merib, 2639–2504 B. C.
Giza/Egypt
Ägyptisches Museum und Papyrussammlung, Staatliche Museen zu Berlin

1 2 3 4 5 6 7 8 9 10 11 12 13 14 15 16 **17** 18 19 20 21 22 23 24 25 26 27 28 29 30 31

AUGUST

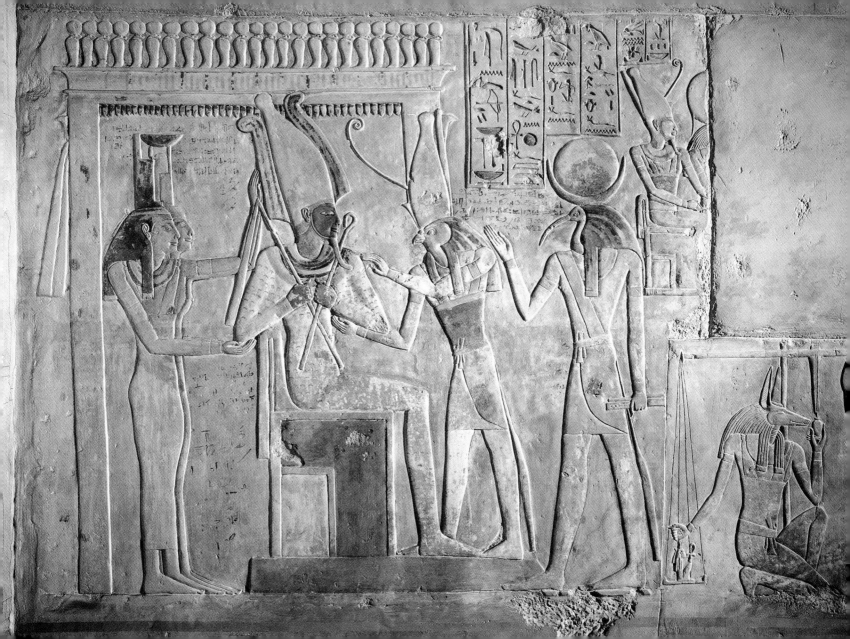

Imagination, which, in truth,
Is but another name for absolute power
And clearest insight, amplitude of mind,
And reason in her most exalted mood.

WILLIAM WORDSWORTH

Rowers, 1873
Hans von Marées
Nationalgalerie, Staatliche Museen zu Berlin

1 2 3 4 5 6 7 8 9 10 11 12 13 14 15 16 17 **18** 19 20 21 22 23 24 25 26 27 28 29 30 31

AUGUST

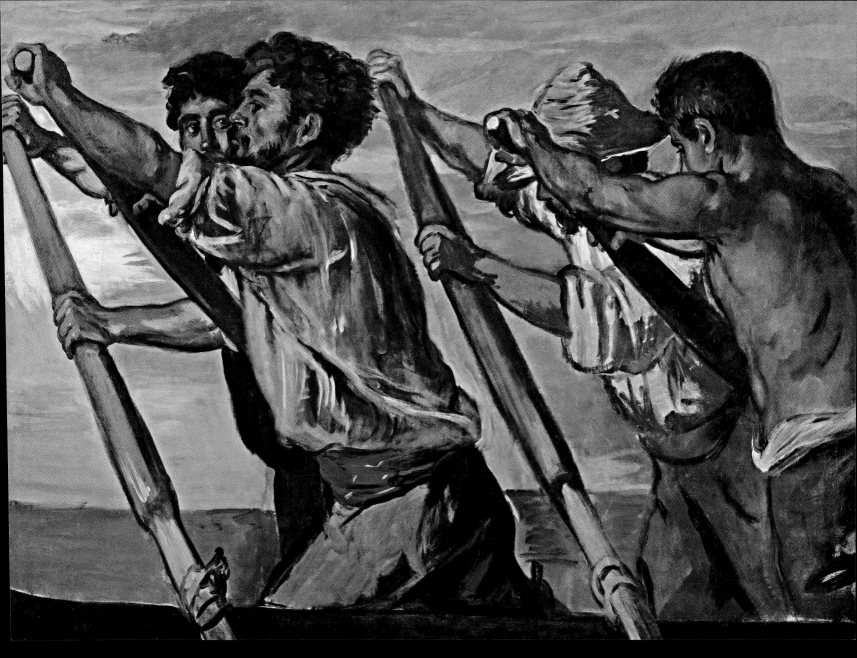

White phantom city, whose untrodden streets
Are rivers, and whose pavements are the shifting
Shadows of palaces and strips of sky.

HENRY WADSWORTH LONGFELLOW

Santa Maria della Salute in Venice as seen from Canal Grande,
before 1730

Canaletto (Giovanni Antonio Canal)
Gemäldegalerie, Staatliche Museen zu Berlin

1 2 3 4 5 6 7 8 9 10 11 12 13 14 15 16 17 18 **19** 20 21 22 23 24 25 26 27 28 29 30 31

AUGUST

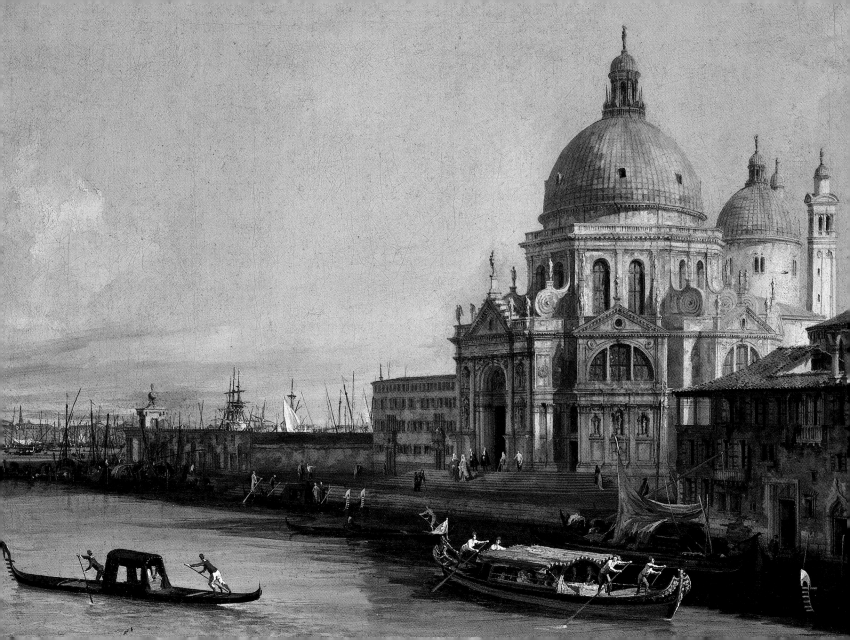

When you start with a portrait and search for a pure form, a clear volume, through successive eliminations, you arrive inevitably at the egg. Likewise, starting with the egg and following the same process in reverse, one finishes with the portrait.

PABLO PICASSO

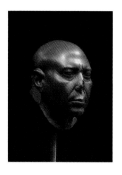

Berlin Green Head, *c.* 522–486 B. C.
Egypt
Ägyptisches Museum und Papyrussammlung, Staatliche Museen zu Berlin

1 2 3 4 5 6 7 8 9 10 11 12 13 14 15 16 17 18 19 **20** 21 22 23 24 25 26 27 28 29 30 31

AUGUST

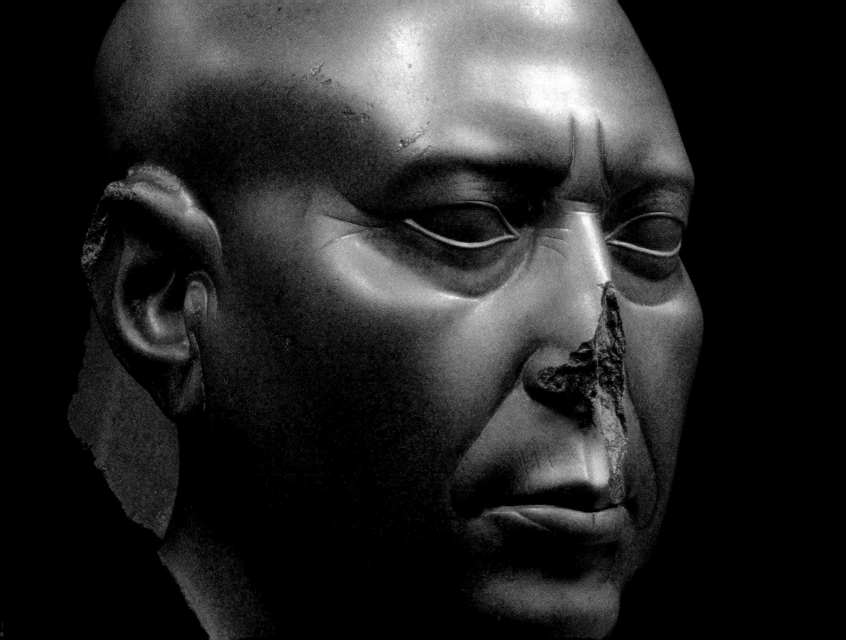

It is closing time in the gardens of the West and from now on an artist will be judged only by the resonance of his solitude or the quality of his despair.

CYRIL CONNOLLY

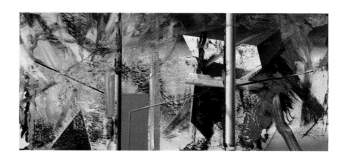

Studio, 1985
Gerhard Richter
Nationalgalerie im Hamburger Bahnhof, Staatliche Museen zu Berlin

1 2 3 4 5 6 7 8 9 10 11 12 13 14 15 16 17 18 19 20 21 22 23 24 25 26 27 28 29 30 31

AUGUST

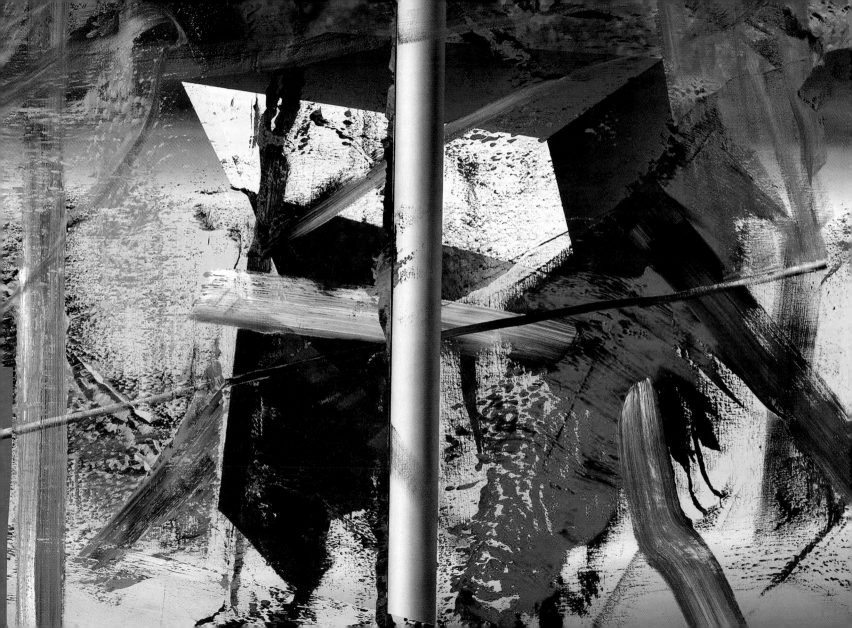

And when the time came for their purification according to the Law of Moses, they brought him up to Jerusalem to present him to the Lord.

LUKE 22:2

The Presentation of Christ at the Temple, *c.* 1465/66
Andrea Mantegna
Gemäldegalerie, Staatliche Museen zu Berlin

1 2 3 4 5 6 7 8 9 10 11 12 13 14 15 16 17 18 19 20 21 **22** 23 24 25 26 27 28 29 30 31

AUGUST

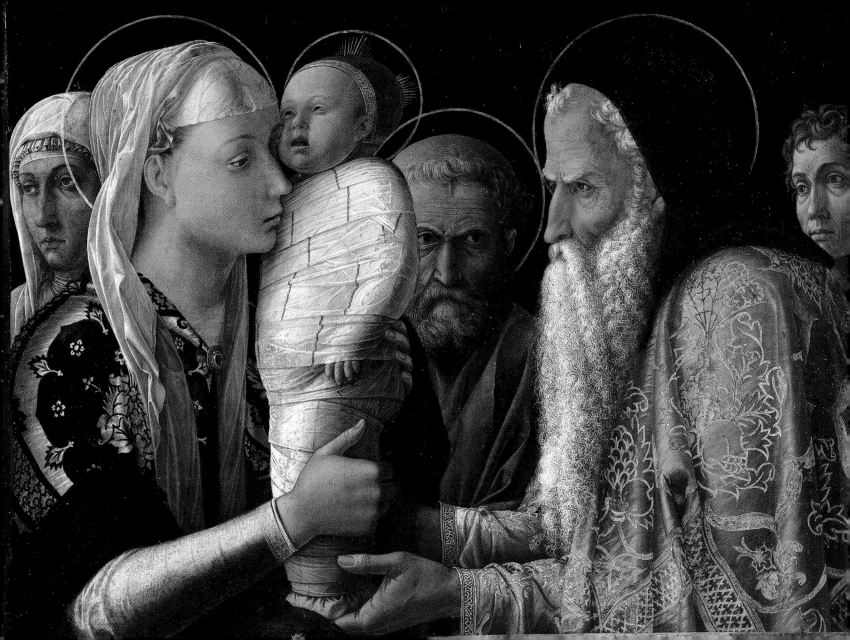

They that go down to the sea in ships,
that do business in great waters,
these see the works of the Lord and his
wonders in the deep.

PSALMS 107:23–34

Choppy Sea with Ships, 1664
Ludolf Backhuysen
Gemäldegalerie, Staatliche Museen zu Berlin

1 2 3 4 5 6 7 8 9 10 11 12 13 14 15 16 17 18 19 20 21 22 **23** 24 25 26 27 28 29 30 31

AUGUST

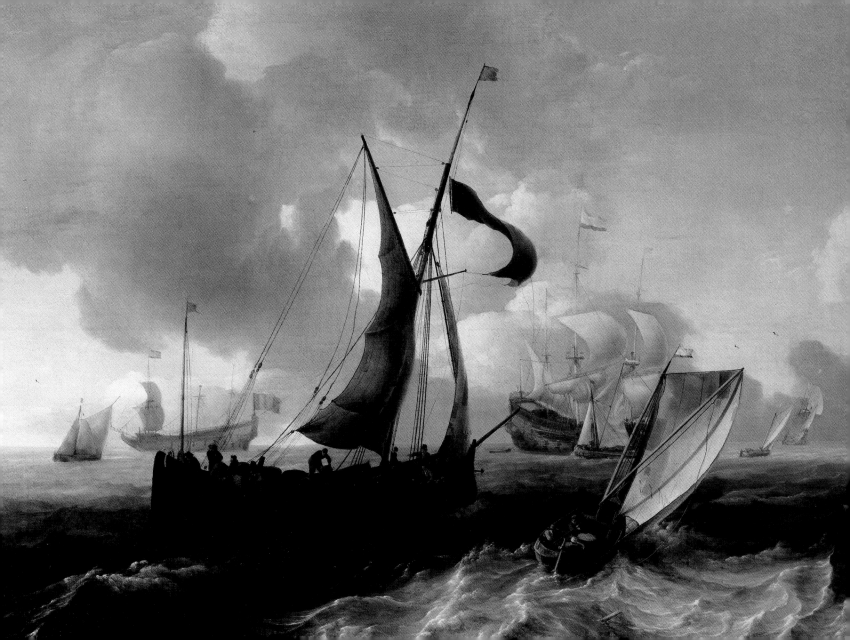

*A little learning is a dangerous thing;
Drink deep, or taste not the Pierian
spring.*

ALEXANDER POPE

**Attic drinking dish: a Scythian tests his spear,
Dokimasia Painter,** beginning of the 5th century B. C.
Orvieto
Antikensammlung, Staatliche Museen zu Berlin

1 2 3 4 5 6 7 8 9 10 11 12 13 14 15 16 17 18 19 20 21 22 23 **24** 25 26 27 28 29 30 31

AUGUST

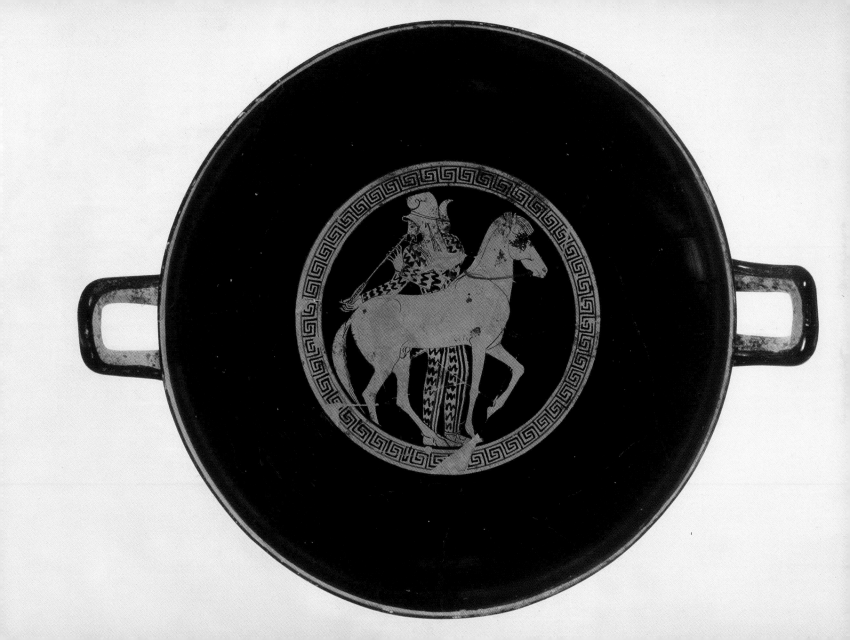

...woman was made first for her own happiness, with the absolute right to herself...

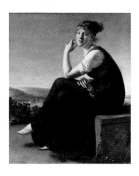

Portrait of Heike Dannecker, 1802

Gottlieb Schick

Nationalgalerie, Staatliche Museen zu Berlin

1 2 3 4 5 6 7 8 9 10 11 12 13 14 15 16 17 18 19 20 21 22 23 24 **25** 26 27 28 29 30 31

AUGUST

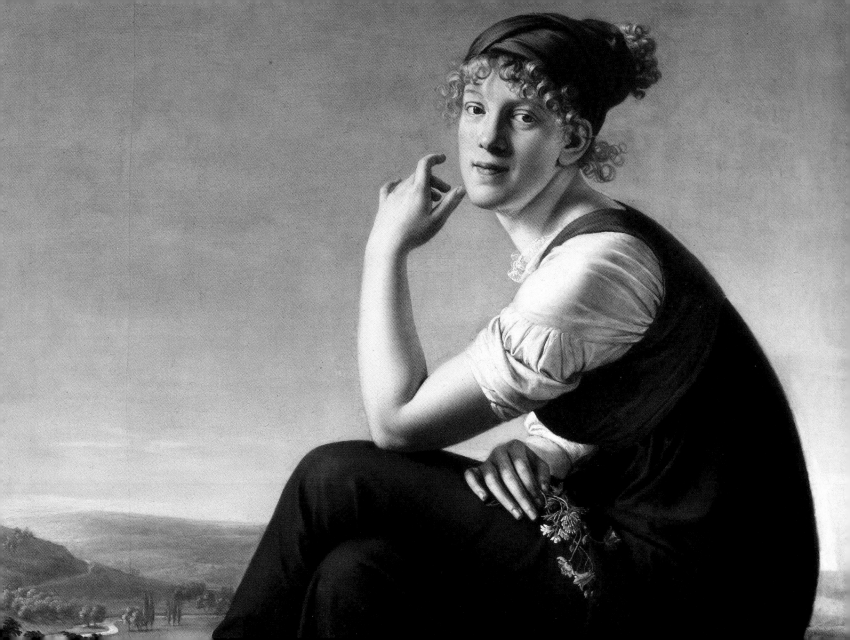

You will not find poetry anywhere unless you bring some of it with you.

The Poor Poet, 1839
Carl Spitzweg
Nationalgalerie, Staatliche Museen zu Berlin (stolen)

1 2 3 4 5 6 7 8 9 10 11 12 13 14 15 16 17 18 19 20 21 22 23 24 25 **26** 27 28 29 30 31

AUGUST

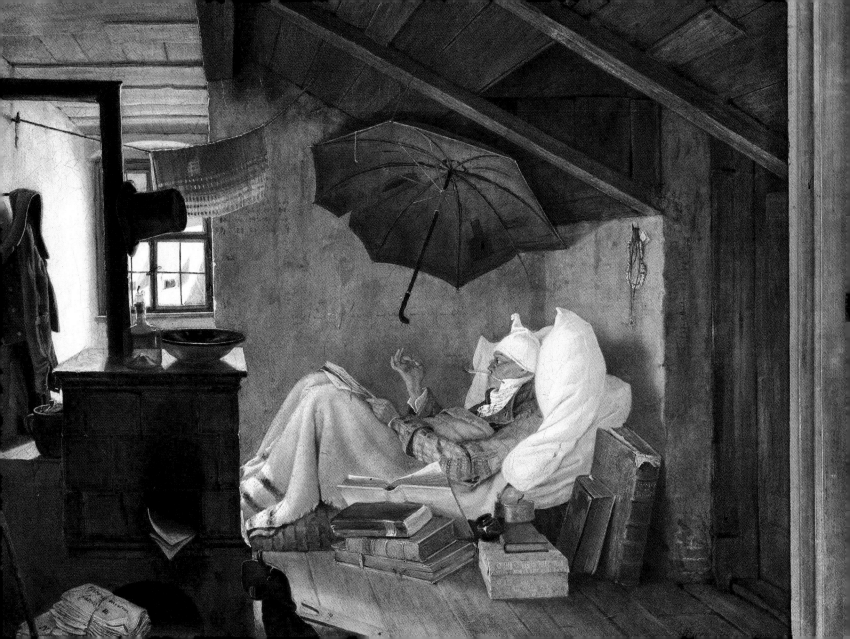

Courtship consists in a number of quiet attentions, no so pointed as to alarm, nor so vague as not to be understood.

<small>LAURENCE STERNE</small>

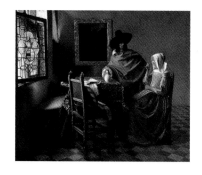

The Glass of Wine, 1661/62

Jan Vermeer van Delft
Gemäldegalerie, Staatliche Museen zu Berlin

1 2 3 4 5 6 7 8 9 10 11 12 13 14 15 16 17 18 19 20 21 22 23 24 25 26 **27** 28 29 30 31

AUGUST

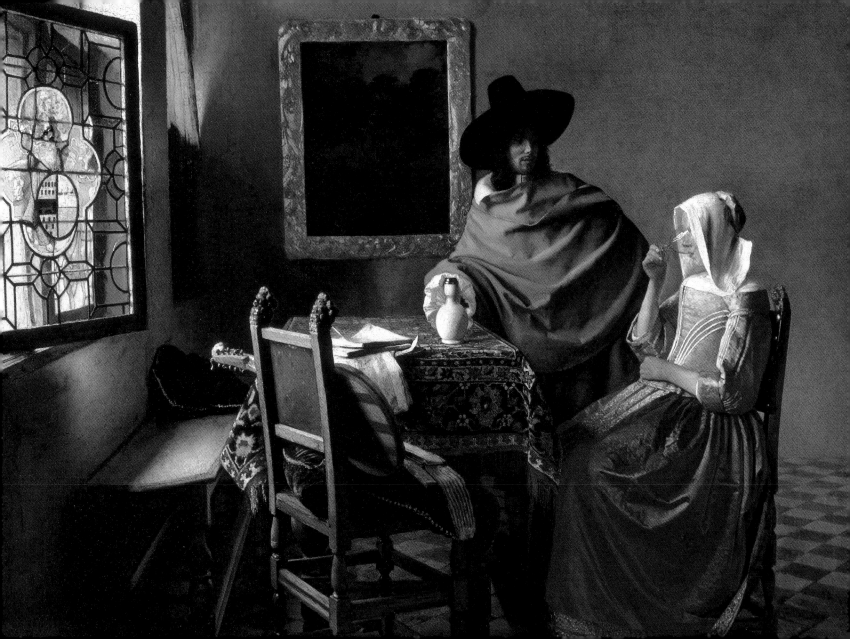

My paintings are allegories not portraits.

ERNST LUDWIG KIRCHNER

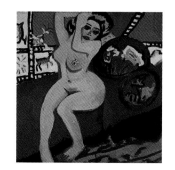

Nude in Studio (Norilein), *c.* 1909–1911
Ernst Ludwig Kirchner
Nationalgalerie, Staatliche Museen zu Berlin

1 2 3 4 5 6 7 8 9 10 11 12 13 14 15 16 17 18 19 20 21 22 23 24 25 26 27 **28** 29 30 31

AUGUST

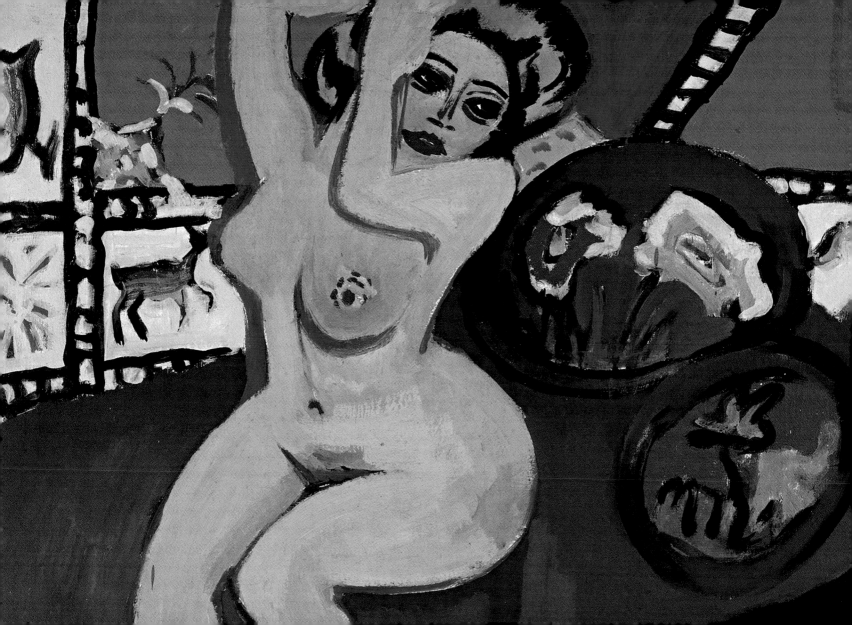

Then Jacob gave Esau some bread and some lentil stew. He ate and drank, and then got up and left. So Esau despised his birthright.

GENESIS 25:34

Esau Sells His Birthright, early 17th century
Hendrick ter Brugghen
Gemäldegalerie, Staatliche Museen zu Berlin

1 2 3 4 5 6 7 8 9 10 11 12 13 14 15 16 17 18 19 20 21 22 23 24 25 26 27 28 29 30 31

AUGUST

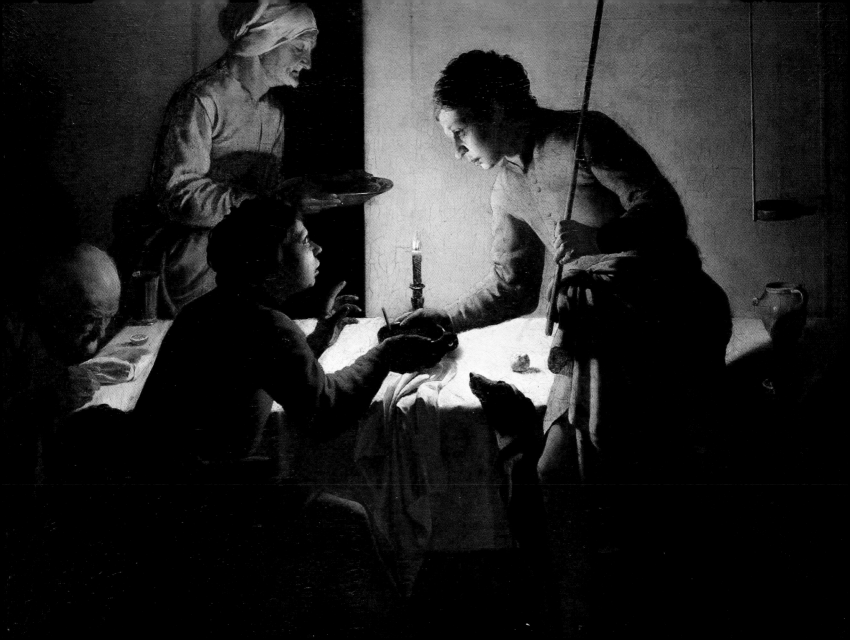

Rome was not built in one day.

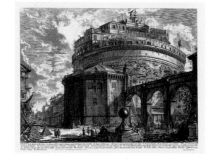

Veduta of Rome, 18th century
Giovanni Battista Piranesi
Kupferstichkabinett, Staatliche Museen zu Berlin

1 2 3 4 5 6 7 8 9 10 11 12 13 14 15 16 17 18 19 20 21 22 23 24 25 26 27 28 29 30 31

AUGUST

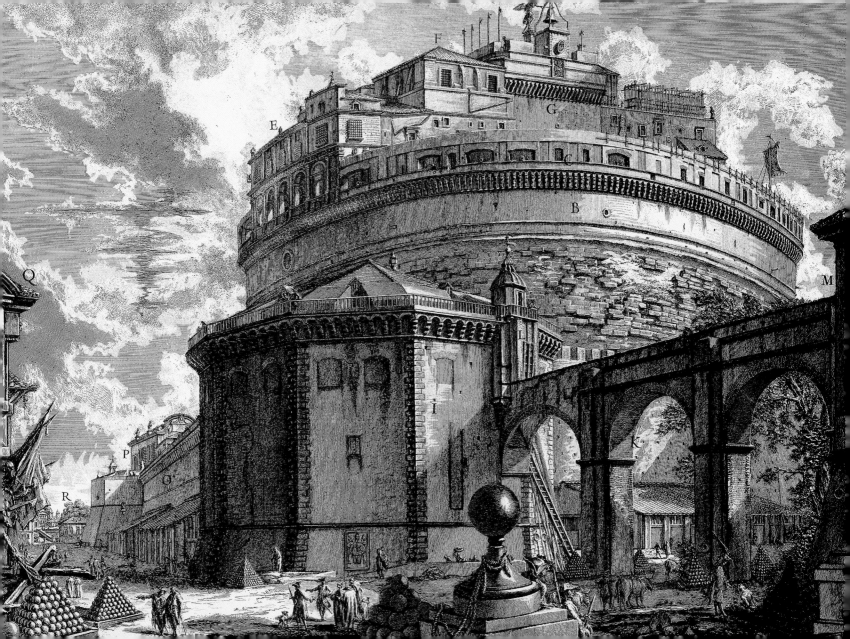

A man is not idle because he is absorbed in thought. There is a visible labor and there is an invisible labor.

<small>VICTOR HUGO</small>

Luke the Evangelist, 1492

Tilmann Riemenschneider

Skulpturensammlung und Museum für Byzantinische Kunst, Staatliche Museen zu Berlin

1 2 3 4 5 6 7 8 9 10 11 12 13 14 15 16 17 18 19 20 21 22 23 24 25 26 27 28 29 30 **31**

AUGUST

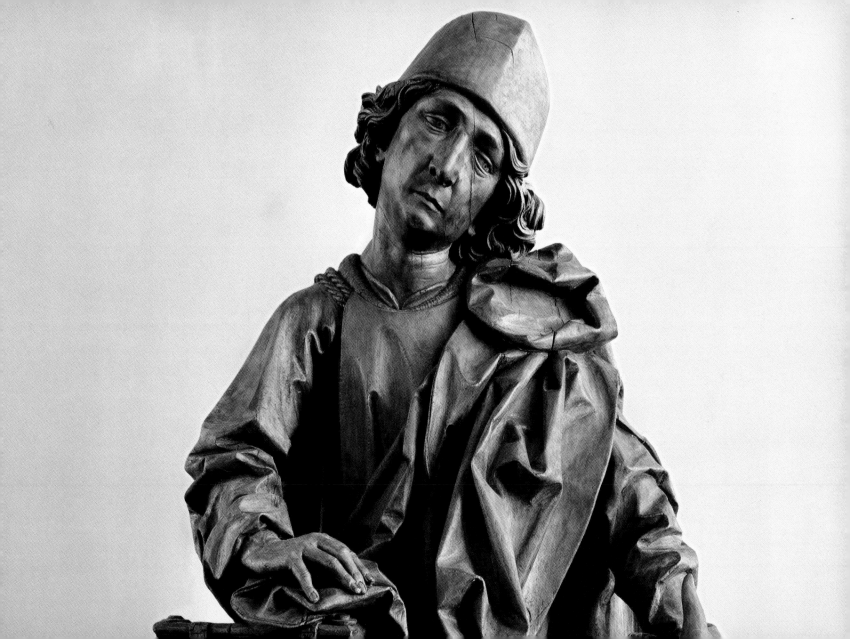

Follow a shadow, it flies you,
Seem to fly it, it will pursue:
So court a mistress, she denies you;
Let her alone, she will court you.
Say, are not women truly, then,
Styl'd but the shadows of us men?

BEN JONSON

The Sisters, 1876
Gabriel Cornelius von Max
Nationalgalerie, Staatliche Museen zu Berlin

1 2 3 4 5 6 7 8 9 10 11 12 13 14 15 16 17 18 19 20 21 22 23 24 25 26 27 28 29 30

SEPTEMBER

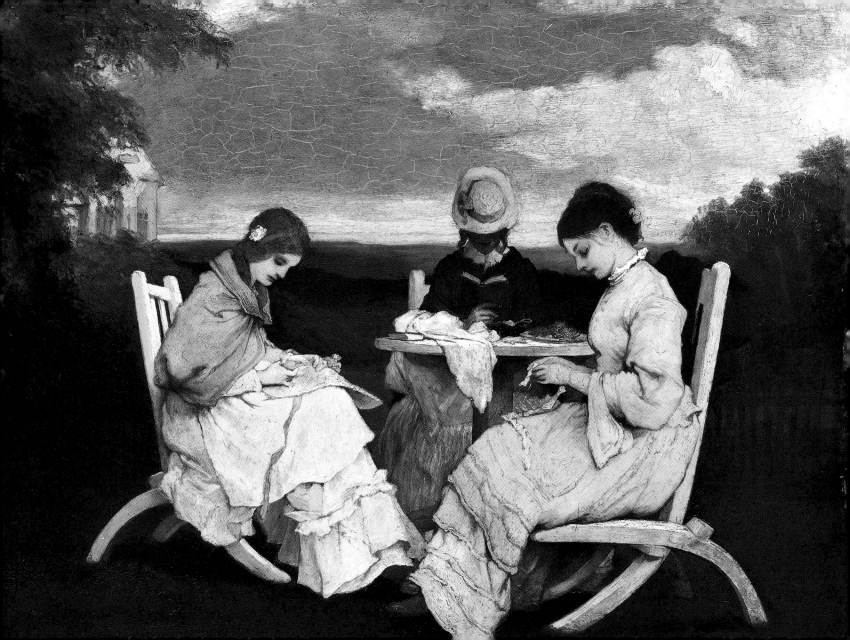

For freedom Christ has set us free.
Stand firm, therefore, and do not submit
again to a yoke of slavery.

Galatians 5:1

Madonna and Child
Rogier van der Weyden (Workshop)
Gemäldegalerie, Staatliche Museen zu Berlin

1 2 3 4 5 6 7 8 9 10 11 12 13 14 15 16 17 18 19 20 21 22 23 24 25 26 27 28 29 30

September

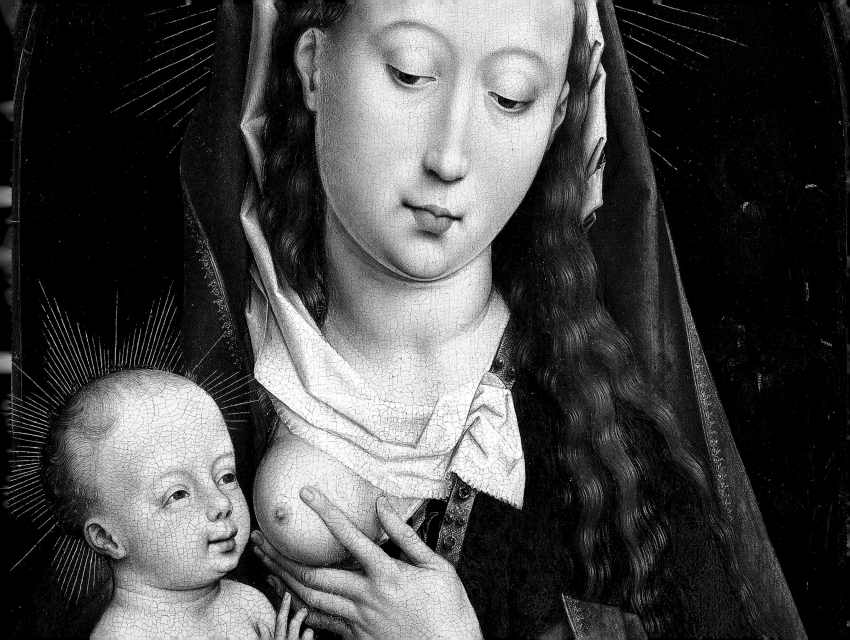

Art is nothing but the expression of our dream; the more we surrender to it the closer we get to the inner truth of things, our dream-life, the true life that scorns questions and does not see them.

Franz Marc

Tower of the Blue Horses, 1913
Franz Marc
Nationalgalerie, Staatliche Museen zu Berlin (missing since 1945)

1 2 **3** 4 5 6 7 8 9 10 11 12 13 14 15 16 17 18 19 20 21 22 23 24 25 26 27 28 29 30

SEPTEMBER

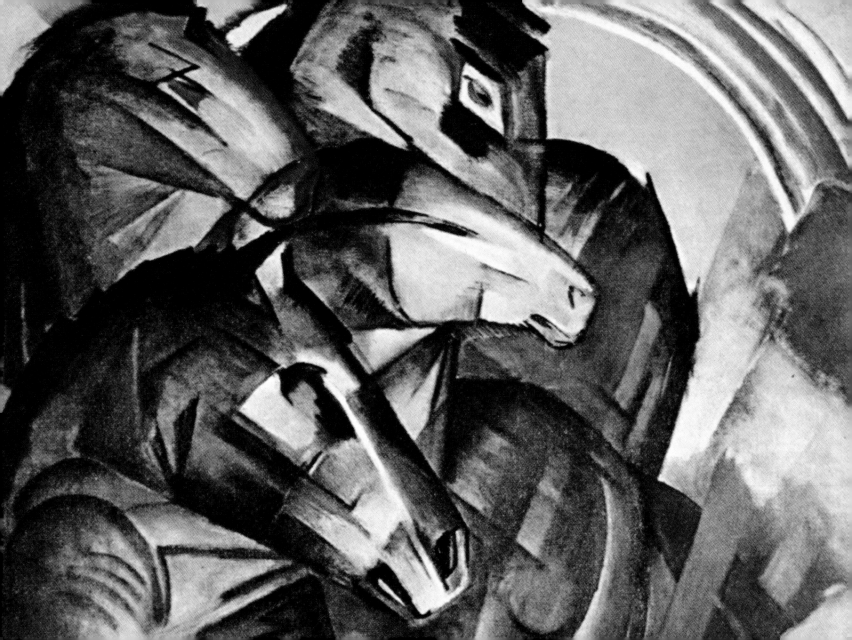

*How can we know the dancer
from the dance?*

<small>WILLIAM BUTLER YEATS</small>

Dancer, 1809–1812

Antonio Canova

Skulpturensammlung und Museum für Byzantinische Kunst, Staatliche Museen zu Berlin

1 2 3 **4** 5 6 7 8 9 10 11 12 13 14 15 16 17 18 19 20 21 22 23 24 25 26 27 28 29 30

SEPTEMBER

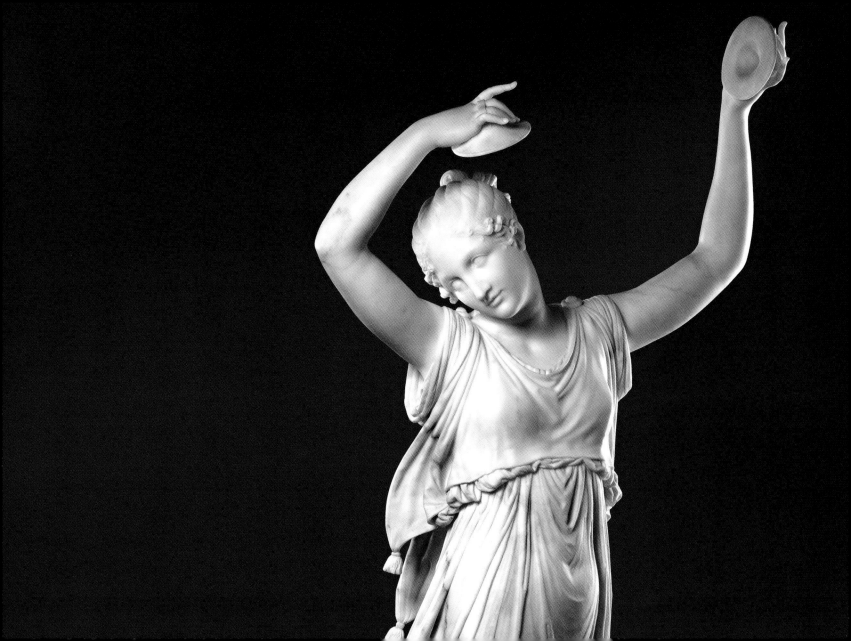

Dust and ashes, dead and done with,
Venice spent what Venice earned.

Robert Browning

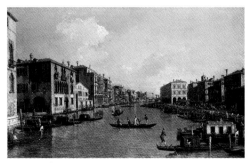

The Canal Grande with a South-eastern View of the Rialto Bridge, 1758–1763

Canaletto (Giovanni Antonio Canal)

Gemäldegalerie, Loan from the Streit Foundation, Staatliche Museen zu Berlin

1 2 3 4 **5** 6 7 8 9 10 11 12 13 14 15 16 17 18 19 20 21 22 23 24 25 26 27 28 29 30

SEPTEMBER

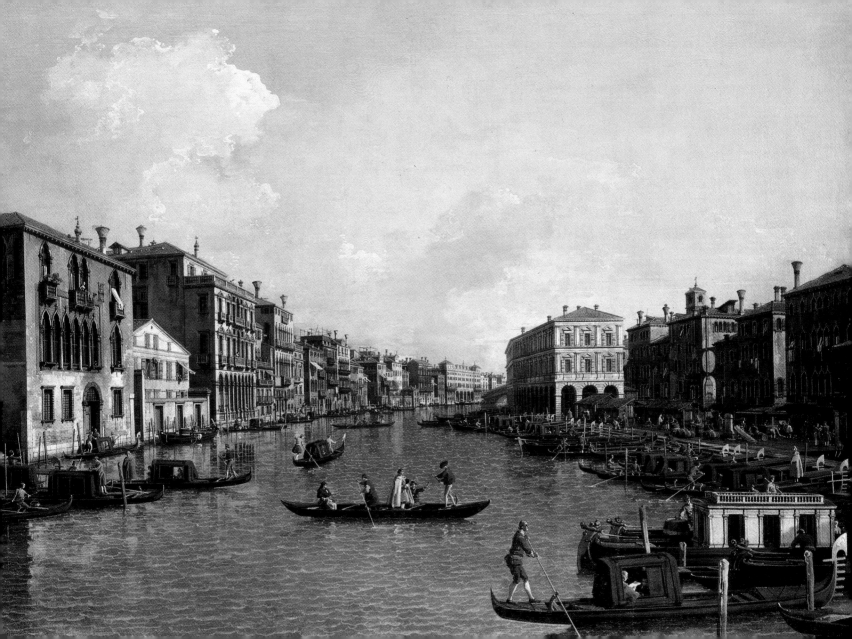

Earth laughs in flowers.

Ralph Waldo Emerson

Anemone, from Caspar Anckelmann's Book of Flowers, *c.* 1700
Kupferstichkabinett, Staatliche Museen zu Berlin

1 2 3 4 5 **6** 7 8 9 10 11 12 13 14 15 16 17 18 19 20 21 22 23 24 25 26 27 28 29 30

SEPTEMBER

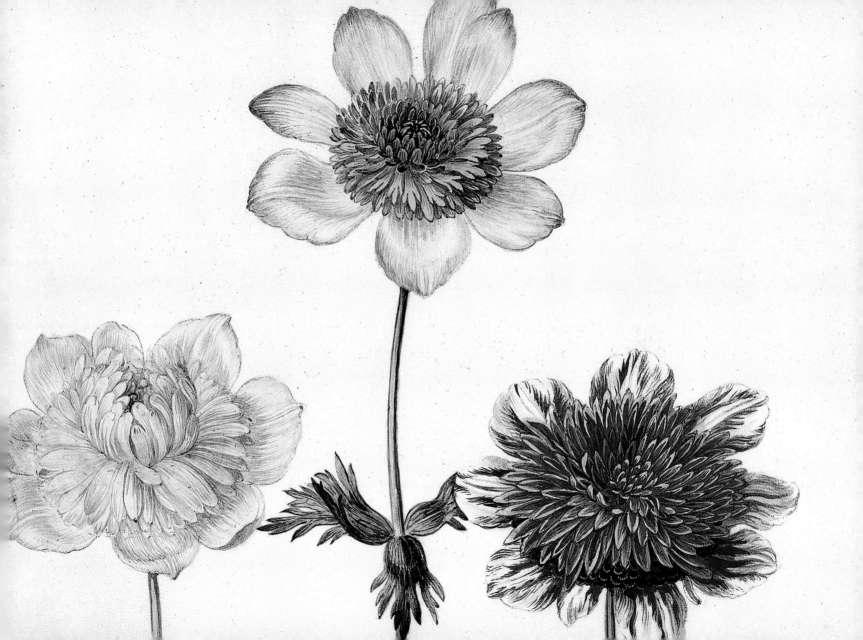

*A good heart is the sun and the moon;
or, rather, the sun and not the moon,
for it shines bright and never changes.*

WILLIAM SHAKESPEARE

**Double Sun Mask, Depiction of the Sun by the
Indian Folk Group Kwaiutl,** before 1881

Johan Adrian Jacobsen

Ethnologisches Museum, Staatliche Museen zu Berlin

1 2 3 4 5 6 **7** 8 9 10 11 12 13 14 15 16 17 18 19 20 21 22 23 24 25 26 27 28 29 30

SEPTEMBER

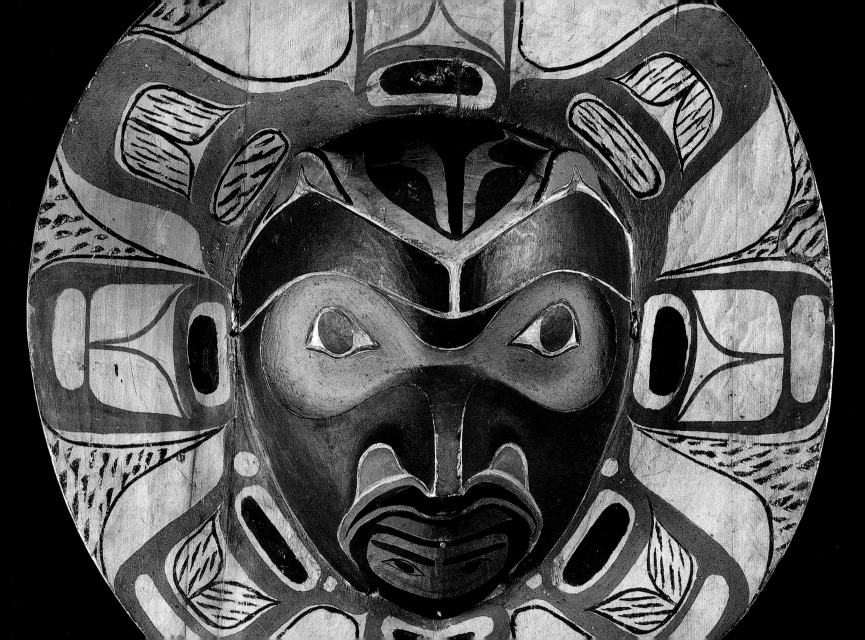

No act of kindness, no matter how small, is ever wasted.

Study Sheet with a Blind Woman, Led by a Young Man, 17th century

Rembrandt Harmensz van Rijn

Kupferstichkabinett, Staatliche Museen zu Berlin

8

1 2 3 4 5 6 7 **8** 9 10 11 12 13 14 15 16 17 18 19 20 21 22 23 24 25 26 27 28 29 30

SEPTEMBER

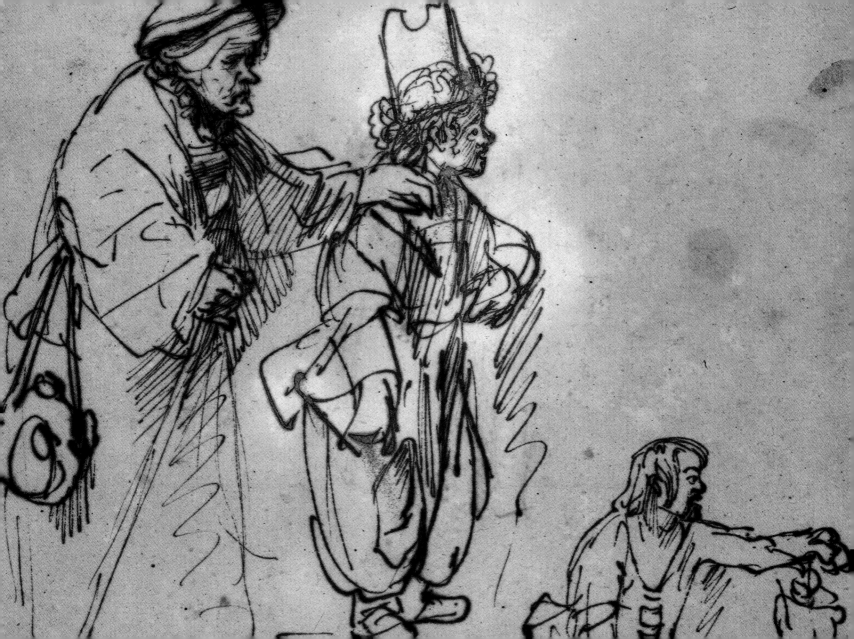

Stolen fruit is sweet.

Still Life with Fruit Basket
Balthasar van der Ast
Gemäldegalerie, Staatliche Museen zu Berlin

1 2 3 4 5 6 7 8 **9** 10 11 12 13 14 15 16 17 18 19 20 21 22 23 24 25 26 27 28 29 30

SEPTEMBER

Orpheus with his lute made trees,
And the mountain tops that freeze,
Bow themselves when he did sing:
To his music plants and flowers
Ever sprung; as sun and showers
There had made a lasting spring.

WILLIAM SHAKESPEARE

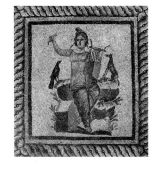

Orpheus Mosaic, last quarter/end of the 2nd century A. D.
Milet/Turkey
Antikensammlung, Staatliche Museen zu Berlin

1 2 3 4 5 6 7 8 9 **10** 11 12 13 14 15 16 17 18 19 20 21 22 23 24 25 26 27 28 29 30

SEPTEMBER

The mark of a successful man is one that has spent an entire day on the bank of a river without feeling guilty about it.

Anonymous

Windmill on a Riverbank, 17th century

Jacob van Ruisdael

Gemäldegalerie, Staatliche Museen zu Berlin

1 2 3 4 5 6 7 8 9 10 **11** 12 13 14 15 16 17 18 19 20 21 22 23 24 25 26 27 28 29 30

September

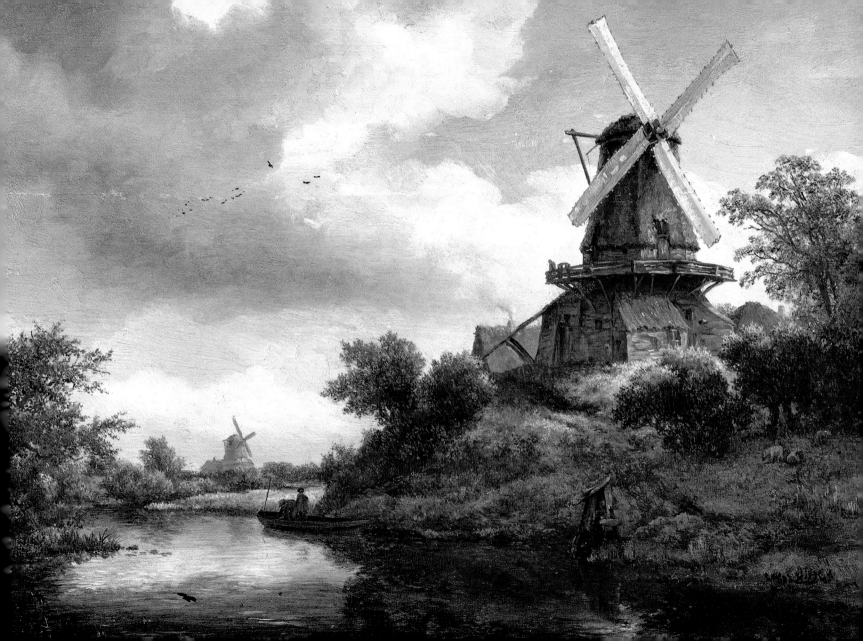

*Character cannot be developed in ease and quiet.
Only through experience of trial and suffering
can the soul be strengthened, ambition inspired,
and success achieved.*

Mater Dolorosa, *c.* 1587–1590
El Greco (Workshop)
Gemäldegalerie, Staatliche Museen zu Berlin

1 2 3 4 5 6 7 8 9 10 11 **12** 13 14 15 16 17 18 19 20 21 22 23 24 25 26 27 28 29 30

SEPTEMBER

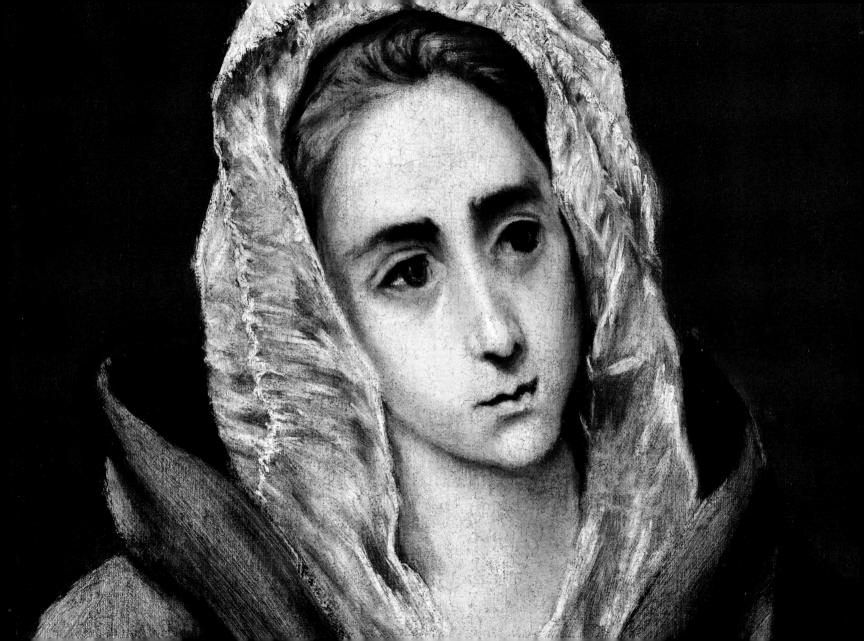

I strive to be brief and I become obscure.

<small>HORACE</small>

Amulet of the Mongalla, *c.* 1900
Congo
Ethnologisches Museum, Staatliche Museen zu Berlin

1 2 3 4 5 6 7 8 9 10 11 12 **13** 14 15 16 17 18 19 20 21 22 23 24 25 26 27 28 29 30

SEPTEMBER

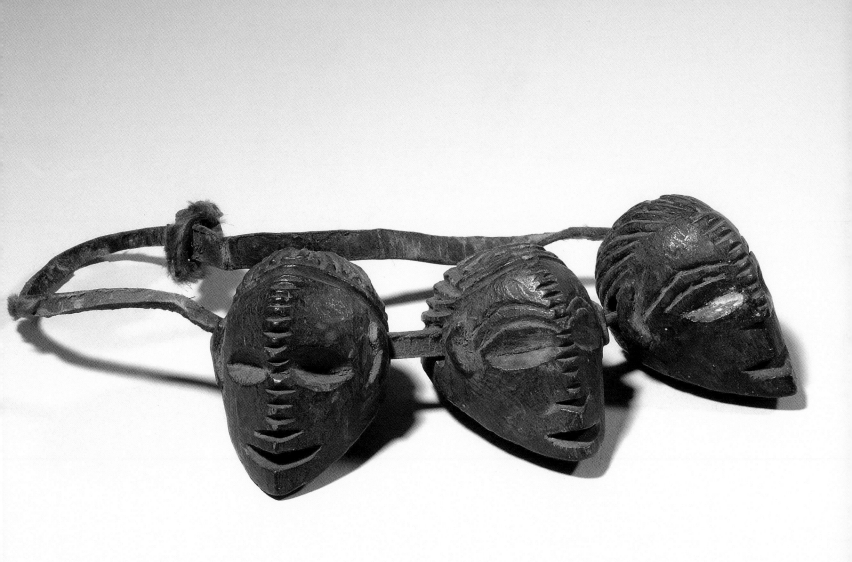

Pergamon Altar (detail of the north frieze showing the Lion Goddess) second quarter of the 2nd century B. C.

Pergamon/Turkey

Antikensammlung, Staatliche Museen zu Berlin

Those who fled will fight another time.

<small>TERTULLIAN</small>

1 2 3 4 5 6 7 8 9 10 11 12 13 **14** 15 16 17 18 19 20 21 22 23 24 25 26 27 28 29 30

SEPTEMBER

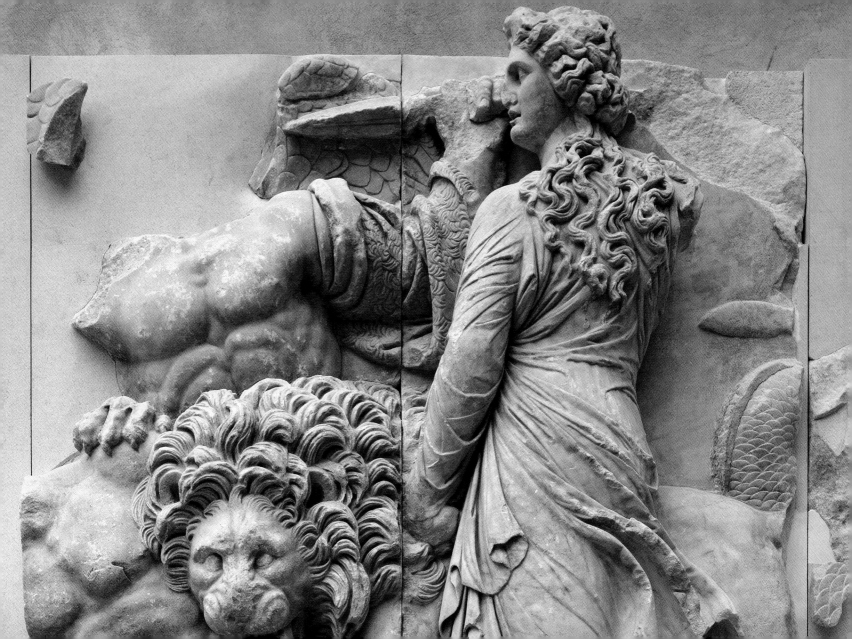

Even in dreams good works are not wasted.

PEDRO CALDERÓN DE LA BARCA

Awakening, 1920
Paul Klee
Museum Berggruen, Nationalgalerie, Staatliche Museen zu Berlin

1 2 3 4 5 6 7 8 9 10 11 12 13 14 **15** 16 17 18 19 20 21 22 23 24 25 26 27 28 29 30

SEPTEMBER

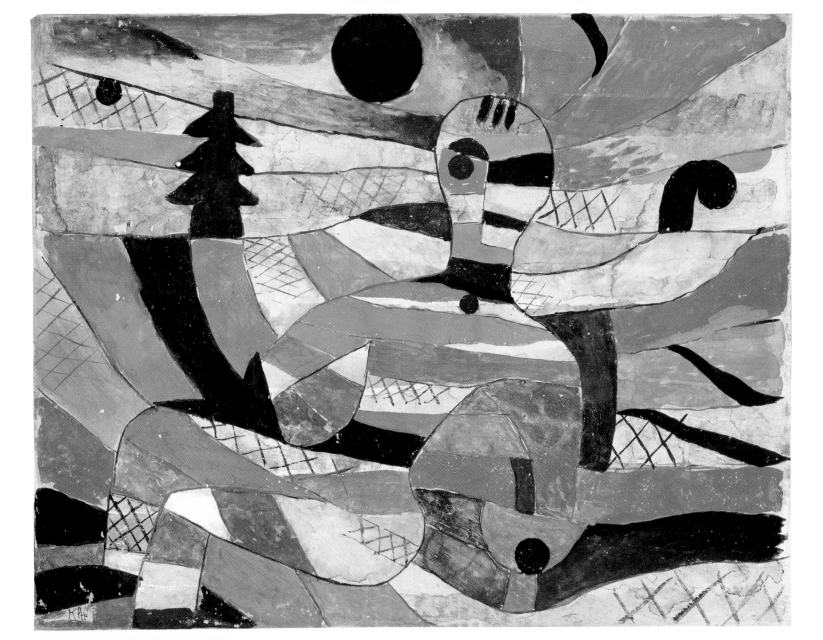

Art is significant deformity.

ROGER FRY

Feudal Ruins, 19th century
Victor Hugo
Sammlung Scharf-Gerstenberg, Staatliche Museen zu Berlin

1 2 3 4 5 6 7 8 9 10 11 12 13 14 15 **16** 17 18 19 20 21 22 23 24 25 26 27 28 29 30

SEPTEMBER

If children grew up according to early indications, we should have nothing but geniuses.

JOHANN WOLFGANG VON GOETHE

Portrait of Carl Friedrich Felix and Carola von Behr
Friedrich August von Kaulbach
Nationalgalerie, Staatliche Museen zu Berlin

1 2 3 4 5 6 7 8 9 10 11 12 13 14 15 16 **17** 18 19 20 21 22 23 24 25 26 27 28 29 30

SEPTEMBER

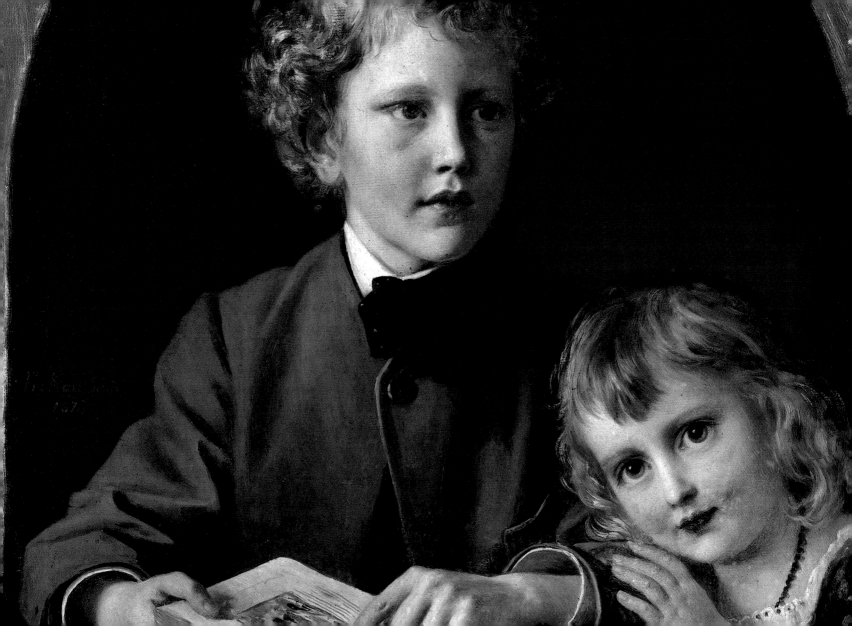

Bull, 323–330 B. C.

Egypt

Ägyptisches Museum und Papyrussammlung, Staatliche Museen zu Berlin

Oh holy simplicity!

<small>John Huss</small>

1 2 3 4 5 6 7 8 9 10 11 12 13 14 15 16 17 **18** 19 20 21 22 23 24 25 26 27 28 29 30

SEPTEMBER

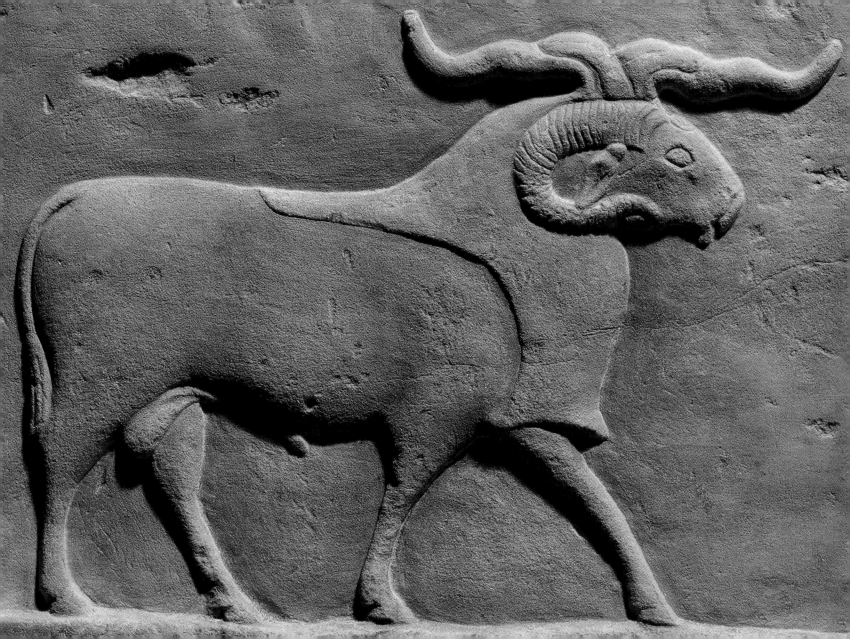

*The wind is rushing after us,
and the clouds are flying after us,
and the moon is plunging after us,
and the whole wild night is in
pursuit of us; but, so far we are
pursued by nothing else.*

CHARLES DICKENS

Man and Woman Observing the Moon, 1818–1824
Caspar David Friedrich
Nationalgalerie, Staatliche Museen zu Berlin

1 2 3 4 5 6 7 8 9 10 11 12 13 14 15 16 17 18 **19** 20 21 22 23 24 25 26 27 28 29 30

SEPTEMBER

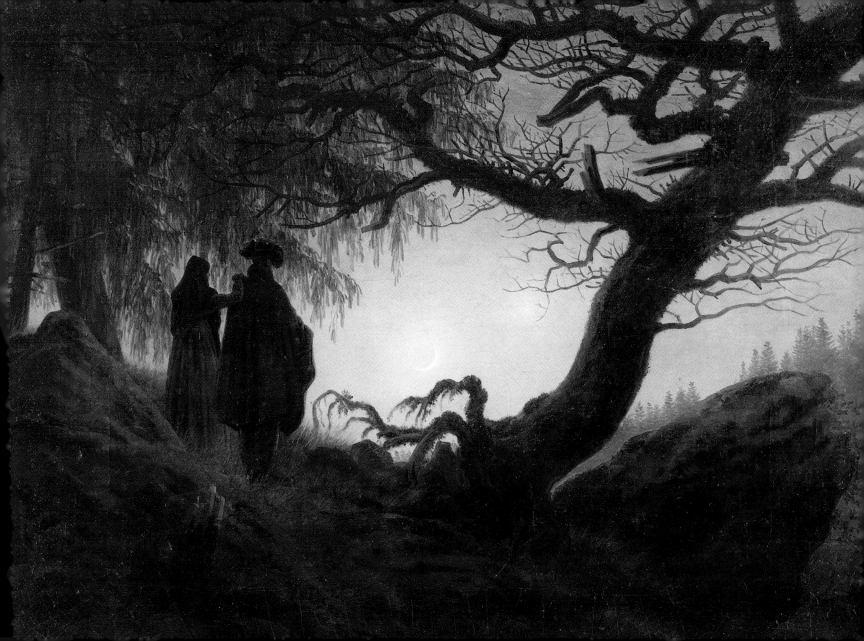

Gentle Jesus, meek and mild,
Look upon a little child;
Pity my simplicity,
Suffer me to come to thee.

CHARLES WESLEY

Madonna and Child
Jan Gossaert
Gemäldegalerie, Staatliche Museen zu Berlin

1 2 3 4 5 6 7 8 9 10 11 12 13 14 15 16 17 18 19 **20** 21 22 23 24 25 26 27 28 29 30

SEPTEMBER

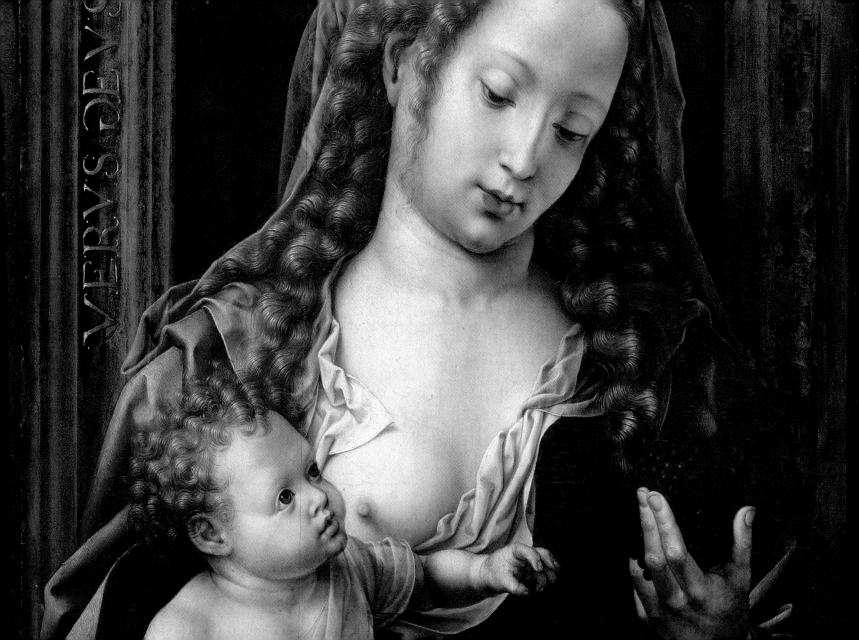

Art requires philosophy, just as philosophy requires art. Otherwise, what would become of beauty?

<small>PAUL GAUGUIN</small>

Tahitian Fisherwomen, 1891
Paul Gauguin
Nationalgalerie, Staatliche Museen zu Berlin

1 2 3 4 5 6 7 8 9 10 11 12 13 14 15 16 17 18 19 20 **21** 22 23 24 25 26 27 28 29 30

SEPTEMBER

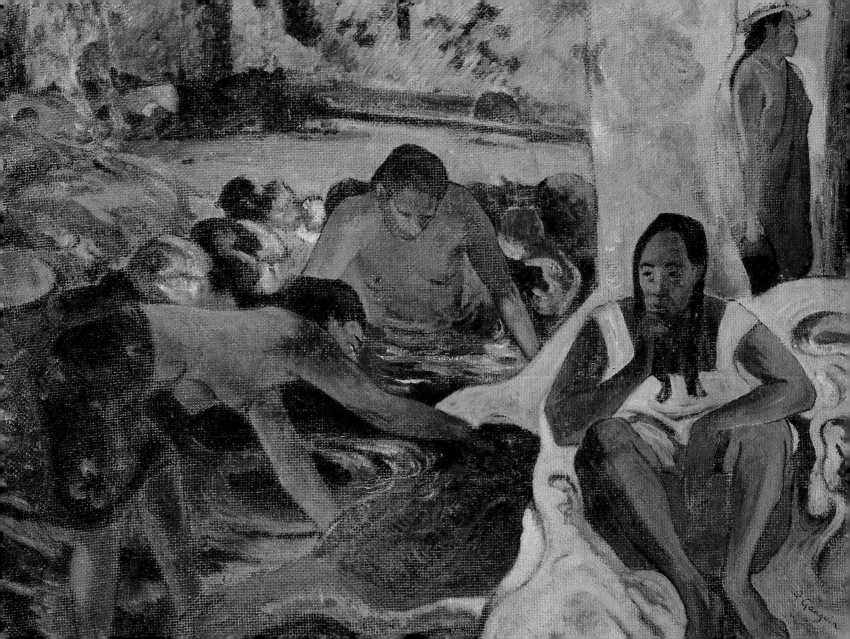

Always washing, and never getting finished.

THOMAS HARDY

Women at the Washing Trough, Attic bowl, *c.* 500 B. C.
Antikensammlung, Staatliche Museen zu Berlin

1 2 3 4 5 6 7 8 9 10 11 12 13 14 15 16 17 18 19 20 21 **22** 23 24 25 26 27 28 29 30

SEPTEMBER

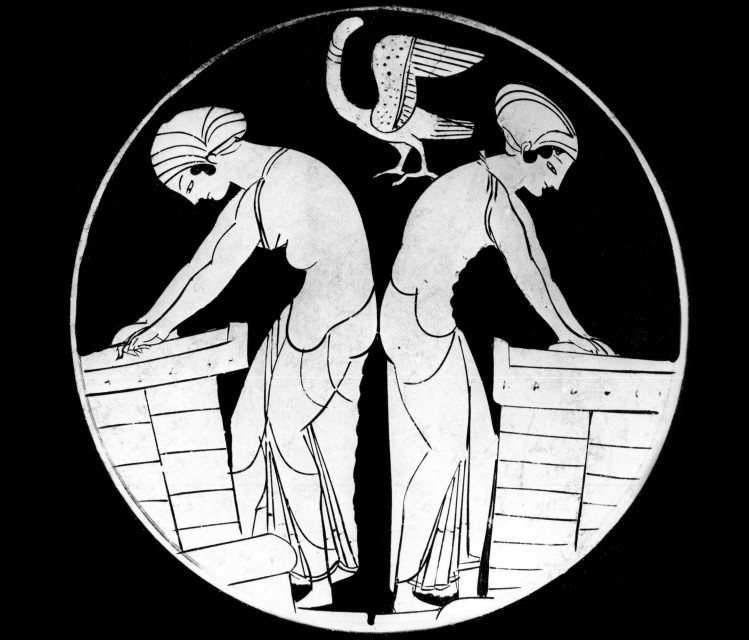

The number of guests at dinner should not be less than the number of the Graces nor exceed that of the Muses, i. e., it should begin with three and stop at nine.

MARCUS TERENTIUS VARRO

Company at Mealtime, 1634
David Teniers the Younger
Gemäldegalerie, Staatliche Museen zu Berlin

1 2 3 4 5 6 7 8 9 10 11 12 13 14 15 16 17 18 19 20 21 22 **23** 24 25 26 27 28 29 30

SEPTEMBER

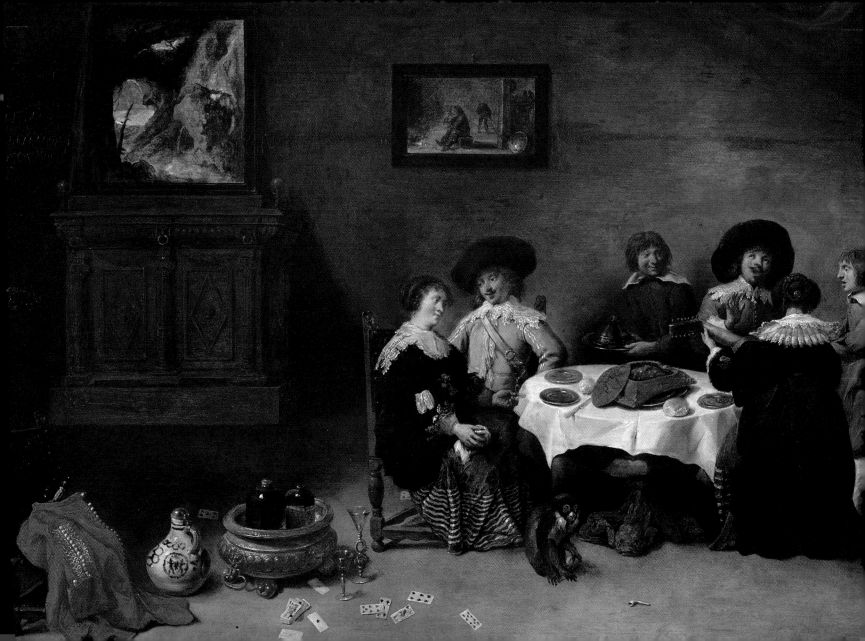

Without tradition, art is a flock of sheep without a shepherd. Without innovation, it is a corpse.

A Lynx Creeps Towards a Flock of Sheep, 18th century
India
Museum für Islamische Kunst, Staatliche Museen zu Berlin

1 2 3 4 5 6 7 8 9 10 11 12 13 14 15 16 17 18 19 20 21 22 23 **24** 25 26 27 28 29 30

SEPTEMBER

> *The countenance is the portrait of the soul, and the eyes mark its intentions.*

<small>Marcus Tullius Cicero</small>

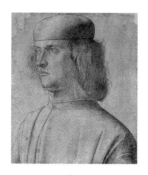

Portrait of a Young Man, *c. 1480–1495*
Gentile Bellini
Kupferstichkabinett, Staatliche Museen zu Berlin

1 2 3 4 5 6 7 8 9 10 11 12 13 14 15 16 17 18 19 20 21 22 23 24 **25** 26 27 28 29 30

SEPTEMBER

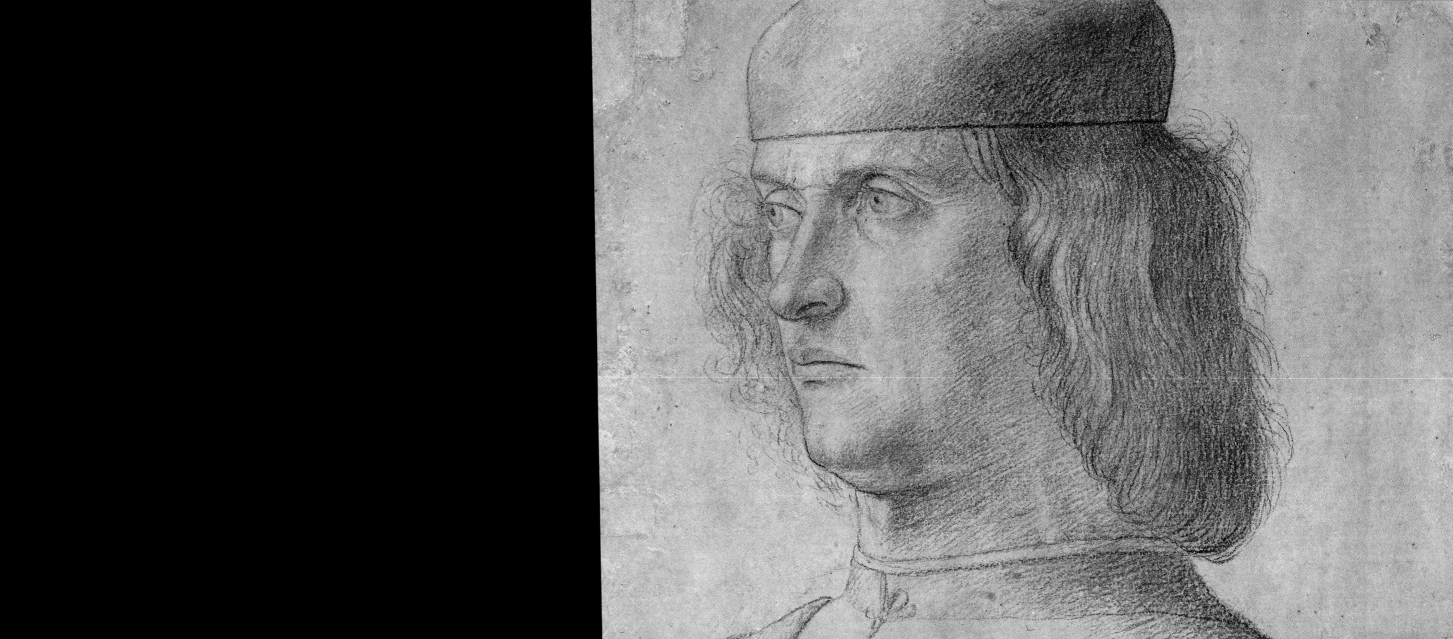

Nature's peace will flow into you as sunshine flows into trees.

John Muir

House on Wannsee, 1926
Max Liebermann
Nationalgalerie, Staatliche Museen zu Berlin

1 2 3 4 5 6 7 8 9 10 11 12 13 14 15 16 17 18 19 20 21 22 23 24 25 **26** 27 28 29 30

SEPTEMBER

The caterpillar on the leaf
Repeats to thee thy mother's grief.
Kill not the moth nor butterfly,
For the Last Judgement draweth nigh.

WILLIAM BLAKE

The Last Judgment
Fra Angelico
Gemäldegalerie, Staatliche Museen zu Berlin

1 2 3 4 5 6 7 8 9 10 11 12 13 14 15 16 17 18 19 20 21 22 23 24 25 26 **27** 28 29 30

SEPTEMBER

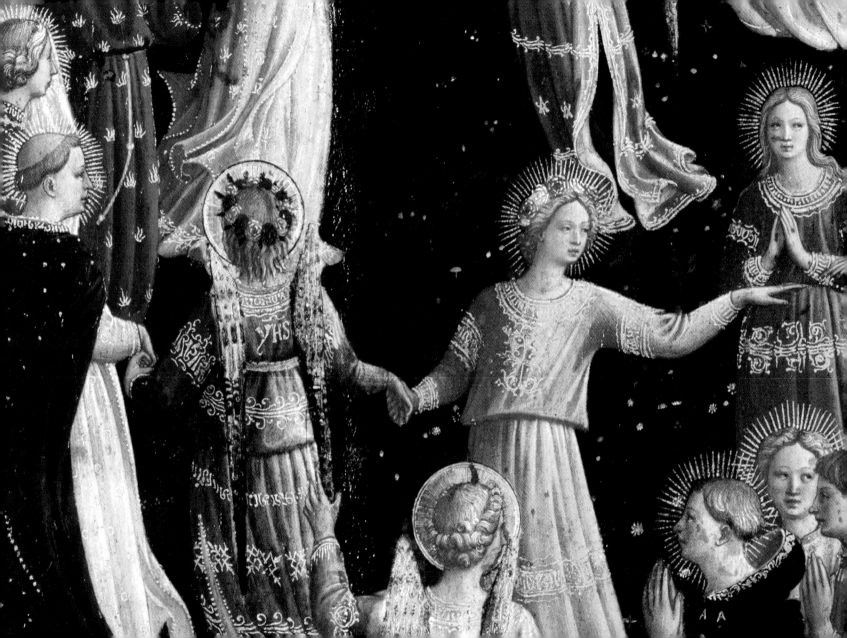

Not all that tempts your wand'ring eyes
And heedless hearts, is lawful prize;
Nor all, that glisters, gold.

THOMAS GRAY

Man with the Golden Helmet, *c.* 1650
School of Rembrandt
Gemäldegalerie, Property of the Kaiser Friedrich-Museums-Verein, Staatliche Museen zu Berlin

1 2 3 4 5 6 7 8 9 10 11 12 13 14 15 16 17 18 19 20 21 22 23 24 25 26 27 **28** 29 30

SEPTEMBER

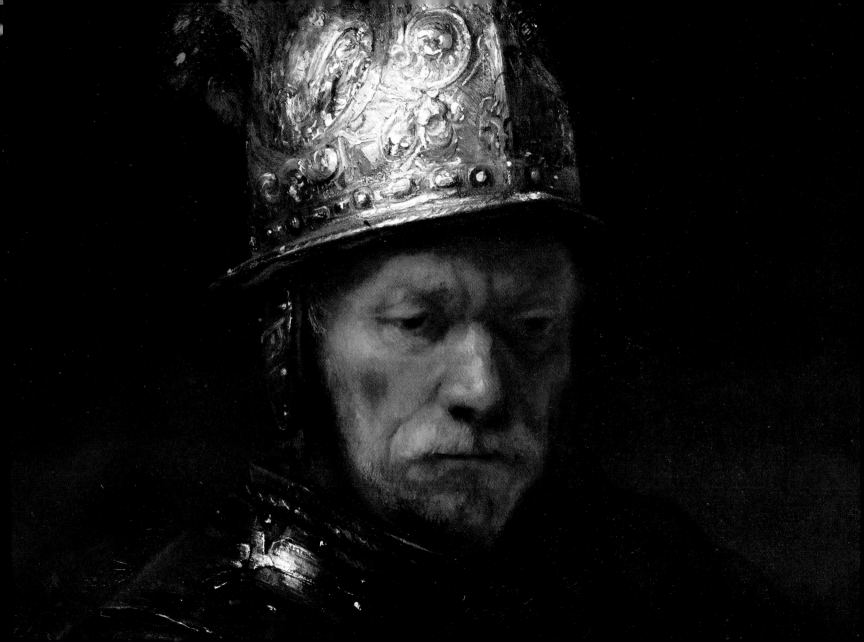

*I hardly need to abstract things,
for each object is unreal enough already,
so unreal that I can only make it real by
means of painting.*

MAX BECKMANN

View of the Havel from the Rupenhorn, 1936
Max Beckmann
Nationalgalerie, Staatliche Museen zu Berlin

1 2 3 4 5 6 7 8 9 10 11 12 13 14 15 16 17 18 19 20 21 22 23 24 25 26 27 28 **29** 30

SEPTEMBER

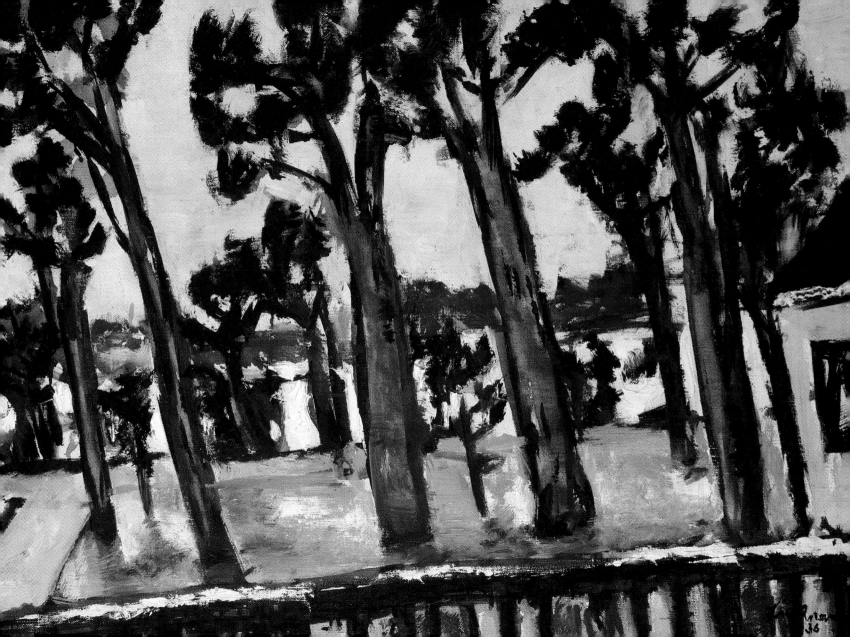

A family in harmony will prosper in everything.

The Painter with his Family, 1645/46
David Teniers the Younger
Gemäldegalerie, Staatliche Museen zu Berlin

1 2 3 4 5 6 7 8 9 10 11 12 13 14 15 16 17 18 19 20 21 22 23 24 25 26 27 28 29 30

SEPTEMBER

Crowds, what a swarm of people!
How they hustle and bustle!
My brain needs oiling, it's probably
dried up

Alfred Döblin

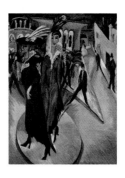

Potsdamer Platz, 1914
Ernst Ludwig Kirchner
Nationalgalerie, Staatliche Museen zu Berlin

1 2 3 4 5 6 7 8 9 10 11 12 13 14 15 16 17 18 19 20 21 22 23 24 25 26 27 28 29 30 31

OCTOBER

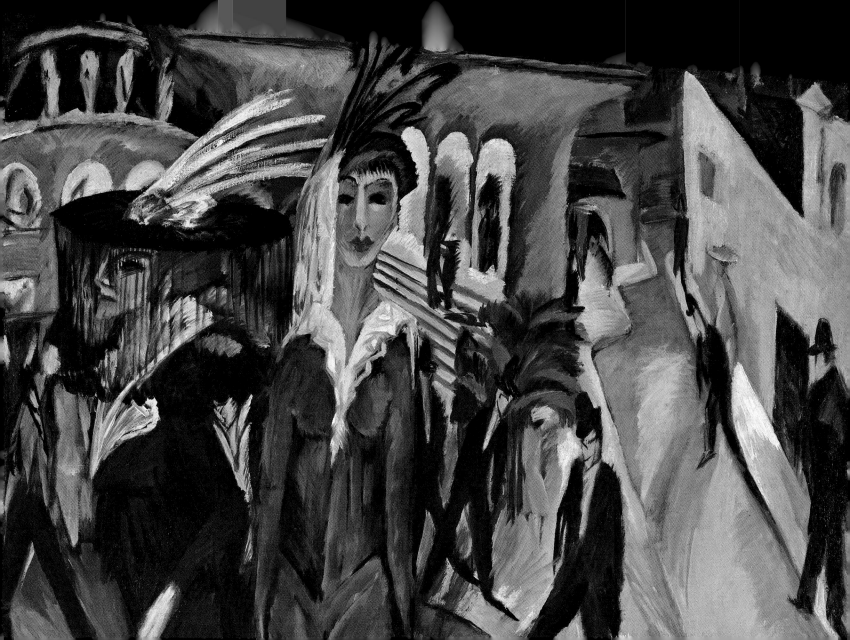

Advice is seldom welcome;
and those who want it the most
always like it least.

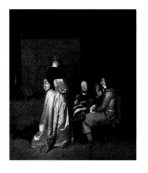

The Fatherly Admonition, *c.* 1654/55
Gerard ter Borch
Gemäldegalerie, Staatliche Museen zu Berlin

1 2 3 4 5 6 7 8 9 10 11 12 13 14 15 16 17 18 19 20 21 22 23 24 25 26 27 28 29 30 31

OCTOBER

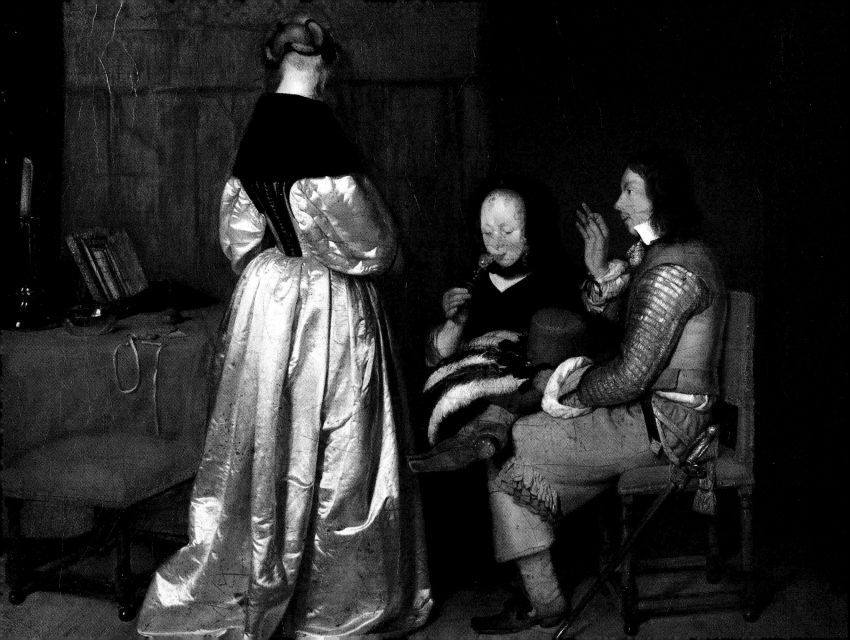

It is not easy to walk alone in the country without musing upon something.

CHARLES DICKENS

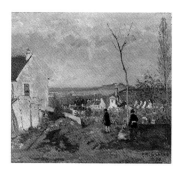

Louveciennes with Mont Valérien in the Background, 1870
Camille Pissarro
Nationalgalerie, Staatliche Museen zu Berlin

1 2 **3** 4 5 6 7 8 9 10 11 12 13 14 15 16 17 18 19 20 21 22 23 24 25 26 27 28 29 30 31

OCTOBER

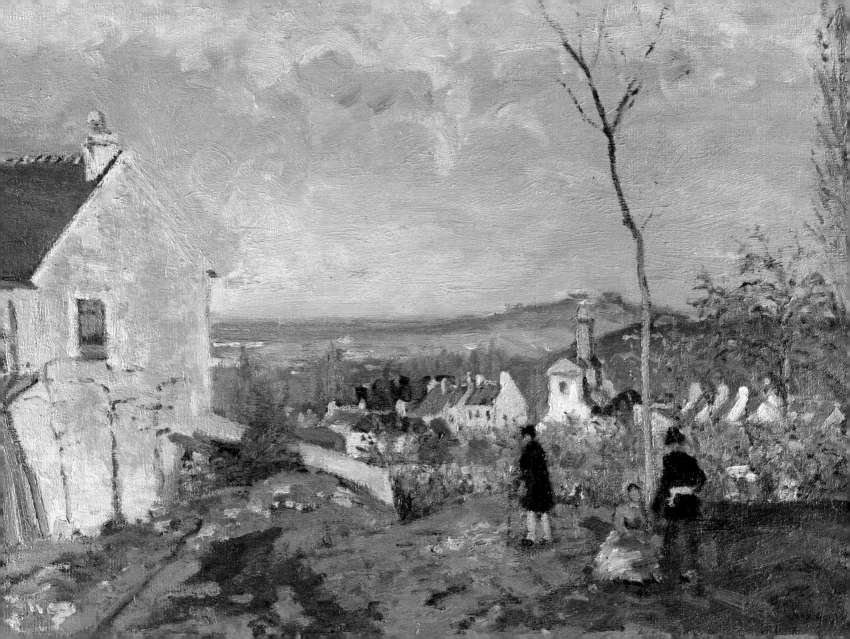

The greater the sinner, the greater the saint.

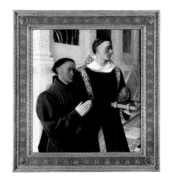

Etienne Chevalier with Saint Stephen, 1454–1456

Jean Fouquet

Gemäldegalerie, Staatliche Museen zu Berlin

1 2 3 **4** 5 6 7 8 9 10 11 12 13 14 15 16 17 18 19 20 21 22 23 24 25 26 27 28 29 30 31

OCTOBER

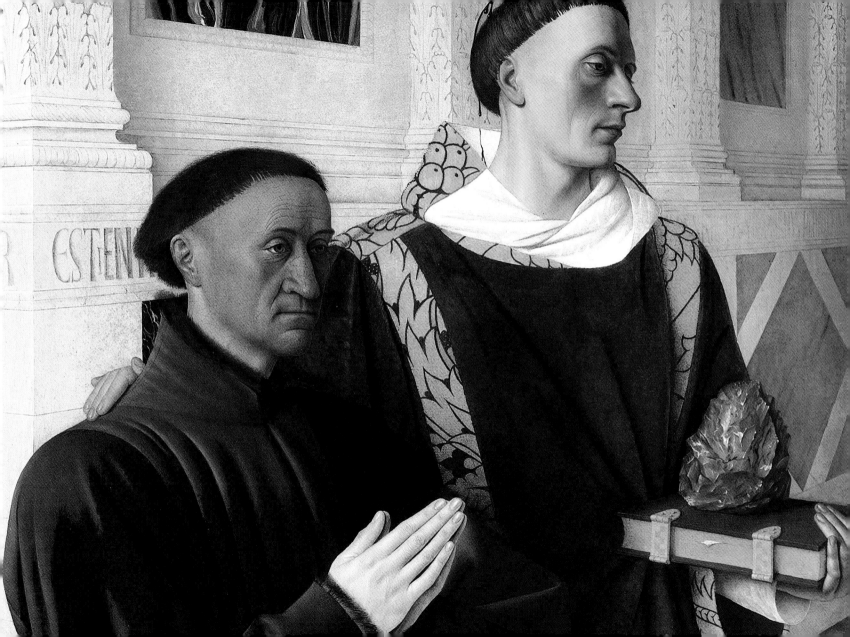

Something secret lies behind people and objects, behind colors and frames, and this connects everything with life and the manifest appearance; that is the beauty I am looking for.

Ernst Ludwig Kirchner

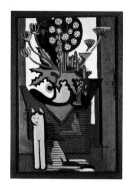

Meadow Flowers with Cat, 1931/32
Ernst Ludwig Kirchner
Nationalgalerie, Staatliche Museen zu Berlin

1 2 3 4 **5** 6 7 8 9 10 11 12 13 14 15 16 17 18 19 20 21 22 23 24 25 26 27 28 29 30 31

OCTOBER

It is written on the arched sky…
It is the poetry of Nature.
It is that which uplifts the spirit
within us.

John Ruskin

Moonrise on the Sea, 1822
Caspar David Friedrich
Nationalgalerie, Staatliche Museen zu Berlin

1 2 3 4 5 **6** 7 8 9 10 11 12 13 14 15 16 17 18 19 20 21 22 23 24 25 26 27 28 29 30 31

OCTOBER

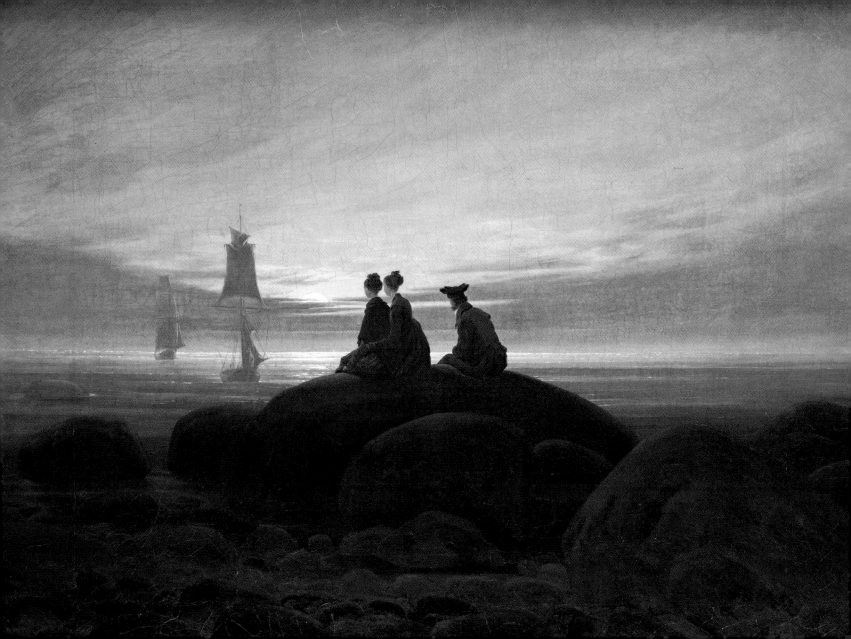

It takes a long time for a man to look like his portrait.

JAMES MCNEILL WHISTLER

Man with a Carnation
Pupil of Jan van Eyck
Gemäldegalerie, Staatliche Museen zu Berlin

1 2 3 4 5 6 **7** 8 9 10 11 12 13 14 15 16 17 18 19 20 21 22 23 24 25 26 27 28 29 30 31

OCTOBER

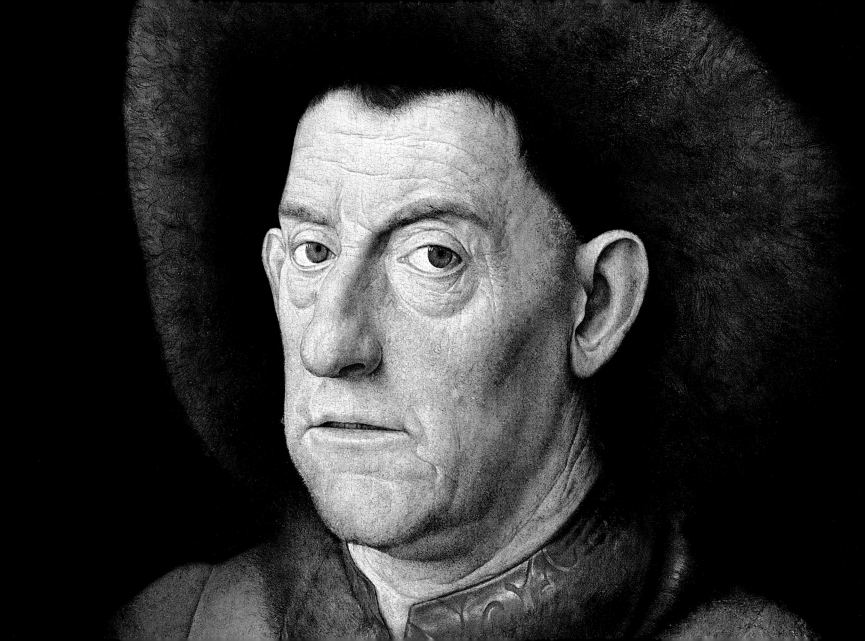

The object in modern painting must become the main character and overthrow the subject. If, in turn, the human form becomes an object, it can considerably liberate possibilities for the modern artist.

FERNAND LÉGER

Woman's Head, 1953
Fernand Léger
Kupferstichkabinett, Staatliche Museen zu Berlin

1 2 3 4 5 6 7 **8** 9 10 11 12 13 14 15 16 17 18 19 20 21 22 23 24 25 26 27 28 29 30 31

OCTOBER

Anything in any way beautiful derives its beauty from itself and asks nothing beyond itself. Praise is no part of it, for nothing is made worse or better by praise.

Marcus Aurelius

Goddess of the Via Trajana, *c.* 1500
Pier Jacopo Alari-Bonacolsi
Skulpturensammlung und Museum für Byzantinische Kunst, Staatliche Museen zu Berlin

1 2 3 4 5 6 7 8 9 10 11 12 13 14 15 16 17 18 19 20 21 22 23 24 25 26 27 28 29 30 31

OCTOBER

It is well that war is so terrible.
Otherwise we would grow too fond of it.

Robert E. Lee

The Battle near Lepanto, 16th century
Jost Amman
Kupferstichkabinett, Staatliche Museen zu Berlin

1 2 3 4 5 6 7 8 9 **10** 11 12 13 14 15 16 17 18 19 20 21 22 23 24 25 26 27 28 29 30 31

OCTOBER

Many hands make light work.

Flax Barn in Laren, 1887

Max Liebermann

Nationalgalerie, Staatliche Museen zu Berlin

1 2 3 4 5 6 7 8 9 10 **11** 12 13 14 15 16 17 18 19 20 21 22 23 24 25 26 27 28 29 30 31

OCTOBER

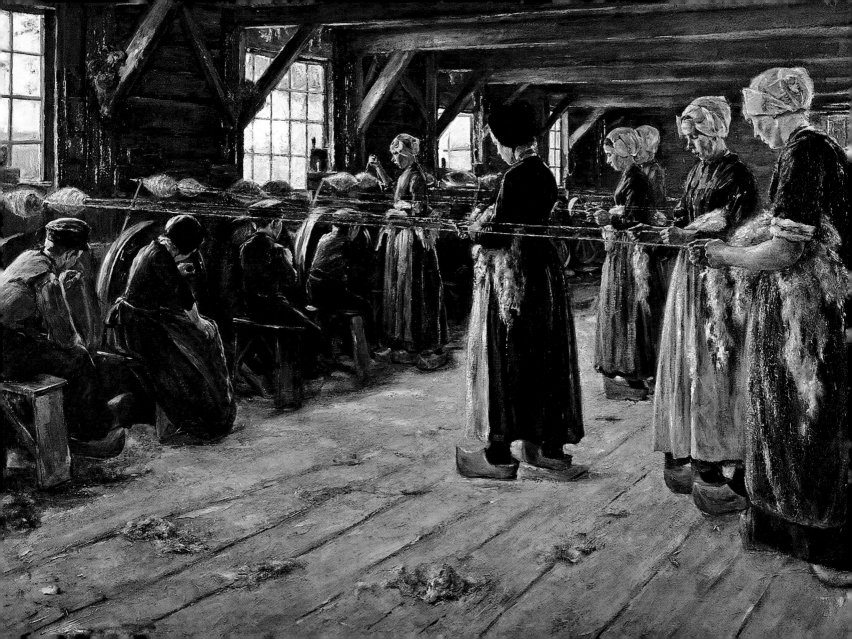

For I have seen God face to face,
and my life is preserved.

GENESIS 32:30

Mary and Child, 15th Century
Dieric Bouts
Gemäldegalerie, Loan from the Kaiser Friedrich-Museums-Verein, Staatliche Museen zu Berlin

1 2 3 4 5 6 7 8 9 10 11 **12** 13 14 15 16 17 18 19 20 21 22 23 24 25 26 27 28 29 30 31

OCTOBER

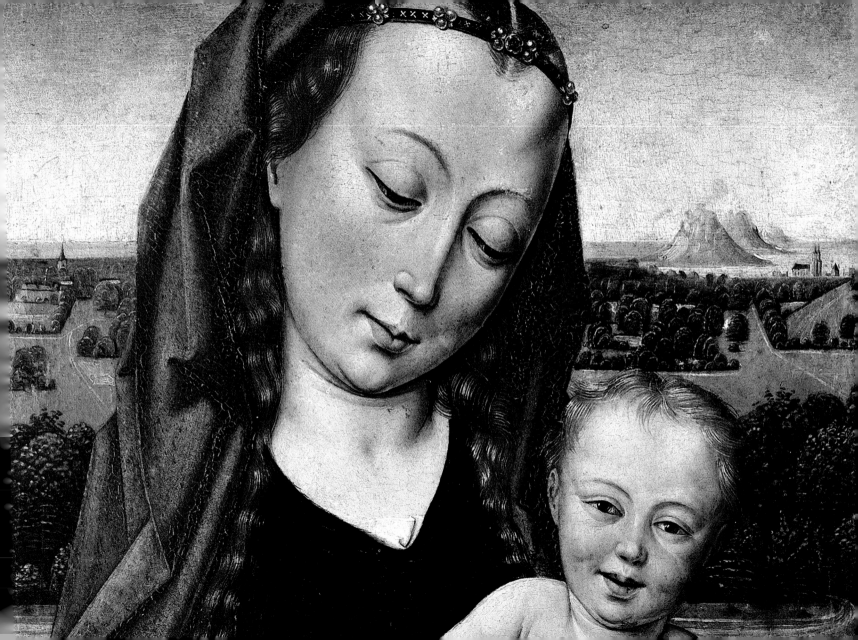

Each work of art excludes the world, concentrates attention on itself.

RALPH WALDO EMERSON

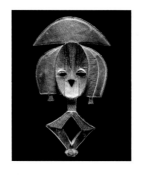

Reliquary figure, wooden mask, *c.* 1900

Gabon

Ethnologisches Museum, Staatliche Museen zu Berlin

1 2 3 4 5 6 7 8 9 10 11 12 **13** 14 15 16 17 18 19 20 21 22 23 24 25 26 27 28 29 30 31

OCTOBER

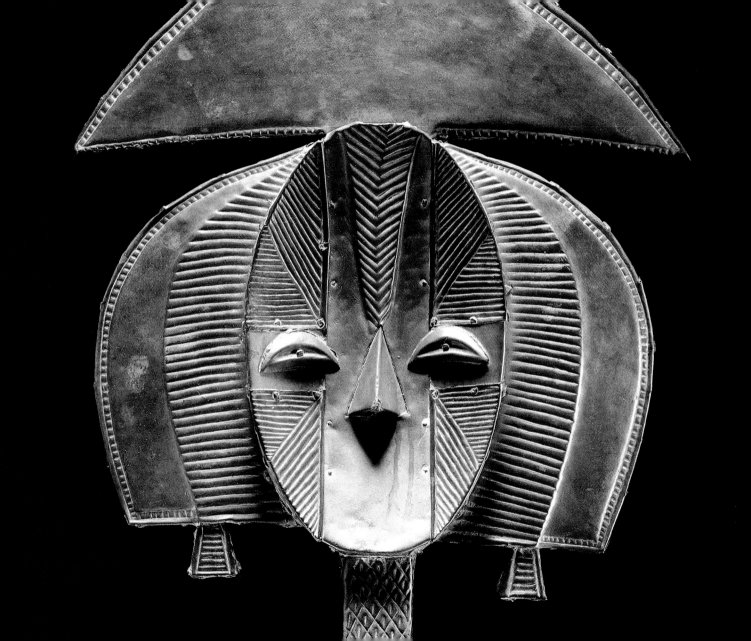

An artist, under pain of oblivion,
must have confidence in himself,
and listen only to his real master:
Nature.

PIERRE-AUGUSTE RENOIR

Children's Afternoon at Wargemont, 1884
Pierre-Auguste Renoir
Nationalgalerie, Staatliche Museen zu Berlin

1 2 3 4 5 6 7 8 9 10 11 12 13 **14** 15 16 17 18 19 20 21 22 23 24 25 26 27 28 29 30 31

OCTOBER

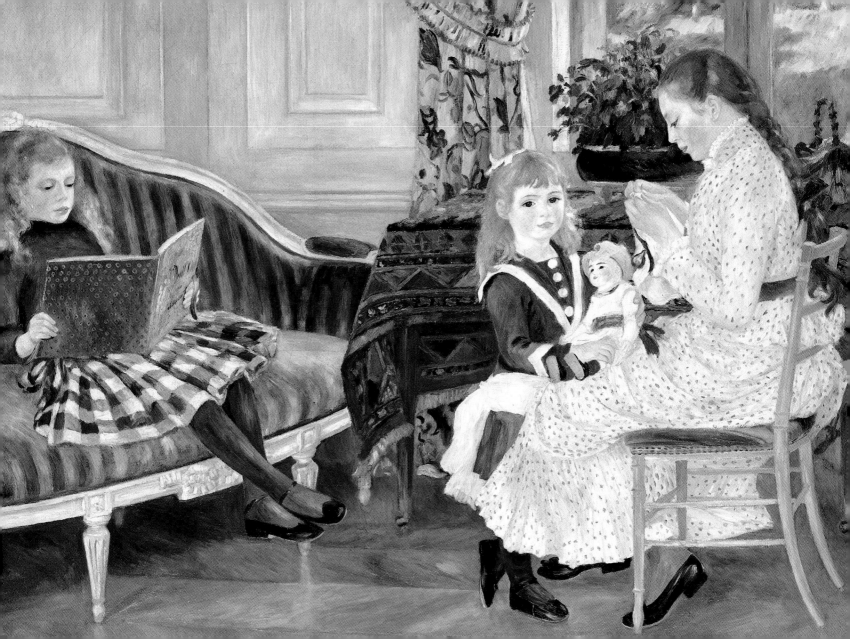

In all things of nature there is something of the marvelous.

<small>ARISTOTLE</small>

Germanic animal sculptures, bronze and silver, 3rd century
Museum für Vor- und Frühgeschichte, Staatliche Museen zu Berlin

1 2 3 4 5 6 7 8 9 10 11 12 13 14 **15** 16 17 18 19 20 21 22 23 24 25 26 27 28 29 30 31

OCTOBER

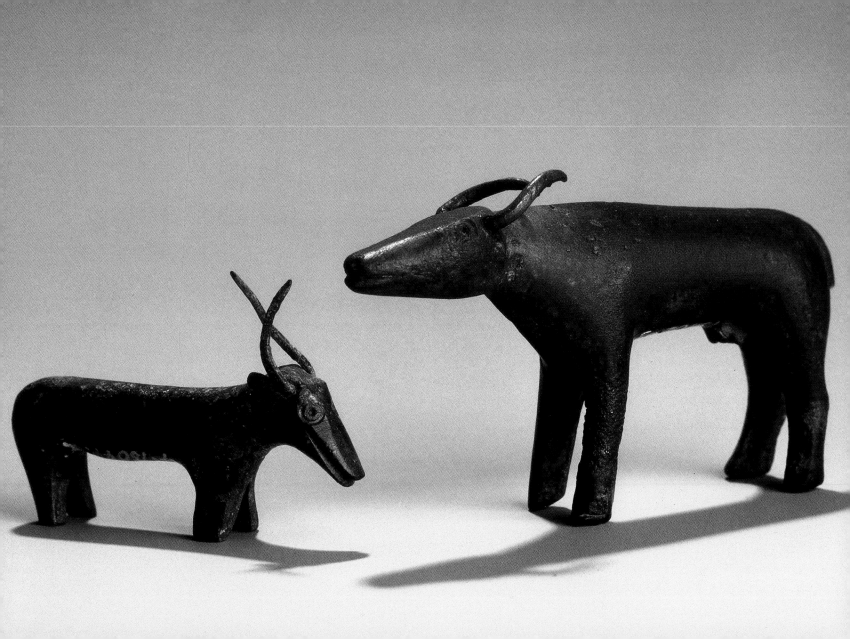

Painting is silent poetry,
poetry is eloquent painting.

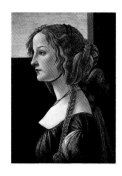

Profile Portrait of a Young Woman
Sandro Botticelli (Workshop)
Gemäldegalerie, Staatliche Museen zu Berlin

1 2 3 4 5 6 7 8 9 10 11 12 13 14 15 **16** 17 18 19 20 21 22 23 24 25 26 27 28 29 30 31

OCTOBER

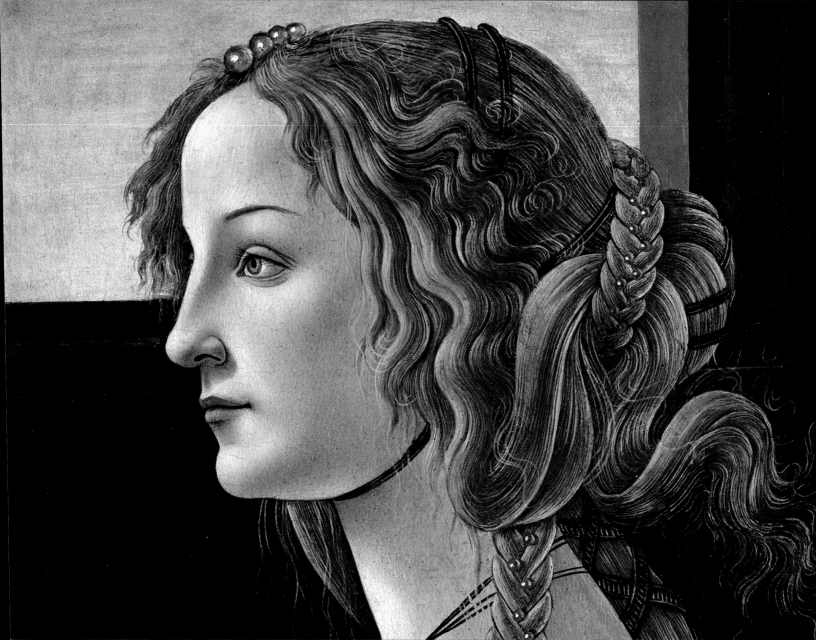

The swan, like the soul of the poet,
By the dull world is ill understood.

Heinrich Heine

Two Swans, *c.* 1863

Adolph von Menzel

Kupferstichkabinett, Staatliche Museen zu Berlin

1 2 3 4 5 6 7 8 9 10 11 12 13 14 15 16 **17** 18 19 20 21 22 23 24 25 26 27 28 29 30 31

OCTOBER

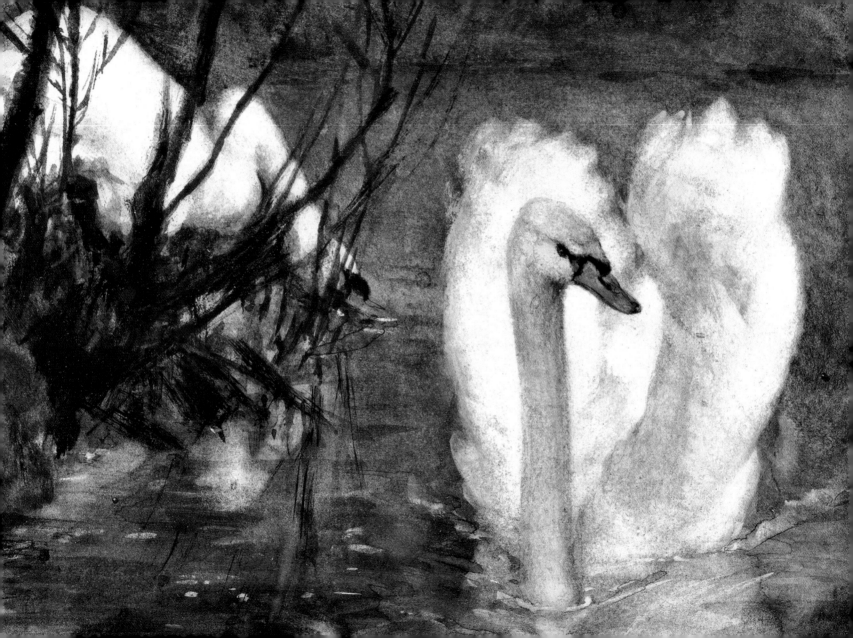

A proverb is a short sentence based on long experience.

Miguel de Cervantes

Dutch Proverbs, 1559
Pieter Bruegel the Elder
Gemäldegalerie, Staatliche Museen zu Berlin

1 2 3 4 5 6 7 8 9 10 11 12 13 14 15 16 17 **18** 19 20 21 22 23 24 25 26 27 28 29 30 31

OCTOBER

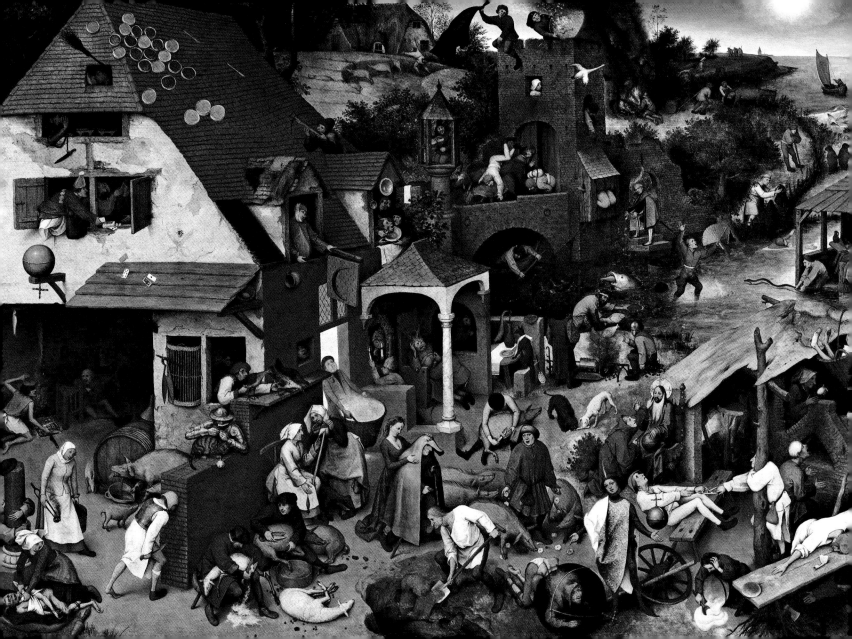

I am convinced that the time will come when hundreds of Englishmen will come to Switzerland for the skiing season. I believe I may be the first, save only two Switzers, to do any mountain work, but I am certain I will not by many thousands be the last.

<small>SIR ARTHUR CONAN DOYLE</small>

Advertising poster for the 1929 Swiss Winter Games in Davos, 1929
Kunstbibliothek, Staatliche Museen zu Berlin

1 2 3 4 5 6 7 8 9 10 11 12 13 14 15 16 17 18 **19** 20 21 22 23 24 25 26 27 28 29 30 31

OCTOBER

Laying out grounds may be considered a liberal art, in some sort like poetry and painting.

Taj Mahal, miniature from the Moghul School, 18th century
Museum für Asiatische Kunst, Staatliche Museen zu Berlin

1 2 3 4 5 6 7 8 9 10 11 12 13 14 15 16 17 18 19 **20** 21 22 23 24 25 26 27 28 29 30 31

OCTOBER

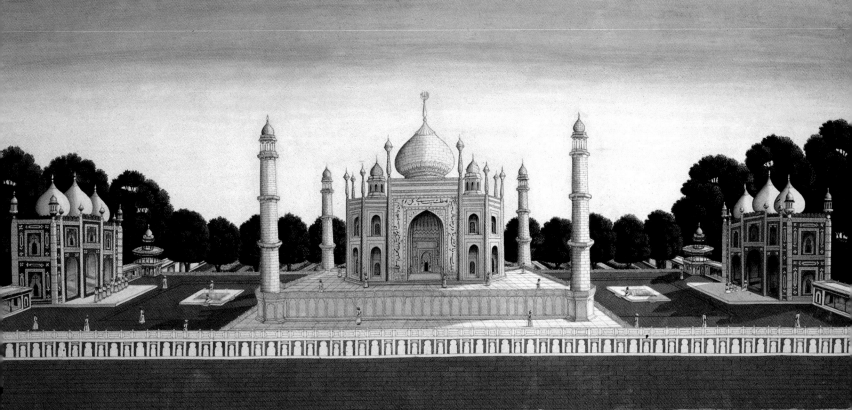

It is not only fine feathers that make fine birds.

Still Life with Pygmy Parrot, Splint Box, Fruit and Fly, *c.* 1610
Georg Flegel
Kupferstichkabinett, Staatliche Museen zu Berlin

Aesop

1 2 3 4 5 6 7 8 9 10 11 12 13 14 15 16 17 18 19 20 **21** 22 23 24 25 26 27 28 29 30 31

OCTOBER

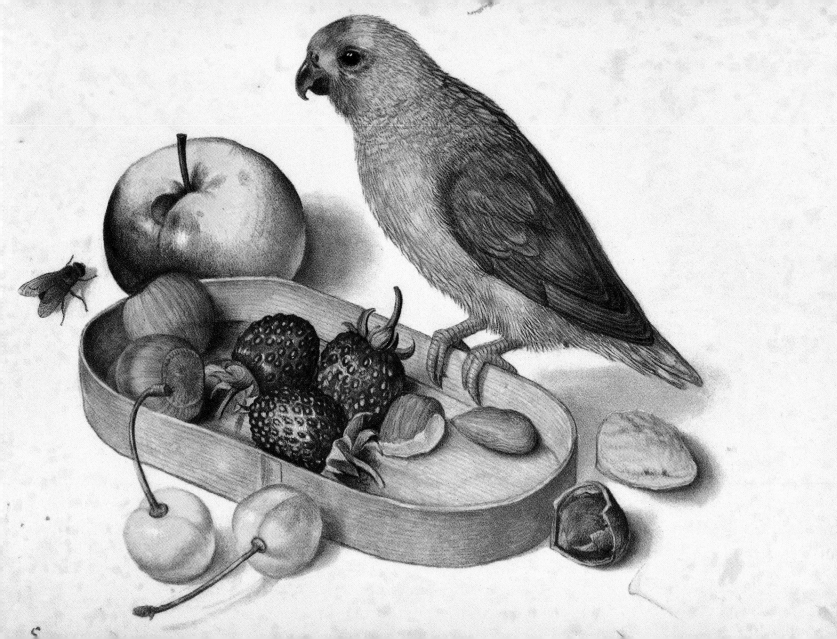

Architecture, of all the arts, is the one which acts the most slowly, but the most surely, on the soul.

ERNEST DIMNET

View of Houses at Schlossfreiheit, 1855
Eduard Gaertner
Nationalgalerie, Staatliche Museen zu Berlin

1 2 3 4 5 6 7 8 9 10 11 12 13 14 15 16 17 18 19 20 21 **22** 23 24 25 26 27 28 29 30 31

OCTOBER

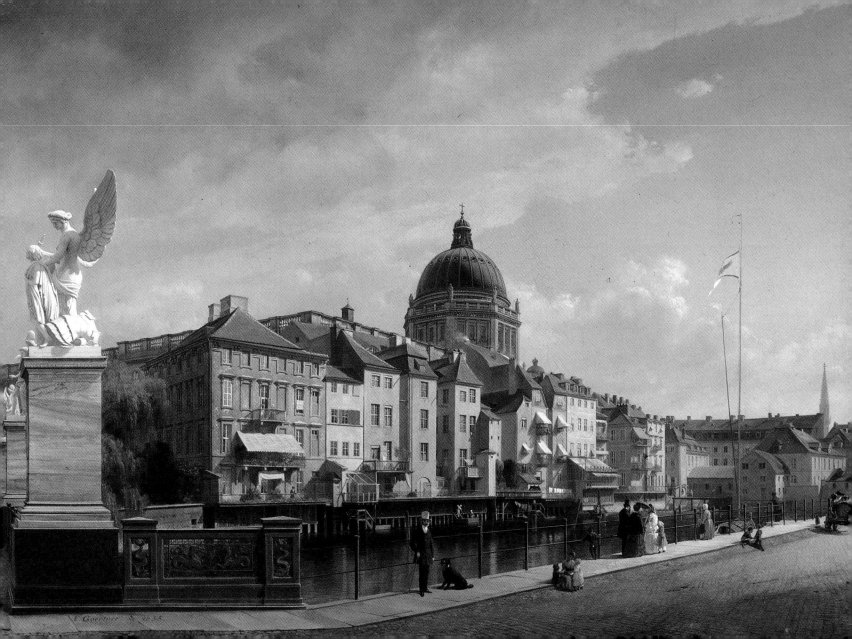

Young Woman on the Beach, 1896
Edvard Munch
Kupferstichkabinett, Staatliche Museen zu Berlin

A dreamer lives for eternity.

<small>ANONYMOUS</small>

1 2 3 4 5 6 7 8 9 10 11 12 13 14 15 16 17 18 19 20 21 22 **23** 24 25 26 27 28 29 30 31

OCTOBER

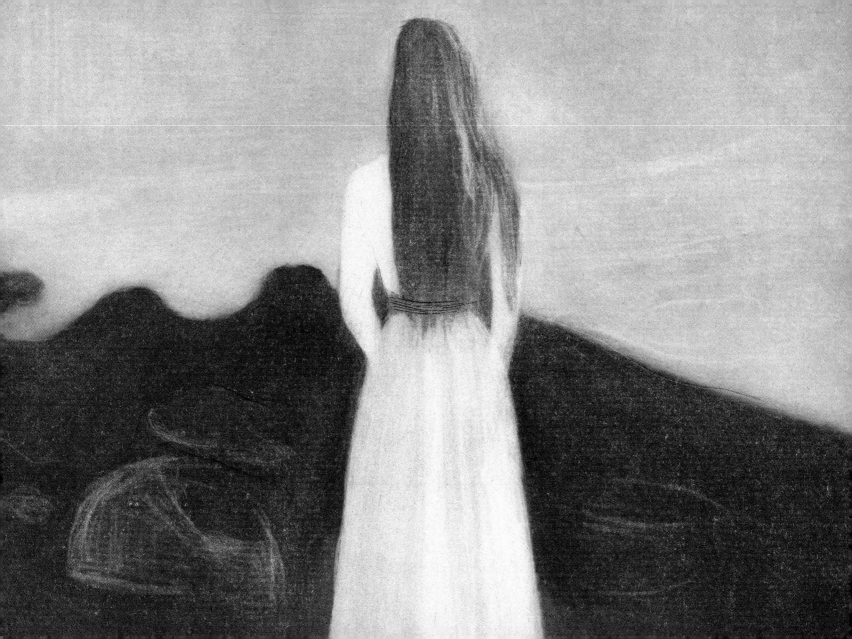

The animal is ignorant of the fact that he knows. The man is aware of the fact that he is ignorant.

Victor Hugo

Stone ram's head, 1070–1046 B. C.
Egypt
Ägyptisches Museum und Papyrussammlung, Staatliche Museen zu Berlin

1 2 3 4 5 6 7 8 9 10 11 12 13 14 15 16 17 18 19 20 21 22 23 **24** 25 26 27 28 29 30 31

OCTOBER

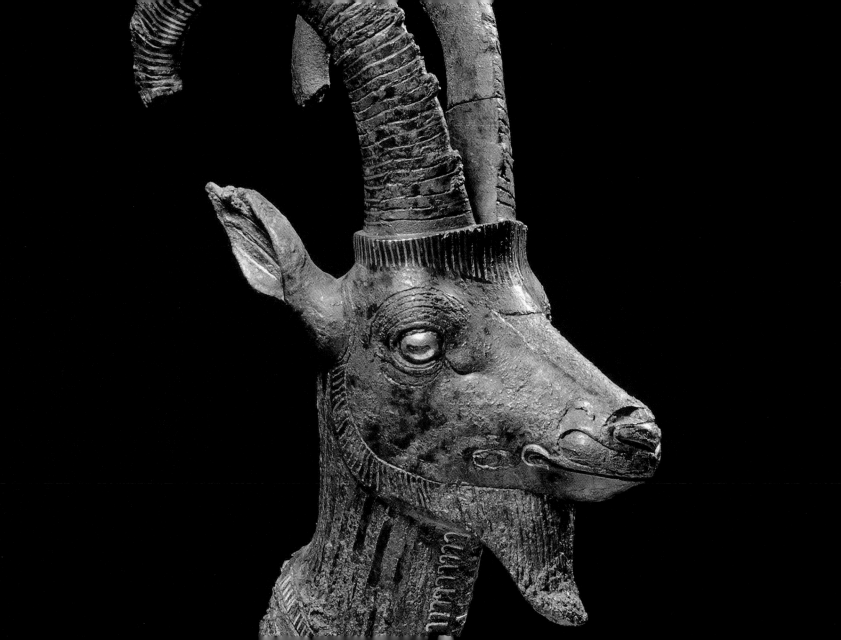

Art owes its origin to Nature herself…
this beautiful creation, the world,
supplied the first model.

GIORGIO VASARI

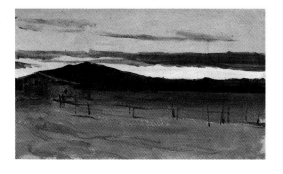

Evening in the Campagna, early 19th century
Carl Blechen
Kupferstichkabinett, Staatliche Museen zu Berlin

1 2 3 4 5 6 7 8 9 10 11 12 13 14 15 16 17 18 19 20 21 22 23 24 **25** 26 27 28 29 30 31

OCTOBER

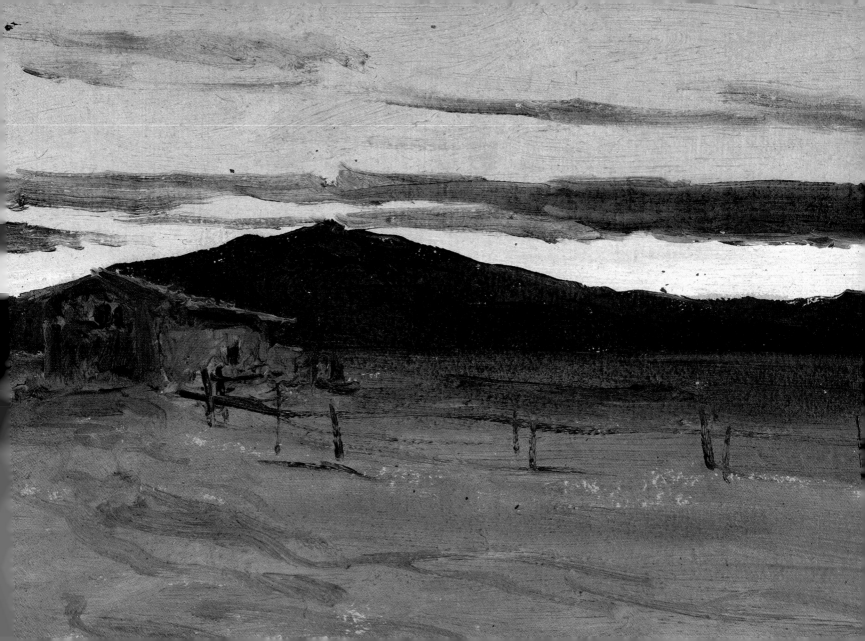

Art is long, and Time is fleeting,
And our hearts, though stout and brave,
Still, like muffled drums, are beating
Funeral marches to the grave.

<small>Henry Wadsworth Longfellow</small>

Family altar, *c.* 1345 B. C.

Egypt

Ägyptisches Museum und Papyrussammlung, Staatliche Museen zu Berlin

1 2 3 4 5 6 7 8 9 10 11 12 13 14 15 16 17 18 19 20 21 22 23 24 25 **26** 27 28 29 30 31

OCTOBER

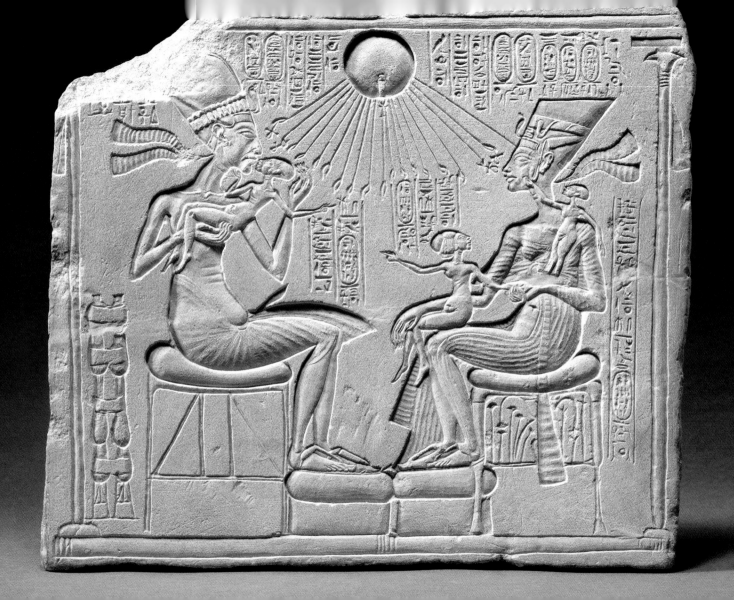

I've always thought flowers had souls.

Lilies (Yuri), *c.* 1830
Katsushika Hokusai
Museum für Asiatische Kunst, Staatliche Museen zu Berlin

1 2 3 4 5 6 7 8 9 10 11 12 13 14 15 16 17 18 19 20 21 22 23 24 25 26 **27** 28 29 30 31

OCTOBER

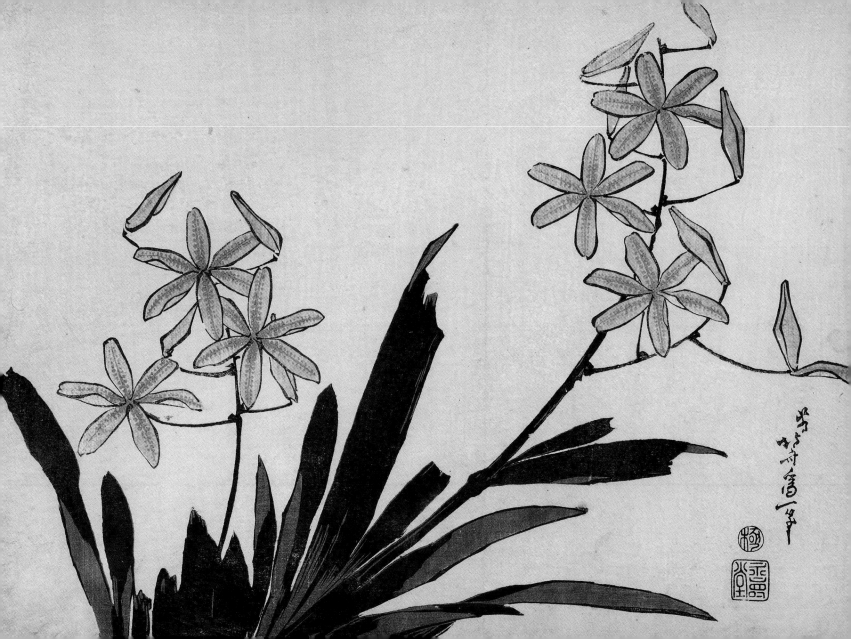

*The most powerful symptom of love
is a tenderness which at times becomes
almost insupportable.*

Amor and Psyche, 1854–1857
Reinhold Begas
Nationalgalerie, Staatliche Museen zu Berlin

1 2 3 4 5 6 7 8 9 10 11 12 13 14 15 16 17 18 19 20 21 22 23 24 25 26 27 **28** 29 30 31

OCTOBER

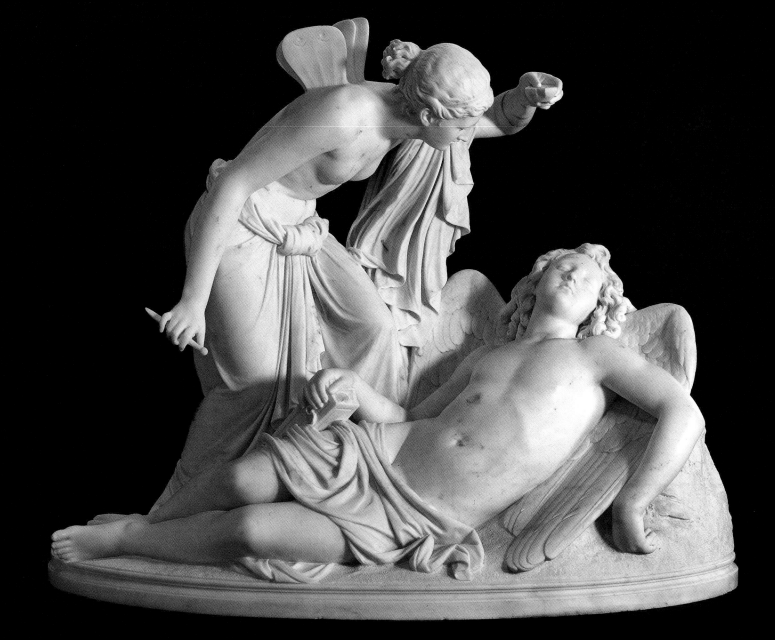

And if I go and prepare a place for you, I will come again, and receive you unto myself; that where I am, there ye may be also.

<small>JOHN 14:3</small>

Farewell to the Apostles in a Sylvan Landscape, *c.* 1523
Albrecht Altdorfer
Gemäldegalerie, Staatliche Museen zu Berlin

1 2 3 4 5 6 7 8 9 10 11 12 13 14 15 16 17 18 19 20 21 22 23 24 25 26 27 28 **29** 30 31

OCTOBER

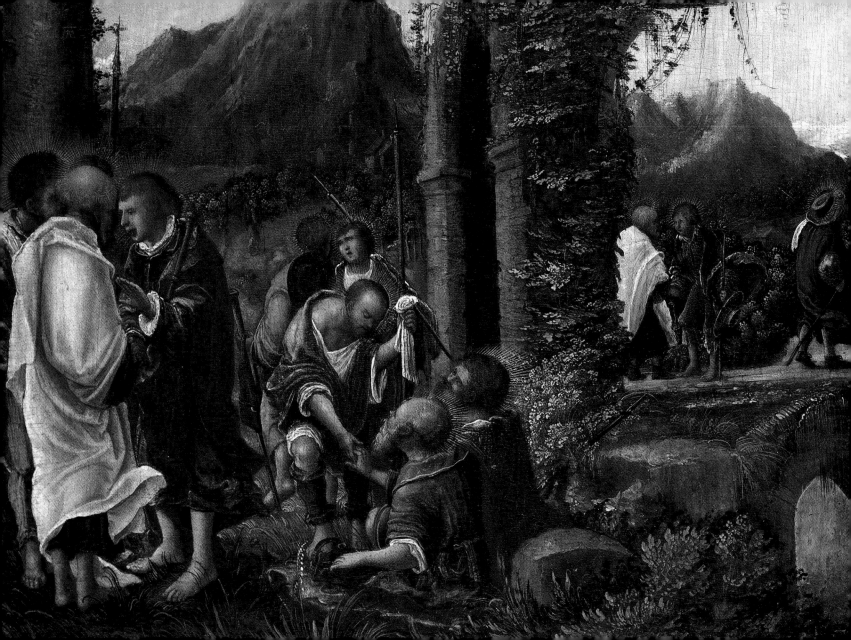

No man should ever display his bravery unless he is prepared for battle, nor bear the marks of defiance, until he has experienced the abilities of his enemy.

<small>HITOPADESA</small>

Heracles and Apollo Fighting Against the Delphic Triclops,
6th century B. C.
Italy
Antikensammlung, Staatliche Museen zu Berlin

1 2 3 4 5 6 7 8 9 10 11 12 13 14 15 16 17 18 19 20 21 22 23 24 25 26 27 28 29 **30** 31

OCTOBER

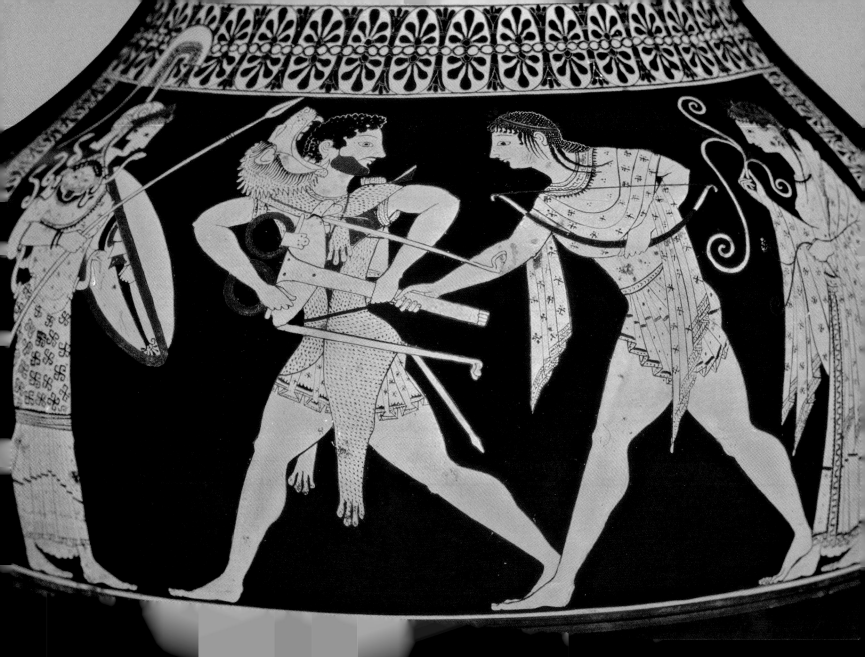

Color has taken hold of me; no longer do I have to chase after it. I know that it has hold of me for ever. That is the significance of this blessed moment.

PAUL KLEE

City Crowned with a Temple, 1917

Paul Klee

Museum Berggruen, Nationalgalerie, Staatliche Museen zu Berlin

1 2 3 4 5 6 7 8 9 10 11 12 13 14 15 16 17 18 19 20 21 22 23 24 25 26 27 28 29 30 **31**

OCTOBER

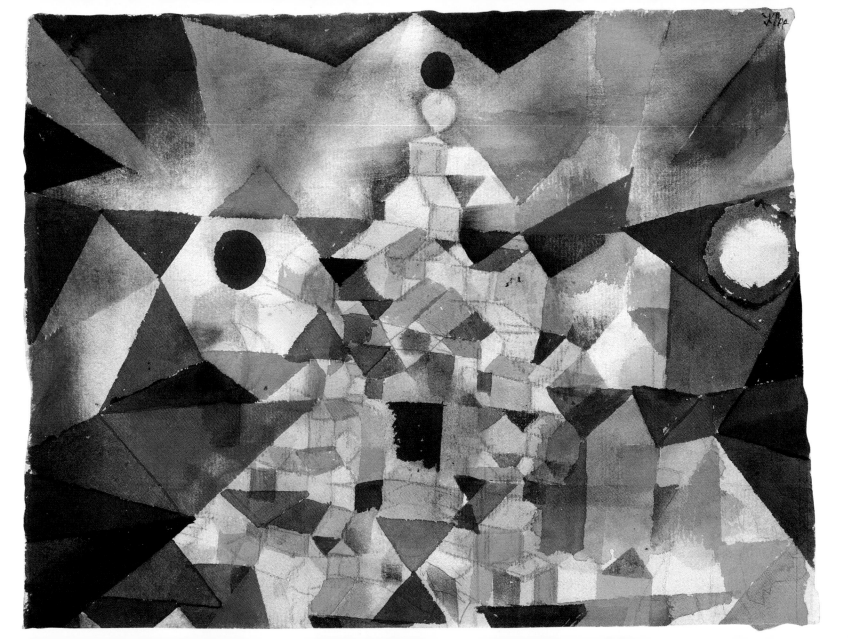

I think I should have no other mortal wants, if I could always have plenty of music.

GEORGE ELIOT

The Flute Concert, *c.* 1850–1852
Adolph von Menzel
Nationalgalerie, Staatliche Museen zu Berlin

1 2 3 4 5 6 7 8 9 10 11 12 13 14 15 16 17 18 19 20 21 22 23 24 25 26 27 28 29 30

NOVEMBER

...the church spire cast a long reflection on the graveyard grass; as if it were a dial... marking, whatever light shone out of Heaven, the flight of days and weeks and years, by some new shadow on that solemn ground.

CHARLES DICKENS

Abbey in Oak Woods, 1809/10
Caspar David Friedrich
Nationalgalerie, Staatliche Museen zu Berlin

1 2 3 4 5 6 7 8 9 10 11 12 13 14 15 16 17 18 19 20 21 22 23 24 25 26 27 28 29 30

NOVEMBER

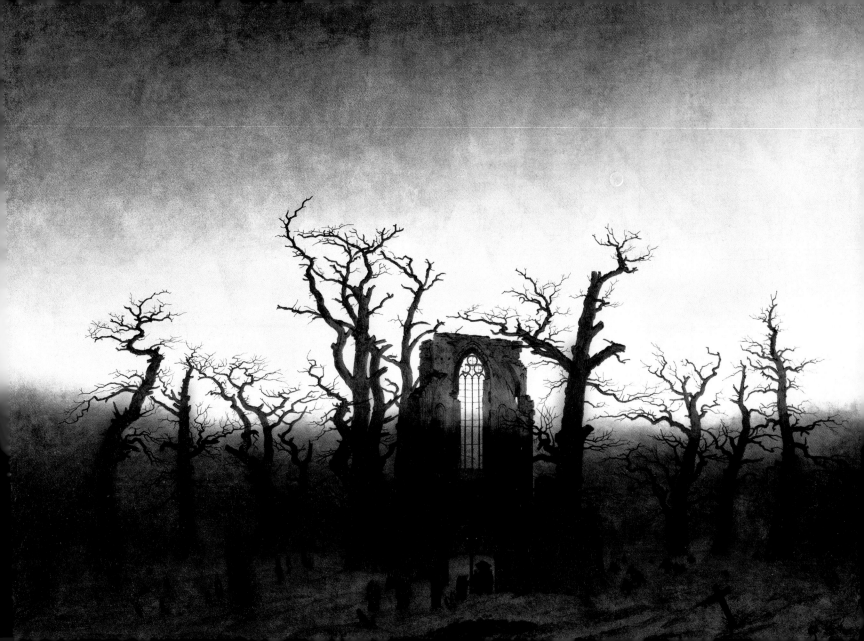

Painters and poets alike have always had licence to dare anything. We know that and we both claim and permit others this indulgence.

HORACE

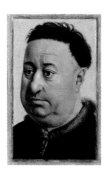

Robert de Masmines
Robert Campin
Gemäldegalerie, Property of the Kaiser Friedrich-Museums-Verein, Staatliche Museen zu Berlin

1 2 **3** 4 5 6 7 8 9 10 11 12 13 14 15 16 17 18 19 20 21 22 23 24 25 26 27 28 29 30

NOVEMBER

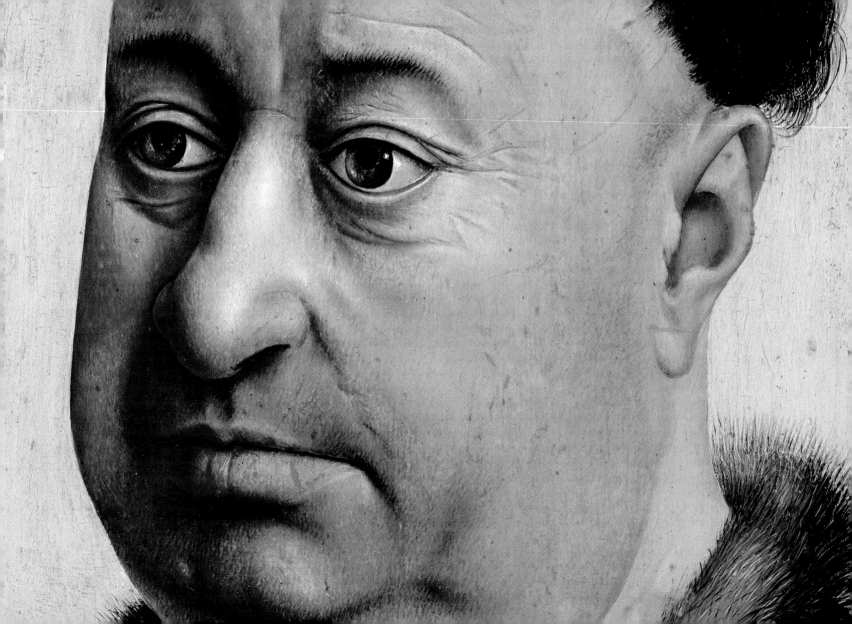

The expense of spirit in a waste of shame
Is lust in action…

WILLIAM SHAKESPEARE

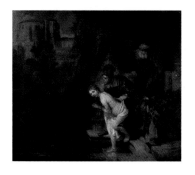

Susanna Surprised by the Elders, 1647
Rembrandt Harmensz van Rijn
Gemäldegalerie, Staatliche Museen zu Berlin

1 2 3 **4** 5 6 7 8 9 10 11 12 13 14 15 16 17 18 19 20 21 22 23 24 25 26 27 28 29 30

NOVEMBER

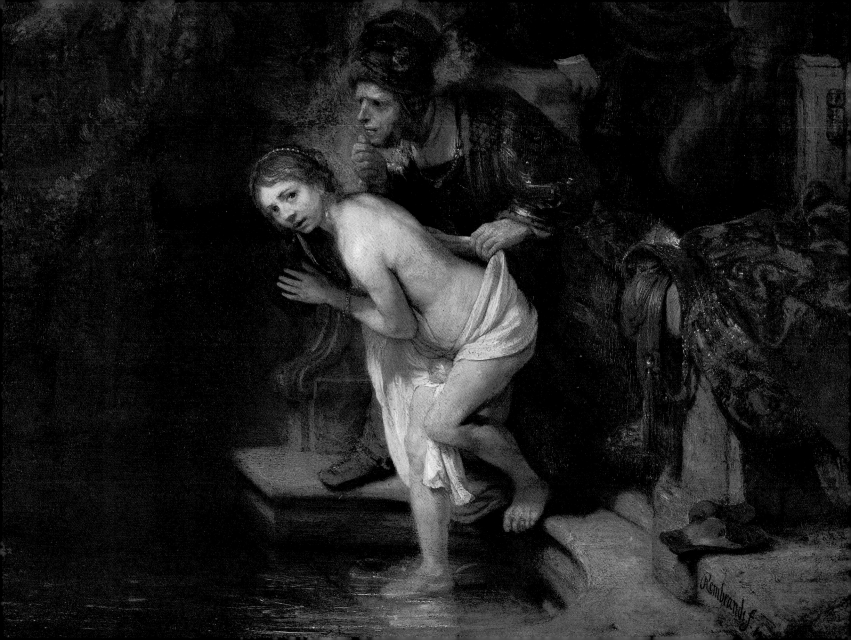

No, painting is not made to decorate apartments. It's an offensive and defensive weapon against the enemy.

<small>Pablo Picasso</small>

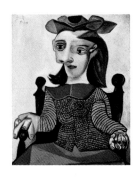

The Yellow Sweater, 1939
Pablo Picasso
Museum Berggruen, Nationalgalerie, Staatliche Museen zu Berlin

1 2 3 4 **5** 6 7 8 9 10 11 12 13 14 15 16 17 18 19 20 21 22 23 24 25 26 27 28 29 30

NOVEMBER

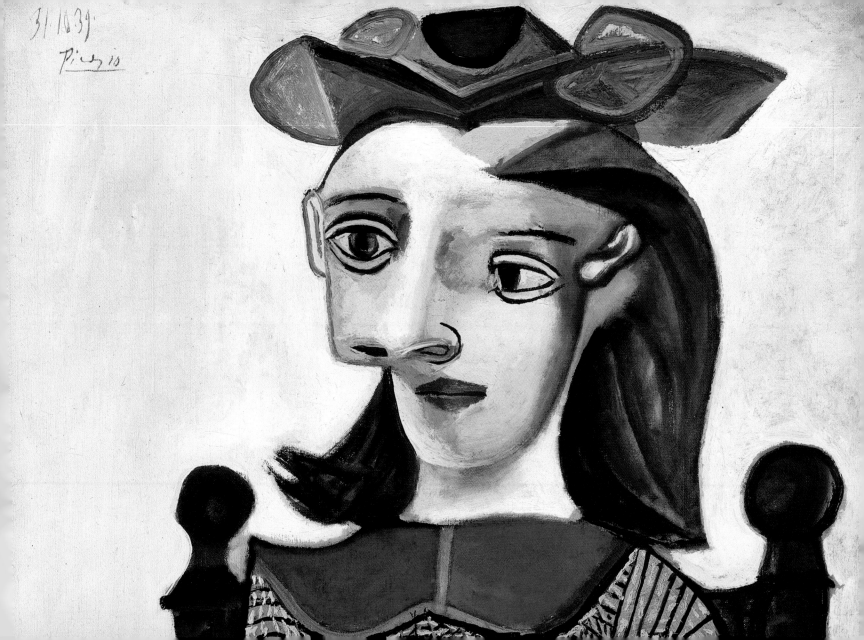

*Where the spirit does not work
with the hand there is no art.*

<small>LEONARDO DA VINCI</small>

Four Hands, 15th or early 16th century
Hans Holbein the Elder
Kupferstichkabinett, Staatliche Museen zu Berlin

1 2 3 4 5 **6** 7 8 9 10 11 12 13 14 15 16 17 18 19 20 21 22 23 24 25 26 27 28 29 30

NOVEMBER

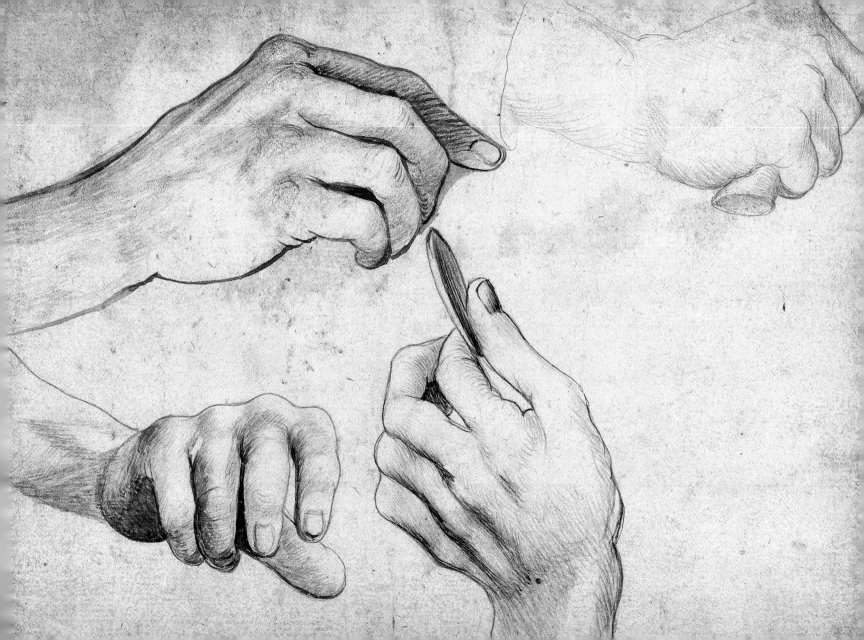

He who fights with monsters might take care lest he thereby become a monster. And if you gaze for long into an abyss, the abyss gazes also into you.

<small>Friedrich Nietzsche</small>

The Vampire, 1853
Charles Méryon
Sammlung Scharf-Gerstenberg, Staatliche Museen zu Berlin

1 2 3 4 5 6 **7** 8 9 10 11 12 13 14 15 16 17 18 19 20 21 22 23 24 25 26 27 28 29 30

November

I am certain of nothing but the holiness of the heart's affections and the truth of imagination—what the imagination seizes as beauty must be truth—wether it existed or not.

<small>JOHN KEATS</small>

LA BELLE AUX MOINEAUX
Robe de Visite de Paquin

The Beauty and the Sparrows: Afternoon Costume by Doucet,
1912
based on a drawing by Georges Barbier
Kunstbibliothek, Staatliche Museen zu Berlin

8

1 2 3 4 5 6 7 **8** 9 10 11 12 13 14 15 16 17 18 19 20 21 22 23 24 25 26 27 28 29 30

NOVEMBER

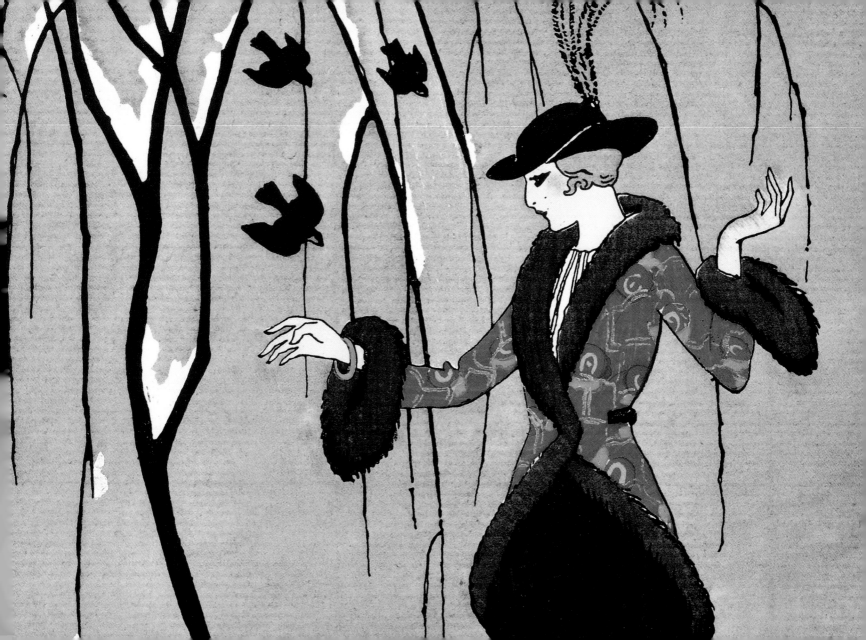

Maid of Athens, ere we part,
Give, oh, give me back my heart!
Or, since that has left my breast,
Keep it now, and take the rest!

LORD BYRON

Bowl, center image showing Minerva/Athena at the helm,
1st century B. C.
Antikensammlung, Staatliche Museen zu Berlin

9

1 2 3 4 5 6 7 8 **9** 10 11 12 13 14 15 16 17 18 19 20 21 22 23 24 25 26 27 28 29 30

NOVEMBER

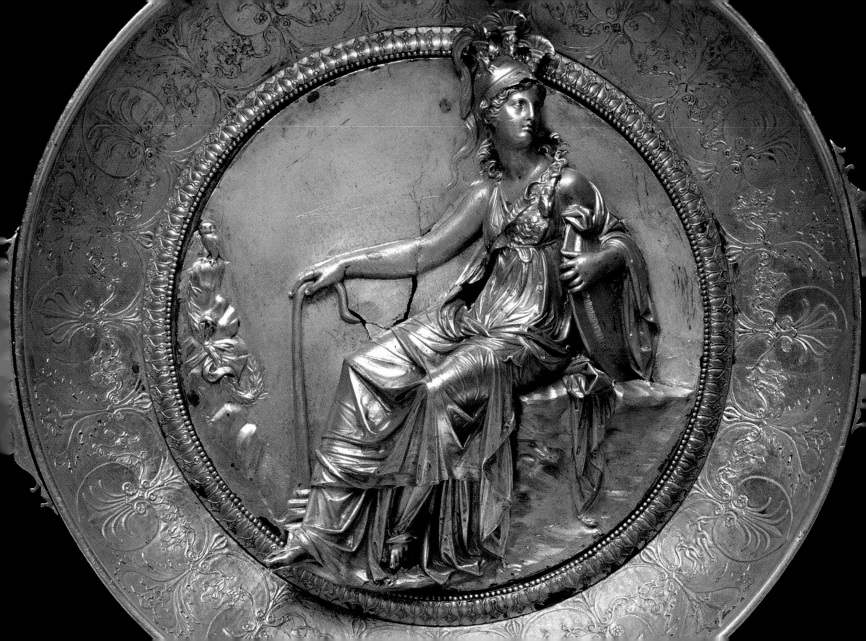

Faith is an excitement and an enthusiasm; it is a condition of intellectual magnificence to which we must cling as to a treasure, and not squander on our way through life in the small coin of empty words, or in exact and priggish argument.

GEORGE SAND

The Sermon of John the Baptist, 15th century
Dierc Bouts
Gemäldegalerie, Staatliche Museen zu Berlin

1 2 3 4 5 6 7 8 9 **10** 11 12 13 14 15 16 17 18 19 20 21 22 23 24 25 26 27 28 29 30

NOVEMBER

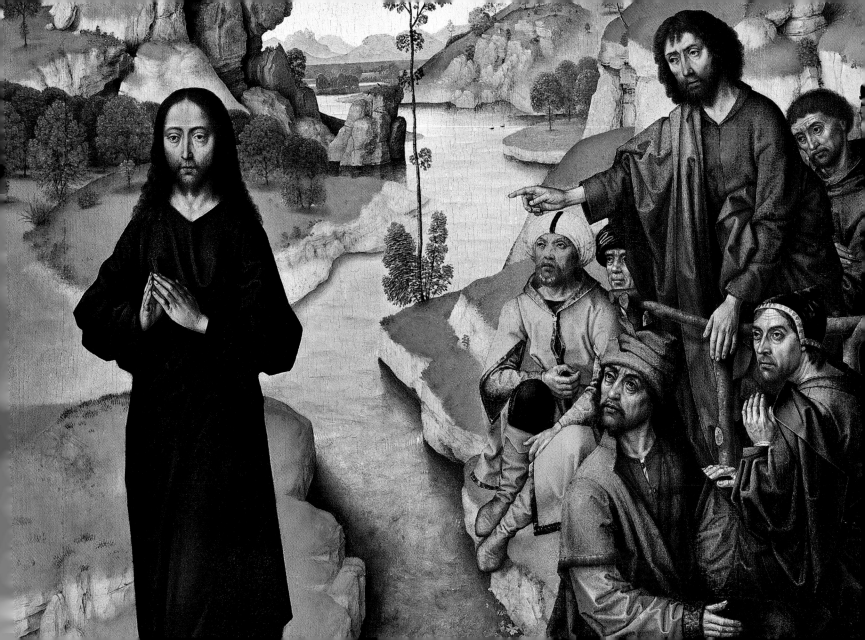

My heart beats more for a raw, average vulgar art, which doesn't live between sleepy fairy-tale moods and poetry but rather concedes a direct entrance to the fearful, commonplace, splendid and the average grotesque banality in life.

MAX BECKMANN

Autumn Still Life with Grapes, 1939

Max Beckmann

Nationalgalerie, Staatliche Museen zu Berlin

1 2 3 4 5 6 7 8 9 10 **11** 12 13 14 15 16 17 18 19 20 21 22 23 24 25 26 27 28 29 30

NOVEMBER

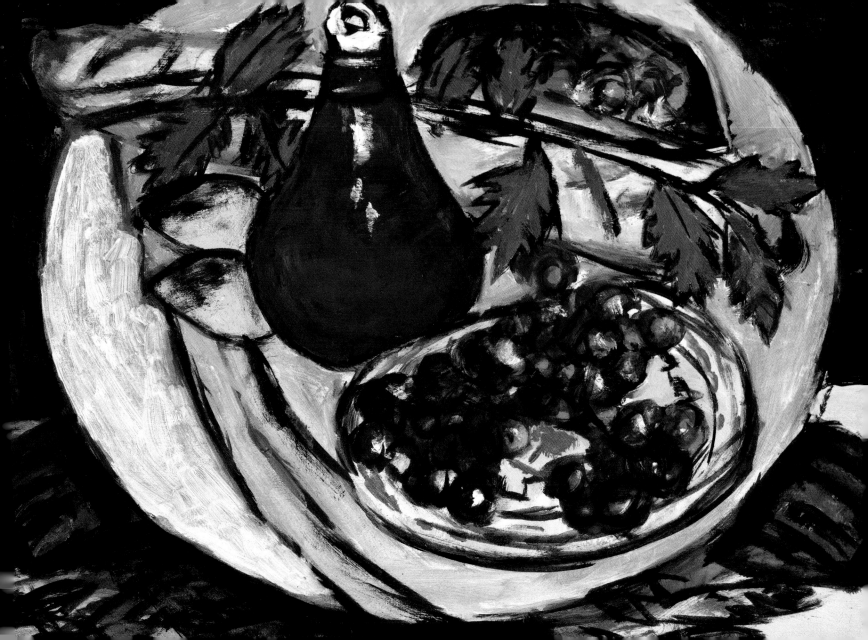

The Naming of Cats is a difficult matter,
It isn't just one of your holiday games;
At first you may think I'm as mad as a hatter
When I tell you a cat must have THREE
DIFFERENT NAMES.

GEORGE ELIOT

Big sitting cat, 664–332 B. C.
Egypt
Ägyptisches Museum und Papyrussammlung, Staatliche Museen zu Berlin

1 2 3 4 5 6 7 8 9 10 11 **12** 13 14 15 16 17 18 19 20 21 22 23 24 25 26 27 28 29 30

NOVEMBER

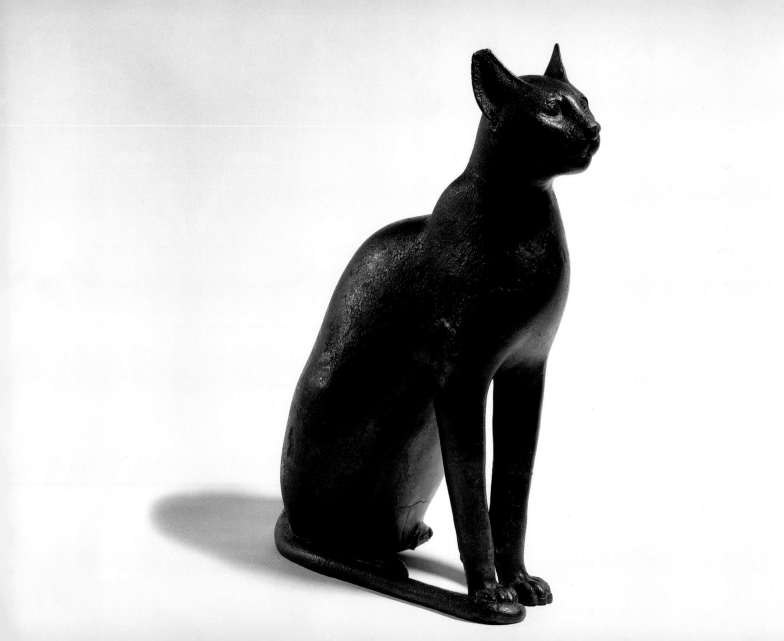

There are no rules of architecture
for a castle in the clouds.

GILBERT KEITH CHESTERTON

View of Haarlem from the Northwest Dunes, 17th century
Jacob van Ruisdael
Gemäldegalerie, Staatliche Museen zu Berlin

1 2 3 4 5 6 7 8 9 10 11 12 **13** 14 15 16 17 18 19 20 21 22 23 24 25 26 27 28 29 30

NOVEMBER

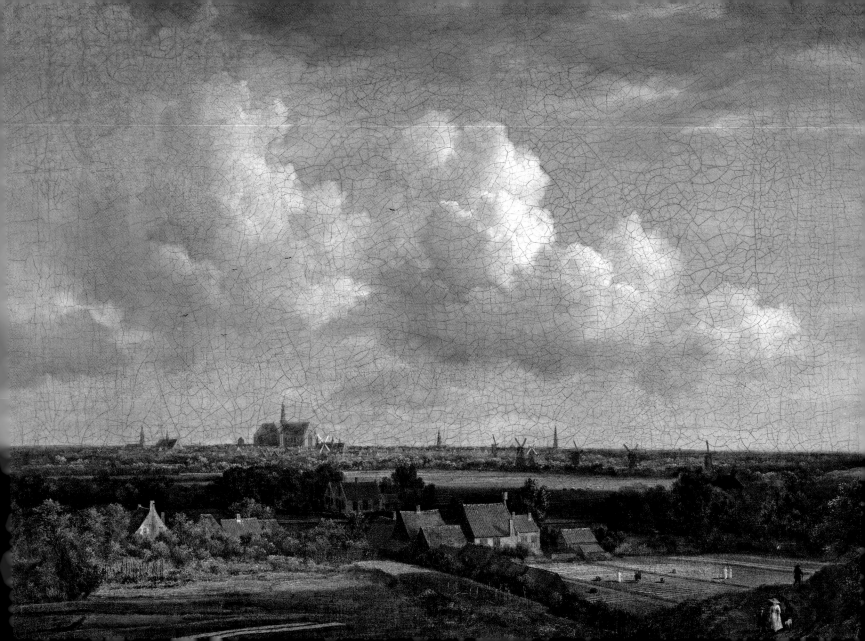

*The English winter—ending in July,
to recommence in August.*

LORD BYRON

Singing Boy with Flute, c. 1623–1625

Frans Hals

Gemäldegalerie, Staatliche Museen zu Berlin

1 2 3 4 5 6 7 8 9 10 11 12 13 **14** 15 16 17 18 19 20 21 22 23 24 25 26 27 28 29 30

NOVEMBER

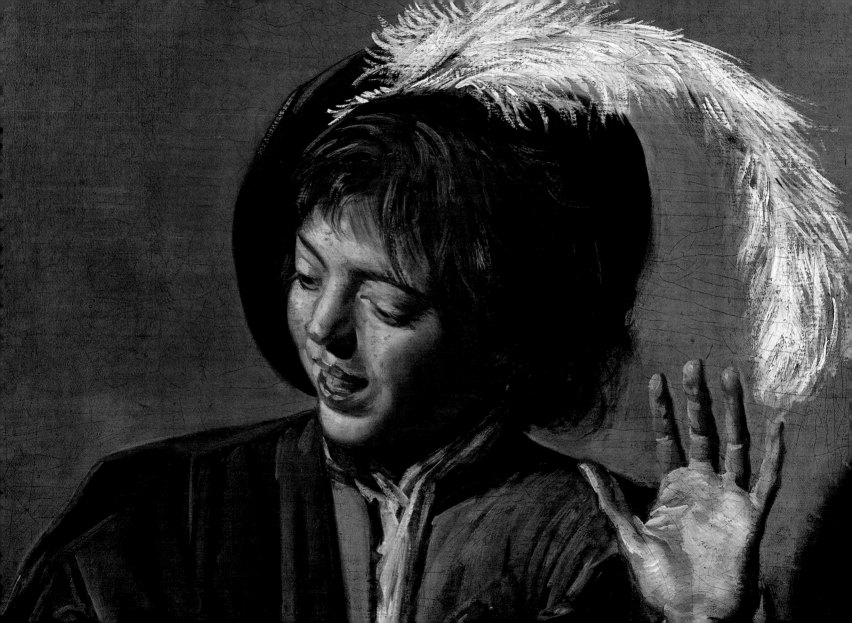

Love of beauty is taste.
The creation of beauty is art.

Statuette of a woman lying down, 1st century B. C. – 2nd century A. D.
Vorderasiatisches Museum, Staatliche Museen zu Berlin

1 2 3 4 5 6 7 8 9 10 11 12 13 14 **15** 16 17 18 19 20 21 22 23 24 25 26 27 28 29 30

NOVEMBER

The sea is everything....
Its breath is pure and healthy.

Marine Station on Capri, early 19th century
Carl Blechen
Kupferstichkabinett, Staatliche Museen zu Berlin

1 2 3 4 5 6 7 8 9 10 11 12 13 14 15 **16** 17 18 19 20 21 22 23 24 25 26 27 28 29 30

NOVEMBER

I am never better than when I am mad.
Then methinks I am a brave fellow; then
I do wonders. But reason abuseth me, and
there's the torment, there's the hell.

Thomas Kyd

Nagoya Sanza and Fuwa Banzaemon, 1855
Utagawa Kunisada
Museum für Asiatische Kunst, Staatliche Museen zu Berlin

1 2 3 4 5 6 7 8 9 10 11 12 13 14 15 16 **17** 18 19 20 21 22 23 24 25 26 27 28 29 30

November

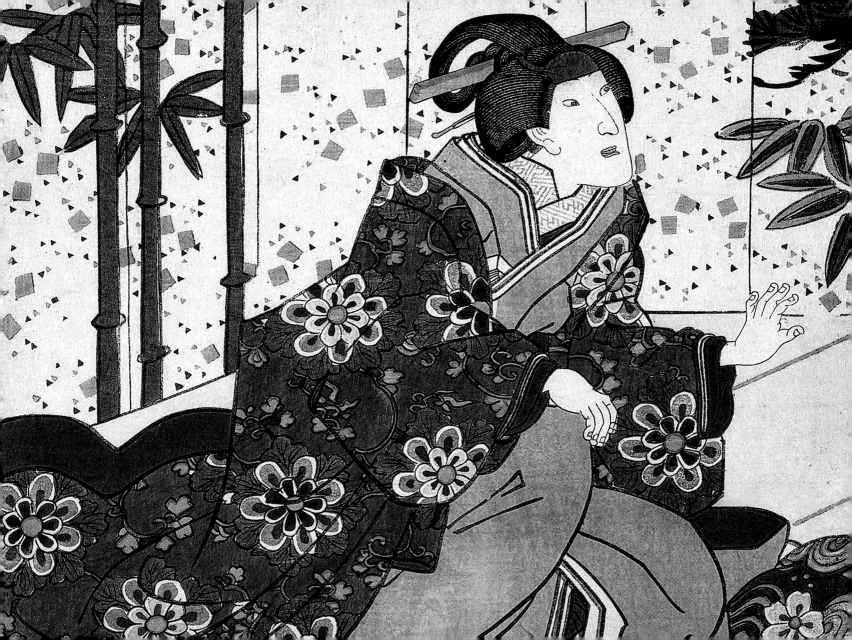

Virtue is like a rich stone, best plain set.

FRANCIS BACON

Symbol of the god of fertility Dumuzi, rosette wall decoration,
c. 2600 B. C.

Uruk

Vorderasiatisches Museum, Staatliche Museen zu Berlin

1 2 3 4 5 6 7 8 9 10 11 12 13 14 15 16 17 **18** 19 20 21 22 23 24 25 26 27 28 29 30

NOVEMBER

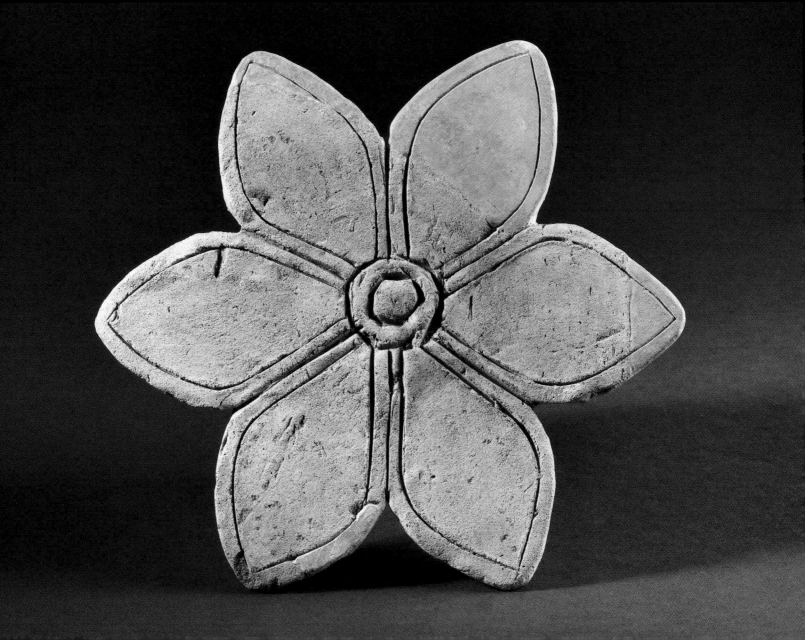

Who loves not woman, wine, and song
Remains a fool his whole life long.

<small>MARTIN LUTHER</small>

Portrait of Martin Luther
Lucas Cranach the Elder (Workshop)
Gemäldegalerie, Staatliche Museen zu Berlin

1 2 3 4 5 6 7 8 9 10 11 12 13 14 15 16 17 18 **19** 20 21 22 23 24 25 26 27 28 29 30

NOVEMBER

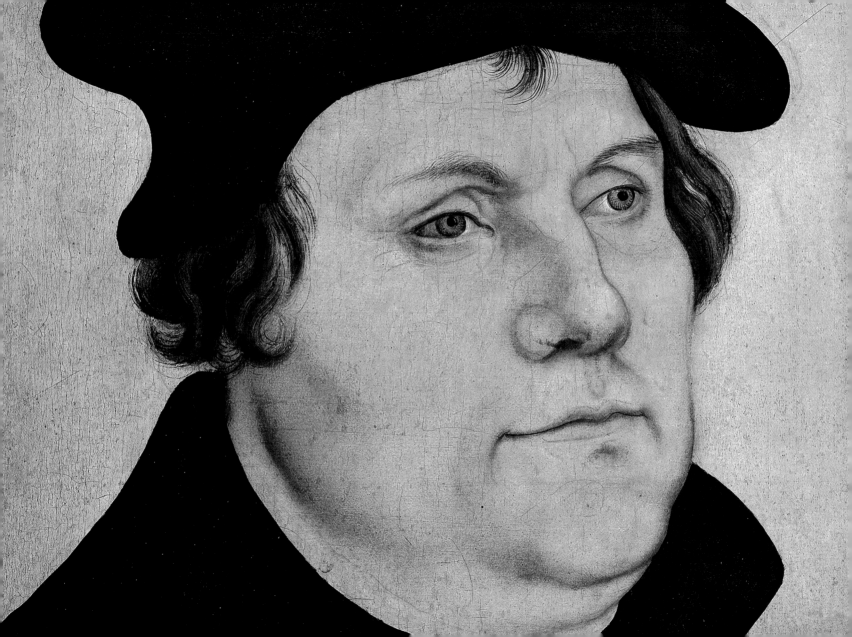

*How does the meadow-flower
its bloom unfold?
Because the lovely little flower is free
Down to its root, and in that
freedom bold.*

WILLIAM WORDSWORTH

Little Heath Princess, 1889
Fritz von Uhde
Nationalgalerie, Staatliche Museen zu Berlin

1 2 3 4 5 6 7 8 9 10 11 12 13 14 15 16 17 18 19 **20** 21 22 23 24 25 26 27 28 29 30

NOVEMBER

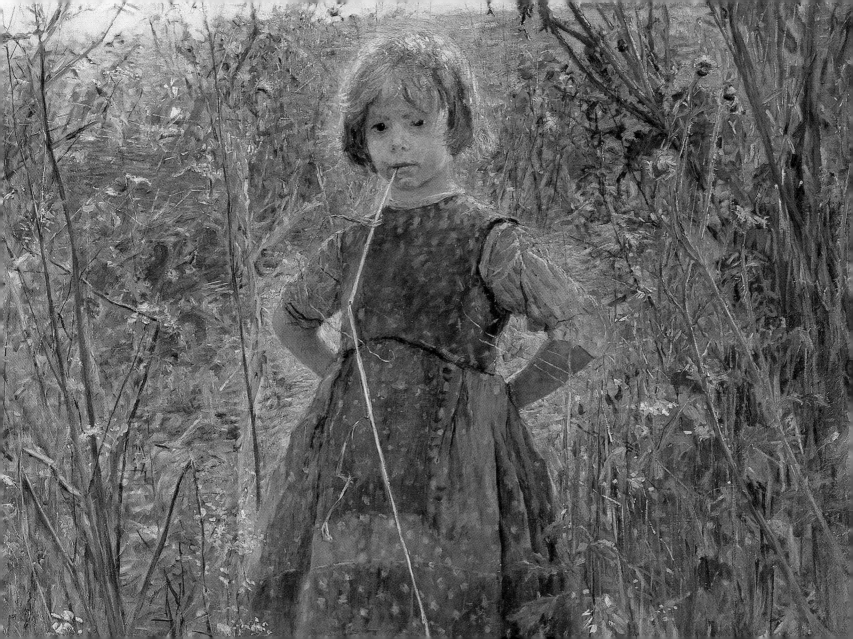

The good seaman weathers the storm he cannot avoid, and avoids the storm he cannot weather.

PROVERB

The Wave, 1870
Gustave Courbet
Nationalgalerie, Staatliche Museen zu Berlin

1 2 3 4 5 6 7 8 9 10 11 12 13 14 15 16 17 18 19 20 **21** 22 23 24 25 26 27 28 29 30

NOVEMBER

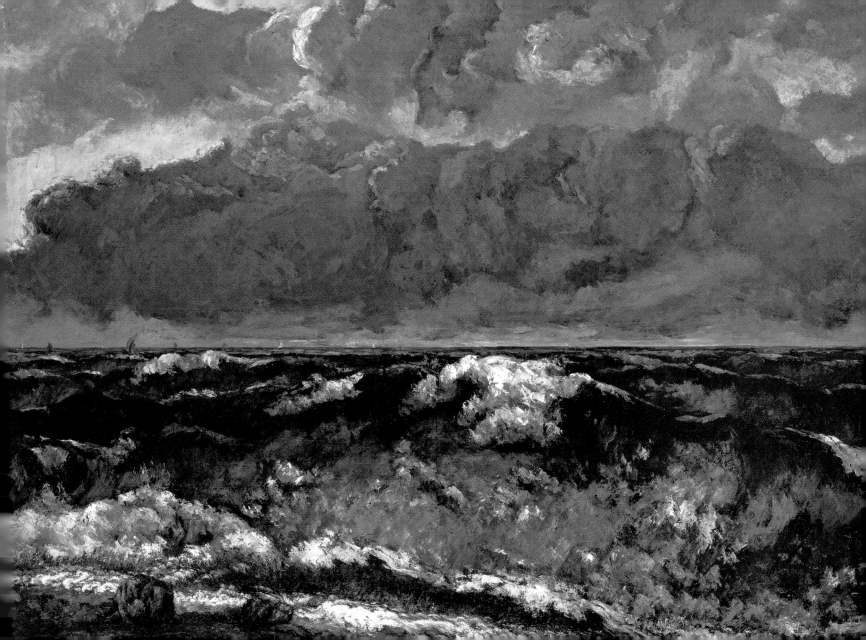

The one excellent thing that can be learned from a lion is that whatever a man intends doing should be done by him with a whole-hearted and strenuous effort.

Chanakya

Lion, bronze fountain sculpture, 11th-12th century
Museum für Islamische Kunst, Staatliche Museen zu Berlin

1 2 3 4 5 6 7 8 9 10 11 12 13 14 15 16 17 18 19 20 21 **22** 23 24 25 26 27 28 29 30

November

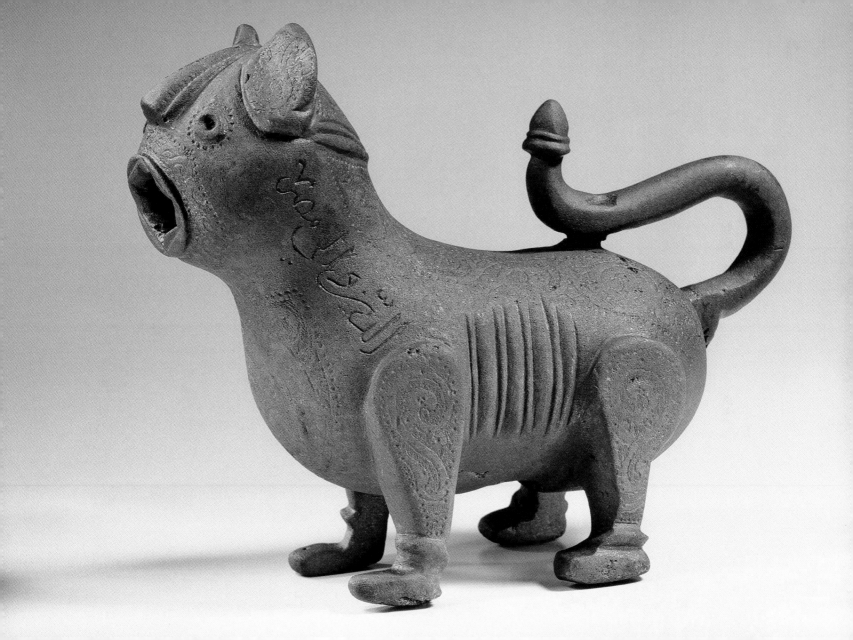

God made the country, and man made the town.

WILLIAM COWPER

Dam Square in Amsterdam, *c.* 1670
Jacob van Ruisdael
Gemäldegalerie, Staatliche Museen zu Berlin

1 2 3 4 5 6 7 8 9 10 11 12 13 14 15 16 17 18 19 20 21 22 **23** 24 25 26 27 28 29 30

NOVEMBER

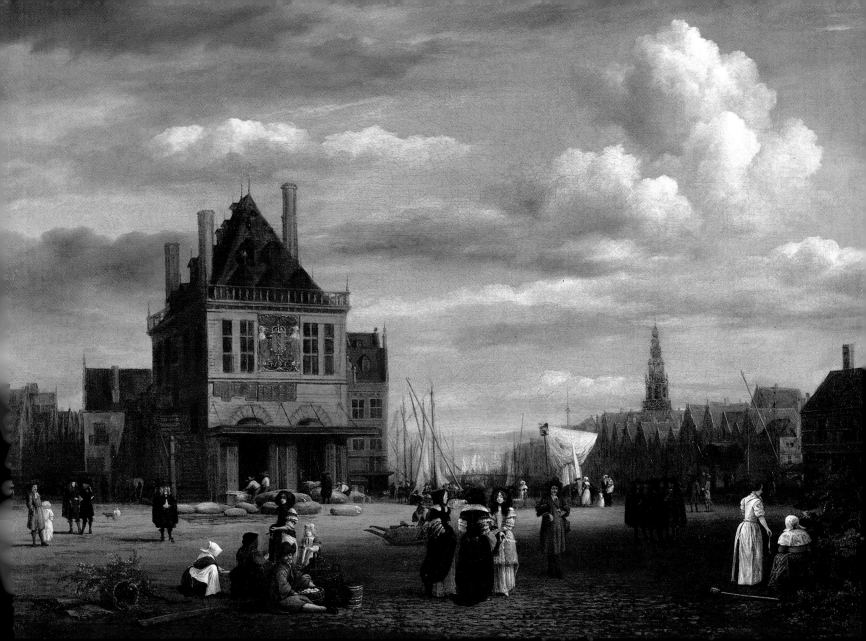

All our knowledge has its origins in our perceptions.

Leonardo da Vinci

Caricature
after Leonardo da Vinci
Kupferstichkabinett, Staatliche Museen zu Berlin

1 2 3 4 5 6 7 8 9 10 11 12 13 14 15 16 17 18 19 20 21 22 23 **24** 25 26 27 28 29 30

NOVEMBER

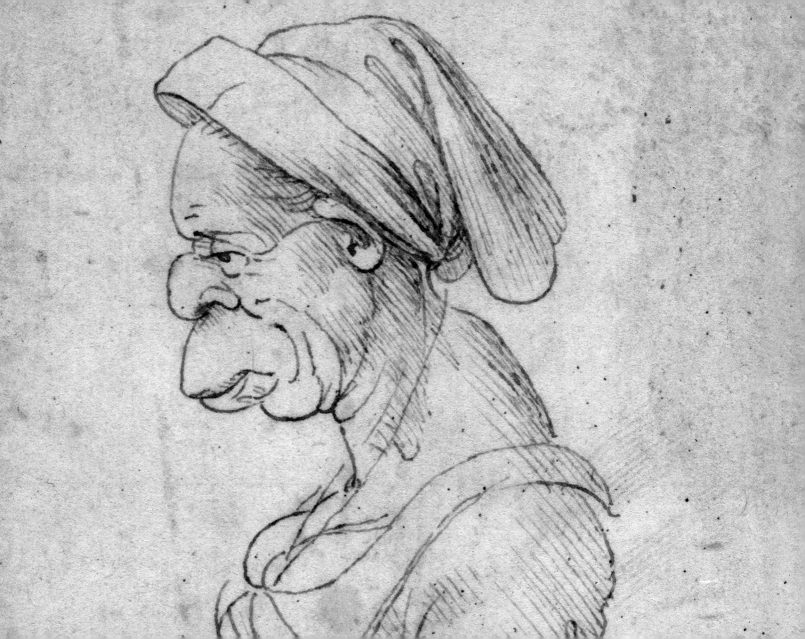

The human heart is like a ship on a stormy sea driven about by winds blowing from all four corners of heaven.

MARTIN LUTHER

The Monk by the Sea, 1809
Caspar David Friedrich
Nationalgalerie, Staatliche Museen zu Berlin

1 2 3 4 5 6 7 8 9 10 11 12 13 14 15 16 17 18 19 20 21 22 23 24 **25** 26 27 28 29 30

NOVEMBER

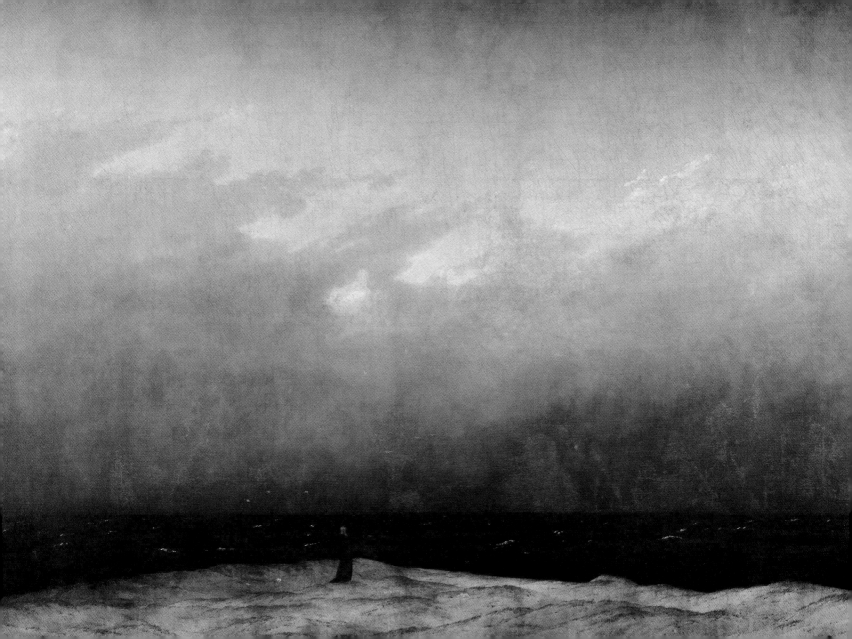

Beauty is a precious trace that eternity causes to appear to us and that it takes away from us. A manifestation of eternity, and a sign of death as well.

EUGÈNE IONESCO

Woman with double-strand pearl necklace, mummy portait,
c. 150 A.D.
Egypt
Antikensammlung, Staatliche Museen zu Berlin

1 2 3 4 5 6 7 8 9 10 11 12 13 14 15 16 17 18 19 20 21 22 23 24 25 **26** 27 28 29 30

NOVEMBER

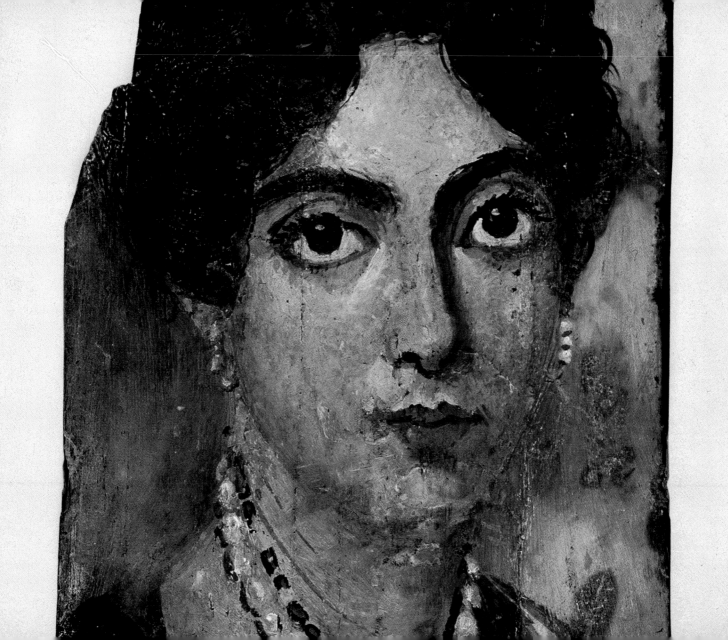

Life is doubt, and faith without doubt is nothing but death.

Enthroned Mary and Child, *c. 1480–1490*
Hans Memling
Gemäldegalerie, Staatliche Museen zu Berlin

1 2 3 4 5 6 7 8 9 10 11 12 13 14 15 16 17 18 19 20 21 22 23 24 25 26 **27** 28 29 30

November

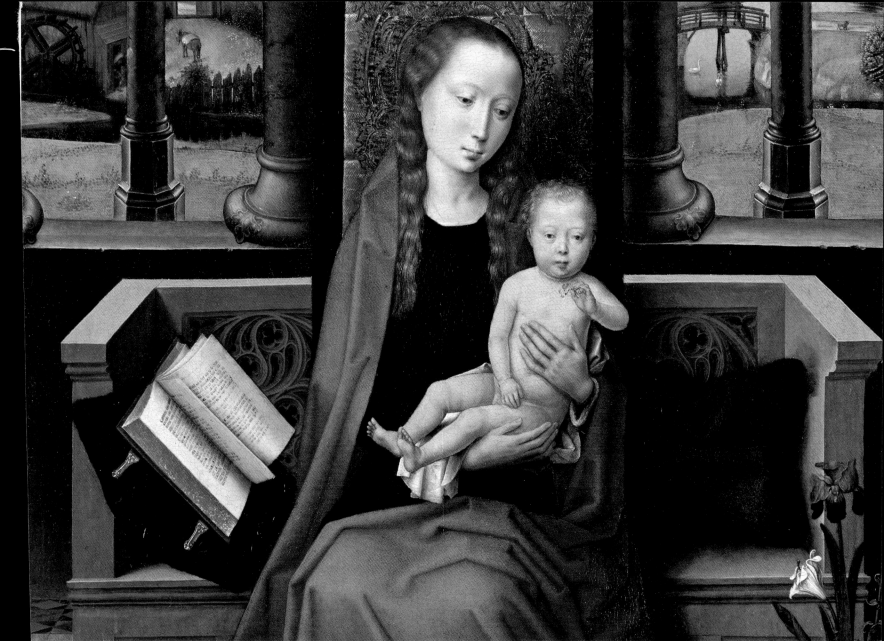

Art is the illusion of spontaneity.

Japanese Proverb

Noh mask, *c.* 1850

Japan

Museum für Asiatische Kunst, Staatliche Museen zu Berlin

1 2 3 4 5 6 7 8 9 10 11 12 13 14 15 16 17 18 19 20 21 22 23 24 25 26 27 **28** 29 30

NOVEMBER

We all know that Art is not truth.
Art is a lie that makes us realize truth.

<small>PABLO PICASSO</small>

Sitting Nude Drying Her Feet, 1921
Pablo Picasso
Museum Berggruen, Nationalgalerie, Staatliche Museen zu Berlin

1 2 3 4 5 6 7 8 9 10 11 12 13 14 15 16 17 18 19 20 21 22 23 24 25 26 27 28 **29** 30

NOVEMBER

The view of Jerusalem is the history of the world; it is more, it is the history of earth and of heaven.

Benjamin Disraeli

Mechanical christmas hill: City of Jerusalem, threepart rotating pyramid

Max Vogel

Museum Europäischer Kulturen, Staatliche Museen zu Berlin

1 2 3 4 5 6 7 8 9 10 11 12 13 14 15 16 17 18 19 20 21 22 23 24 25 26 27 28 29 **30**

NOVEMBER

Monday's child is fair of face,
Tuesday's child is full of grace,
Wednesday's child is full of woe,
Thursday's child has far to go,
Friday's child is loving and giving,
Saturday's child works for its living,
And a child that's born on the Sabbath day
Is fair and wise and good and gay.

MOTHER GOOSE

Catharina Hooft with her Nurse, 1619/20
Frans Hals
Gemäldegalerie, Staatliche Museen zu Berlin

1 2 3 4 5 6 7 8 9 10 11 12 13 14 15 16 17 18 19 20 21 22 23 24 25 26 27 28 29 30 31

DECEMBER

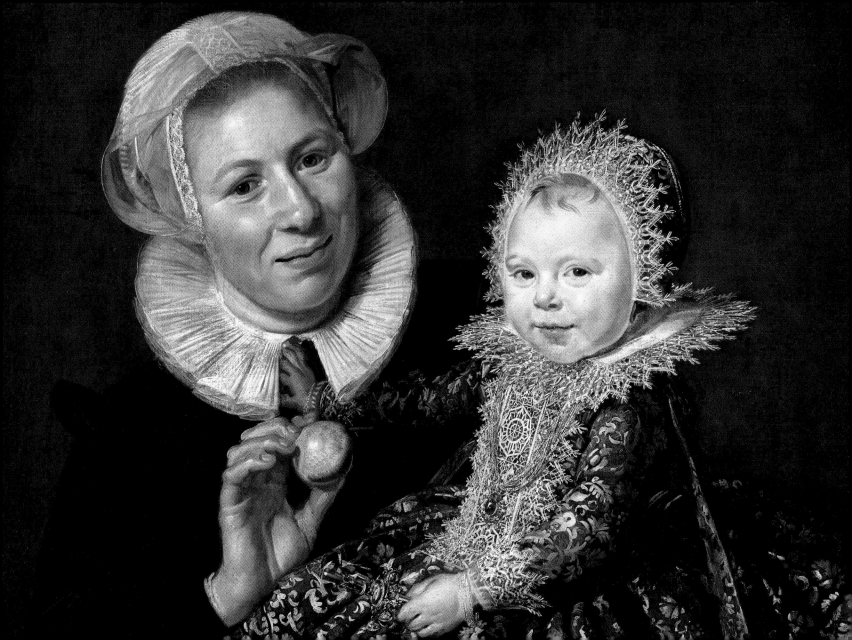

A painter paints the appearance of things, not their objective correctness. In fact, he creates new appearances of things.

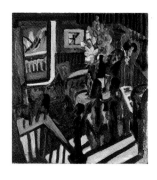

Studio Corner, 1922
Ernst Ludwig Kirchner
Nationalgalerie, Staatliche Museen zu Berlin

1 **2** 3 4 5 6 7 8 9 10 11 12 13 14 15 16 17 18 19 20 21 22 23 24 25 26 27 28 29 30 31

DECEMBER

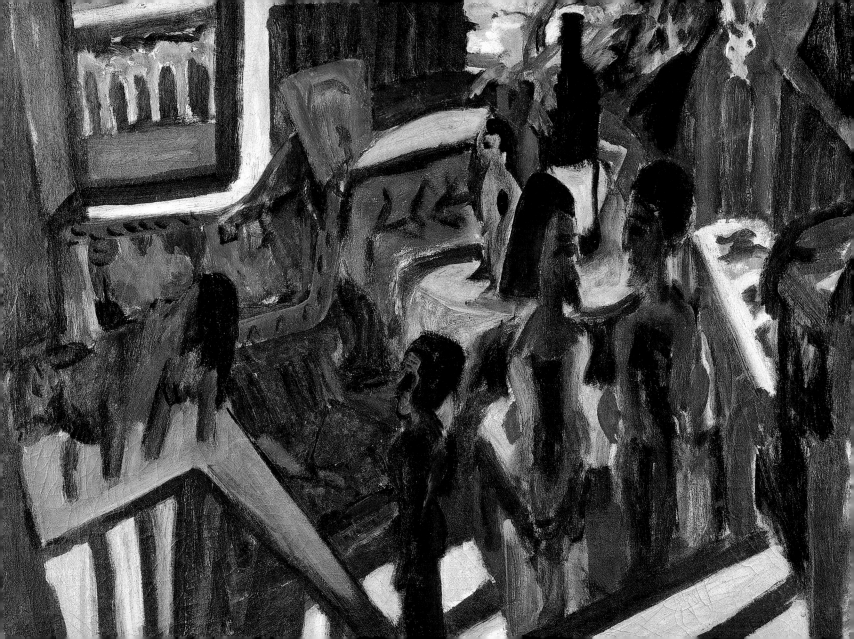

A man's face is his autobiography.
A woman's face is her work of fiction.

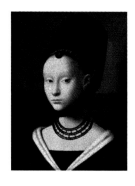

Portrait of a Young Lady, c. 1470
Petrus Christus
Gemäldegalerie, Staatliche Museen zu Berlin

3

1 2 3 4 5 6 7 8 9 10 11 12 13 14 15 16 17 18 19 20 21 22 23 24 25 26 27 28 29 30 31

DECEMBER

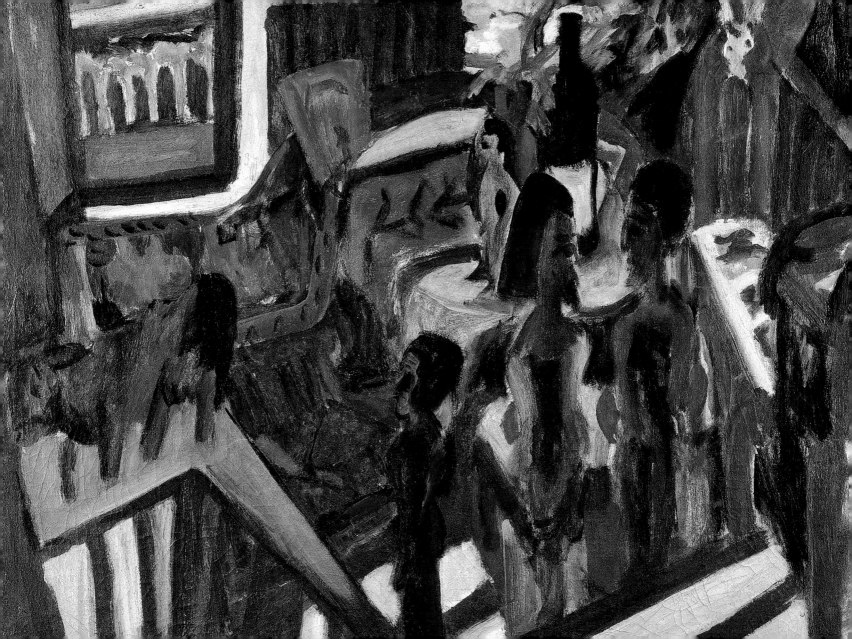

A man's face is his autobiography.
A woman's face is her work of fiction.

OSCAR WILDE

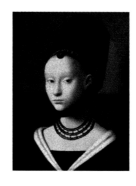

Portrait of a Young Lady, c. 1470
Petrus Christus
Gemäldegalerie, Staatliche Museen zu Berlin

1 2 **3** 4 5 6 7 8 9 10 11 12 13 14 15 16 17 18 19 20 21 22 23 24 25 26 27 28 29 30 31

DECEMBER

An artist never really finishes his work;
he merely abandons it.

Paul Valéry

Young Girl Resting, 1826
Johann Gottfried Schadow
Nationalgalerie, Staatliche Museen zu Berlin

1 2 3 **4** 5 6 7 8 9 10 11 12 13 14 15 16 17 18 19 20 21 22 23 24 25 26 27 28 29 30 31

DECEMBER

He who binds to himself a Joy
Doth the winged life destroy;
But he who kisses the Joy as it flies
Lives in Eternity's sunrise.

WILLIAM BLAKE

Italian Coastal Landscape at Dawn, 1642

Claude Lorrain
Gemäldegalerie, Staatliche Museen zu Berlin

1 2 3 4 **5** 6 7 8 9 10 11 12 13 14 15 16 17 18 19 20 21 22 23 24 25 26 27 28 29 30 31

DECEMBER

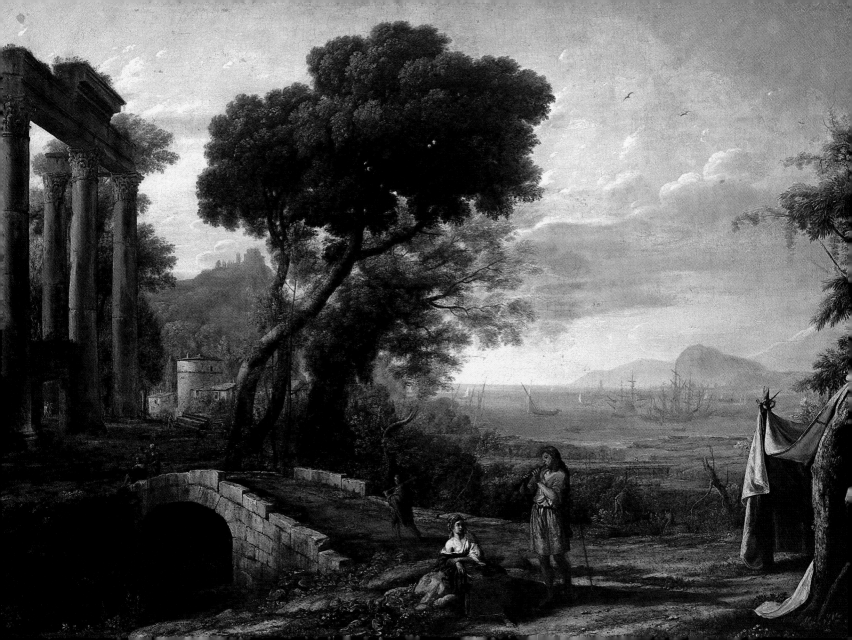

Piety practised in solitude, like the flower that blooms in the desert, may give its fragrance to the winds of heaven, and delight those unbodied spirits that survey the works of God and the actions of men; but it bestows no assistance upon earthly beings.

SAMUEL JOHNSON

Bust reliquary of Saint Blasius from the Guelphs' treasure in Braunschweig, middle of the 14th century

Kunstgewerbemuseum, Staatliche Museen zu Berlin

1 2 3 4 5 **6** 7 8 9 10 11 12 13 14 15 16 17 18 19 20 21 22 23 24 25 26 27 28 29 30 31

DECEMBER

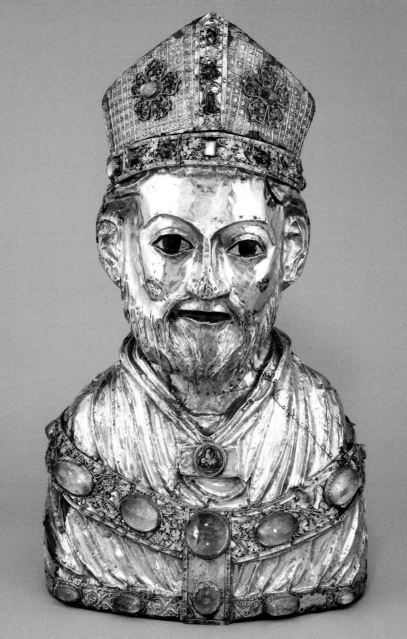

Perceive ye not that we are worms, designed
To form the angelic butterfly, that goes
To judgment, leaving all defence behind?
Than to be mindful of the happy time
In misery.

<small>Dante Alighieri</small>

Illustration for The Divine Comedy – Purgatorio I, after 1480
Sandro Botticelli
Kupferstichkabinett, Staatliche Museen zu Berlin

1 2 3 4 5 6 7 8 9 10 11 12 13 14 15 16 17 18 19 20 21 22 23 24 25 26 27 28 29 30 31

DECEMBER

Death is a delightful hiding place for weary men.

The Isle of the Dead III, 1883
Arnold Böcklin
Nationalgalerie, Staatliche Museen zu Berlin

1 2 3 4 5 6 7 **8** 9 10 11 12 13 14 15 16 17 18 19 20 21 22 23 24 25 26 27 28 29 30 31

DECEMBER

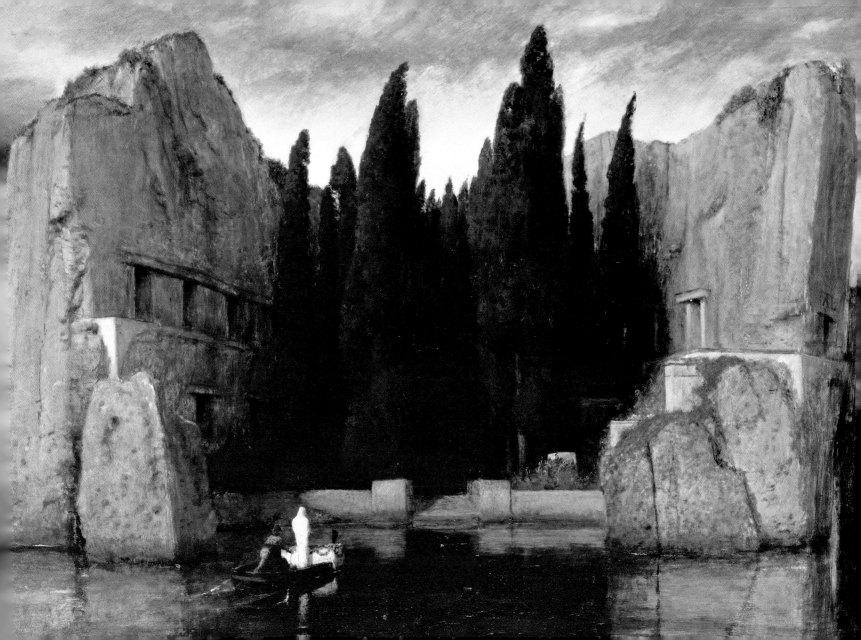

A horse is a thing of beauty. None will tire of looking at him as long as he displays himself in his splendor.

Xenophon

Amber horse from the Early Stone Age (replica), 4000 B. C

Museum für Vor- und Frühgeschichte, Staatliche Museen zu Berlin

1 2 3 4 5 6 7 8 **9** 10 11 12 13 14 15 16 17 18 19 20 21 22 23 24 25 26 27 28 29 30 31

DECEMBER

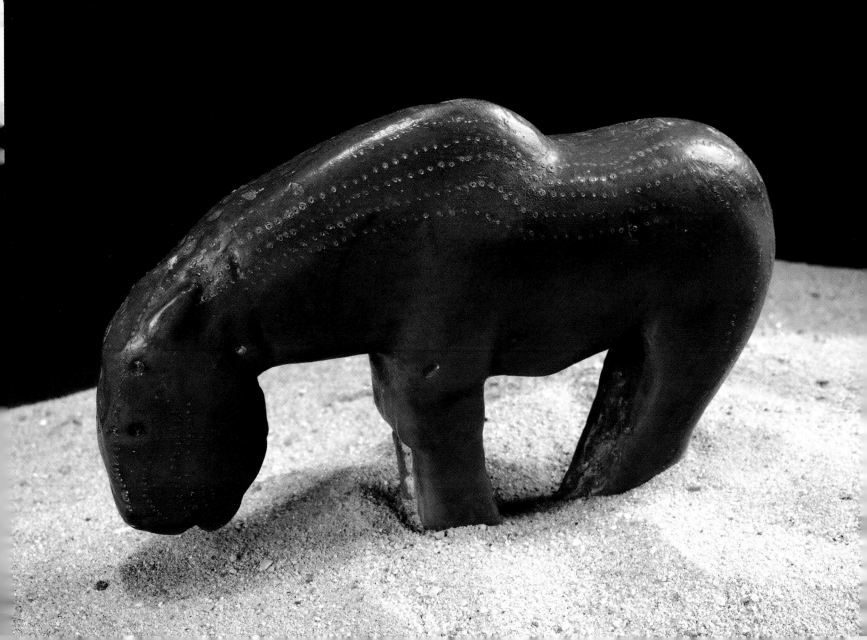

Mid pleasures and palaces we may roam,
Be it ever so humble, there's no place like
home.

J. H. PAYNE

The Mother, *c.* 1670
Pieter de Hooch
Gemäldegalerie, Staatliche Museen zu Berlin

1 2 3 4 5 6 7 8 9 **10** 11 12 13 14 15 16 17 18 19 20 21 22 23 24 25 26 27 28 29 30 31

DECEMBER

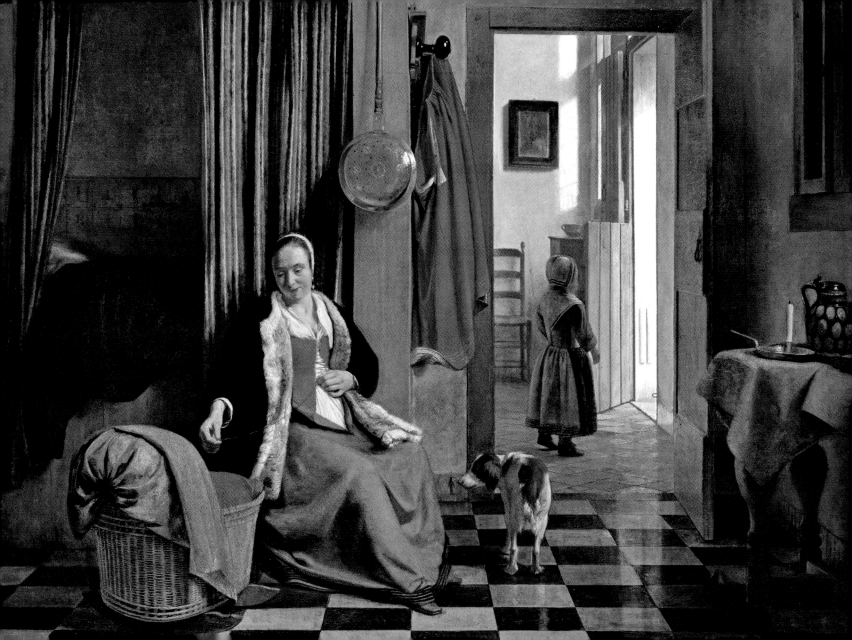

Mother is the name for God in the lips and hearts of little children.

WILLIAM MAKEPEACE THACKERAY

Madonna Pazzi, *c.* 1420
Donatello
Skulpturensammlung und Museum für Byzantinische Kunst, Staatliche Museen zu Berlin

1 2 3 4 5 6 7 8 9 10 **11** 12 13 14 15 16 17 18 19 20 21 22 23 24 25 26 27 28 29 30 31

DECEMBER

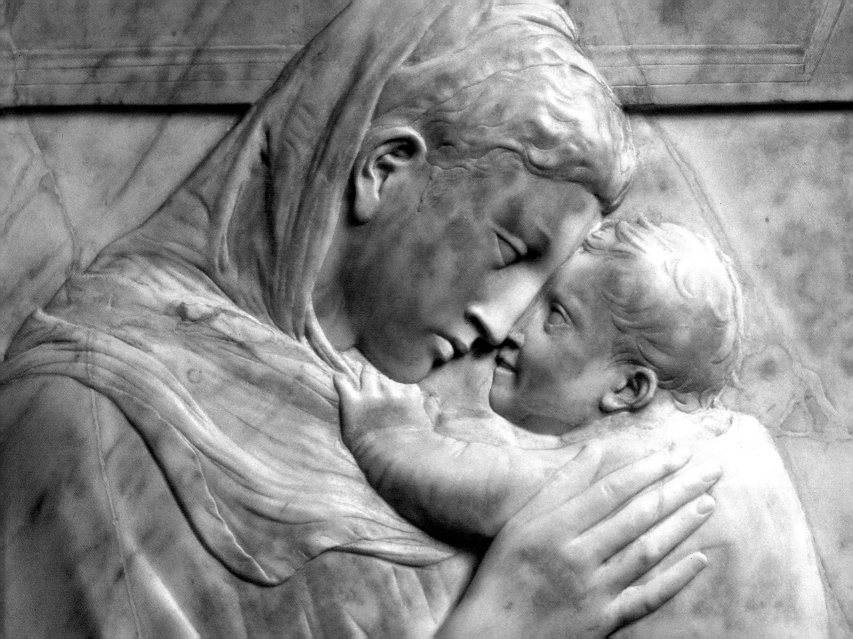

Nothing would be more tiresome than eating and drinking if God had not made them a pleasure as well as a necessity.

VOLTAIRE

Columbus Cocktail Titbit, before 1971
Karl Borro Palleta
Museum Europäischer Kulturen, Staatliche Museen zu Berlin

1 2 3 4 5 6 7 8 9 10 11 **12** 13 14 15 16 17 18 19 20 21 22 23 24 25 26 27 28 29 30 31

DECEMBER

What does little birdie say
In her nest at the peep of day?

Handle of a stone lantern, 9th century B.C.
Assur/Assyria
Vorderasiatisches Museum, Staatliche Museen zu Berlin

1 2 3 4 5 6 7 8 9 10 11 12 **13** 14 15 16 17 18 19 20 21 22 23 24 25 26 27 28 29 30 31

DECEMBER

If heart of a man is deprest with cares,
The mist is dispell'd when a woman
appears.

John Gay

Perseus Liberating Andromeda, *c.* 1620–1622
Peter Paul Rubens
Gemäldegalerie, Staatliche Museen zu Berlin

1 2 3 4 5 6 7 8 9 10 11 12 13 **14** 15 16 17 18 19 20 21 22 23 24 25 26 27 28 29 30 31

DECEMBER

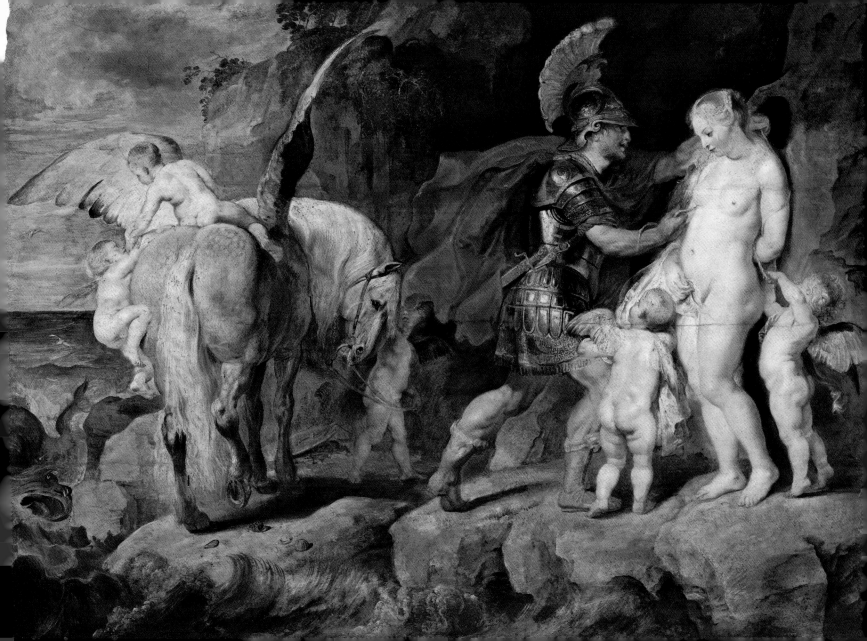

Do penance: for the kingdom of heaven is at hand.

Matthew 3:2

John the Baptist in Solitude, late 15th century

Geertgen tot Sint Jans

Gemäldegalerie, Staatliche Museen zu Berlin

1 2 3 4 5 6 7 8 9 10 11 12 13 14 **15** 16 17 18 19 20 21 22 23 24 25 26 27 28 29 30 31

DECEMBER

A mere copier of nature can never produce anything great.

Sir Joshua Reynolds

Ritual chariot with bird- and bull-ornaments (replica),
12th–9th century B. C.
Burg/Spreewald
Museum für Vor- und Frühgeschichte, Staatliche Museen zu Berlin

1 2 3 4 5 6 7 8 9 10 11 12 13 14 15 **16** 17 18 19 20 21 22 23 24 25 26 27 28 29 30 31

DECEMBER

*First keep the peace within yourself,
then you can also bring peace to others.*

Thomas à Kempis

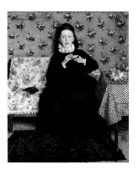

On the Sofa, 1872
Wilhelm Trübner
Nationalgalerie, Staatliche Museen zu Berlin

1 2 3 4 5 6 7 8 9 10 11 12 13 14 15 16 **17** 18 19 20 21 22 23 24 25 26 27 28 29 30 31

DECEMBER

O, Wind, If Winter comes,
can Spring be far behind?

Percy Bysshe Shelley

Winter Landscape with a Boardwalk

Philips Wouwerman

Gemäldegalerie, Staatliche Museen zu Berlin

1 2 3 4 5 6 7 8 9 10 11 12 13 14 15 16 17 **18** 19 20 21 22 23 24 25 26 27 28 29 30 31

DECEMBER

The world is charged with the grandeur of God.

<small>GERARD MANLEY HOPKINS</small>

Incense vessel, Sampaya, 500–1100 A.D.
Bolivia
Ethnologisches Museum, Staatliche Museen zu Berlin

1 2 3 4 5 6 7 8 9 10 11 12 13 14 15 16 17 18 **19** 20 21 22 23 24 25 26 27 28 29 30 31

DECEMBER

The poetry of the earth is never dead.

Valley in Fog, 1989
Higashiyama Kaii
Museum für Asiatische Kunst, Staatliche Museen zu Berlin

JOHN KEATS

1 2 3 4 5 6 7 8 9 10 11 12 13 14 15 16 17 18 19 **20** 21 22 23 24 25 26 27 28 29 30 31

DECEMBER

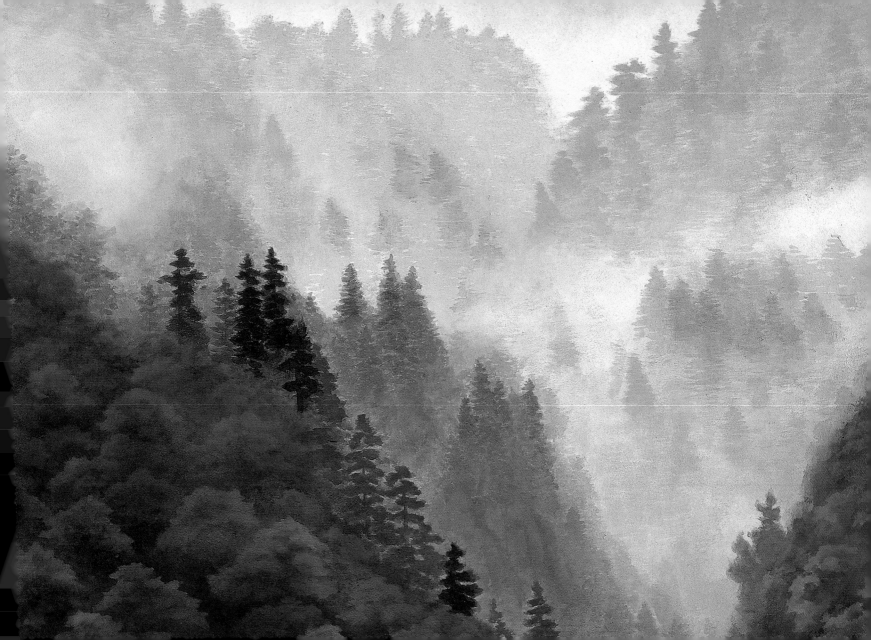

I never can feel certain of any truth but from a clear perception of its beauty.

JOHN KEATS

Bust of Nefertiti, 1351–1334 B. C.

Amarna/Egypt

Ägyptisches Museum und Papyrussammlung, Staatliche Museen zu Berlin

1 2 3 4 5 6 7 8 9 10 11 12 13 14 15 16 17 18 19 20 **21** 22 23 24 25 26 27 28 29 30 31

DECEMBER

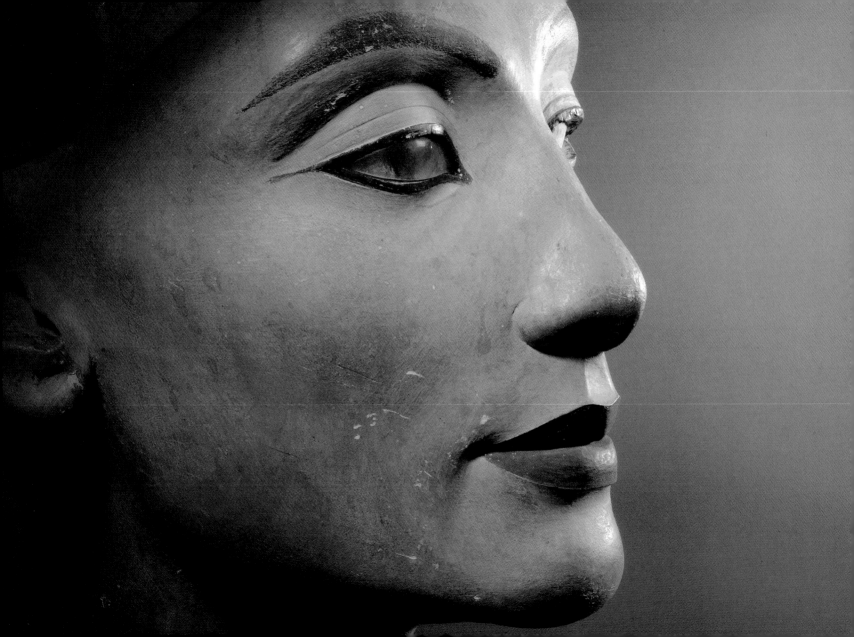

This ice is not made of such stuff
as your hearts may be.

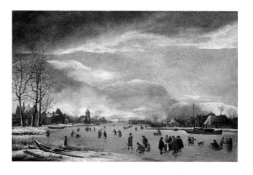

Frozen River Ice, Skaters and Strollers, 17th century
Anthonie Beerstraten
Gemäldegalerie, Staatliche Museen zu Berlin

1 2 3 4 5 6 7 8 9 10 11 12 13 14 15 16 17 18 19 20 21 **22** 23 24 25 26 27 28 29 30 31

DECEMBER

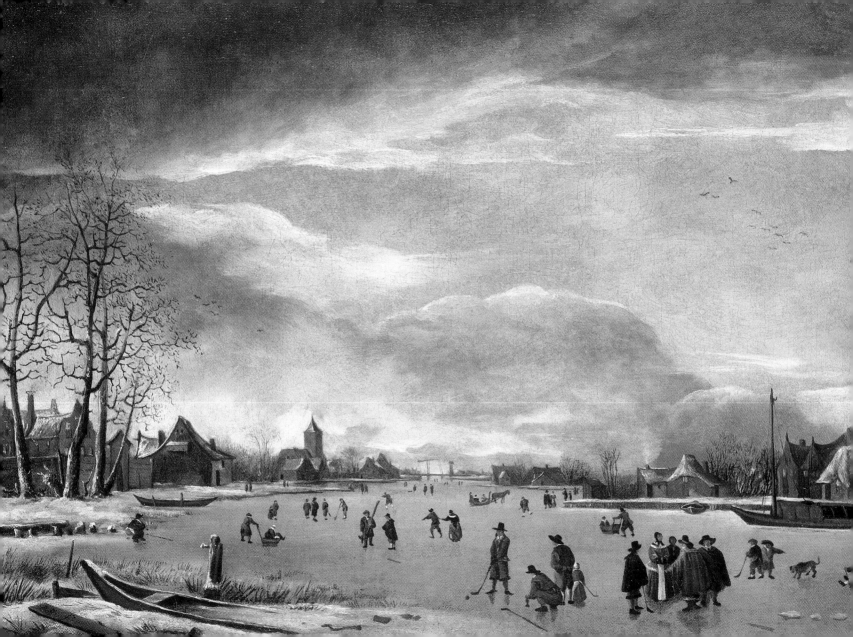

*The noblest function of an object
is to be contemplated.*

Miguel de Unamuno

Building charter in the form of a barrel with inscription,
604–462 B. C.
Vorderasiatisches Museum, Staatliche Museen zu Berlin

1 2 3 4 5 6 7 8 9 10 11 12 13 14 15 16 17 18 19 20 21 22 **23** 24 25 26 27 28 29 30 31

DECEMBER

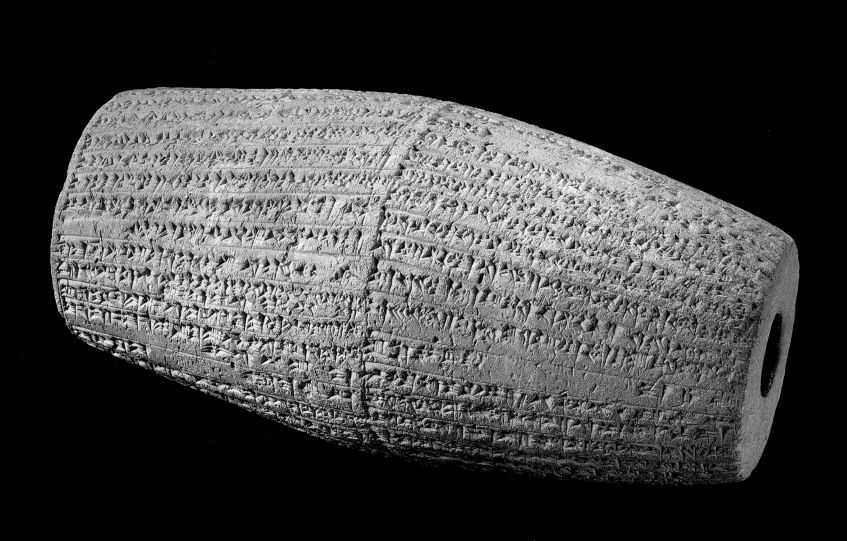

In the beginning was the Word,
and the Word was with God,
and the Word was God.

JOHN 1:1

The Birth of Christ, *c.* 1480

Martin Schongauer
Gemäldegalerie, Staatliche Museen zu Berlin

1 2 3 4 5 6 7 8 9 10 11 12 13 14 15 16 17 18 19 20 21 22 23 **24** 25 26 27 28 29 30 31

DECEMBER

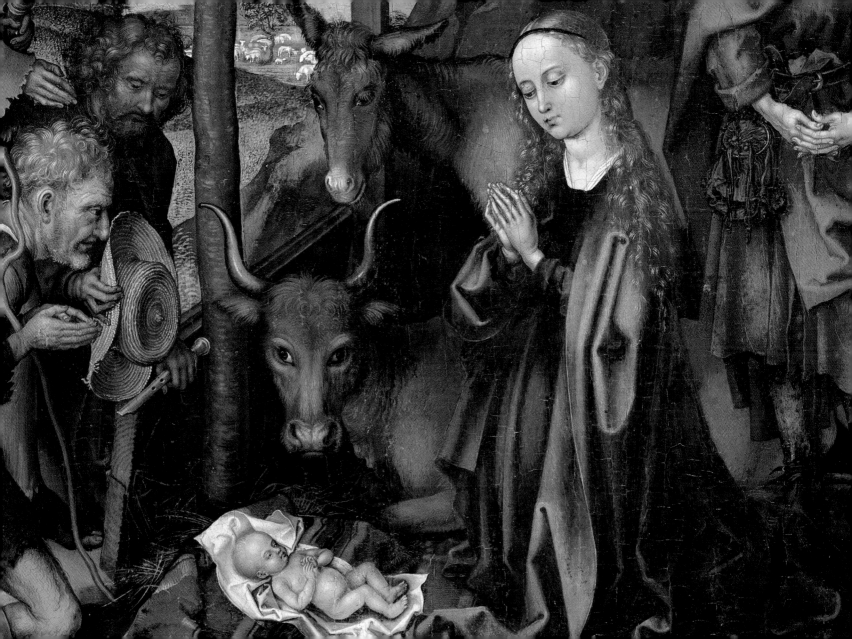

*A garden enclosed is my sister,
my spouse; a spring shut up,
a fountain sealed.*

SONG OF SOLOMON 4:12

Madonna on Crescent in Hortus Conclusus (enclosed garden),
1456
Unknown Master
Gemäldegalerie, Staatliche Museen zu Berlin

1 2 3 4 5 6 7 8 9 10 11 12 13 14 15 16 17 18 19 20 21 22 23 24 **25** 26 27 28 29 30 31

DECEMBER

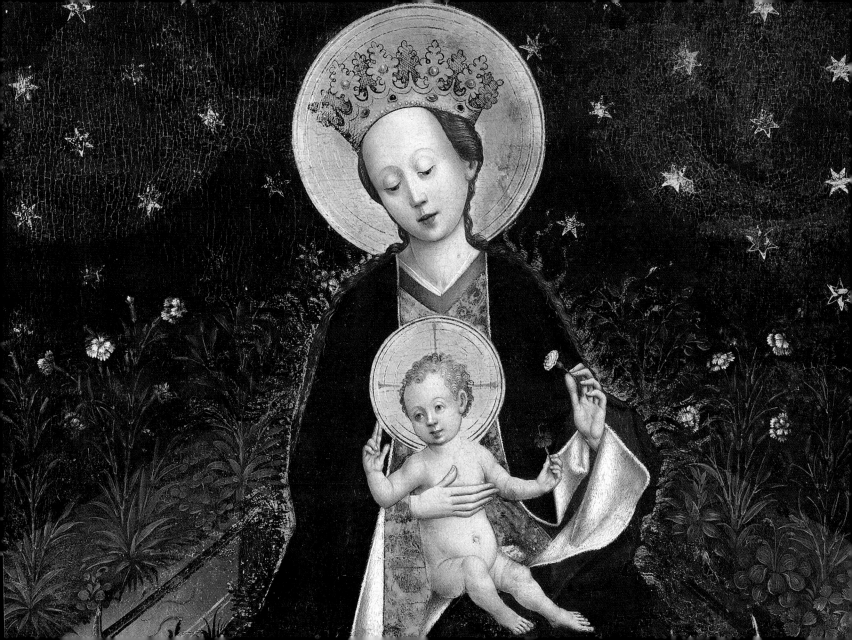

After Jesus was born in Bethlehem in
Judea, during the time of King Herod,
Magi from the east came to Jerusalem
and asked, "Where is the one
who has been born king of the Jews?
We saw his star in the east and have
come to worship him."

MATTHEW 2:1–1

Nativity, 18th century
Naples, kings and shepherds by Max Dietl
Museum Europäischer Kulturen, Staatliche Museen zu Berlin

1 2 3 4 5 6 7 8 9 10 11 12 13 14 15 16 17 18 19 20 21 22 23 24 25 **26** 27 28 29 30 31

DECEMBER

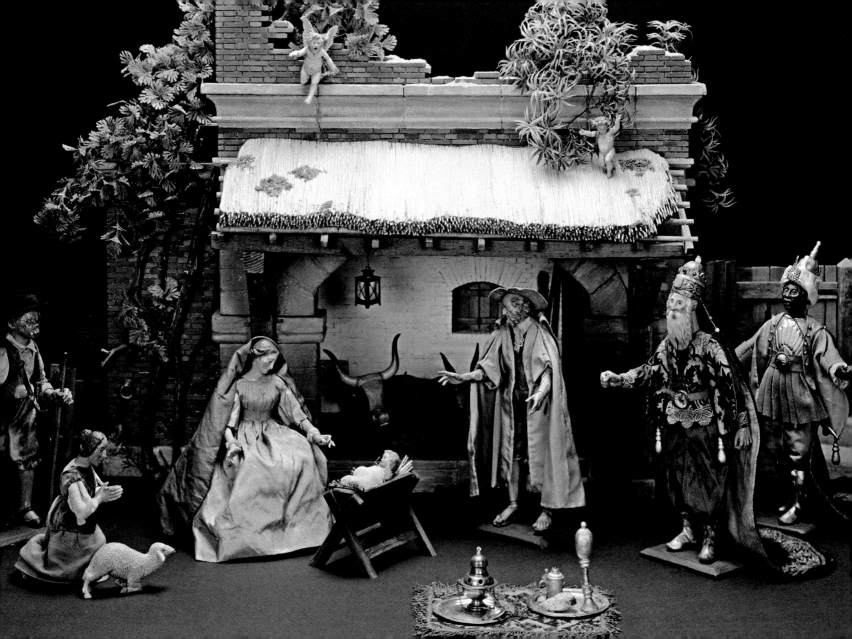

Clay mask

Peru

Ethnologisches Museum, Staatliche Museen zu Berlin

No one can wear a mask for very long.

Seneca

1 2 3 4 5 6 7 8 9 10 11 12 13 14 15 16 17 18 19 20 21 22 23 24 25 26 **27** 28 29 30 31

DECEMBER

She is Venus when she smiles;
But she's Juno when she walks.
And Minerva when she talks.

Ben Jonson

Venus with an Organ Player, 1550–1552
Titian
Gemäldegalerie, Staatliche Museen zu Berlin

1 2 3 4 5 6 7 8 9 10 11 12 13 14 15 16 17 18 19 20 21 22 23 24 25 26 27 **28** 29 30 31

DECEMBER

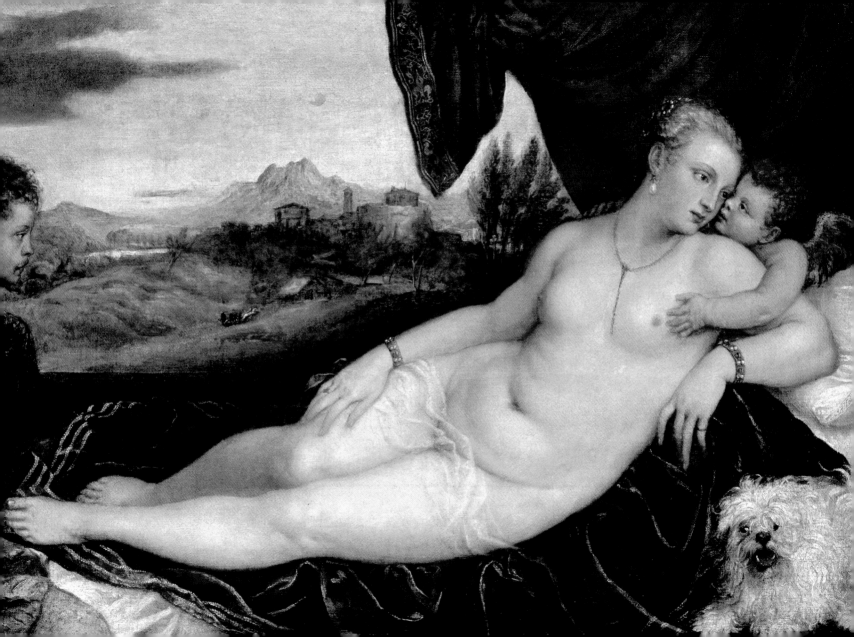

He that would be a painter must have a natural turn thereto. Love and delight therein are better teachers of the Art of Painting than compulsion is.

Albrecht Dürer

Wire Pulling Mill, c. 1494
Albrecht Dürer
Kupferstichkabinett, Staatliche Museen zu Berlin

1 2 3 4 5 6 7 8 9 10 11 12 13 14 15 16 17 18 19 20 21 22 23 24 25 26 27 28 **29** 30 31

DECEMBER

Ev'ry day a little death
On the lips and in the eyes,
In the murmurs, in the pauses,
In the gestures, in the sighs.
Ev'ry day a little dies.

STEPHEN SONDHEIM

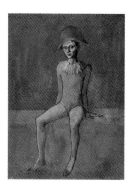

Sitting Harlequin, 1905
Pablo Picasso
Museum Berggruen, Nationalgalerie, Staatliche Museen zu Berlin

1 2 3 4 5 6 7 8 9 10 11 12 13 14 15 16 17 18 19 20 21 22 23 24 25 26 27 28 29 **30** 31

DECEMBER

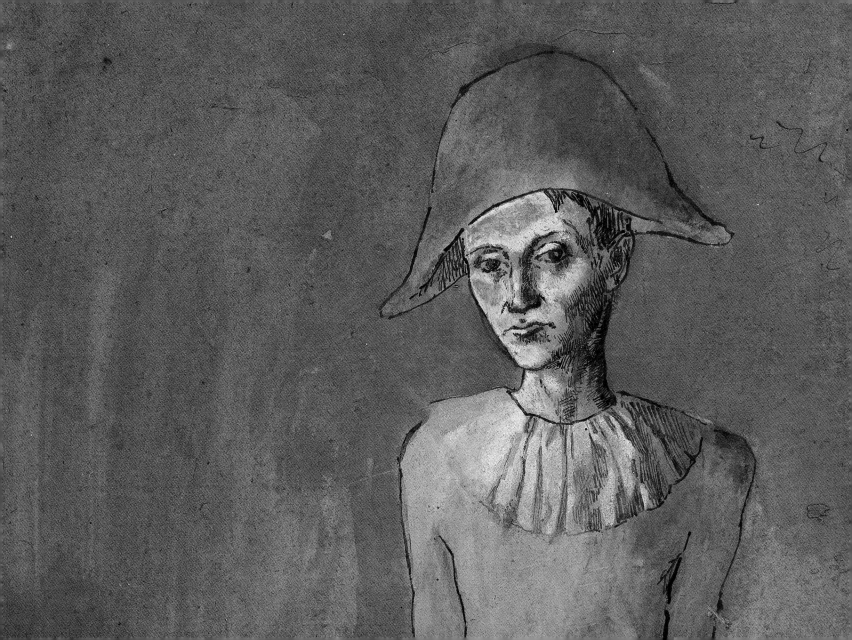

Astronomy compels the soul to look upwards and leads us from this world to another.

Astrolabe – Muhammad Zaman al-Mashadi,
second half of the 17th century
Iran
Museum für Islamische Kunst, Staatliche Museen zu Berlin

1 2 3 4 5 6 7 8 9 10 11 12 13 14 15 16 17 18 19 20 21 22 23 24 25 26 27 28 29 30 **31**

DECEMBER

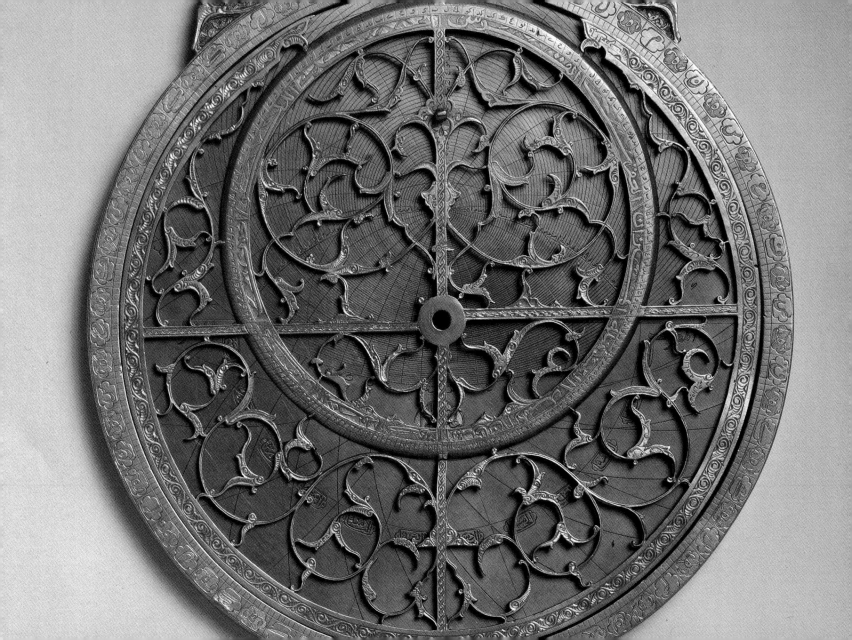

List of Artists

Alari-Bonacolsi, Pier Jacopo *October 9*
Altdorfer, Albrecht *October 29*
Amman, Jost *October 10*
Asselijn, Jan *May 22*
Ast, Balthasar van der *September 9*
Avercamp, Hendrick *March 1*

Backhuysen, Ludolf *August 23*
Barbier, Georges *November 8*
Baselitz, Georg *May 18*
Beckmann, Max *September 29, November 11*
Beerstraten, Anthonie *December 22*
Beerstraten, Johannes *January 7*
Beert, Osias *June 3*
Begas, Reinhold *October 28*
Bellini, Gentile *September 25*
Blechen, Carl *October 25, November 16*
Böcklin, Arnold *December 8*
Bol, Hans *March 8*
Borch, Gerard ter *October 2*
Bordone, Paris Paschalinus *March 12, July 21*
Botticelli, Sandro *May 5, October 16 (Workshop),*
 December 7
Boucher, François *March 23*
Bouts, Aelbrecht *July 29*
Bouts, Dieric *July 14, October 12, November 10*
Bronzino, Agnolo *April 19*
Bruegel the Elder, Pieter *March 16, October 18*
Bruegel the Younger, Jan *May 4*
Brugghen, Hendrick ter *August 29*
Bry, Theodor de *January 13*

Canaletto *January 18, August 19, September 5*
Campin, Robert *November 3*
Canova, Antonio *September 4*
Caravaggio *March 4 (copy), April 4*
Catel, Franz Ludwig *June 2*
Catlin, George *June 10*
Cézanne, Paul *March 3, April 18, July 10*
Chagall, Marc *January 29*
Chardin, Jean-Baptiste Siméon *March 10*
Chirico, Giorgio do *April 22*
Christus, Petrus *December 3*
Cima, Giovanni Battista *January 22*
Claesz, Pieter *January 14*
Corinth, Lovis *March 26, July 23*
Correggio *July 28*
Cosimo, Piero di *March 2*
Courbet, Gustave *June 5, November 21*
Cranach the Elder, Lucas *February 23, March 27,*
 November 19 (Workshop)
Cranach the Younger, Lucas *August 5*

Dalí, Salvador *February 22*
Degas, Edgar *March 18*
Dietl, Max *December 26*
Donatello *December 11*
Dürer, Albrecht *March 13, March 22, April 17,*
 June 13, July 1, December 29
Duyster Willem Cornelisz *February 11*

Eilbertus Master *July 19*
El Greco *September 12 (Workshop)*
Erhart, Michel *February 27*
Ernst, Max *March 20*
Eyck, Jan van *June 30, July 5, October 7*
 (Pupil)

Feininger, Lyonel *May 16*
Fiorentino, Rosso *July 30*
Flegel, Georg *April 26, July 3, October 21*
Fohr, Carl Philipp *January 21*
Fouquet, Jean *October 4*
Fra Angelico *September 27*
Friedrich, Caspar David *July 20, September 19,*
 October 6, November 2, November 25

Gaertner, Eduard *October 22*
Gainsborough, Thomas *August 2*
Gauguin, Paul *September 21*
Gentileschi, Orazio *March 30*
Gheyn, Jacques de *August 11*
Ghezzi, Pier Leone *May 21*
Giacometti, Alberto *June 17*
Goes, Hugo van der *January 6*
Gossaert, Jan *September 20*
Grien, Hans Baldung *June 6*
Günther, Ignatz *February 2*

Hackert, Jacob Phillip *June 7*
Hals, Frans *November 14, December 1*
Heckel, Erich *January 11, August 8*
Heem, Jan Davidsz de *June 16*
Hering, Doman *July 24*
Higashiyama, Kaii *December 20*
Hildebrandt, Eduard *July 18*
Hippius, Gustav Adolf *June 8*
Höch, Hannah *June 4*
Hoffmann, Hans *May 8*
Hooch, Pieter de *December 10*
Hokusai, Katsushika *April 13, October 27*
Holbein the Elder, Hans *November 6*
Holbein the Younger, Hans *May 14*
Horny, Franz *February 17*
Hugo, Victor *September 16*

Vermeer van Delft, Jan *January 1, August 27*
Verona, Michele da *February 26*
Verrocchio, Andrea del *May 19*
Vogel, Max *November 30*

Waldmüller, Ferdinand Georg *February 1*
Warhol, Andy *July 4*
Watteau, Jean-Antoine *April 27, May 20, June 25*
Weyden, Rogier van der *March 19, September 2 (Workshop)*
Witz, Konrad *June 11*
Wouwerman, Philips *December 18*

Photo Credits